AUGUSTUS JOHN

Autobiography

AUGUSTUS JOHN

Autobiography

With an Introduction by
MICHAEL HOLROYD

JONATHAN CAPE
THIRTY BEDFORD SQUARE LONDON

First published in one volume 1975
© 1964, 1975, by the executors of the late Augustus John
Introduction © 1975 by Michael Holroyd

Jonathan Cape Ltd, 30 Bedford Square, London WC1

ISBN 0 224 01060 3

Chiaroscuro was first published in 1952
and *Finishing Touches* was first published in 1964

Printed in Great Britain by
Lowe & Brydone (Printers) Ltd,
Thetford, Norfolk

Contents

List of Illustrations

Introduction

'I AM TWO people instead of one: the one you see before you is the old painter. But another has just cropped up – the young writer.' With these words at a Foyle's Literary Lunch in March 1952, Augustus John announced the publication of *Chiaroscuro*, his 'fragments of autobiography'. It had been a lengthy cropping-up – a month or two short of thirty years. 'I think we must all write autobiographies. There would be such side-splitting passages,' he had urged Henry Lamb on June 13th, 1907. But it was not for another fifteen years that he was first importuned by a publisher, Hubert Alexander. 'I've been approached by another firm on the subject of my memoirs,' he replied on February 21st, 1923. The approaches multiplied, grew bolder; the delay lengthened, became confused. A synopsis – three-and-a-half sides of Eiffel Tower paper in fluent handwriting reaching forward to 1911 – was probably done before the end of 1923, but sent to no one; and another period of fifteen years slipped by before a contract was signed. The interval was full of rumours: whispers of vast advances and extraordinary disclosures, almost all of which were unfounded. 'Did I tell you about August[us] John, whom I duly tackled or rather sounded, weeks ago?' T. E. Lawrence asked Jonathan Cape. 'He said lots of publishers had been at him. One offered him £10,000 in advance of royalties for his memoirs. He said, "Oh, that's not enough: I want £20,000." They rose to £13,000.'

John was surprisingly well-read – surprisingly because he was never *seen* with a book. Visitors were made to feel that it was somehow reprehensible to be caught in the act of book-reading. John himself read in bed. He devoured books voraciously, reading himself into oblivion to escape the horrors of being alone.

Introduction

His library, an unselfconscious accumulation, reflected the wide extent of his tastes – occultism, numerology, French novels, Russian classics, anarchical studies, Kaballah – and the ill-discipline with which he pursued them all.

He had long dreamed of writing. Privately he composed verse – ballads, sonnets, limericks – and was immoderately gratified when Dylan Thomas exhorted him to pack in painting for poetry. But he had also written for publication: first, with the encouragement of Scott Macfie, for the *Journal of the Gypsy Lore Society*; then, with the approval of T. E. Lawrence, a preface for a J. D. Innes Catalogue; after that, with the help of T. W. Earp, eight articles on painting for *Vogue* in the late 1920s; finally, with Anthony Powell's support, an essay on Ronald Firbank for Ifan Kyrle Fletcher's symposium. He needed encouragement, and when Jonathan Cape offered him a contract in 1938 he responded eagerly.

This contract is an engaging work of fantasy. John was to deliver his completed manuscript by All Fools' Day 1939 'or before'. The length was to be 'at least 100,000 words' and it should be 'copiously illustrated'. The prospect excited everyone. 'I believe this to be a big book on both sides of the water,' enthused his American publisher, Alfred McIntyre of Little, Brown and Company. Much correspondence crossed this water over the next twelve months from one publisher to the other: but from John, nothing. He had equipped himself with a literary agent to whom, on May 2nd, 1939, he expressed his appreciation of their dismay. Nevertheless 'the idea of the book has developed and interests me more and more,' he maintained.' ... when I am quite myself again it will unroll itself without much difficulty and turn out a success.' This game continued for another year. To each fast service he would return the same slow lob. The war, interpreted by both publishers as a vital need for acceleration, he reinterpreted as a fresh reason for delay. Yet he continued patiently

to play the optimist. Already, by January 1940, he had made 'an important step forward in destroying what I have already written,' he promised Cape. In vain his agent would expound John's method of allowing 'his work to accumulate until everybody loses his patience and subsequently complete it in an incredibly short time'. It was a case of 'this year, next year, some time – ' growled Cape. 'Each time I have seen him [John], he has told me how busy he is, painting portraits.' The publishers formally conceded defeat in the autumn of 1940. No money had changed hands, but the fabulous contract expired and the first stage of negotiations was at an end.

Jonathan Cape, however, had not surrendered. 'I have the strong conviction that John is a natural writer,' he had told Alfred McIntyre. The book had been conceived; what it now needed was a team of midwives to nurse it into the world. First of these *aides-mémoire* was Cyril Connolly, who had recently launched his monthly review of literature and art, *Horizon*. In conversation with Connolly one day, John volunteered to write something for the review, and this led to an arrangement whereby Cape allowed Connolly to have, without fee, what amounted to serial rights in John's autobiography. Between February 1941 and April 1949, when he relapsed with nervous exhaustion, John contributed eighteen instalments to *Horizon*. He liked writing in short sections and, every time he had a few pages ready, he would organize an evening with Connolly in London. Without this constant support, it is unlikely that the book would ever have been written. John's letters are full of author-complaints. 'Writing costs me great pain and labour,' he pointed out to Leonard Russell, 'besides taking up much time.' He seized upon air raids, black-outs, apple-tree accidents, electricity cuts, bouts of 'Mongolian Flu', broken ribs, operations, thunderstorms – any narrow squeak or Act of God that made painting impracticable – to turn to 'my literary responsibilities'. The guaranteed publication in *Horizon*

helped to give him impetus, but his contributions there have a stranded look – unconnected with anything happening in the world or with much else in the review.

At the beginning of 1949 Jonathan Cape tiptoed back into the arena, and John was persuaded to reorganize his *Horizon* pieces into a book. He made heavy weather of this 'colossal task'. Secretaries were provided; he changed his agent; joined the Society of Authors: but the written word was still recalcitrant. In place of Cyril Connolly, Jonathan Cape dispatched John Davenport as literary philosopher and friend, and the two of them 'spent many pleasant days together at odd intervals'.

Back in London, Cape foamed with impatience. He began to petition some of John's friends and, a bad blunder, girlfriends. Learning of this, John fell into a passion. His publisher was excavating for 'scurrility and scandal which I'm not able or willing to provide'. To John Davenport he pointed out the terrible lesson this had taught him against over-familiarity with tradespeople. 'I regret having been inveigled into getting on friendly terms with this businessman … he had incidentally an eye on Mavis.'

In 1950 Cape sent his last ambassador to John's home – Daniel George. 'My function was merely that of the tactful prodder, the reminder of promises, the suggester of subjects, the gentle persuader,' Daniel George wrote. John's writing technique, similar to his method of painting, depended upon timeless revision. 'From time to time I would receive from him two or three quarto sheets of small beautifully formed and regular script,' Daniel George remembered. ' … On one such sheet now before me are twenty-five lines, only seven of which are without some emendation. One line reads: "I am a devil for revision. I cannot write the simplest sentence without very soon thinking of a better one." Here the words "very soon" have been changed to "at once".'

John called it 'putting my stuff in order'. Once a few pages had

been typed, they were sent back to him, and after further copious corrections he would submit them for retyping. They were then returned to him and he would set about 'improving certain recent additions and making a few new ones'. This process would jog on until, somewhere on its peregrinations, the typescript was mislaid. 'I am most unmethodical,' John admitted, 'and have been troubled too by a poltergeist which seizes sheets of writing from under my nose and hides them, often never to reappear.' It was Daniel George who released him from this deadlock by inventing a conspiracy of forgetfulness. He 'forgot' to send the revised revisions back to John who forgot never having received them. It worked perfectly. After this John's area for revision was restricted to the title, which he altered a dozen times before uniting everyone in opposition to his final choice, *Chiaroscuro*.

The book was reviewed widely and favourably. Lawrence Hayward in the *Guardian* called John 'a writer of genius', and other distinguished authors, including Desmond MacCarthy, Sacheverell Sitwell and Henry Williamson all praised the quality of his prose. 'Augustus John is an exceptionally good writer; and upon this reviewers have dilated, with a tendency to compare him with painters who have written books,' criticized Wyndham Lewis in the *Listener*. 'This is the obvious reaction it would seem, when a painter takes to the pen: to see a man of that calling engaged in literary composition, affects people as if they had surprised a kangaroo fountain-pen in hand, dashing off a note. The truth is that Augustus John is doubly endowed: he is a born writer, as he is a born painter ...'

These reviews were an accurate measurement of the great affection in which John was held – an affection that ignored the unhappy complications of his character. 'What a pleasure it is to read this robust autobiography of a man who has achieved all he has desired from life,' exclaimed Harold Nicolson in the *Observer*. To the devastating irony of such a conclusion many

Introduction

were blind. Only Tom Hopkinson, in *Tribune*, attacked the book in print; otherwise criticisms were voiced in private. One of the most severe critics was the man who, perhaps more than any other, had helped to get it written – Cyril Connolly. In Connolly's view, despite the long years of preparation, John had not gone through enough agony. 'For someone who was such a brilliant conversationalist he was terribly inhibited when he wrote ... He would fill his writing with the most elaborate clichés. He couldn't say "she was a pretty girl and I pinched her behind." He would say, "The young lady's looks were extremely personable and I had a strong temptation to register my satisfaction at her appearance by a slight pressure on the *derrière*."

Only in the opening pages, recalling his boyhood in Pembroke-shire, did John achieve a sustained and imaginative narrative. The rest of the autobiography arranges itself into a scrapbook, broken up into brief, haphazardly plotted incidents without reference to dates or chronological sequence. The absence of any discussion of his work, or any self-revelation, disappointed some readers. Increasingly he relied on a procession of famous names and a chain of indistinct, even inaccurate[1] anecdotes relating, with much relish, the misfortunes of his friends and the loss of their women to him – traits that were to be amusingly parodied by J. Maclaren-Ross.

John's preference for a combination of long reverberating syllables to a single short word greatly encumbers his prose, but does not conceal his genuine enjoyment of language. There are many passages of sudden beauty, of wit and penetrating irony: but being unattached to anything they do not contribute to a cumulative effect. He had laboured long at these fragments, but never to connect them, and the result, he concluded, was 'a bit crude and unatmospheric'. Contrasting Caitlin Thomas's *Leftover Life to*

[1] For example, compare John's references to Vera Oumançoff and Jacques Maritain with Maritain's *Carnet des Notes* (Desclée de Brouwer, Paris, 1965) pp. 412–14.

Kill with *Chiaroscuro*, he wrote to Daniel George: 'As a self-portrait it's an absolute knock-out. Unlike me she cannot avoid the truth even at its ghastliest.'

As soon as *Chiaroscuro* was published, he started 'writing on the sly' a second series of fragments. John Lehmann, editor of the *London Magazine*, and Leonard Russell of *The Sunday Times* assisted one section or another into print, and 'Book-lined Dan' as he now called Daniel George, continued with him to the end. As with *Chiaroscuro*, there are good pages. But generally the second volume is scrappier than the first. The fragments are often abrupt and composed with such a wealth of hintings and obscurities that it is difficult to quarry out any meaning. John had become so 'literary' that he could not achieve an innocent style. Against the background of his paintings, simple and primitive at their best, the deviousness of this writing is extraordinary. Like a cataract, it had spread over his eyes, obscuring his painting too. In the book he focused his mind retrospectively on the actual world which, in these last years, held for him a lessening interest. His dream world, an anthology of past sights and sensations, lay elsewhere serenading his imagination. In almost ten years he completed 110 pages – and his passion for postponement seemed to extend even beyond the grave. Not until three years after his death, and four years following the death of Jonathan Cape, was it published in 1964. There could be no amendments this time to a title which, perhaps unintentionally, summarized all that had plagued him most: *Finishing Touches*.

Artists, because of their involvement, are prejudiced judges of their contemporaries; but their opinions are always interesting. It is for the authentic first-hand impressions, not for any painstaking reconstruction of the past or scholarly contribution to art-history, that Augustus John's autobiography will continue to fascinate readers. For this reason, the present edition, which for the first time amalgamates *Chiaroscuro* and *Finishing Touches*, repro-

duces John's own chronology and the editorial arrangement of Daniel George. To re-order the sequence, pepper the narrative with indignant dates, produce an undercurrent of knowing footnotes would be to deprive the book of its charm and originality. These are John's own words. He had enough help in his lifetime; he needs no further interference now.

MICHAEL HOLROYD

Chiaroscuro

Pembrokeshire

PEMBROKESHIRE is divided into two parts by a line cutting across the county separating it sharply into Welsh- and English-speaking districts. Upon the basic Welsh, not to speak of pre-Celtic aborigines, have imposed themselves Scandinavian, Roman, Norman, Saxon, Irish and Flemish elements. The English spoken is good but the Welsh, I am told, is better. Haverfordwest, the centre of the Flemish colonization, was the home of my father's people. Successive bands of mercenary troops, weavers and masons from Flanders at the beginning of the twelfth century, by royal permission, and with a view to keeping the turbulent Welsh in check, were allowed or encouraged to intrude on the then Scandinavian town and district of Haverford (Havrefiord), and ended by dominating more than half the county. The name of a suburb of Haverfordwest, Prendergast, attests the permanence of the colonization, and the neighbouring village of Langum is reputed to be still inhabited by authentic descendants of the 'Flemings', who elsewhere seem to have amalgamated with the Welsh. In view of the mist that hides my origins, mysterious as those of any hero of antiquity, I have sometimes wondered if a strain from Flanders may not have enriched the family bloodstream. Nothing could be likelier.

If I was ever curious about our past history, I was not encouraged to investigate it by my father. 'We come of a line of professional people' was all I could get out of him. This caginess was characteristic of the lawyer, by training unaccustomed to hand out information for nothing. I volunteered the suggestion that such paucity of detail might easily be taken as reflecting adversely on the character of our antecedents. We couldn't *all* have been lawyers. Could there have been among them less

reputable people who were best forgotten? This tactless conjecture wasn't well received by my respectable parent. The subject was then dropped and I never revived it. Whoever my forbears might have been, the main thing, I thought, was to discourage any traits I might have derived from them. To me, the possession of inherited characteristics was humiliating: like borrowed plumes, they added nothing to one's real stature, and only converted what should be a unique, new and indivisible entity into a mere chip of some old forgotten block or series of blocks. I wanted to be my own unadulterated self, and no one else. And so taking my father as a model, I watched him carefully, imitating his tricks as closely as I could, but in reverse. By this method I sought to protect myself from the intrusions of the uninvited dead.

My mother would no doubt have been helpful, but she died when I was a small child, after, I fear, a very tearful existence. Her place was taken by a couple of aunts, who devoted themselves conscientiously to the upbringing of the children, of which there were four.

At that time a powerful evangelical wave was sweeping the country. 'Salvation' was the order of the day. General Booth's war-cry was heard in the land and his troops went into battle to the sound of tambourines. These were heroic years. Nothing could withstand the assaults of the maenads in poke bonnets. Strong men, pickled in sin, were seen to waver and wilt before them, till at last they flung themselves to the ground, and, crying like little children, begged for mercy. Both my aunts had joined the Army and held high rank. The elder of the two, Lila, already a notable saver of souls, had toured the U.S.A., bringing many to Jesus. In her travels she had acquired a slight American accent and an improved platform technique.

Even Royalty felt the power of this spiritual revival. Aunt Lila was a prominent member of The Princess Adelaide's Circle,

though she never mentioned this fact herself. Her sister Rose had at one time belonged to the Countess of Huntingdon's Connexion, but both, in their quest for the truth, had tried, it seemed, every form of religious practice except Roman Catholicism. They had even 'tried the spirits'. Our servant girls knew that the R.C.s worshipped the Virgin Mary, and this, I never knew why, was held in the greatest horror by them. My father, with his strong distaste for change and eccentricity, stuck to the established church. His children were brought up and confirmed in it. I too prefer the traditional religious styles as developed in the past, and am no modernist. Nothing I know of approaches the vulgarity of the chapels or places of worship erected by the sectarians. Such monstrosities, one would think, could only be the offspring and nurseries of cant and ignorance. There exist, however, old-fashioned little Bethels, Zions and Bethesdas of an earlier period which charm me. We used sometimes to be taken to these by our Welsh servants of a Sunday. The fervid singing, the praying and the preaching, in a language the more moving for being incomprehensible, affected me powerfully, and when the orator broke into the *hwyl* or afflatus, with which all Welsh sermons should terminate, it sounded to me like the veritable voice of God.

We used to visit the home of our nurse, somewhere in the wilds of Prescelly. The men here were small, dark and bearded. They were woodmen and probably Euskarians. Everybody wore pointed clogs with brass toe-caps. We sat on our stools with our bowls of *cawl* and listened, in wonder, to the clatter of the clogs on the stone flags and the unceasing bavardage of our Welsh friends, few of whom knew a word of English.

Haverfordwest

On market day at Haverfordwest the streets and squares were full of life and movement. Noise too, with the continual lowing

21

of cattle, the screaming of pigs and the loud vociferation of the drovers. Among the crowd were to be seen the women of Langum, in their distinctive and admirable costume, carrying creels of the famous oysters on their backs. Tramps, looking like peripatetic philosophers of the school of Diogenes, would congregate idly at street-corners. Perhaps they had passed a night on the lime-kilns where sometimes, it was said, the unwary among them, seeking warmth, would fall asleep upon the upper stones, till, sinking gradually, they would soon be asphyxiated and reduced to ashes by the morning.

Gypsies arrived on the scene with their horses and light carts. These people interested me greatly. Those sardonic faces, those lustrous oriental eyes, even then did cast their spell upon me. We were taught to beware of the Gypsies; their habit of kidnapping children was notorious; yet they seemed to have plenty of their own. Aloof, arrogant, and in their ragged finery somehow superior to the common run of natives, they could be recognized a mile off. I was destined to know these people better in time to come.

The path by the river Cleddau known as the Frolic was my favourite walk. Looking back across the tidal flats, the grey town rises steeply from dilapidated wharves, to culminate in the dark silhouette of a Norman castle now used as a goal. In the middle distance a train, issuing apparently from a group of ivy-clad ruins, rumbles along under its woolly banner, till with a despairing wail, it plunges into the hillside and is lost to view. I never ceased to marvel at this phenomenon.

Passing a pyramid of carved blocks which marked the industry of a clog-maker, the path, all too soon, comes to an end, and the river, turning, vanished between wooded shores on its way to Milford Haven (Midfiord), the pride of the county.

Another walk we loved was, for some unknown reason, called Scotch Wells. The approach to this led us past a water-mill,

which, when in action, emitted pleasant thumping and booming sounds: sometimes the miller himself would appear to greet us, smilingly, white with flour from head to foot, like a figure in a folk-tale. Entering by an iron turnstile, which always played a little tune, we followed a path by the millstream under a colonnade of tall trees. In front walked 'Papa' at a moderate but unvarying pace, while his children straggled fitfully in the rear. Among Papa's habits was gathering primroses in their season, and, when at the seaside, shells. His collection of cowries alone would have made a rich man of him in Central Africa.

The South Parade made a third popular promenade. This was on a height overlooking the valley of the Cleddau. The Workhouse, or Union, was up here, and we sometimes met a procession of pauper girls in their blue uniforms, out for exercise. Descending a zigzag path which passed dangerously near the cottage of a reputed witch, we reached the road below. Here it was necessary to bury our faces in nosegays plucked for the purpose, as we hurried past the frightful exhalations of a tannery.

Broad Haven

In the summer we moved to Broad Haven on St Bride's Bay, where my father had a house. The drive there was thrilling from the start, but our excitement reached its climax when the sea was first caught sight of over the flower-starred hedges. Once arrived, we lost no time in discarding shoes and stockings and raced past the *liac*, or brook, down to the sea. At Broad Haven we were happier, for the wild world was at our doorstep, and the aunts, fully occupied in good works, left us much to our own devices, while they perambulated the district in a wickerwork pony-trap, known locally as the 'Hallelujah Chariot'.

These good ladies showed some weakness when they made no

23

firm stand against our being taken to our first circus at Haverford-west. They disapproved of course, and rightly, for I, for one, came away corrupted for life. They may have heard of but never saw the superb creature in tights who sang 'His moustache was down to heah, Tiddy-fol-lol!' I shall never forget her, though I can't remember the date: but the song should indicate it sufficiently. There must be few of our elder sportsmen left who, reading this, will not hear a bell ring, especially if I add a quotation from another ditty which went: 'I've a penny in my pocket, La-di-da!'

A curious experience befell me as a small boy when one day I was taken to a fair. In the charge of an attendant maid, I was watching the roundabout revolving, when a boy about my own age fell off his wooden horse and was picked up howling, with a bleeding mouth. By some mysterious dreamlike process I transferred this occurrence to myself, and for some years was, off and on, under the impression that my tongue was wholly or in part amputated. This possibly gave rise to a stupid and irritating dumbness which my father sometimes felt obliged to apologize for in company.

At Broad Haven the children went bathing with the female members of the household under the shelter of the cliffs. Our aunts did not join us in this exercise. The disrobing of our attendants and their drying and dressing operations permitted glimpses of feminine grace and plenitude, which, speaking for myself, was both educative and stimulating.

A primitive sect in the district practised the rite of Baptism by Total Immersion. This ceremony was conducted in a brook or sometimes in the sea, and we used, on occasion, to attend it. The Minister, up to his waist in water, would dip the neophytes, one by one like sheep, to the accompaniment of singing by the congregation on the banks. The girls with their skimpy black frocks, saturated and clinging, emerged like Naiads from the

ordeal. Without making these observations at the time, I admired the spectacle and would willingly have undergone initiation on such lines, for I was fond of water, and often got my clothes wet for worse reasons.

An artist would sometimes appear in the neighbourhood and set up his easel. My sister Gwen and I, full of curiosity, would approach as near as we dared, to watch the mystery of painting. Even at that early age we were vaguely aware of Art and Beauty.

An interesting family named George lived near by. Handsome and haughty, they attracted and repelled us, but all the same we forgathered on the beach sometimes. I have often regretted the timidity and false pride that kept Teresa George and me apart so long. She called on me in London years later and informed me that my father was seeking her hand in marriage. He and I had something in common after all, then! In spite of my approval of the match, Teresa, to my disappointment, decided against it.

Once I saw a phantom island rising from the bay. It was steep and squarish. Excitedly I pointed it out to my father, with whom I was walking: but averting his head after one glance, he hastened his steps, murmering unintelligibly, and it had vanished when I looked again. I knew it wasn't Ireland, but could it have been Tir-nan-Ogue, the magic Island of the Young? I think so now.

When indoors I was happiest sitting in a 'skew' by the kitchen fire. I liked the comings and goings and the witty chatter that went on there. Sometimes a drunken man would come in to make a nuisance of himself. The women knew how to deal with such a one. Making him comfortable in an armchair, they sang and even danced to him, until the wretch would at last subside in tears of sweet contrition.

The day started with prayers in which all joined. Those who could read were given tracts, and such improving literature as *Jessica's First Prayer*, *Christy's Old Organ*, *The Lamplighter*, etc., etc.

25

Chiaroscuro

Tenby

Soon after the death of my mother, when I was five or six, my father made the great decision of his life. He left Haverfordwest with all its old associations, its family traditions such as they were, with all his professional and social links, and moved to Tenby. (It was here, as a matter of fact, that I was born, during a former sojourn of my parents at this town.) His reasons for the move are obscure. Perhaps some crisis of the soul which visits men of middle age had filled him with disgust for all the homely sights and sounds he was accustomed to. Perhaps his recent bereavement had something to do with it, or maybe he wished to escape from the proselytizing zeal of the Aunts. In any case, I think the superior gentility of Tenby attracted him.

Portrait of my Father

Having established himself and family in a dreary little street which gave on the sea-front, my father threw away his professional brass plate; but he still practised Law, though on the quiet, as if it were a private and not quite reputable hobby. His standards were so high that in his eyes professional money-making may have seemed hardly less degrading to a gentleman than manual labour. Not that he was averse from pocketing his dues; no one was more alive to the value of money. Too shy to be sociable, he made few friends; and these few he often found an embarrassment. Walking at his side through the town, I would be surprised by a sudden quickening of pace on his part, while at the same time he would be observed to consult his watch anxiously as if late for an important appointment: after a few minutes' spurt he would slow down and allow me to catch up with him. This manœuvre pointed to the presence of a friend in the vicinity. An upright carriage, a commanding nose and heavy moustaches lent my father a slightly military air: he was delighted when a

bemused soldier from Penally Barracks, mistaking him for a retired officer of high rank, saluted him. In reality he lacked every martial quality, except, of course, honour. Excessively squeamish, he would never have been able to accustom himself to the licence of the camp; even the grossness of popular speech shocked him as much as would have done the politer bawdry of the smoking-room. He once confessed that 'vacillation' was his chief fault but he never wavered as regards propriety of language. A good Churchman, his faith was securely based on a shrewd estimate of its contingent rewards and penalties. Timid in public, at home he took a strong authoritarian stand, which if opposed was apt to become explosive and rather alarming. On the other hand, his parental prerogative once set aside, he could be both playful and humane. As an old Cheltonian he knew his Latin and, on occasion, would quote a few lines from Virgil; but he was no great student of literature though he possessed the complete works of Henri Conscience, an obscure Belgian author, which, rather haltingly, he would translate aloud to us. His Welsh seemed to be elementary but his pronunciation of this language was correct. An amateur of music, his performance on the piano was conscientious, deliberate and weighty. He had composed a few pieces of his own too, and made a practice in later life of walking out to the village of Gumfreston on Sunday mornings, wet or fine, to play the organ in the little church. At the age of ninety-one he died, as he would have wished, in the odour of respectability: his other basic aim, financial security, turned out to have been more than achieved, although, with his usual modesty, he had kept it dark from all.

Tenby Days

Tenby's ancient name, Dynbich y Piscod, Tenby of the Fishes, would still have been appropriate at the time we lived there.

The fleet of fishing smacks existed then and, in my opinion, were the town's chief ornament and pride; but now they have gone, and you look in vain for the russet sails of the trawlers in the Bay. What can have become of them I know not. The Harbour is now empty but for a few motor launches moored under the old stone pier. The tall plain houses above it, formerly yellow, are now painted white. The marble statue of the Prince Consort still adorns the Castle Hill: unmellowed by the years, it is as fresh as when it came from the factory. The rows of bathing machines which used to line the shores, and were hauled in and out of the sea by frantic men on horseback, are seen no more: these cumbersome adjuncts of a Victorian modesty have been scrapped. The town walls, or what is left of them, have not been demolished: an ugly and dangerous gap in the 'Five Arches' has even been restored and strengthened recently by a structure which, in imitation of antiquity, looks like a piece of cheese nibbled by colossal rats.

The band, which used to be engaged for the season, is no longer heard. In my time the principal social function of the day was the evening promenade on the Esplanade, the Castle Hill or the Croft. These rites, performed in semi-darkness or moonlight, with the sound of the sea merging with fitful gusts of melody, were calculated to promote a spirit of Romance and Adventure. Some of the members of the County Club, even, were impelled to desert their sanctuary for an hour or two, and mingle with the crowd in search of new sensations, or perhaps old ones. The annual influx of visitors presented interesting possibilities. The numerous caves below, easily accessible, provided privacy for those in need of it. But the retired Naval and Army officers seem to have departed, along with the orchestra. The town, in consequence, has lost much of the old diversity and style which the proletariat, now in occupation, is unable to supply.

Apart from the classy elements, the Tenby of my memories

abounded in characters of a Dickensian originality. There was, for instance, Cadwalladyr, said to be the last of a princely line. This mysterious personage, tall, massive and hairy, enveloped in ragged oilskins, and up to his waist in the sea, seemed impervious to cold, as he pushed his great shrimp-net before him for hours at a time. He was never heard to speak, and perhaps only knew the language of his ancestors, which would not be understood in Tenby.

A tall, ragged, strolling fiddler was sometimes met with, especially about Christmas time, when he and his jigs were more likely to be tolerated, though his character remained in discredit. I was much attracted by this artist but was discouraged from cultivating him as I would have liked to do.

The fantastic beldames who kept 'apartments' met every train, to fight like vultures over the new arrivals, but Mrs ——, the queen of them all, disdaining competition, feathered and furred, drove her carriage about the town in expert supervision of her numerous properties, which included the big mauve house on the Esplanade in which I was born.

Mr Prydderch, Bank-manager and Captain of the Fire Brigade, once achieved an hour of glory, though it was his last. On getting up one morning, he was seized by an irresistible desire for action and high deeds. Donning his uniform, after completing an extra careful toilet, which included the artistic emphasis of his most notable contours, he called out his men and, placing himself at their head, paraded the town to the martial strains of a brass band. Swaggering fantastically, with buttocks strangely protuberant, he cast from left to right death-dealing *œillades* at the excited servant girls assembled at every window. There was just time to stage this perfect Dostoievsky act before the hero was captured and removed to Carmarthen Lunatic Asylum.

A handsome, carefree group of young women were to be seen at the threshold of their house by the Five Arches. They were

understood to devote themselves principally to the entertainment of the troops at Penally. They always smiled at me in a friendly way and I wondered if, when I joined the Army (for that step was at one time under consideration), I might get to know them better.

The cassocked figure of the Rector as he tottered through the town, exchanging greetings with his parishioners, lent a pleasantly theatrical touch to the scene, which the handsome old comedian was well aware of. He felt that he was playing the leading role in this Pantomime and playing it well. When Father Bull arrived, hot from Rome, to take over the brand-new church, dedicated to St Teilo, the plot thickened. The rather good-looking priest with his knowing smile and mincing gait soon made a good many converts, especially among the girls. Cardinal Vaughan came down to consecrate the new church. Moving in stately fashion up the aisle, under a silken canopy borne by his acolytes, he looked truly majestic. I came under his blessing myself, and may have benefited by it.

The annual Fair used to be held under the town walls. For three days a kind of pandemonium reigned. The air was rent with the blaring and whooping of roundabouts, the banging of shooting galleries, the crashing of swings. Cheapjacks rattled their crockery madly: there were boxing booths, wax-works and freaks. All this fascinated me, and tormented me too, for I was desperately short of cash. The better class people and the police disapproved of the Fair: it interfered with the traffic and was vulgar and noisy, so it was eventually moved to a field in the outskirts, losing thereby much of its medieval charm. Similarly the Nigger Minstrels on the beach were displaced in time by the Pierrots, who were more refined and up to date. They were even invited to tea sometimes by their admirers, in spite of wagging tongues.

The strictest rules of snobbery were observed in my home town. Families might reside side by side for years in exactly

similar houses without once exchanging a word or salute. But the children, though keenly aware of the invisible barriers of caste, would sometimes surmount them and fraternize openly on the beach. We drew the line at cads, that is, tradesmen's sons, of course, but common sailor boys were admissible on account of their special knowledge and entertainment value. In the numerous caves we found ideal cover for our private gatherings, at which a strong note of ribaldry prevailed.

One family in our street was remarkable for the stature and blond beauty of all its members. They would have illustrated perfectly Pope Gregory's celebrated dictum: *non Angli, sed Angeli*. One of the girls especially, Blanche, may not have been an angel, but she certainly looked like one; yet I think a pair of wings would only have embarrassed her.

The Swinburne children were in every way a credit to their distinguished relative, being both beautiful and rebellious.

Another family provided a son with whom I consorted. He had numerous brothers and one sister. The golden-haired mother, distraught with domestic cares, though always good-humoured, tried bravely to bring some order into the ceaseless turmoil of her home: her husband, though by profession accustomed to command, took daily refuge in the County Club, where he passed his days as it were in perpetual amnesty.

The Prusts lived in a big house on the South Cliff, now converted into an hotel. Major Prust, looking like an Elizabethan courtier qualifying for the block, had brought back from his service in the Far East numerous souvenirs of native workmanship, to which a privileged parrot was in the habit of adding, in careless profusion, its own finishing touches. The gallant major, like many military men, practised in private the art of painting: he confided to me the creditable fact that he had never had a lesson in his life. His son Robert was for long my greatest friend and hero, until there came as usual the inevitable disillusionment.

The beaches, caves, sand dunes and burrows in the neighbour-
hood of Tenby provided ideal playgrounds. We took full
advantage of them. Long days were spent in and out of the sea at
Lydstep, Monkstone and other lonely spots along the coast.
Sometimes in the course of my own solitary explorations I
climbed down the precipitous cliffs beyond Giltar, to narrow
virgin beaches of wet shingle, and from there gazed upward
through the terrifying blow-holes which in stormy weather
projected, while bellowing, volumes of yellow sea-spume over
the fields. The cliffs seemed unscalable from below, and mean-
while the tide was on the turn.

There were the woods of Scotsborough, and the marshes
stretching to St Florence: I liked to day-dream by a rocky pool I
had discovered and made my own. I would share it with no one
but the nixie, who, I imagined, must be hiding in its depths, and
might rise at any moment to give me one sweet sad smile.

Hoyle's Mouth was near, a narrow, deep and devious cave, its
walls polished by the shoulders of ancient hunters who had left
their arrowheads and bones for us to dig up in the breccia.

Northwards, Prescelly Top, the apex of the county, presided
over the surrounding hills and moors, bearing ancient monu-
ments and the sacred blue stones quarried here and transported to
Salisbury Plain by the builders of Stonehenge. I love such old
stones: I pass my hand over them and seem to feel under their
grey patina the subtle emanations of ten thousand years.

As I grew I joined with my comrades in the cult of the 'noble
savage'. In imitation of my favourite author, Gustave Aimard, I
imagined myself to be an adopted son of the Antelope Comanche
nation. More than half my life was fantasy! Under the discipline
of the Red Man's code, I practised severe austerities, steeled
myself against pain and danger, was careful not to betray any
emotion and wasted few words. My companions, bitten by the
same bug but with less serious results, as time went on, began to

lose their morale. Older than I, they were not ashamed of making vulgar jokes while on the warpath, and, what was worse, were beginning to take an active interest in *squaws*! Soon I realized that I was alone, the very 'last of the Mohicans'. But before long I was to undergo, in my turn, a similar metamorphosis, though I think in my case the dawn of manhood was accompanied not by raucous levity so much as gloom, terror and bewilderment. I have learnt since that sex is the greatest joke in the world, but I didn't think so then.

The works of the Pre-Raphaelites, which I occasionally found reproduced in the magazines, helped to infect me with an intense romanticism leading to a conflict between the world of reality and a dream-land peopled by voluptuous ghosts. Unable to find an outlet for the emotional stress which now became chronic, I consumed myself in dumb adoration. The girls we met were not so shy: they responded merrily to the crude gallantries of my companions; some of them, and not the least well-bred either, going further, were ready to exhibit themselves in a comprehensive way for our edification. In my innocence I hardly realized the meaning of all this by-play, but I knew that in the domain of Love existed a mysterious enclave, forbidden to little boys. When at last the matter was explained to me with the usual crude humour, I was never so horrified in my life. So this was the Great Taboo; it was thus our parents amused themselves; to this in fact we owed our very existence! I thought of Rossetti's lines:

> I looked and saw your heart
> In the shadow of your eyes,
> As a seeker sees the gold
> In the shadow of the stream;
> And I said, 'Ah me! what art
> Should win the immortal prize,
> Whose want must make life cold
> And Heaven a hollow dream!'

Chiaroscuro

Was it possible that in such terms the poet was alluding to the subject of my informants' obscene giggles? Revolting thought! I wished myself dead or far away in the dim fenland of my dreams, where on some flower-starred bank a Queen of Faery would be waiting to greet, and take me, fainting, into the cool ritual of her embrace.

Puberty

THE male adolescent is usually seized at an early stage of growth with that form of divine discontent which concerns itself with the wardrobe and the urge to imitate to the last button the style of his seniors. As the youth examines himself in the glass, he begins to suspect that the secret of success can be found only in sartorial perfection. I hated my clothes and tried to wear them out as quickly as possible, though with little hope of immediate renewal. I often felt unfit to be seen in such habiliments, and, when alone or in suitable company, would often strip and run naked. Under the eye of Beauty, my gaucherie was painful but, thanks to a few Swiss governesses met with at this period, I began gradually to gain in assurance. With such generous and sentimental girls, I felt less timid, and could respond, at least coquettishly, to their gentle overtures. Perhaps a fellow-feeling linked me to these aliens, since, though native to it, I was slow to accustom myself to a country so beset as this one with surprises, enchantments, deceptions and alarms. Acclimatization, however, comes with time, and I have made some progress since that far-distant hour when a warm-hearted girl, taking me in hand, offered to complete my education by an object lesson which only resulted in a severe shock to my sensibilities, rendered particularly vulnerable by a too literal acceptance of the conventions of classic statuary. Further investigations both in Art and Nature, completing the process of enlightment thus begun, brought me down from cloud cuckoo-land to the equally treacherous bed-rock of Mother Earth.

Home

Small children accept their surroundings as a matter of course, but view them in a private light of their own: chosen objects are

often invested by them with a sacred character, as if imbued with personality and power: these fetishes in course of time lose their magic and revert to insignificance. Many of my household gods suffered such a process of decline, as, growing up, I began to doubt their authenticity. Our house itself became suspect: the paint was peeling to show the lath and plaster of a false façade, and when one looked behind, it was to find nothing there worth mentioning. If our furniture was of mahogany, it was mechanically produced: our venerable 'ornaments' turned out to be mostly articles of commerce, not excepting the precious majolica upstairs, souvenirs of a tour on the continent by one of my forbears; the pictures on the walls were, to put it mildly, mediocre: even our Old Master, the 'Van Dyck' in the dining-room was, I at last decided, only a fake, designed to trap some tourist like the afore-mentioned gentleman, who brought it back from Italy; such books as adorned our shelves were either devotional works or examples of current light fiction; as for the display of heavy volumes in my father's 'office', treating of Law, they interested no one, and were only there for show. I felt at last that I was living in a kind of mortuary where everything was dead, like the stuffed doves in their glass dome in the drawing-room, and fleshless as the abominable 'skeleton-clock' on the mantelpiece: this museum of rubbish, changing only in the imperceptible process of its decay, reflected the frozen immobility of its curator's mind.

But as I rummaged among the piles of dusty books in the attics, I made some surprising discoveries: Hamilton's *Memoirs of the Duc de Grammont*; Mme Blavatsky's *Isis Unveiled*; Richard Carlyle's *Key of the Arch*; *Jane Eyre* by Currer Bell; The Works of Tobias Smollett; those of Christopher Marlowe! Where could these have come from? My father was never distinguished for literary curiosity. Possibly they bore witness to the cultural adventures of an earlier progenitor.

On visiting with my father my Uncle Alfred at St David's

City, I was struck by the contrast presented by the brothers. Alfred, who as a youth had run away to Paris to study Art, had made no success of a life quite unremarkable, except for a certain musical proficiency which the world had no opportunity of appraising, since it was his custom to practise his flute in bed only. His haggard, melancholy but far from unprepossessing features, his almost inadequate clothing, his modesty and grace of manner, were opposed on my father's side by an air of prosperity which struck me as vulgar, a self-satisfaction I thought fatuous, and a rosy smile of superior virtue in which I did not believe. The Dean and Chapter of the Cathedral, at any rate, were not unappreciative of my Uncle Alfred's merits, for on his death they accorded him a first-class funeral, gratis.

Manorbier

We used often to stay at Manorbier. Here, in the castle, Giraldus Cambrensis was born. He described this place as the most delectable spot in all Wales: we thought so too. We lodged with a homely German lady whose husband, immersed in philosophy, kept his room. These departures from the routine of home life were hailed with joy, for at Manorbier we did as we pleased. I think my father himself was glad to be released from the society of his strange, silent and sometimes mutinous children. We weren't so silent at Manorbier: the recluse upstairs used to complain of 'those turbulent Johns'.

Begelly

Another resort of ours was Begelly. Left to ourselves in the big house overlooking a wide infertile common, disdained by the land-grabbers, and populated only by a few cattle, geese and gypsies, we ran happily wild. But the messages of earth and

changing sky, our observation of birds and beasts, and the example of the nomads, in their caravans below, our desultory but voracious reading and unfettered day-dreams – all conspired to stir up discontent and longing for a wider, freer world than that symbolically enclosed by Tenby's town walls; we craved for Art, Liberty, Life, perhaps Love!

Problems and Squalls

My father's reaction to my bent for Art was not violent. He had been encouraged to accept the general opinion that I was not unfitted by nature for the profession of painting, and had no objection to such a course provided it proved sufficiently lucrative. As a legal man himself he would have preferred the Bar; but success there meant the possession of talents I could hardly lay claim to, besides involving long and expensive preparation with no likelihood of immediate returns.

Though himself no connoisseur of the Arts, my father was fully alive to their importance, and rarely missed his annual visit to the Royal Academy. He was aware that R.A.s usually made a good and sometimes a considerable income; in his day this was true: besides, Art, especially landscape painting, was a peaceable occupation and harmed nobody. Was he not himself a lover of Nature? Our local artist, if not exactly a gentleman, was a pleasant fellow who managed to live in comfort and hardly ever got drunk. 'He's been hung in the R.A. too, hasn't he?' Having informed himself of the fees at The Slade, a school he had heard recommended, it was decided that, although pretty stiff, they could be met somehow: there was always the possibility of a scholarship if I turned out as competent as some people thought, and as for my upkeep, a legacy from my mother would cover this. I was an unsatisfactory type of fellow, moody and unpredictable, with no sense of figures nor respect for the value of

money; it was certain I would never be any good in serious business: perhaps Art might be just the thing for me, since it involved irregular hours, few social obligations and no arithmetic. Anyhow I would be out of sight for a while. Such, I imagine, were the cogitations of my parent, and they were not unreasonable. The suspicion, almost amounting to certainty, that I was determined to go my own way irrespective of his views, no doubt moved him as a man of peace to take the easier risk.

Was I lacking in the filial instinct? Not at all! But I found it more and more difficult to adjust this to spiritual independence. I couldn't admit parental infallibility. My father's pretensions seemed excessive. There was no coming to terms: unconditional surrender only was demanded. Failing this, no gesture of sympathy was acceptable, and any attempts at *rapprochement* only earned me a snub. There was no open revolt on my part, only a progressive widening of the gulf between us. Not so with my sisters. On one painful occasion, they combined in an attack, the violence of which still makes me shudder when I think of it. After mercilessly enumerating his failings, which included a hateful parsimony and a recurrent disposition to some fresh matrimonial adventure, they accused 'Papa' of plotting the ruin of their lives! Overcome by an intensity of passion, against which no protestations of his could avail, the unfortunate man, in his despair, appealed to me. I was furious at this heartless and extravagant outburst, and took his part: but my overheated intervention only earned me the disapproval of all three. Next day, much to our satisfaction, we were dismissed to Begelly, a true haven after the storm.

This passage illustrates my sister Gwen's implacable nature when roused: but Winifred too, on this occasion, displayed a fierce and unexpected intransigence.

Our elder brother, Thornton, being absent, was spared a share in this disturbance. I have sometimes wondered what attitude his

inexorable conscientiousness would have prescribed had he been present.

School Days

Cocoa is one of the slowest of coolers and I was late again: relinquishing my untasted cup, I rushed out of the kitchen, seized my satchel, and, with death in the soul, headed for school. I had, perhaps, ten minutes before the bell, and over a mile to run through the devious lanes of the lower quarter of the town. At last, bursting into the precincts by way of the playground, I raced across it to arrive gasping for breath, just as the bell went, and before the door of the big classroom was closed against me.

The Head Master, a noted champion of liberty, wielded at the same time a heavy ruler... Every morning the labours of the day were prefaced by a short homily by this little man, followed by a hymn or perhaps 'Scots, wha hae', and lastly the doxology. Our Head, as he stood before his assembled charges, presented a distinctive and memorable figure. His large, spectacled face was crowned with a lofty crest of white hair; he wore a white tie, a frock coat and button boots. His trousers always seemed to me a little short (without being turned up). This ardent Gladstonian was a pillar of the local Congregational Tabernacle.

Greenhill was an exceptional type of school, not exactly a grammar school, being unendowed, but it catered for the middle classes in the widest sense and Latin was certainly taught, after a fashion. The Head was assisted by a staff comprising two of his daughters and several under-masters. The latter came and went with surprising frequency and seemed to belong to the pauper section of society, being always hungry, ill-clad and down-at-heel. A third daughter of the house actually took lessons with us, but at a desk apart. In her proximity the boys became more than ever *gauche* and incompetent, whereas the saucy young girl,

while diffusing an atmosphere of unease, compounded of love and fear, seemed, herself, only to gain in assurance and facility.

During recreation hours, I passed my time performing solo on the trapeze which, attained by a ladder, hung from a kind of gibbet in the playground. I was keen too on such local games as 'Kingery' and 'Whip-tin'.

One day, being out of order during drill, I caught a smashing box on the ear from our drill-master, an athletic and most conscientious officer. This blow nearly knocked me out. The result was that I was deafened for life. A cricket-ball did the same for the other ear. On one occasion at least I took part in a proper stand-up fight such as one reads about in boys' books. All went according to plan. My opponent, who was, of course, bigger and older than me, got the worst of it, and was led away beaten. Unfortunately, instead of enjoying my victory, and the con-gratulations of my backers, I spoiled the whole show by bursting into tears. My sympathies were apparently with the loser!

As for my Art education, in addition to the official task of copying lithographs of Swiss scenery in three chalks, I went further on my own account, and practised drawing from the life. I found good models in the masters. Great caution was necessary, for this form of study was clandestine and punishable. One day while thus occupied, I was caught at work on my favourite subject, the Head himself: calling me up before him, he examined my effort with a wry smile, and then attacked me viciously with his ruler, almost disabling my hand for good. Without knowing it, I may have been putting into practice the dictum of Prosper Mérimée: *L'Art, c'est l'exagération à propos.*

The second master, in imitation of his chief but with greater cunning, also employed the ebony ruler, which, like a king's sceptre, seemed here to be a symbol of authority. It amused him to approach his pupils softly from behind, as they bent over their books, and skilfully tap on their bonier prominences with this

instrument. When it came to my turn to be thus stimulated, I reacted instantly, landing a stiff back-hander to the face of the sadist, which sent him pale and shaken, back to his rostrum. This exploit was the climax to a series of misdeeds which had been reported to my father: always methodical, he made a list of them, and summoning me to his study or office, read it out. Then, working himself up to a suitable pitch of indignation, he took a cane and with a 'Now, sir!' proceeded to apply it in the usual way, though without enough conviction. His heart, it appeared, was not in it. His duty done, he sent me to my room where at last I could freely give vent to my mirth. My father's performance had been indifferent and added nothing to his reputation.

My reading and writing improved immensely at Greenhill, but not my arithmetic. Both my brother and I were so backward in this subject as to require a separate class to ourselves, the lowest of the low.

Greenhill came to an end and a new school had to be found; on the recommendation of some casual acquaintances, my brother and I were sent to one in Clifton. I would not recommend this school myself, but as it no longer exists, it is no matter. There were a good many pupils from South Wales here and even from Ireland, with some very raw specimens among them: in fact, it was a very odd assortment of boys among whom my brother and I found ourselves. We were odd, too. Not even the toppers and Eton jackets and collars worn on Sunday could mould us into anything like the desired uniformity. The many disparate elements in our population seemed to be all represented here in a form exaggerated and unassimilable. This was no disadvantage from the point of view of a budding draughtsman who, least of all, would be interested in the norm. I was not seeking the norm at this stage, but rather the more obvious deviations from it. If a youth called Keith Williams had been provided by his ancestors with a somewhat disproportionate nose, I was more interested

in this than in any common denominator he shared with his comrades. My brother was rather closely allied with this fellow, and became known as 'Keith Williams's interpreter'.

I made no deep or lasting friendships at this place, but I will always remember with tenderness my association with one poor boy who, though considered a half-wit, displayed an affection, honesty and trust which we usually attribute to saints but meet with more commonly in dogs.

This school was of the preparatory order: it is difficult to decide to what great end we were being guided and prepared. Neither the Head nor his assistants, I think, would have been able to answer this question satisfactorily. No prophetic voice caused our hearts to burn within us; no breath from Heaven came to set aflame our smouldering and very smoky imaginations. Philosophy was eschewed, Art apologized for, and Science summarized in a series of smelly parlour tricks. Patriotism was certainly inculcated as the foreign masters learnt to their cost: 'But this is pandemonium,' exclaimed one unfortunate Belgian tutor, amidst the uproar of the tribal celebrations for which his class was held to be a suitable occasion. My sensibilities, I must say, forbade me to join in such excesses. Sport was encouraged; I enjoyed football and hockey but not cricket, for which I showed no aptitude. The long hours spent in fielding might, I thought, have been so much better employed. For example, there were the docks of Bristol to be explored, and the river Avon, flowing westwards under wooded cliffs, seemed to invite one to follow it to the Golden Valley and the Sea. In spite of general gloom, boredom, and sometimes anguish of mind, there were moments of exhilaration, fun and laughter; now and then one even found oneself strangely absorbed in one's lessons ... I have not forgotten the kind eyes of the Head Master's handsome wife, nor the generous bosom, on which, in great distress, I once laid my head and wept ...

On dark autumn evenings, as we sat at prep, I would often hear a melancholy wail coming from far off. It might have been the cry of an itinerant street vendor, but to me it sounded more mysteriously. I hear it now ...

On leaving this school I was sent to yet another, only just opened at Tenby. Here everything was new and shiny. The Head was a slightly anglicized Welshman with Scottish proclivities. His Welsh wife, however, was altogether homegrown and extremely pretty in a dark way. This school was so small that it was like a family gathering. We had only one undermaster who, as usual, was a bird of passage, subject to continual replacement. But at last the Head obtained the services of his brother, who was not so easy to get rid of – he had been a policeman. Although scholarship was hardly his strongest card, he found the job suited him on the whole, and stuck to it. In contrast to his predecessors he soon became famous for the splendour of his appearance. Draped in bold sporting tweeds, with his bundle of golf clubs suspended from his shoulder, and moving with the stately deliberation which his training in the Force had fostered, this tall, blond and muscular Adonis excited general admiration, particularly among the ladies.

His story would provide a fund of material for a novel in the Flaubertian style with more than a touch of Dickens, but as it does not concern me directly, I will here leave our Welsh adventurer and return to his brother.

This man, with no outward marks of distinction to recommend him, had, no doubt, some charm, which though illusory, sufficed to arouse the hero-worshipping propensities of a lonely adolescent. Possibly through unconscious transference of the filial instinct, I 'fell' for him, and though at first he responded genially, later on the naive warmth of my affection, which had begun by flattering him, was felt as a menace, bound sooner or later to show up the meanness of soul which it was his chief

business in life to conceal. His dignity, although protected by an imaginary gown of authority, was in danger. I had become an embarrassment. A trifling incident provided him with an opportunity to discredit me, and by a drastic amputation, regain his *amour propre*. I had absentmindedly overlooked some new and fiddling regulation. The schoolmaster, making a mountain of this molehill, arraigned me before the class. I was accused of deceit. My plea of forgetfulness, though exactly true, fell flat; a long discourse followed on the subject of veracity. The solemnity of this performance was beyond belief, the charge contemptible and the treachery of a being to whom I had accorded almost divine honours was more than I could bear. I broke down. The distress I could not control seemed, no doubt, clear evidence of guilt in the eyes of my comrades. The operation was a complete success: I was cured of my idolatry. Soon afterwards I went to the Slade; but the pedagogue shortly after came to an unhappy end. I have sometimes wondered if I possess the evil eye.

Mafeking

THE Boer War was on. Things weren't going well. Old gentle-men in clubs and pubs were shaking their heads with misgiving. Our neighbours across the Channel were jubilant, for the British Lion was being worried to death by a small community of out-of-date Dutch farmers. Perfidious Albion appeared to be getting the worst of it. Was the Empire's civilizing mission then to cease, and were we to relinquish the gold-fields? But we weren't done yet. The music halls, those true-blue temples of Patriotism, were more crowded than ever. 'Old Kroojer' with his Bible and whiskers was a gift from the gods to the lowest of low comedians. The Lion could still roar, and Kipling had provided him with a special hymn for the occasion. Dukes', cooks' and belted Earls' sons were buckling on their armour and rushing to the field but, alas! they were apt to fall almost as soon as they got out there. The cowardly Boers could shoot, and after potting our men from kopjes, were off again like greased lightning. And then came Mafeking. I strolled down to Trafalgar Square to see the fun. The Square, the Strand and all the adjacent avenues were packed with a seething mass of patriots celebrating the great day in a style that would have made a 'savage' blush. Mad with drink and tribal hysteria, the citizens formed themselves into solid phalanxes, and plunging at random this way and that, swept all before them. The women, foremost in this mêlée, danced like maenads, their shrill cat-calls swelling the general din. Feeling out of place and rather scared, I extricated myself from this pandemonium with some difficulty, and crept home in a state of dejection. What was the matter with me? I admit I was a 'Pro-Boer', that is, averse from a war of aggression; still, wasn't I an Englishman of a sort – or at least *British*, as we now say.

I don't propose to dwell on that tough but tiresome struggle which enriched our language with a new and ugly word, still less discuss the merits of the combatants, except to observe that Boer and Briton turn out, in fact, to have had much in common. The biblical tradition which they shared had imbued both with the same bestial cruelty to inferior, that is to say, less well-armed, races. The former people extirpated the Bushmen like vermin, and the latter made a still more thorough job of the primitive Tasmanians, besides debauching and decimating a vast multitude of other interesting and inoffensive populations during the brutal business of colonization. A young Australian I met the other day reminds me of these horrors. I had mentioned the aborigines of his country. 'Oh, them,' he said with a grin, 'my grandfather used to go out every morning and shoot half a dozen before breakfast.'

A Short Way with Gypsies

WE must all acknowledge the pre-eminence of Hitler and his disciples in the methods of human extermination. Without referring to his well-known and brilliant operations in this line as regards the 'chosen people', I will draw attention for a moment to his no less successful efforts to extirpate as far as possible an infinitely smaller, and less important, though as some think, an equally obnoxious section of the Mittel-European population: I refer to the Gypsies. By the application of the latest scientific techniques, these Indo-Aryan 'hedge-crawlers' were, in fact, within the Reich, very substantially thinned out; but in Poland they were completely eliminated. In the latter country, I am assured, not a single specimen of these 'anti-social pests' remained alive, though with their well-known and incorrigible elusiveness, a few did manage to slip across the frontier in time.

In Great Britain the problem is attacked from a different angle, with results less drastic and spectacular, but in the long run equally effective. It is the *spirit* we go for. 'Harry the Gypsies' is the political slogan, and 'Move on' the word of command. I do not know what department of Government is responsible for the present drive in the cause of uniformity, subservience and the sedentary life, but I am sure the police perform their duties conscientiously, though, as I suspect, not always without compunction. As Englishmen, they will naturally not be insensible to the spectacle of animals, and especially horses, in distress.

This routine of bloodless persecution soon wears down the powers of resistance both of the Gypsies and their beasts and they are forced inevitably into overcrowded and insalubrious slums, where, cut off from their traditional and healthy ways of life, they degenerate and are gradually absorbed in the general squalor.

A Short Way with Gypsies

At this rate, before long there will be no dark and friendly strangers encamped in the green lane, and, as it has been remarked, our children will be the poorer. There will, of course, be plenty of respectable motor-drawn caravanners, but that isn't quite the same thing. Although nobody so far has proposed to liquidate these nomads after the Hitler style, is it possible that, in his own country, John Bunyan's people have been sentenced to a lingering death? But by whom, I would like to know.

The Slade

THE Slade School of Art forms part of University College, London. The student was first introduced to the Antique Room, which is furnished with numerous casts of late Greek, Greco-Roman and Italian Renaissance sculpture: no Archaic Greek, no Oriental, no 'Gothic' examples were to be seen. This studio is used by both sexes. The student was set to draw with a stick of charcoal, a sheet of 'Michelet' paper and a chunk of bread for rubbing out. My first efforts seemed at once to surprise, amuse and interest Henry Tonks, who, under Professor Frederick Brown, was the leading spirit of the staff. Tonks seemed to think that I ought to take longer over my studies. 'Observe the construction of the forms and explain it,' said he. Formerly a surgeon, he was a good anatomist, and this fact influenced him greatly in his conception of intelligent drawing. Alone among the Art teachers of his time, he directed his students to the study of the Masters. Rubens, Michelangelo, Rembrandt, Watteau, Ingres, such were the exemplary figures to whom he drew our respectful attention.

I spent most of my spare time in the National Gallery, the British Museum and other collections, thus loading my mind with a confusion of ideas which a life-time hardly provides time to sort out. A student should devote himself to one Master only; or one at a time. After qualifying in the Antique, the student was promoted to the Life Room, where he drew and eventually painted from the living model. I entered this studio with considerable awe, which deepened on finding myself before a nude Italian girl. I set about my drawing rather tremulously. During the rests, as I looked around me, I was astonished to find the work of my fellow-students to be, as far as I could judge, no better than my own! Some of it, however, was so queer that I was ready to

50

credit it with qualities beyond my comprehension, for I was conscious of my immense ignorance.

The visits of Tonks were looked forward to with excitement and some alarm, for he was a sharp critic and not given to mincing his words. His natural benevolence was disguised under an austere and forbidding mask. He had been known to reduce girl students to tears, much, I am sure, to his own consternation: pretentiousness or 'cleverness' more than anything moved him to wrath. Tonks had a passion for teaching drawing, and the Slade was his mistress.

Wilson Steer

Wilson Steer's criticisms and advice were always helpful and stimulating. With no pose of omniscience or display of authority, he made his quiet comments with dignity and humour. His not-so-common-sense was allied to a decidedly uncommon sense of colour. According to him, the secret of colour is to be found in 'the play of warm and cool'. As he grew older his style lost the adventurous and surprising character which had excited and charmed me so at first: by degrees it approximated itself to that of the eighteenth century at its most engaging. Next to Nature he delighted in Chelsea china, which, with sound taste and judgment he collected, while admitting with due modesty the existence of greater things. When in the Life Class, taking a student's brush and palette, he was moved to work on the defaced canvas before him with that flickering and voluptuous touch of his, it seemed as if a new and more enchanting world was blossoming before our eyes! Perhaps, at such moments he was at his best, because, detached and irresponsible, he could treat the model with complete simplicity and gusto, as one plucks a flower. He always managed to keep his seat and his sangfroid throughout the lively disputations of contemporary art politics: it is doubtful if he was

interested in the principles at issue, but, to judge by his casual asides, he had a sharp and sometimes malicious eye for the personalities involved. Such trivialities as may be charged against him, certainly betray spiritual limitations, which did not prevent this good bourgeois from cultivating, with loving care and understanding, the pleasant garden allotted to him by Providence.

Ambrose McEvoy and Benjamin Evans

I met at the Slade several students with whom I became very friendly: Ambrose McEvoy for one. His general appearance, owing something to Whistler, whom he knew personally, and to Aubrey Beardsley, whom he didn't, comprised a straight low fringe of black hair, a monocle, a high collar of modulated white, a black suit and patent leather dancing pumps; he was in fact a perfect 'arrangement in black and white'. He never seemed to work hard, but had great facility and an immense zest for life which for him seemed to be a kind of melodrama.

Benjamin Evans, a Welshman whom I had met at a school at Clifton, made a third party in the trio we formed. Evans was an original and witty draughtsman, well versed in Rembrandt. At his suggestion I attempted etching: my first plate was a portrait of him. I held him in the highest regard and perhaps on insufficient grounds considered him immensely gifted. But eventually, betraying both himself and me, he transferred his energies to the problems of sanitary engineering; he went, so to speak, 'down the drain', in fact, and as far as I know, has never emerged from it.

Camping with a Donkey

The three of us decided to go camping in Pembrokeshire. We assembled at Tenby where we acquired a donkey, a light cart and a tent. Although our baggage consisted of little but the tent, some

blankets, cooking utensils and our sketching materials, these formed a sufficient load for the little donkey, who, though willing enough, when going uphill sometimes required a helping hand. This task, I noticed, always fell to me, my companions taking care to be well ahead on such occasions and deep in discussion. On the principle of division of labour, they, by common consent, had cheerfully undertaken all intellectual responsibilities, leaving the simpler problems, involving only muscular exertion, to me. We managed very well in this way, though I got no fatter. Our objective was St David's Head. In consideration of our donkey we made no great mileage and were careful to pull up at every roadside inn to rest the animal, while offering ourselves a glass of beer or two at the same time. I noticed the brain-workers' thirst was at least equal to my own. This surprised me. Stopping first on Begelly Common, we then made for Haverfordwest, where, falling in with a party of Irish Tinkers, we profited by their company and conversation, which was rich in the wisdom of the road. At Newgale we encamped under the shelter of a disused lime-kiln by the shore. Some painting was done here before we moved on to Solva. Solva proved so pleasant that two or three weeks passed before we took the road for St David's. The village of Solva is situated at the head of a little fiord. It was on the side of this that we set up our tent. Soon making friends among the villagers, we joined with the youths and maidens in their old-fashioned country games which included a good deal of singing and kissing. When funds permitted, that is, when a postal order arrived, a good blow-out at the Solva Arms followed: a welcome break from the austere regimen of treacle and onions instituted by Evans, who claimed to be something of a specialist in food values. An old tramp we met, engaged in snaring rabbits, told us we'd be 'bloody fules' if we didn't do likewise. We *were* bloody fules and didn't. After a sojourn at Whitesands Bay near the Head we struck the home

Chiaroscuro

trail. Back at Solva, where a Regatta was in progress, my companions insisted on my entering for a swimming race. I was bound to win, they said, and we'd all have a proper feast on the prize money. Although incapacitated by a stomach-ache, due perhaps to Evans's dietary, I with great reluctance agreed to have a try. I came in, more dead than alive, a bad third. Encamped within the picturesque ruins of a Priory at Haverfordwest, McEvoy being at the time in the town shopping, Evans and I and the donkey were disturbed by the arrival of a person suffering, it would seem, from an acute attack of homicidal mania. Flourishing a pitchfork and foaming at the mouth, the paranoiac, in a spluttering mixture of Welsh and English, claimed ownership of the scrap of infertile ground we occupied and had intended to pass the night on. It was clear that this plan was now impracticable, or at least could hardly be carried out in comfort or security. We were unarmed. There was nothing to do but out-span and trek southwards, leaving McEvoy to follow us by instinct. It was late when we reached Begelly Common, and later still when our friend's despairing halloos were heard across the moor. Making our presence known, we soon had the pleasure of welcoming him back to our fireside. But far from congratulating us on our successful though forced march, the unreasonable fellow greeted us with bitter accusations of treachery and desertion. Explanations followed and a bottle of whisky, with which, knowing the shortest way to his heart, we had wisely provided ourselves in case of trouble. Harmony reigned at last. The next day took us to Tenby by a short stage, where we disposed of our donkey with all accessories to its original owner, Mr Lewis the Sweep. Our adventures in Pembrokeshire were over.

Flemish Expeditions

When a Centenary Exhibition of Rembrandt was held at Amsterdam, at Evans's suggestion we all three decided to visit it.

This was a great event. As I bathed myself in the light of the Dutchman's genius, the scales of aesthetic romanticism fell from my eyes, disclosing a new and far more wonderful world.

Other expeditions in the same company, to Belgium, implanted in me for ever a love and reverence for Memling, the Van Eycks, Van der Weyden, Breughel and Bosch. Some would argue that we might just as well have stayed at home as Rembrandt did. Had we not in London the pickings of all Europe? But even Rembrandt is rumoured to have visited Yarmouth. Doubtless the bloaters would have appealed to the great realist.

Student Days

Le café concert est souvent pur; le théâtre toujours corrompu.

JEAN COCTEAU

AN artist prefers the music-hall even when he gets thrown out of it, as I was now and then. Who gets thrown out of a theatre?

One bought a seat in a box at old Sadler's Wells for a shilling. First there was 'Variety' and then a melodrama to follow. In the foyer were photographs of former stars, among them a mistress of Rossetti's.

Some of the older comedians had an accomplishment and a style which has passed away. The cockney dialect had not been stereotyped in the hideous form we now hear on the wireless, provoking unseen audiences to frenzied applause.

There were snags indeed. How I hated Herbert Campbell, that brazen monster! But I loved Gus Elen, Vesta Victoria, T. E. Dunville, Harry Tate, Victoria Monks and a good many others. When I last saw Marie Lloyd, it was at a pub in Bournemouth, where she was treating a large number of what appeared to be lodging-house keepers to bottles of stout. Dan Leno, after his mental collapse, reappeared for a short while, more brilliant, it seemed, than ever. I made a portrait of that prince of buffoons, Arthur Roberts, which is now in the National Portrait Gallery.

Again for a shilling, we used to get a seat in the pit of the 'Empire', where we watched the ballet, following the celestial motions of Adeline Genée, in adoration – and despair.

The circus, which I loved, is barred to me since I realized the misery suffered by the horses, made to prance with their noses strapped to their chests. We think ourselves a horse-loving people

yet permit this abomination. 'But it makes them arch their necks so prettily.'

With sketch-book handy, we attended anarchist meetings in the neighbourhood of Tottenham Court Road. Many of the speakers were foreigners. The Spaniards seemed the most vehement. I listened to Peter Kropotkin. He cut an impressive figure in his revolutionary frock-coat, and his bearded countenance radiated benignity, faith and courage.

Louise Michel, 'the Red Virgin', who, attired as a man, had fought on the Barricades during the Commune, now a little old lady in black, pointed a denunciatory claw at a Society of mammon worshippers, built on force and fraud, rotten from top to bottom.

Do present-day art-students bring their sketch-books with them to the cinema, night clubs or wherever they go in the evenings? I think not. For one thing, drawing seems to be out of fashion and the curriculum of the State schools, requiring the absorption of numerous learned works on Anatomy, Architecture, Economics, Stained glass, Perspective, Illumination, Foundry-work, Enamelling, besides History, Geography and Mathematics, leaves the poor aspirant for a Government grant pretty well exhausted by the end of the week and unfit for further exertion.

One day at the Slade, when at work in the 'Life', the door of the balcony above opened and Professor Brown appeared with a jaunty little man in black, who had a white lock in his curly hair and wore a monocle. Mr Whistler! It is difficult to imagine the excitement that name aroused in those days. An electric shock seemed to galvanize the class: there was a respectful demonstration: the Master bowed genially and retired.

The Slade in my time abounded in talented and highly ornamental girl students: the men cut a shabbier figure and seemed far less gifted. Among the more outstanding of the former were

Ursula Tyrwhitt, Edna Waugh, Gwen Salmond and Ida Nettle-
ship. I formed an attachment to the last named, which was to
fructify in time. Her father was a painter, specializing in wild
animals which he studied in the Zoo. If his technique was sticky,
his carnivores were well constructed, and he had a certain strain
of mysticism in his nature. A picture of a black panther with a
butterfly, which, much later, I saw in a shop window, pleased me
so much that next day I went back intending to buy it, but I was
too late. The Nettleships' house in Wigmore Street was visited
by some interesting people: I met there old William Michael
Rossetti and young Walter Sickert, the latter just emerging from
the anonymity of *élève de Whistler*. W. B. Yeats used to be seen
there, and Ellen Terry, Mrs Patrick Campbell, Will Rothenstein,
Max Beerbohm and other celebrities. Nettleship had been a
friend of Browning, and had written a book about him. He
knew Browning's poems by heart: during his last illness he recited
page after page of them. He told me God was nearer to him
than the door. His daughter and I had not been encouraged by
Nettleship to put into practice our theory of 'free association',
so, conceding a civil marriage, we negotiated this on the quiet
with Evans and McEvoy as witnesses and co-celebrants after-
wards in a Charlotte Street restaurant. When the cat was out of the
bag, Jack Nettleship bore no umbrage: it might have been
worse.

It wasn't long before my sister Gwen joined me at the Slade.
She wasn't going to be left out of it! We shared rooms together
subsisting, like monkeys, on a diet of fruit and nuts. This was
cheap and hygienic. It is true we were sometimes asked out to
dinner, when, not being pedants, we waived our rule for the time
being.

On the arrival of William Orpen, a new force made itself felt
in the School. This Dubliner's industry, combined with his
native drollery, soon won him a leading place. We were much

together on and off: later on when he became the protégé of big business our ways diverged.

My First Show

Encouraged by Will Rothenstein, I held my first show at the newly established Carfax Gallery, Ryder Street, St James's. Already I had exhibited at the New English Art Club, then housed at the old Egyptian Hall, Piccadilly. Recruited from the Slade chiefly, the 'New English' sought to carry on the tradition of 'Impressionism'. Its spokesman, D. S. MacColl, was (with Arthur Symons) the first to acclaim my appearance at the Carfax Gallery. Pawky and didactic, this accomplished writer's perceptions appeared to be somewhat limited, except where Wilson Steer was concerned, when they became boundless. My little show was a success. I made thirty pounds. With this sum in my pocket there was nothing to prevent me joining Will Rothenstein, Orpen and Charles Conder in France. Rothenstein had found a good spot not far from Etretat on the Normandy coast. Alice Rothenstein and her sister Grace (to become Orpen's wife) provided the refining influences which some of us required. Arthur Clifton, of the Carfax Gallery, with his red-haired wife, joined us. All went well at Vattetot-sur-mer.

Charles Conder

Conder was not the robust and formidable figure of a man Will Rothenstein had led me to expect. Having once had occasion to knock him down, Will, physically small, may have unconsciously exaggerated the exploit. But though out of training (he admitted to being 'gone at the knees'), Conder was a charming personality. He spoke in an exhausted and muffled voice, which made it difficult sometimes to follow him with intelligence. A

lock of brown hair always hung over one malicious blue eye. Though his ordinary gait could be described with some accuracy as a shuffle, given a sufficient incentive he was capable of great speed and endurance. On our evening walks to Vaucotte, a neighbouring seaside resort, Conder would outpace us all, and on arriving at the little Casino, we would find him already half way through his second 'whisky-soda'. Seated in the village café with a bottle of Pernod at his elbow, used both for its refreshing properties and as a medium for his brush, he painted fans, filling the silken fabric before him with compositions illustrative of the *Commedia dell' Arte* or Verlaine's *Fêtes Galantes*. His elegant figures, posturing in a moon-blue ambience, had recaptured from Watteau or St Aubin a romantic languor which owed nothing to the rusticity of his surroundings, nor recalled in any way his upbringing on an Australian sheep range. Turning to Balzac, he would trace with his weak but sympathetic pencil luxurious scenes from the *Comédie Humaine*. I prefer, myself, his seaside pictures painted at Dieppe, Swanage or Brighton. Some of these, in my opinion, are better than anything of the kind by Whistler or anyone else.

After the day's activities, which for me at least always included a swim in the sea, the evenings were spent in the village café where all assembled to give thanks to the gods in a glass or two of Calvados before going to bed. Under this discipline we ripened steadily. Will Rothenstein had the start on us others, however, and with his habitual austerity showed himself superior to the allurements of the local product mentioned: but Orpen and I, not to speak of the ladies, felt impelled, as novitiates, to impregnate ourselves with the quickening properties of this liquor which seemed to wed us to the soil of which it was the quintessence, and, as we calculated, would, by a kind of magic, induce on the morrow a corresponding fertility. Conder, already initiated, preferred to draw upon his imagination and a bottle of Pernod.

William Orpen

Will Rothenstein, while alive to Orpen's merits, was equally aware of his limitations. He seemed to be blind to mine. To our new friend, fresh from Paris and already enjoying a considerable notoriety, the monosyllabic style of the Irishman must have sounded provincial and naive. Mother-wit wasn't in Will's line, even when reinforced by the ever popular brogue. His own speech owed nothing to his native Yorkshire, being modelled closely on the best examples to be met with at Oxford, a town he had visited personally. Interchange between such contraries could only result in discord or at least discomfort.

Orpen and I, as a means of financial improvement, decided to start a School of Art in Chelsea. I already rented a studio in Flood Street and below this we found another suitable for our purpose. It filled up rapidly and soon there was hardly room to move. I was at this time principally occupied in drawing and painting a subject, Alick Schepeler, to whose strange charm I had bowed. I made many drawings of Miss Schepeler who, of Slavonic origin, illustrated in herself the paradox of Polish pride united to Russian abandon. An infinite capacity for laughter was the result – laughter and sometimes tears. My best painting of Alick Schepeler was destroyed in a fire at Fryern Court, but I am still at work on another version of it.

The Art School flourished but the visits of Orpen and myself became more and more infrequent. There was some murmuring among the students. We were getting tired of this venture, although it had proved successful; we began to waste too much time in conversation at the Cooper's Arms opposite. Finally we disposed of the business to a Mr Trevor Haddon.

Orpen, with his infinite capacity for avoiding pains, soon made a success of his portrait painting. He was acclaimed by businessmen, otherwise no doubt hard-headed enough; but the little Dubliner managed to find time for a game of billiards like

anyone else and was good at it. This versatility, combined with a homely facetiousness, set all doubts at rest. Their friend was a genius! There were some who, going further, accorded him a reverence which must have been embarrassing, but these were only the bores.

Oscar Wilde

Rothenstein, who was not without a decided streak of romanticism himself, once suggested that he would like to play the part of Vautrin to my Lucien de Rubempré! Neither of us would have been suitably cast in those roles. He used to talk of his friend Oscar Wilde, and quoted this wit's *mot*, 'The death of Lucien was the greatest tragedy of my life.' Wilde was now at large, and Rothenstein proposed a visit to Paris where he was to be found. Accordingly, the Vattetot expedition concluded, Will and Alice Rothenstein, Charles Conder and myself proceeded thither to pass a week or two, largely in the company of the distinguished reprobate. I had heard a lot about Oscar, of course, and on meeting him was not in the least disappointed, except in one respect: prison discipline had left one, and apparently only one, mark on him, and that not irremediable: his hair was cut short ... We assembled first at the Café de la Régence. Warmed up with a succession of Maraschinos, the Master began to coruscate genially. I could only listen in respectful silence, for did I not know that 'little boys should be obscene and not heard?' In any case I could think of nothing whatever to say. Even my laughter sounded hollow. The rest of the company, better trained, were able to respond to the Master's sallies with the proper admixture of humorous deprecation and astonishment: 'My *dear* Oscar ... !' Conder alone behaved improperly, pouring his wine into his soup and so forth, and drawing upon himself a reproof: 'Vine leaves in the hair should be *beautiful*, but such childish behaviour is merely *tiresome*.' When Alice Rothenstein, concerned quite unnecessarily for my reputation, persuaded me to visit a barber, Oscar, on seeing me the next day, looked very grave: laying his hand on my shoulder, 'You should have consulted me', he said,

'before taking this important step.' Although I found Oscar thoroughly amiable, I got bored with these seances and especially with the Master's entourage, and was always glad to retire from the rather oppressive company of the uncaged and now maneless lion, to seek with Conder easier if less distinguished company.

The Monarch of the Dinner-table seemed none the worse for his recent misadvantures and showed no sign of bitterness, resentment or remorse. Surrounded by devout adherents, he repaid their hospitality by an easy flow of practised wit and wisdom, by which he seemed to amuse himself as much as anybody. The obligation of continual applause I, for one, found irksome. Never, I thought, had the face of praise looked more foolish.

Wilde seemed to be an easy-going sort of genius, with an enormous sense of fun, infallible bad taste, gleams of profundity and a romantic apprehension of the Devil. A great man of in-action, he showed, I think, sound judgment when in his greatest dilemma he chose to sit tight (in every sense) and await the police, rather than face freedom in the company of Frank Harris, who had a yacht with steam up waiting for him down the Thames. I enjoyed his elaborate jokes, had found his *De Profundis* sentimental and false, the *Ballad* charming and ingenious, and *The Importance of Being Earnest* about perfect. When I read *The Picture of Dorian Gray* as a boy, it made a powerful and curiously unpleasant impression on me, but on re-reading it since, I found it highly entertaining. By that time it had become delightfully dated.

One evening Conder, Wilde, Bibi la Purée and I forgathered in the old seventeenth-century Café Procope. Bibi had been the devoted friend and factotum of Verlaine. He was indeed a strange bird. A member of the underworld, he traded in other people's umbrellas. When Verlaine died, Bibi followed the funeral cortège to the cemetery, weeping copiously all the way, but, combining business with burial, he returned, it was said, with a sheaf of his favourite stock-in-trade under his arm. No umbrella-user myself,

I liked Bibi and enjoyed his company. He looked like an under-nourished and fugitive Voltaire: bat-like, he was only seen to flit at night; a figure from Toulouse-Lautrec's sketch-book.

Now enters a superb specimen of blond manhood. It is Robert Sherard. As he approaches Oscar rises, and without a word, leaves the building. Sherard had been a staunch champion of Wilde, one of the few who stood by him in his trouble. He only got snubbed for his pains. Oscar had said: '*Dear* Robert is *wonderful*, *quite* the *worst* writer in the *world*, but alas! he defends me at the *risk of my life*!' Sherard, addressing himself to me, denounced his former hero whose complete works, autographed and inscribed, he offered to present me with; but 'Not one of them is worth a damn,' he assured me. Taking him at his word, I declined the gift. Moving from one *boite de nuit* to another, with a young woman of my fancy in attendance, it was not till the first gleams of dawn appeared that we dispersed.

With Conder and Sherard I once visited Ernest Dowson at Catford, where Sherard's French wife kept a bricklayers' lodging house and had taken charge of the sick poet. He did not seem particularly glad to see his old comrades, but eyed me with a shy friendliness: I responded similarly. It was our only meeting.

Swanage—A Seaside Affair

CONDER and I decided to visit Swanage, where an eccentric friend of mine, Mrs Stewart Everitt, kept a *pension* in a good position by the sea. Mrs Everitt was a fervent Evangelist and used to hold revivalist meetings for Slade students in Fitzroy Street.

Conder painted some very good sea-scapes at Swanage. The sea air is known to be an excitant, and Conder felt his stay would be incomplete without a romance. A charming and gifted Slade student, who happened to be a fellow boarder, provided the motif, and it was not long before an engagement was announced. When Conder interviewed the young lady's mother to make a formal request for her hand, he was met with the objection of a certain disparity of age between the parties. 'In any case,' he was told, 'there's no need to hurry: Jacob waited seven years for Rachel.' 'Yes,' replied Conder, 'but you must remember that he lived to be three hundred and seventy-six.'

I, too, must have felt the compulsion of the sea air. Anna Carolina von Hohenheim served at table. She had taken to her present employment while in hiding from a husband, from whom she sought release. I was enthralled by this young beauty. Approach was difficult, however. Under the eye of her employer, extreme caution was necessary: besides, the young woman I admired seemed to be highly elusive by nature. Constantly baffled by her playful and exasperating technique, which I judged to be on the continental model, I at last sought Conder's advice. 'You must buy her a ring,' he said; 'the first step is to buy her a ring.' Borrowing a few pounds from him, I went and did so. I had already ascertained where she, with a somewhat less decorative compatriot, slept. Choosing a darkish night, I appeared at their window, which at some risk I had reached by means of a drain-

pipe. Alarmed at first by such a visitation, Anna Carolina, on recognizing my silhouette, opened the window; no doubt she intended to scold me, but without waiting, I pressed the trinket into her hand and with a whispered *Gute Nacht*, descended. Conder had assured me of the magical effect of this overture and I now awaited proofs of his sagacity. The magic worked; during the meals which followed, the ring was much in evidence, indeed, in view of Augusta Everitt's observant eye, much too conspicuous, but it showed I was being taken seriously. At last a nocturnal meeting on the cliff was arranged and a plan agreed upon to reunite in France where I was shortly due to go with my friend Michel Salaman. I then left Swanage to join Salaman. We established ourselves at Le Puy for the summer. I awaited with impatience the arrival of the Viennese girl whose letters continued to encourage me. But presently they ceased. I learnt later from her own lips the reason. Augusta Everitt, becoming aware of our correspondence, and burning with religious zeal, intercepted my letters, read them, and taking it upon herself to intervene, succeeded in dissuading Anna from her purpose, pointing out that from what she knew of me the young woman would have everything to regret by persisting in such folly. I gathered from Anna Carolina when I met her in London later on that she had much to regret as it was ... And so this episode which began so auspiciously, ended in fiasco. I was sadly disappointed. Michel Salaman suffered too. A sense of frustration is no aid to companionship. Aunt Augusta earned a black mark for her share in this affair. I saw her no more.

The Rothensteins joined us at Le Puy for a while. Hiring bicycles, we visited the Trappist Monastery of Notre-Dame des Neiges, further south, and spent a night there. Each of us was given a cell and a good breakfast of wine and cheese. Will Rothenstein thought it was here that Huysmans had retired, but we got no news of him from the lay brother who attended on us.

The silent bearded monks went about their labours in the fields: some made the liqueurs they sold to visitors: others busied themselves in the garden. I revisited Le Puy with my sister Gwen and Ambrose McEvoy. This stay was marred by an unfortunate circumstance. Gwen, like me, had been crossed in love, but, unlike me, was inconsolable, and spent her time in tears.

John Sampson and the Gypsies

Now married and installed as art-master at a school of Art in Liverpool which was affiliated to the University College, I became acquainted with John Sampson, its Librarian and our foremost Gypsy scholar. We immediately struck up a close friendship, which with occasional disturbances lasted till his death. He introduced me to his Gypsy friends, and we made a practice of visiting the tents together. Under his tutelage and by personal contact with the Gypsies, I soon picked up the English dialect of Romani, and during our expeditions to North Wales began to cultivate the inflected or 'deep' speech of the descendants of Abraham Wood which Sampson has recorded in his magnum opus, *The Dialect of the Gypsies of Wales*.

John Sampson could turn a phrase better than most. If his manner and speech verged on the ponderous, it was only in keeping with his physique, which was big and portly. He was an all-round scholar, and besides Romani, had acquired the secret jargon of the tinkers, known as *Shelta*. He had also mastered both back and rhyming slang, and, as a necessary aid to his investigations in the language of his choice, he later added Sanskrit to his stock. Sampson's measured utterance, overbearing manner and sardonic humour, which he was apt to accentuate with strangers, served him as a conversational style well calculated to reduce his interlocutor to the condition of discomfort aimed at, while protecting his own highly vulnerable sensibility from attack. It used to move me to irrepressible merriment. He made numerous experiments in verse, including translations from Heine, Fitzgerald, etc., into Romani. He always spoke with love and admiration of his friend Walter Raleigh, and in later years formed a close attachment to Robert Bridges. His edition of William Blake is

69

regarded as exemplary and definitive. The fact that the *Rai*, as he was called, was nearly twice my age, helped to preserve our relations from the hazards of his somewhat perverse temper and my quick one. If we sometimes quarrelled, sooner or later we made it up.

Our visits to Cabbage Hall and other camping grounds were rich in incident. 'Cabbage Hall' for us denoted a large patch of waste ground, where the Boswells were in the habit of encamping during the winter months. Under Sampson's aegis I was made welcome in the tents and got to know their occupants, who bore such exotic names as Noah, Kenza, Eros, Bohemia, Sinfai, Athaliah, Counseletta, Alabaina, Tihanna, Simpronius, Saiforella … By showing a sympathetic interest in their speech and customs, and without neglecting the lubricative medium of liquor, the collusion of the men was assured: they admitted us into their confidence and disclosed their tribal secrets unreservedly. The *Chais*, or young women, were more difficult: provocative and yet aloof, they were capable of leading the tyro into a region of pitfalls, where indiscretion might land him in serious difficulties. By the exercise of an oblique and derisory intelligence, Gypsy girls are eminently qualified to take their own part.

Liverpool

Liverpool, commonly considered a dull, ugly and commercial city, for me abounded in interest and surprise. With what wonderment I explored the sombre district of the Merseyside! This was largely populated by Scandinavian migrants on their way to the New World.

The Goree Piazza, with such a name, for ever reeking of the slave-trade, might still harbour a few superannuated buccaneers musing over their rum: in the Chinese quarter, while visiting certain tenebrous dens, I attempted, but failed, to attain the bliss-

ful *Kif* in the company of dishevelled and muttering devotees of the Laughing God: off Scotland Road I penetrated, not without trepidation, into the lodging houses of the Tinkers, where a rough nomadic crew gathered round the communal fire in a spirit of precarious good-fellowship.

With a few notable exceptions, I had little to do with the University people. Oliver Elton and Kuno Meyer, the Celtic scholar, I knew well; I painted their portraits, and also Chaloner Dowdall's. The latter picture, on being exhibited, nearly led to a riot; why, I don't know. When Walter Raleigh visited his old friends, the Dowdalls, with whom I was staying, I was astonished by the cool brilliance of his mind. He shone even at breakfast! Another visitor from Oxford, York Powell, charmed me. The French Professor, Charles Bonnier, was more interested in the theory and practice of *pointillisme* than his academic duties. He imported a mild whiff of Parisian artiness into the frowsy atmosphere of Brownlow Hill. C. H. Reilly, who occupied the Chair of Architecture, was a valuable force in Liverpool: besides distinguishing himself in his own line, he founded the Repertory Theatre, and saved the Sandown Building from the bulldozer of commercial progress. Scott Macfie, an eccentric sugar refiner and Gypsy scholar, when on good terms with Sampson, joined us in our adventures.

Several of my Liverpool portraits hang in the hospitable University Club, and include one of Sir Charles Sherrington, O.M., which was painted later.

Esmeralda Groome

Hearing that Esmeralda Groome (*née* Boswell) was encamped on the Wirral, Sampson and I paid a visit to this famous Gypsy,

Chiaroscuro

whose beautiful younger sister, sharing, unfortunately, the van of a red-haired Irish tinker, I had met and greatly admired. Esmeralda was still a handsome, lively woman, retaining much of the charm which had subjugated, first Hubert Smith, a rich bourgeois, and then Francis Hindes Groome, the future doyen of Romani Rais. Her forced marriage to Smith was followed by elopement with Groome and this led her on a lengthy trail of wandering throughout Europe in the company of the author of *In Gypsy Tents*, *Kriegspiel*, etc., till at last, coming respectably to rest and remarriage in Edinburgh, the high-spirited daughter of the tents, as much probably through native restlessness as jealousy (though she did adversely allude to a certain redhaired *jukli*)[1] left her second husband to return to freedom and the open road. Groome's efforts to recapture her were of no avail. Before I took leave of Esmeralda, she presented me with a book of poems, *Rhona Boswell's Courtship*, by Theodore Watts-Dunton, who had given it to her. Writing her name on the back page, she remarked *Sor dinveriben, Raia* (it's all nonsense, Sir), which criticism I thought a little too severe.

Sampson in London

Sampson and I once called upon Watts-Dunton at The Pines, Putney, hoping to see Swinburne, but Swinburne unfortunately was indisposed. Watts-Dunton had had some intercourse with Gypsies, having in fact married one. He remarked that Gypsies were great snobs. Their old and false assumption of Egyptian origin has certainly entered permanently into their consciousness. According to my Gitano friend, Fabian de Castro, 'Anyone can see by looking at us that we are descended from the Pharaohs.' (Fabian's own countenance hardly bore of this statement.) A

[1] Bitch

72

Spanish *copla* runs thus, if I remember:

> Por esas sierras y valles
> > Bajan los pobres Gitanos,
>
> En buscar de Pharaon,
> > Que era au primo hermano.

and another:

> Se pasate por el desierto,
> Figate de las Gitanitas,
> Que resuscitan los muertos;
> > Se alguna vez vas a Egypto,
> > Pasate por el desierto.

An old English Gypsy once informed me that his grandfather was born and bred in Egypt, but this was sheer rodomontade.

Lately it has been discovered by Mr Edward Harvey, who speaks with some authority, that 'all nomads are exhibitionists.' Whatever the truth of the matter, these 'aristocrats of the road', as they have been called, possess a fatal attraction for some people. Groome told Sampson that he hated Gypsies, but couldn't keep away from them, which statement Dora Boswell pronounced *ondiculous*.

Sampson's visit to London lasted rather too long; growing tired of his company, I abandoned him in the Euston Road while he was immobilized under the hands of a shoe-black. I made my way to Matching Green, Essex, where I was then living. By a curious hallucination I seemed to hear the Rai's voice croaking in my ear all the way. Like making a new friend, to break with an old one, even at some physical discomfort, may be a refreshing experience. Doubtless Sampson's relief was as great as mine.

Caravanning

A SUMMER passed on Dartmoor was notable for the birth of the child Pyramus. I had erected a tent after the Gypsy pattern to supplement the accommodation provided by our caravan. A spring of water was at hand and a lonely inn stood a mile away by the high road. This inn was run by two primitives, called appropriately Mr and Mrs Hext. A peat fire warmed the plain flagged kitchen, which was provided with settles. I have since called there and found everything changed. The place has been smartened up unbelievably. Gone are the Hexts; gone the big hearth and the smouldering peat fire; the flags have been disguised under cheerful linoleum from Tottenham Court Road. Dainty teas are now served on 'plastic' tables, and creaky wicker-work chairs have taken the place of the settles. A few choice advertisements provided gratuitously by benevolent business firms complete the décor. It is as if the Spirit of the Age, in passing, had paused for a moment to touch with her fairy wand the homely old house, transforming it in an instant to a resting-place fit, if not for heroes, at any rate for cockney tourists in search of the beauties of nature. The prices too have gone up.

A year or two later my caravan was fetched up from Dartmoor, and rested now at Effingham in Surrey. I obtained a second van, a light cart and a few horses, including an old black hunter. I engaged a young man to help as groom, and with two sisters and a little band of children, set forth upon the road, myself usually riding ahead on my black hunter. Skirting London, we made for Cambridge, where I had some work to do. One evening, the horses being tired, we halted at a wayside inn near Watford. I inquired of the landlord if he could oblige us with a pull-in for the night. Very civilly he told us his yard was full, but

that a mile further on we would find accommodation and to spare at another inn. Riding forward then to this place, I put our case before the publican, who agreed to take us in. On my re-appearance at the head of the procession, this man rushed out in a state of frenzy, and, making the extraordinary statement that he 'had thought we was *pantechnicons*', swore he would have nothing to do with our class of people! As night was falling there was nothing for it but return and throw ourselves on the mercy of our first acquaintance, who, appreciating our predicament, with great good nature made room for us in his yard. Here we stayed not one night but three or four. Our host turned out to be an accomplished clown. Every evening he dressed up in fantastic attire and entertained his customers with his excellent buffoonery. I was loath to leave this delightful inn, but Miss Jane Harrison awaited me at Cambridge. On reaching this town we encamped in a field by the river at Grantchester.

Cambridge

I drove in every day to paint Miss Harrison at Newnham College. I portrayed the Greek scholar reclining on her couch, while she smoked innumerable cigarettes and talked learnedly with Gilbert Murray. Above her hung an early Wilson Steer. Murray used to visit our camp with Rupert Brooke. Both were charming, good-natured and playful with the children. Rupert Brooke had a blond, robust style of good looks, of which he was naturally not unconscious: a delightful fellow, I thought, but perhaps none the better for a too roseate environment. Except for a visit to James Strachey at King's, I saw nothing of University life. The atmosphere of those venerable halls standing in such peaceful and dignified seclusion seemed to me likely to induce a state of languor and reverie, excluding both the rude shocks and the joyous revelations of the rough world without.

Chiaroscuro

A party of undergraduates boating past our camp one day were reported by D. to have permitted themselves observations, to which the subject of them replied in a style as forcible as it was unexpected ... The young gentlemen were observed to row away in silent thought.

One evening after a sitting with Miss Harrison, I found my groom, Arthur, awaiting me as usual with the trap at the appointed pub: but this time, to my surprise, he showed no inclination to move, and when I insisted on an immediate return to the camp, he struck a pugilistic attitude. I quickly accommodated myself to his mood, and with a few blows, sent him for safety under the horse's belly, whence, much crestfallen, he was extricated, assisted into the trap and driven home by me. I had long been dissatisfied with his services and shortly afterwards decided to dispense with them altogether.

Norfolk

From Cambridge we trekked to Norwich. Here I left the family on a piece of waste ground near the river while I proceeded to Liverpool to paint the Lord Mayor. This task accomplished I returned, and harnessing up again we moved on in the direction of the coast.

As I rode ahead one day my old horse stumbled and fell, projecting me neatly over his head: none the worse myself, the horse, as it turned out, was internally injured. I walked him to the village of Palling, where I stabled and had him treated as well as the local wiseacres knew, but out efforts were of no avail: after a fews days the beast expired. The condition of the other horses was bad through Arthur's neglect, and I now fired him. After an unprofitable stay at Palling we moved northwards to pull in at last at the home of a friend, Charles Slade. On the way I lost another horse: a Gypsy gave me a pound for the carcase, and I

bought a skewbald pony off him, which turned out badly. To induce this animal to move required a greater expenditure of muscular energy on the part of the driver than the beast was able to exert in return. I now received a letter from a New York lawyer, John Quinn, asking me to paint his portrait during a visit to London which he was about to make. This decided me to return to Chelsea, and our wanderings came to an end for a time.

Chiaroscuro

Whistler

It was in the Salle Carrée of the Louvre that I first met Whistler. We were both alone. As usual the slight dapper figure was clad in black. Acutely aware of the defects of my own attire, which resembled that of a tramp, I rose from the bench on which I was seated and introduced myself as the brother of one of his pupils. Mr Whistler with great politeness asked me to make Gwen his compliments. I ventured to inquire if he thought well of her progress, adding that I thought her drawings showed a feeling for character. 'Character?' replied Whistler, 'Character? What's that? It's *tone* that matters. Your sister has a fine sense of *tone*.' Taking charge of me he led me round the gallery, commenting on the pictures in a lively style: of Titian's 'L'Homme au Gant' he remarked with a caressing gesture, 'Look! It's as smooth as polished bronze!' and then, conscious of his own years, 'What does age matter? Titian would have been painting now, if he hadn't caught the plague at ninety! Rembrandt, Leonardo, Raphael, Velasquez – all elicited an appreciative remark from this man, said to be so egotistic and arrogant as to decry all merit but his own.

He left me with an invitation to visit him in his studio: I did so with Gwen. We found him engaged on an immense self-portrait. He had worked long on this canvas. The subject is hardly discernible. Presently a ghostly figure is seen to emerge. It must be about seven feet high. I am reminded of Balzac's *Chef d'œuvre inconnu*. The Master, lost in over-subtlety, paints into the dark.

Anquetin

Conder used often to speak of Anquetin, a painter for whom he had a great respect. He advised me to visit him. On doing so, I found this burly genius at the summit of his Rubensesque phase.

For the fifth time he had discovered the only way to paint, and was surrounded by superb nudes glazed with bistre and carmine over a monochrome of black and white. On parting he invited me to come and work with him, 'et nous en ferons des choses,' he roared. Sometimes I regret not having acted on this proposal. Under his robust leadership I would have mastered what he called *le grand métier*, and within its salutary limitations have become illimitably productive. What a dream!

Maurice Cremnitz

In Paris my most valued friend was a Frenchman, Maurice Cremnitz. Employed nobody knew how during the day, in the evening he would emerge from some mysterious *bureau* and sally forth on the boulevards. His familiarity with the 'low' and out-of-the-way corners of Paris, his sharp and sometimes scarifying wit, his genial and well-informed mind and his ceaseless curiosity for life, made him a delightful companion. A member of the literary circle presided over by Jean Moréas, which used to meet at the Closerie des Lilas in Montparnasse, he introduced me to this assemblage of poets and writers. Paul Fort, André Salmon, Guillaume Apollinaire, Colette, and many others were among his friends to be met with here. Jean Moréas, with his top-hat and monocle, presented a rather fierce front to the world. In this society his word was law. Paul Fort, with his brother Robert, conducted the journal *Vers et Prose*: in their capable hands it ran successfully for some years. After the *Cercle* broke up at a late hour, Cremnitz, the *Prince des Poètes* (Paul Fort) and I were in the habit of roaming in the old quarters of the city, visiting the wine shops where the *vin blanc* was good – and cheap. Sometimes our explorations took us to the *Caveau des Innocents*, a subterranean haunt in the *Halles*. My companions, well aware of the dangerous character of this ill-frequented den, were a little self-conscious and

79

on their guard, but I, curiously enough, felt very much at my ease in a society which comprised a major proportion of *apaches* and *maquereaux* with their female companions or *mômes*.

Cremnitz, one night, after visiting some of his favourite Gothic churches with me, was discoursing enthusiastically on the beauties of this style, insisting especially on its *classic* quality of symmetry. I remarked that Notre-Dame at any rate wasn't exactly symmetrical. Indignantly he asserted the contrary, upon which I challenged him to come and settle the point there and then. So, as the dawn was breaking, we descended from Montmartre to the Pont du Louvre, whence we viewed the cathedral in question. Cremnitz was forced to admit that in this case I was right: the two towers of Notre-Dame were seen to be decidedly unequal.

Picasso

Cremnitz one day brought to my studio a rather silent young man of about my own age. His name, Picasso, pronounced at that time with some hesitation, was beginning to be mentioned as belonging to a new Spanish painter of mark. He examined my drawings attentively and, on leaving, invited me to come and visit him at his studio on Montmartre. When I did so, I was at once struck by his unusual gifts. A large canvas contained a group of figures which reminded one a little of the strange monoliths of Easter Island: other works showed influences from nearer home. He was seeking freedom, he said. Picasso, unlike some of his admirers, is steeped in the Past and no stranger to the *Musée Ethnographique*. His explorations have led him to stylistic exercises which at first sight disturb or even horrify, but which, on analysis, reveal elements derived from remote antiquity or the art-forms of primitive peoples. Such contacts which might conceivably have imbued his style with a primordial freshness, seem to become

infected in the process of assimilation by a bizarre and morbid strain, as if the painter were labouring under the effects of a drug. This condition, which seems to be chronic, makes it possible for him to invest the most innocent aspects of nature with a dream-like, not to say nightmarish, character, though it by no means excludes a perception of grandeur and poetry. Perhaps only in his treatment of children does Picasso drop his mask. At one period, Daumier's grandeur of spirit, before which this artist necessarily bowed, inspired him to execute a series of designs, which, while recalling his great exemplar, are imbued with a strain of sentiment all his own: the great Saltimbanque now reappears sadly wasted by T.B.; the old mendicant, apparently no longer in full possession of his faculties, listlessly plucks at the loose strings of his guitar; an idiot boy gazes out on a blue and empty world; a pseudo-classic woman attends abstractedly to her unlikely brood; before the remains of an unsatisfactory meal and in an electric penumbra, an emaciated pair are seated – the woman stares into space while her companion in a bowler hat turns apprehensively towards the inner door, from which, one supposes, the waiter may be expected to emerge at any moment with the bill. In a later stage, the artist, at the behest of his perverse daemon, contrives stylistic modes of no known source, which seem to illustrate the torments of the unconscious in a series of flamboyant, obscene and highly convoluted simulacra. If his earlier cubistic experiments now appear to me unamusing, I cannot forget the power, wit and ingenuity which subjugated me once as I faced a two-dimensional adumbration of the *Commedia dell' Arte*, and I have nothing but admiration for his zoological studies, and his recent experiments in pottery. Such ceaseless industry, leading to a torrent of *articles de nouveauté*, may seem to some, capricious and rootless, but it un-doubtedly deserves its reward in the greatest snob-following of our time. The secret of this Master is, perhaps, hinted at in his own words: *Je déteste la Nature*. In his youth preoccupied by the

macabre, he has since learnt, in his maturity, to wink the other eye. His solemn following must be an embarrassment, but he will never be overhauled. He has answered them adequately in his recent playlet, *Desire caught by the Tail*. Devil take them!

Equihen

Two summers spent at Equihen near Boulogne were productive of numerous studies of the fisher-folk, who, with their distinctive costumes, made admirable models. I am partial to fisher-folk. The *matelots* of Boulogne have lost their magnificent coifs, now only seen in old photographs. In the eighteenth century the popular life and character must have been far richer, but Sir Joshua Reynolds, who visited this region, makes no comment on the scene in his diary. He and his compeers were, it seems, too concerned with rank and fashion to waste their time on common folk. With the rise of a new bourgeoisie, flourishing on the principles of self-help, child-torture and mass-enslavement, all manifestations of the folk-spirit were frowned upon as vulgar and un-Christian: the old songs and dances were gradually forgotten, and the hereditary costumes folded and put away, to be replaced by the shoddy products of the factory: and now that the country crafts have gone too, there is not much joy left in the land. The *genius loci* has become a disreputable character, interesting only to the policeman.

Returning one evening from a walk on the sands which stretch westwards from Equihen towards Étaples, I was surprised and puzzled to see the sun setting opposite me, that is, in the east. This illusion is rare but not, I am told, unheard of. I was also mystified by the discovery of an unknown sea-monster at Equihen. Featureless, streamlined, torpedo-shaped, with its blunt nether end provided with a propeller, it had been washed into shallow water

and was helpless. Turning it I launched it into deeper water and watched it progress seawards by means of the apparatus at its stern, which was now working rhythmically with an opening and shutting movement. This creature seems, so far, to have eluded scientific observation.

Paris

The atmosphere of Paris, usually so favourable to the artist, ends by defeating him who, without domicile or workshop, is condemned, while waiting, to kick his heels in the streets. The people pass in endless procession, animated and purposeful, leaving him to revolve like a foreign body in a back eddy of the stream of life and getting nowhere. The boredom of this is excruciating. On the other hand, in luckier circumstances, to go forth upon the boulevard after a day of work is always exhilarating. Then one unites with the crowd and enjoys it the more for being, in some respects, an outsider. As I watched the scene, I used to wonder who those long-bearded young men who passed so often could be, and what the black portfolios they always carried might contain. What might they be thinking of, those interesting-looking exiles who mused alone for hours over a cup of cold coffee? Could this elderly and stately personage in voluminous brown velvet and lace cuffs be Barbey d'Aurévilly? As for the tourists, they aroused no sense of mystery. The waiters attended summarily to their too frequent orders, for these people seemed to imagine they had arrived in a city given up to debauchery, and were determined at all costs to be in the swim. On the terraces of the Nouvelle Athènes or the Rat Mort I conjured up the ghost of the last enchanted epoch. The forms of Manet, Pissarro, Renoir, Cézanne, Degas seemed to rise again to argue, laugh or quarrel across the marble tables. The little Place du

Tertre above had not at this time been converted into a bad open-air restaurant for bewildered globe-trotters in search of the *Vie de Bohème*, and no specious fellows in peg-top trousers, nor their female counterparts in student's rig, paraded their bogus works of art, together, in the latter case, with the more valid attractions of their person, before the innocent excursionists. The sails of the Moulin de la Galette revolved as usual, and the Bal Tabarin, not yet smartened up, was popular and gay. Long before the caterwauling of the 'crooner' had come to afflict us, such pleasant ditties as 'Caroline', 'Petite Miette', 'Viens pou-poule', and 'La Petite Tonkinoise', were all the rage, and eagerly committed to memory as they appeared, by poets and populace.

Henry Lamb and I used to sit for hours in the Rue de la Gaîté under the spell of an unusually efficient mechanical orchestra. As a musician himself, Lamb, better than I, was able to disentangle the obscure symbolism of its infernal din.

In the cosmopolitan world of Montparnasse, P. Wyndham Lewis played the part of an incarnate Loki, bearing the news and sowing discord with it. He conceived the world as an arena, where various insurrectionary forces struggle to outwit each other in the game of artistic power politics. Impatient of quietude, star-gazing or wool-gathering, our new Machiavelli sought to ginger up his friends, or patients as they might be called, by a whisper here, a dark suggestion there. As for me, I have never been particularly interested in Art politics and have managed to remain unidentified with any camp. When Marinetti came to London to preach his gospel, unlike Lewis and a few ladies of fashion, I remained unmoved; even when the prophet of speed assured me of his *grande sympathie*, I could only reply politely, 'Monsieur je le ressens.' It seemed to me clear that there could be no future, as there was no past, for Futurism. Lewis's 'Vorticism', which followed, might have been suitably prefixed with an A, for it came to nothing. The noisy journal *Blast* contained much

rude and violent propaganda with some very good drawings of toothy 'tyros' by the editor. Here the satirist and draughtsman revealed himself. One does not cavil anyhow with the author of *Tarr, The Lion and the Fox, Time and Western Man*, etc. etc.

Stray Thoughts

THE religious conventions of the nursery had been replaced, with adolescence, by a kind of pantheism, devout and emotional as the former but without their terrors. Freed, as I thought, from the burden of sin (original or otherwise), but not from the consequences of error, I began to look about me with a bolder and more critical eye.

The artist, above all a spectator of life, though he may, and usually does, take a hand in it himself, is also a born adventurer. His explorations, unlike those of the tourist, are rewarded by the discovery of beauty-spots unmentioned in the guide book, and with tireless curiosity and an exceptional proneness to wonderment, he will come upon objects of remarkable interest overlooked or even shunned by more disciplined observers. Such deviations from the official itinerary are bound sooner or later to land him in trouble and justify the popular belief that, as the accredited exponent of Beauty, the artist more than most people needs the control and direction of authority.

In whom is this authority to be vested? The masses, who, we know, are always right, have decided this point. It is the Business-man who, by training and experience, is best fitted to estimate aesthetic as well as material values. He can then impose them on others. At periods of national crisis, the people, reasserting their sovereignty, cry out for a Government of solid business or tradesmen under which every patriot can sweat or die, with confidence. Is the artist alone to be exempted from the rule of common sense and the laws of supply and demand?

The established canons of Beauty are now recognized by all decent people and should be enforced. Do we not all 'know what we like' – if nothing else?

Beauty at its highest is of course sexual and can be calculated. The Pretty Girl is the supreme criterion. This is why prudent young men in search of the ideal will always carry a tape-measure in their pocket.

If the artist is concerned fundamentally with visual facts, ultimate reality is only apprehended by the mystic. The artist, however, is the first to recognize a multiplicity of signs pointing to it, though in different directions.

An artist may be a visionary, but his visions assume a livelier and more enduring shape than anything he sees around him.

Artists, like children, are excited by the irrational, the bizarre and the outlandish.

Plato's *Republic*, in which the philosopher attempts to construct a form of society founded, as he erroneously imagined, on the tribal economy of a more ancient and heroic age, has ever since bedevilled the wells of western political thought. It is the ancestor of Fascism, Kremlinism and all the horrors of the police state.

Whatever material advantages distinguish the era of the atom bomb, there's no denying that contemporary life, considered as a spectacle, is a wash-out. Old men are apt to bewail the vanished glories of their youth. Perhaps they are right.

At times, overcome by spleen or boredom, one may, like Columbus, speculate on the existence of a better 'land to the West', but on investigation, Goethe's dictum, 'America is here,' turns out to be literally true and saves us a voyage.

* * *

At Eric Gill's instigation, Jacob Epstein, Ambrose McEvoy and I used to gather at my studio in the King's Road, Chelsea, to discuss the question of a New Religion. Gill's idea took the form of a Neo-Nietzschean cult of super-humanity under the sign of the Ithyphallus. Epstein's, more simply, would be realized

by the apotheosis of himself on a colossal scale, alone, and blowing his own trumpet. I was in favour of the rehabilitation of the Earth-Mother and Child, whose image installed in a covered waggon would be drawn by oxen and attended by dancing corybantes: as for the necessary miracles, Will Rothenstein could be depended on to turn wine into water for a start, and the rest would follow. There was nothing new in this, I admit. McEvoy remained unmoved by these suggestions and offered none of his own.

The Café Royal

WITH the rebuilding of the Café Royal vanished the only
establishment of this type in our capital. The smaller Café Verrey,
also in Regent Street, which was charming, had also fallen under
the onset of big business, which was to replace Nash's quadrant
by the present confusion. In this country the designation *café* is
now of wider application and may denote a tea-shop or even a
cheap restaurant. Survivors of the period will remember the
famous saloon of the old Café Royal with its gilded caryatids and
painted ceiling, its red plush benches and marble tables, its con-
versational hum mixed with the clatter of dominoes. Here, as on
the Continent, writing materials were supplied as readily as a cup
of coffee, and without charge. Well-differentiated groups dis-
posed themselves according to habit. There were the sporting,
journalistic, literary, political and artistic sets, interspersed, of
course, with a floating hotch-potch of nondescript elements.

Many persons of note were seen at the Café. My introduction
to the author of *A Shropshire Lad* was not auspicious. Although
A. E. Housman looked like a solicitor, he did not behave like one.
The publisher, Grant Richards, had beguiled him for once from
what was, no doubt, a more satisfactory isolation, for the poet
looked round on the crowded scene with an expression of disgust
which I thought superfluous: Havelock Ellis, ushered in by Arthur
Symons, appeared to be oblivious of his companion's high-pitched
propositions, having to all appearances achieved the 'undisturbed,
innocent somnambulatory state' recommended by Goethe.

Charrington, the pioneer producer of Ibsen, would be accom-
panied by Janet Achurch; this famous interpreter of the poet's
heroines, brought with her all the marks of a more than Nor-
wegian neurosis.

A hawk-eyed private detective stationed near the entrance of the Café, kept a close watch on the 'bohemians', while leaving the confidence-men and other crooks to their own devices.

It was here I made the acquaintance of T. W. Earp, just down from Oxford, where he had made his mark as President of the Union, and still carried with him traces of the benign authority proper to that Office. This meeting began a long and close friendship, not without practical motives on my side, for Tommy has proved one of my best and most long-suffering of models. Brought up in the Gladstonian tradition of Liberalism, he had dreamt of a political career, but fortunately for us all, his literary loyalties have successfully taken the place of the burdens of public responsibility.

Roy Campbell's connection with Oxford had been less distinguished: unable to adapt himself to the routine and manners of the university, and pining for the more bracing air of his native Zambesi, he took to beer in a big way, till, pulling himself together, he sent himself down and came to London. Later on I was lucky enough to be of some service to this Jingo of genius. He had lent me the manuscript of his first long poem, *The Flaming Terrapin*. I thought it a most remarkable work, in spite of its unflagging and, to me, rather exhausting grandiloquence. I showed it to T. E. Lawrence, who, much excited, bore it to Jonathan Cape, with the result of its publication in due course.

The protean Walter Richard Sickert exhibited himself from time to time in his latest impersonation. During my friendship with Dick Innes we used the Café habitually, and sometimes joined Sickert, with Spencer Gore, Gilman and Ginner in attendance. Belonging to no particular camp, I had a footing in all.

Horace Cole, the practical joker, with his girlfriend, Lilian or

'Shelley', known also as 'Billy', was both conspicuous and audible. His whoops and antics seemed out of place here, and were not acclaimed by the management; but his remarkable agility and instinct always saved him from humiliation or arrest, except once, when, most unwisely, he pitted himself against the impervious defences of Ralph Peto, another incorrigible Peter Pan. The man was never born who could 'haze' this fire-eater. Peto, though of moderate stature, sometimes appeared to be considerably larger than life, like a Dickens character. If this peculiarity made conversation difficult, he and I managed to get on very well all the same, for we had nothing in common to quarrel over. Thanks to my turbulent friend, I made the acquaintance of that rare spirit, Maurice Baring. I met the two one day when they insisted on coming back with me to Mallord Street, where they spent the afternoon roaring songs together like a couple of schoolboys. Maurice Baring promised to sit for me, for I admired him and his egg-like cranium, but his illness intervened and to my deep regret the project failed.

Narrowly escaping enrolment in the category of the 'naughty nineties', I got in with the tail-end of that period, and with the infallible instinct of youth reacted violently against it. I would have preferred the 'forties' or even 'sixties', not to speak of the Renaissance …

Oscar Wilde left numerous followers who used the Café Royal as he had done, and were impossible to avoid. Few of these, I thought, were justified in employing a conversational style which only the Master's wit and personality had made acceptable. The attribution 'School of Oscar' was, to my mind, enough to damn anybody. Weren't there other schools of thought in existence, other doctrines in the air, undreamt of by these elegant hedonists, who like the rococo décor which formed their background, seemed to be by this time decidedly out of date, if not actually fly-blown? But Max Beerbohm, whose appearance, like

that of his contemporary Dan Leno, provoked applause even before he opened his mouth, always exhilarated me, as he still does. Frank Harris, with his booming voice, baleful eye and hardy wit, imposed himself by sheer force of bad character. William Nicholson, whose pernickety mannerisms first repelled me, on further acquaintance revealed the sensitive mind and warm heart he had taken so much trouble to conceal under a too elaborate mask. James Pryde affected to disclaim all interest in art and consorted for preference with festive characters found in the neighbourhood of the Strand, but was not above visiting the Café now and then. 'Jimmy' had been an actor and still appeared to be playing an important role in some out-of-date melodrama: the performance was non-stop and must have put a strain on even his constitution. When I saw him last, at Rules's in Maiden Lane, it looked as if it were time to ring the curtain down. Sometimes I used to visit Pryde when he lived at Notting Hill. His lofty studio had the same dignified and somewhat sinister atmosphere we find in his pictures; upon an easel a perennial and carefully unfinished masterpiece, presented, under an ominous green sky, a scene of dilapidated architectural grandeur, haunted rather than inhabited by the spectral tatterdemalions of Jimmy's dreams. Always observing the taboo, I forbore to speak of art, though I would have wished to discuss, at any rate, his own efforts and encourage him, if I could, to cultivate with greater diligence the powerful, sombre and romantic spirit of which he showed such convincing evidence. In the same building was the studio of Ricketts and Shannon. Unlike Pryde, these two made no secret of their profession, nor did they waste their time with unprofitable bohemians of the Adelphi. They lived with the Masters: even their W.C. was hung to the ceiling with the stimulating productions of Titian and Giorgione. Ricketts, the more vocal of the two, was at all times ready to pontificate, while his gentle partner moved unobtrusively in the background. Shannon's style,

a discreet distillation from the Venetians and Van Dyck, had been
purged of all earthiness. His eviscerated virgins remain inviolable,
even in the embrace of their melancholy lovers, who appear to
share with them a similar immunity. Between James Pryde and
the fashionable firm upstairs, there could be little understanding
and no collusion.

It was Charles Conder who first introduced me to the Café
Royal. Conder certainly belonged to the 'nineties', but his
'naughtiness' was all his own and part of the pure romantic
nature which had ripened so fruitily in the hot-houses of Mont-
martre. He treated Orpen and me to our first 'Pernod', modified,
in consideration of our youth, with *anisette*. We both enjoyed this
drink; took to it in fact like ducks to water, and, so far as I can
remember, with no ill results of any importance.

I used to observe with much curiosity a figure which frequently
appeared in the Café. It was that of a tall blond young man,
usually accompanied by two or three young females bearing
portfolios and scrolls: a poet perhaps, for he seemed to be engaged
on some urgent literary work. This young man's pale handsome
face always wore a smile, but not a reassuring smile: it was more
of a derisive smile and made one feel rather uncomfortable. I got
to know the owner of this smile later, in the company of our
common and his then inseparable friend, Cecil Gray. It was Philip
Heseltine, better known as 'Peter Warlock'. He was busy editing
The Sackbut, a musical journal he had founded. He displayed
remarkable conversational powers and a fund of curious know-
ledge. As Cecil Gray has pointed out, Philip Heseltine's delicate
and vulnerable sensibility was carefully hidden under 'Peter
Warlock's' armoury, but it was impossible to remain unaware of
the deeper side of this man's nature, try as he might to dissimulate
it under a show of uproarious wit and effrontery. My memory of
this extraordinary being will always be saddened with the reflec-
tion that had we but set out betimes on the tour in Wales we had

planned, that hour might have been deferred, when, having put his cat out, he locked the door and turned on the gas.

* * *

I met Aleister Crowley occasionally both in London and Paris. I cannot say I was greatly attracted by him, in spite of his sinister reputation, which some people found irresistible. He held me by his glittering eye as any bore is apt to do, but I was not overawed by his learned mystifications. Yet he was a master of the subject he specialized in, and had, apparently, nothing to learn as regards the history and practice of 'magic', white or black. But one memorable evening in the Café Royal I found him in a rare and happy mood. On this occasion he astonished and charmed me by a sustained exhibition of verbal effervescence such as I had never suspected him capable of: moreover, his performance appeared to be inspired by nothing more recondite than a bottle of brandy to which he had recourse at regular intervals. I watched him carefully: there was no deception: he had turned his sleeves up. At other times his efforts to 'put it over' were cruder and less fortunate; but once his Cagliostro pose was discarded, he could be good company: in course of time he developed into a very likeable old gentleman. He had sadly changed when he called on me recently to be drawn. I was scared by his appearance. He had shrunk unbelievably and his eyes were staring. But a book of poems he published shortly afterwards shows no sign of decrepitude. I was cheered by their vigour and verve and told him so. His poetry has been described as 'Swinburne and water'. I dispute the justice of this too facile estimate: the mixture was much more potent. The fact is the Magus had a good deal more than the stock-in-trade of a charlatan, and perhaps only lacked good taste. Here follows the last letter from him, received shortly before his death. The hierophant speaks again. I found it unanswerable.

'Netherwood'
The Ridge
Hastings
27th September, 1947

Ex Castro Ann lxxl
 Nemoris Inferioris Sol in O°Libra

Care Frater,

Do what thou wilt shall be the whole of the Law.

The greetings of the Equinox of Autumn!

The Word of the Equinox is brill*iance* (Ring settled on the last five letters.) AL. 1 64.

The Oracle of the Equinox is time (AL 11 36).

The Omen of the Equinox is VIII Pî (love).

Love is the law, love under will.

Yours fraternally,

$9° = 2$ A

★ ★ ★

A. R. Orage presided genially at a gathering of 'New Agers', which might include the philosophers T. E. Hulme and de Maeztu, and possibly Dikran Kouyoumdjian, who, under the name of 'Michael Arlen', was to become the mouthpiece of Mayfair, and a best-seller.

Lord Alfred Douglas, accompanied by his ponderous friend Crosland, was often seen at the Café. I had met him at Will Rothenstein's, and we always greeted each other in a friendly way. There was no reason why we shouldn't, for I played no part in the tumultuous life of this gifted but cantankerous sonneteer, who, while trying so violently to live down his past, with each successive effort succeeded only in reviving it.

95

Chiaroscuro

Roger Fry, at the head of the Bloomsbury coterie, might well be on his guard in the proximity of the conspiratorial Wyndham Lewis with his small band of blood-thirsty Vorticists.

Nancy Cunard, Iris Tree, Sybil Hart-Davis, Marie Beerbohm and Inez Holden formed the efflorescence of another section, both ornamental and literary in colouring. John Currie and Mark Gertler, accompanied by the red-headed Irish girl, Henry, Nora Carrington and possibly Dorothy Brett, might be seen to confabulate in a corner.

Lady Ottoline Morrell

I THINK I must have been the only friend of Lady Ottoline Morrell who never visited her at Garsington. But I had met her first at a dinner party long before she took this house and had been at once greatly struck by her personality and style. Becoming great friends, we used to meet and correspond, off and on, for a long period. I had difficulty with her letters which were written in a character of her own invention, so original and precious as to be almost indecipherable. At one time she had fallen under the sway of D. H. Lawrence and talked constantly of his wonderful charm and wisdom. As I had not then read a word by this author, nor ever met him, my response to these rhapsodies was only luke-warm. However, I eventually came across a book, *Sons and Lovers*, which I read. It quite bowled me over! I hastened to announce my conversion. But Lady Ottoline received this news in chilly silence: I wondered what was amiss. It turned out I was just too late, for the Master had by then offended his disciple somehow, and his name was not to be mentioned.

Villiers de l'Isle Adam has a story of that Duke of Portland who built an underground palace at Welbeck in which to reside in solitary state: the poet explains this eccentricity as being due to a disfiguring disease which the Duke had contracted and wished at all costs to conceal. I inquired of Lady Ottoline the truth of the story. Her uncle, she said, suffered from nothing more objection-able than inordinate vanity and selfishness. I painted a portrait of Lady Ottoline which she hung in her dining-room: whatever she may have lacked, it wasn't courage: in spite of a dull and con-ventional upbringing, this fine woman was always prepared to do battle for Culture, Freedom and the People.

Chiaroscuro

Charlie Chaplin

It was at the Morrells that I once met Charlie Chaplin. He found it difficult, I think, to preserve his natural cheerfulness amidst the habitual gloom of the Bloomsburyites who formed the rest of the party, but his spirit was more than equal to these adverse conditions: he was not one to be silenced and he had the hearty backing of his hostess to count on.

While he was speaking on social conditions in a strain which seemed to me familiar and sympathetic, I was impelled to slap him on the back, saying 'Charlie, why, you're nothing but a dear old anarchist!' Recovering, he replied, 'Yes, that's about it.' Although he agreed that London was his proper habitat, he admitted to being enticed by the powerful lure of Hollywood. Recalling his early days and the vicissitudes of his family, all rolling stones of the music hall, he mentioned that his mother had been courted by a lord: 'Oh,' drawled Ottoline, much interested, 'which lord?' 'Ah, I'm not going to tell you,' replied Charlie.

D. H. Lawrence

I MET D. H. Lawrence in the flesh once only. Lady Cynthia Asquith, whose portrait I was painting, brought him round one day to my studio. Lady Cynthia would have liked me to paint Lawrence and I would have been interested to do so. But Lawrence protested that he was too ugly. I didn't agree. I never did insist on an Adonis for a model, and I thought Lawrence's features would have done very well for my purpose; even if they didn't conform to any known canon of beauty, they didn't lack character. Besides, did I not recognize in them the mask of genius? On this occasion the poet made a point of compensating himself for his physical drawbacks by a dazzling display of cerebral fireworks. Originality or Death seemed to be his motto. Lady Cynthia treated us to a box at the Opera that evening. A resplendent guardsman was of the party: Frieda Lawrence, who also was present, assured us all that her German father's uniform was much grander than that of this officer. On leaving what Sir Edwin Lutyens used to call the 'uproar', D. H. L. announced that he would like to howl like a dog ...

It will be remembered that when Lawrence held a show of his paintings at Dorothy Warren's Gallery in Maddox Street, the police raided the exhibition, removing such works as offended their sense of propriety, and while they were about it, carried off a number of designs by William Blake as well! The Force is nothing if not thorough. I made several attempts to capture Lady Cynthia's strange satyr-like charm. Perhaps in one of these efforts, I succeeded in approaching it, but like so many similar projects, it began, I think, better than it ended. Perhaps it isn't ended ...

The death of Lady Cynthia's uncle, Evan Charteris, was, like

that of her husband Herbert Asquith, a nasty blow for me for I loved them both. The magnificent Lord Wemyss, the former gentleman's father, whom Sargent painted, used to contribute regularly to a paper edited by Auberon Herbert called *Free Life*. It was the organ of what was known as 'voluntaryism', a respectable variant of 'anarchism'. I used to take it in for I found it very much to my taste.

St Honorine and the Coppersmiths

A STAY at St Honorine-sur-mer on the Normandy coast was memorable for the birth of a son, Romilly, the arrival in the district of a band of Piedmontese Gypsies and a visit from Wyndham Lewis. When he and I made an excursion to see the Gypsies whom I knew to be stopping near Bayeux, Lewis did not wish his Scandinavian friend to come with us, but she was not going to be left out. I thought she was justified. Lewis, after half a century, quoted only the other day, my opening phrase on greeting one of the Gypsies: 'Sar šan miri p'en', although ignorant of its meaning. What a memory!

Perhaps a year later, I found myself and family at Cherbourg. Here I made my first contact with the 'Coppersmiths', then in course of a new migratory outflow from Middle Europe. I collected specimens of their hitherto unrecorded dialect which has since been investigated more thoroughly by Sampson and other scholars in the columns of the *Journal* of the Gypsy Lore Society. The married women of this tribe habitually wore numerous gold coins as ornaments; this custom, exciting the cupidity of the baser elements of the Cherbourg population, made it necessary for the men to stand guard at night with their revolvers ready.

Travelling by *diligence* through the Jean François Millet country, we reached the village of Dielette by the sea, and settled there for the summer. A small circus arrived at the same time, and I soon became friendly with its personnel. A venerable member of the troupe, Nicholas Klising, took a fancy to me. The attraction was mutual; we spent much time together. The old man when in the café had a disconcerting way of questing for alms in an attitude of abject humility: then, having collected a sufficient sum,

he would resume his seat at my side and, with a lordly air, order another bottle of wine under the eyes of his benefactors. This highly intelligent comedian discussed 'affairs of Egypt' with unusual frankness for a Gypsy.

I made some headway at Dielette, where I employed with advantage the method of restricting my palette to the three primary colours represented by ultramarine, crimson lake and cadmium, with green oxide of chromium.

Flamenco

Through Henry Lamb I made the acquaintance in Paris of Royall Tyler, a sympathetic young Bostonian who occupied a luxurious apartment in the Rue Vaugirard. Tyler was a literary student and had written of 'Spain, her Life and Arts'. He was, as they say, *muy aficionado*. Here also I met Horace de Vere Cole, Lyulph Howard, Tudor Castle and a Gypsy guitarist, Fabian de Castro, *El Gyptano*, as he signed his pictures, for he was now a painter too. My life now began to take on a Spanish colouration. 'La Macarona' and 'El Faico' and others would join us at the flat to entertain the company in the style known as 'Flamenco'. A first-rate performer, La Macarona was a celebrated woman. No longer young, she was still acclaimed as the finest living Flamenco artist. The intricate rhythms of this musical form, and especially that variety known as *cante xondo*, always described by Fabian as *fatal* music, seemed to stir up strange undercurrents of anguish, longing and regret. The voice of the singer rising convulsively from the bowels, merged with the insistent thrumming of the guitar-strings in an agonizing ululation, suggesting the outcry of beings thrust from grace (for what unimaginable delinquency?) and left with nothing but the bitter passion and irony of the damned. The dances, on the other hand, illustrated with exquisite precision and vigour the pride, power and glory of the flesh.

Horace de Vere Cole

HORACE COLE was at this time in his prime. The great practical joker, in full possession of good looks and an ample fortune, presented to the world the interesting spectacle of a pseudo Anglo-Irish aristocrat impersonating the God of Mischief. A plentiful crop of white, but by no means venerable, hair crowned his almost classic head-piece which was, in addition, furnished with upstanding moustaches in the style of the late Kaiser Wilhelm. His fine blue eyes blazed with malice and self-assurance. Dressed like a 'milord', he strode magnificently along the boulevard, on the lookout for a chance to indulge at any moment in some mad prank. No practical joker myself, I would have preferred to view such activities at a certain distance. It was embarrassing to find myself, without warning, in charge of an epileptic in convulsions on the pavement and foaming at the mouth; or to be involved in a collision between a whooping lunatic, and some unknown and choleric gentleman who had been deprived suddenly of his headgear, and who had all my sympathy. Cole used to say he was at war with pomposity. Whatever his motives, I have never known a Frenchman to respond to this branch of humour with anything but disgust.

My association with this *grand farceur* continued, though often at a distance, till his death, but suffered frequent interruptions (our tempers weren't always in unison). It began well certainly, and from time to time the original charm would reassert itself after what might have been a serious set-back. At its best his style had great distinction, with that touch of absurdity combined with devilment which I found endearing. Though no amateur of the practical joke, I agree that Horace Cole's famous exploits in this line were in the grand style, and with astounding nerve, luck, and

high spirits he managed to get away with it. When all went well he could be amiability itself; when it didn't, that is, when his excessive vanity had received a jar, he would manifest his resentment in language which any bargee would have envied. It was at such moments that he came near to achieving true expression, and it was a relief to be able to pay tribute to a genuine home-grown accomplishment.

Cole's first marriage having proved a failure, his second ended unfortunately with his death at Ascaigne in the Pyrenees. His fortunes had fallen meantime and his glory, with his wife, had departed. I went to his funeral, which took place near London, but I went in hopes of a miracle – or a joke. As the coffin was slowly lowered into the grave, in dreadful tension I awaited the moment for the lid to be lifted, thrust aside, and a well-known figure to leap out with an earsplitting yell. But my old friend disappointed me this time. Sobered, I left the churchyard with his widow on my arm. She had arrived just too late for the final act, or, as I might perhaps put it, the last fiasco.

Funeral of John Sampson

AFTER the death and cremation of John Sampson, arrangements were made for the disposal of his ashes according to the terms of his Will. The ceremony was to take place upon a mountain, Foel Goch, in North Wales. I travelled to Ruthin, a town in the neighbourhood, with Stephen Tomlin the sculptor. Tomlin was always ready to make a journey in any direction with anybody at any moment. Gathered at the appointed meeting-place, we found some hundreds of people: among them Professors Oliver Elton and Garmon Jones; the Gypsiologist, Miss Dora Yates, and other representatives of Liverpool University. Also present were a band of Welsh Gypsies with their musical instruments, including a heavy 'triple' harp. Robert Scott Macfie, somewhat ill, was provided with a pony for the ascent of the mountain. This ascent was long and arduous, but at length we arrived at a suitable spot near the summit. The Rites, which had been drawn up in Welsh Romani, were conducted by me. I was to wind up with the recitation of the departed Rai's valedictory verses to Francis Hindes Groome, commencing *Romano Raia, p'rala, junimañgero, Konyo čūmerava tō čikat*[1]. In spite of the long period of time since I had memorized this poem, I was able to recall it without fault. Finally Sampson's son Michael, with, I thought, an expression of some disdain, scattered the ashes from the box, which the Gypsies were careful to burn before striking up some lively Welsh airs. At the inn of Cerrig-y-Druidion that evening, in accordance with the Rai's instructions, there was merriment, dancing and singing, but I thought this celebration lacked spontaneity.

[1] Gypsy gentleman, brother, scholar, silently I kiss thy forehead.

County Clare

I FIRST visited the West of Ireland as the guest of Francis Macnamara, poet, philosopher and economist. He lived at Doolin on his ancestral estate in County Clare. Much given to solitary and gloomy cogitation, he would sometimes shake himself out of this mood and, warmed with what he called the 'hard stuff', become genial, popular, and, as the police were apt to think, dangerous. As the hereditary squire of Ennistymon, he was treated by the local people with a deference which sometimes embarrassed him. In spite of this circumstance, he would often take me down to the little 'shebeen' in the village of Fisher Street, to watch the dancing and listen to Irish sagas and songs. Mary Shannon, a remarkable woman, though no longer in her first youth, excelled in these arts, and with her wit and wisdom outshone everybody. Treated by all with consideration, her status in society I never understood until Macnamara confided to me the secret: she was the priestess of a cult, as I thought long since extirpated with snakes from Ireland; that of Brigit, the Irish Venus ... Her last words to me were, 'Goodbye now, ye'll remember me when ye're betwixt the sheets.'

Out at sea lay the three islands of Aran. An expedition to the southernmost was not unattended with danger, for on our return a storm overtook us. All had to take a turn at the oars, and rowing for our lives, we managed under expert direction to bring the *curragh* safely to shore, though not where we had intended.

Sometimes Francis Macnamara, breaking away from his meditations and the delights of a beautiful blond family, would harness his horse and trap, and drive me out in exploration of the countryside: we visited Ennistymon, where stood my host's ancestral mansion; Lisdoonvarna, with its ugly 'hydro', a resort

of priests on holiday, who, I was informed, might here relax the strictness of their Rule, and linger a while in sentimental dalliance with scared colleens; and Ballyvaughan of the sculptured cliffs and dark blue gentians, whence, across the glittering bay, the cubes of Galway City were seen clustered above the water in a pattern of grey and white.

Galway

With what excitement, on my part at any rate, did we cross over on the steamer *Dun Aengus*, and step ashore at last on the quays of the western capital! Tall warehouses alternated with low white-washed or pale coloured dwellings beside the wharves: across the harbour, the old Irish village of The Claddagh, a complex of thatched cabins, appeared to have sprung up in a fairy ring, like mushrooms from the ground: bevies of shawled, bare-footed girls passed, laughing, as we threaded the labyrinthine streets which resounded with the cries of fish-women: somewhere a voice, sweetened by distance, wailed nostalgically: 'Eileen allanah, Eileen asthore!' Black hookers lay along the quayside; among them Macnamara's newly rigged *Mary Ann*, 'a boon', as Oliver Gogarty remarked with customary malice, 'to the local washer-women'. In Flaherty's little bar by the New Dock, where charming Kitty McGee presided, men of Aran awaited their passage to the islands; 'mountainy' women refreshed themselves with stout, and Welsh seamen, newly landed, celebrated the day in noggins of whisky. At dusk, dark forms could be espied, lurking among the fallen balks of the old timber-yard beyond, and women still lingered, murmuring, by the Spanish Gate – a face, or part of a face, blooming for an instant from shadowy veils and quickly averted. The Claddagh in the half-light begins to look unsubstantial and dream-like; the waters of Lough Corrib pour through the arches of the bridge, where salmon, massed in

wavering rows, await the signal to ascend: more water gushes through the cavernous apertures of a dilapidated mill: in the main street stands Lynch's Castle, a rectangular tower of fine-cut stone: a tinker-girl, drunk and of a Raphaelesque beauty (in spite of a black eye), utters sweet bird-like sounds, while incessantly readjusting her shawl: Dick Innes's English accent, acquired at Llanelly, was becoming more marked: God knows how or whence he appeared, but we had certainly been, all three, to the Races, where we had found the tinker-girl and conveyed her back safely, her parcel of pig's-trotters and all. The fish-wives in the bar, ensconced with their stout, hand the pipe round as they pass derisory comments on current events: Winny Corcoran, my 'fond girl', goes dodging by, on her way to the docks, and over Oranmore the pale sky darkens as Mr Heard, the D.I., taking a stroll, comes under the verbal fire of vainglorious patriots issuing from pubs: ridiculing them scornfully, he proceeds on his way, swaggering.

Aran

When we made the passage to the North Island of Aran, we were fortunate to synchronize with a mission conducted by two Jesuit Fathers. Their departure was the occasion for a great concourse of the islanders, who gathered on the strand in their grandest clothes, to give the holy men a send off. Their cause enriched appreciably by the sale of medals, pledges, badges, scapulas, rosaries, etc., the missionaries in return rewarded the faithful with the blessing of the Pope himself, as they were rowed out to the attendant hooker. It was a grand sight. The good Fathers, besides putting the fear of Hell into their flock, had seized the opportunity to ban the *Patterne*, a yearly festival surviving from pagan times, at which it was customary to hold horse-races on the strand. No doubt the stout flowed freely on

these occasions, but it was the one holiday of the year. I trust it has been resumed long since.

The Aran Islanders are a polite, dignified people. They speak the best Irish, and their English is slow, ornate and somewhat archaic. It is in fact Elizabethan English. Self-supporting and weaving their own garments, these survivors of an ancient civilization are practically untouched by the industrialism which was beginning to leave its unsightly marks on the mainland. The tiny fields, enclosed in stone fences, yield from rich soil in the interstices of the rock exceptionally good grass for the island cattle: the smoke of burning kelp rose at intervals along the shores: women and girls in black, red and saffron draperies, moved in groups with a kind of nun-like uniformity and decorum: along the precipitous Atlantic verge some ancient breed of men had disputed a last foothold from the ramparts of more than one astounding fortress. Who were these people? Formorians, Milesians, Tuatha-de-Danaan, Firbolg? Eastwards the speckled mountains of Connemara rose in the series of the 'Twelve Pins', and to the north, the sacred cone of Croagh Patrick pointed its apex over against Westport.

Dublin

While staying at Equihen, I received an invitation from Lady Gregory to come to Coole Park, Co. Galway. She proposed that I should paint W. B. Yeats, who was her frequent guest. Again I set out for Ireland. Arriving at Dublin I entered a restaurant and ordered a meal. The waitress seated herself at my table and inquired in a friendly way my provenance, destination and business. Satisfying her curiosity on these points, a pleasant conversation ensued. I left this engaging young Irishwoman with some reluctance, but feeling distinctly less forlorn. Orpen had recommended me to get in touch with Oliver St John Gogarty.

Chiaroscuro

Following Orpen's directions I found the celebrated wit, surgeon and poet at 'Baillie's', a favourite resort of literary Dubliners. Gogarty welcomed me with the greatest good nature, and for several days occupied his leisure in introducing me to all that was notable in the city and its neighbourhood. Though my cicerone's ceaseless effusion of wit and wisdom was exhausting, and the pace of intellectual Dublin faster than I was used to, I was never better entertained. I had arrived at the latter end of a great epoch. Dr Tyrrell was dead, but Provostmaster Mahaffy was very much alive. George Wm Russell (AE.), Seamus O'Sullivan, James Stephens, Padraic Colum, Lord Dunsany, Tim Healy, President Cosgrave, General Mulcahy, John Keating, Paul Henry, John McCormack, Cecil Baring, J. M. Hone, George Moore, Kevin O'Higgins, Professor McCran, Compton Mackenzie: such were some of the outstanding figures I met with in these and other crowded Dublin days. At last I boarded the train which was to take me across the bogs to the West.

George Bernard Shaw

Once aboard the Trans-Ireland Express, and Dublin left behind, the weak spot in Oliver Gogarty's system of social intercourse became apparent. The surgeon-poet's magical exuberance and *joie de vivre* seemed to blossom best on a basis of 'John Jameson', but this underpinning required regular renewal. I now found myself minus the prescribed standby to which, on Gogarty's professional advice, I had accustomed myself. 'Float your intellect!' the Magus had adjured me, as he raised a final cup to his lips in the station bar. This, his last injunction, I would willingly have held sacred; but, as it happened, all buoyancy having left me long before I reached the West, there was no means of recovering it. Arriving at Coole Park in poor shape, I might indeed have applied to Lady Gregory for first aid, but I knew of nothing in her

tore capable of subduing the frightful cough which now plagued me, and all within hearing. It seemed to me to be organic, and so, incurable. Several days passed, with no sign of betterment, till my hostess, alarmed, suggested sending me to bed; but my fellow guest, Bernard Shaw, had a brighter idea – he handed me over to his chauffeur, a man, he assured me, of infinite resource, who would know how to deal with my case if anybody alive could. This chauffeur was a character of Shaw's creation and had figured in one of his plays: it was only later that he was discovered to exist in the flesh, and like all the inspired projections of the dramatist's imagination, turned out to be true both to Art and to Nature. His spiritual father of course engaged him on the spot.

The chauffeur drove me to the town of Gort, where, entering a chemist's shop, he ordered a concoction, which, to judge by the apothecary's face, was unexpected, to say the least, but whatever its ingredients, the cure must have been sovereign, for it worked like a charm. My cough weakened at the first dose and soon petered out altogether. To complete my rehabilitation Robert Gregory insisted on my mounting a horse. Uneasy at first, I gradually adapted myself to this strange animal's ways, and after a few days' practice was able, to some extent, to control them. When, eventually, my mount and I succeeded in clearing one of the stone walls characteristic of this country, without mishap, Robert complimented me on my performance, and my apprenticeship was over. I was now enjoying myself, but other problems remained to be dealt with. I had come with no less serious a purpose than to paint Bernard Shaw. But with my newly regained health, I felt ready for anything, and faced my task with confidence. Shaw's head had two aspects, as he pointed out himself: the concave and the convex. It was the former that I settled on at the start. I produced two studies from that angle and a third from the other. In the last he is portrayed with his eyes shut as if in deep thought. Although he had just consumed his

midday vegetables, there was no question of nodding: he had avoided a surfeit.

'What!' exclaimed my model, when I informed him of my fee, 'do you mean to say you work for so paltry a sum?' But before I had time to revise my charges, the cheque was written and handed over. G. B. S. was always kind and helpful to the young, especially when they showed talent and honesty of purpose. Perhaps as an old campaigner he kept a good look out for possible recruits; nor did he forget them, as his occasional postcards testify. Without being exactly a recruit myself, our differing outlooks in no way precluded friendship: perhaps they even enhanced the charm of intimacy by adding an element of the unknown.

In the evenings we sometimes collected in the drawing-room. Shaw would, when so disposed, seat himself at the piano and sing a succession of pieces in his gentle baritone. His effortless, unassuming and withal accomplished performance was welcomed by everybody. His conversation, however, (at any rate, in my experience) was sometimes apt to be irritating. The style proper to privacy is not that suitable to the platform, but this practised orator seemed sometimes to overlook the distinction. Mrs Shaw and Lady Gregory, each in her amiable way, adopted a humorous, appreciative but slightly aloof attitude, as if in the presence of a difficult, precocious, but an essentially lovable wonder-child. What the society of Coole lacked, I thought, was the participation of some innocent, even naive, but rather contentious person to act as feeder to the Master: with that we should all have had more fun. As it was, the monologues, unenlivened by opposition, gained only in length what they lost in piquancy. Is not inconsequence the fuel of wit? Unanimity, besides being the cause of moral discomfort, inhibits repartee. Pomposity, however, could never be charged against G. B. S., and he would have been the last to encourage 'the foolish face of praise'.

One of Shaw's hobbies was colour photography. He had acquired the latest mechanical device. Going over to Bally-vaughan one day, he brought his toy with him, and we 'took' each other with it. Results not bad. Ballyvaughan is a strange moon-like district with gentians growing galore and still rarer plants hiding amidst the rocks.

Although this was a long time ago, Shaw on arrival extracted himself with some difficulty from the car, murmuring as he did so, 'Age tells ...'

When the time came to leave, Shaw offered me a lift home-wards. I was glad to accept as I calculated this would mean closer contact with the country and people than the railway journey afforded. On nearing any town of importance, G. B. S., well aware of what he was in for, prepared himself suitably, with an eye to the photographers, who, apprised of his approach, posted themselves with their cameras in readiness to shoot, as our car, in slow motion, passed majestically along the main street.

Sometimes the Philosopher himself took the wheel. I thought his driving faultless if a trifle slow. At our rare stopping-places, perhaps impatient of his ceaseless philosophizing and cold-blooded war talk, I would seize an opportunity to escape and do a little exploration on my own. An hour's field work with the natives would not be unprofitable, I thought, for I was, and am, a keen amateur of Anthropology. This was a subject in which Shaw showed little interest. I had of course no time to master or record the language I heard spoken, but could listen to it with pleasure, while studying the speakers. I observed that the Irish, especially when young, are often quite good-looking, even when judged by civilized standards. Apart from such breaks, and an accident I incurred outside Dublin in Gogarty's company, which I have mentioned elsewhere, the journey was uneventful, except for a stop at Shrewsbury where Shaw took me with him to pay

our respects to Samuel Butler's memory at the church which his distinguished precursor had attended.

I parted from my kindly hosts at their house at Welwyn. What I have sketched here was more than an ordinary episode: it was a great occasion, for I had come to know in intimacy a true Prince of the Spirit, a fearless enemy of cant and humbug, and in his queer way, a highly respectable though strictly uncanonical saint.

Coole Park

Lady Gregory's big plain house at Coole stands in a well-wooded park, watered by a river which, flowing underground, reappears on the surface at intervals; near by a lovely lake, or *Turlough*, mysteriously rises and subsides. I spent many an hour rowing idly on its placid waters with only Yeats's swans for company. The lake's outflow engulfs itself in a low grotto which, I thought, should be adorned with the statue of a guardian nymph. Listening at its mouth I heard what sounded like the chanting of hosts in distant caverns beneath.

Yeats, slightly bowed and with his air of abstraction, walked in the garden every morning, deep in literary confabulation with his Egeria. With his lank hair falling over his brow, his myopic eyes, his hieratic gestures, he looked every inch a poet of the twilight. He never joined her Ladyship and me in our excursions, fearful perhaps, being no great linguist, of meeting some Irish-speaking fairy. I met none of the *Sidhe* myself, but had seen pictures of them taken from life by George Russell in his rooms at Dublin. AE. as well as being a poet was a Sunday painter, and an orator. To hear him in disputation with George Moore was alone worth the journey.

Having produced several paintings and drawings of Yeats, a portrait of Augusta Gregory's grandson, with some drawings of

herself, her son Robert and his Welsh wife, I returned to England.

On another stay at Coole Park, I painted three portraits of Bernard Shaw. One he kept himself, the second he gave to the Fitzwilliam Museum, Cambridge, and the third, after some vicissitudes, now belongs to the Queen.

Renvyle

Travelling west with Provost Mahaffy we were approaching the Connemara mountains. I remarked that their barren outlines seemed to evoke the Heroic Age of Ireland: the Provost replied, 'Tut, tut. What you see now are only the denuded skeletons of mountains which in the period you allude to, were covered with soil and thickly wooded.' 'But when and how did the soil get upon them then?' I inquired innocently; but the great Illuminate, with an impatient gesture, changed the subject.

We were on our way to Renvyle, where Gogarty had acquired a house once belonging to a member of the Blake tribe. Here Mahaffy, who had written a treatise on the Art of Conversation, displayed his accomplishment in this line by a series of instructive and highly entertaining monologues, which even Gogarty was unable to interrupt.

* * *

I returned to Renvyle many years later. The Gogartys had converted the house into an hotel. Again I had the poet Yeats to portray. He was now a silver-haired old man, much mellowed and humanized. He had had time to amass an endless store of humorous anecdotes, most of them on the subject, and at the expense, of George Moore or other distinguished contemporaries. I was familiar with most of these stories, or variants of them, for the Irish literary movement nourished itself largely on scandal, which, as it circulated, gained, at each telling, an added lustre of

wit and acerbity. Lord Longford accompanied the poet's recitations with well-timed bursts of stentorian laughter, while Oliver Gogarty was usually able to contribute a finishing touch of his own. Besides Yeats, Mrs Edgar Scott had come with her husband all the way from Pennsylvania to be painted. We were shy on meeting for the first time, but this soon wore off, for Mrs Scott proved to be as sympathetic as she was beautiful. When Ralph Peto and his son Timothy appeared, a new note of old-fashioned turbulence made itself felt in the atmosphere of the hotel. I did not lack models at Renvyle. Besides Mrs Scott, the Ladies Dorothea and Lettice Ashley-Cooper and their sister Lady Alington sat for me, as did Miss Brenda Gogarty. We met other friends at this hospitable spot – the painters Adrian Daintrey and George Lambourne; Mr and Mrs Hugo Pitman and Mr Harry de Vere Clifton.

Meeting to my astonishment my New York friend Mrs Pad Romsey, in Galway, I persuaded her to come over to Renvyle for an hour or two with the bevy of girls she had in her charge. The demure correctitude of these young ladies impressed me greatly. We have nothing like it in England.

I drove the Scotts and Mary Alington to Lettermullen, a tidal island to the south, famed for its lobsters. I had already been presented by Macnamara to 'Mocky', the King of the Island, so we were accorded diplomatic honours and taken to an upper room where 'poteen' was dispensed. This excellent beverage, locally and illegally distilled, was much appreciated. Under the new dispensation the industry has been suppressed, and an ancient source of inspiration lost to Ireland.

I nearly acquired a castle. Roofless and sheltering only cattle, its tower rose above a deep stream flowing into Lough Corrib. Gogarty failed as an intermediary, for the price was raised on me. Perhaps in his new role of Lord of Kinvarra he wanted no rival châtelain in the district. I relinquished my plan with sorrow, for

the place was enchanting and so was its name, *Aughnanure*. Innes and I had had designs on a dilapidated mill in Galway City, but this too had its inconveniences, for the water poured through every room. Eventually I took a house on the Tuam road. It belonged to some nuns, and the Bishop's approval was needed. An interview having been arranged, Bishop O'Dea, author of the celebrated phrase, 'the degrading passion of Love', inspected and passed me, with one stipulation: I was on no account to paint the nude. The possibility of this had not occurred to me, but Mr Fahy, the agent, saw no great difficulties there: 'You'd get any woman in the town for sixpence,' he said, 'but they might blab ... ' Having taken the house for three years, with the help of Mrs Gogarty, I got one or two rooms partially furnished and passed a week or two in it. The War had now started. Men were entraining at the station with their women-folk seeing them off 'to fight England's battles'. There was much weird *keening* on the platform as the trains moved out. My plans frustrated, I too departed. If they have not improved the place too much I might go back yet. Surely there will be a shawl or two left.

Madame Strindberg

I NOW come to an incident which turned out to be the prelude to a long series of grotesque and unedifying adventures. Alone one day in my house in Church Street, Chelsea, I heard the bell ring: opening the front door I was confronted with a strange lady, who smilingly and with a foreign accent inquired the whereabouts of Percy Wyndham Lewis. Having informed her as best I could (for Lewis's address was never certain), my caller, though uninvited, entered the house, and, with great good nature, made herself at home. This lady was Frida Strindberg (*née* Uhl), an Austrian, and the second wife of the Swedish dramatist, August Strindberg. It appeared that she had had some literary dealings with Lewis, who had mysteriously disappeared. Always the amateur of genius, she was anxious to trace and continue to befriend this one. The conversation (on my side but halting) turning to the subject of Art, Mme Strindberg expressed a keen interest in my efforts and a wish to purchase some of them. Disliking, as I always do, the role of salesman, I referred her to my dealer. Finally, with a promise to revisit me and many expressions of good-will, the lady departed. When I next saw Lewis and mentioned this meeting, he betrayed great agitation and made me swear not to reveal the address of his new lodging. Mme Strindberg, he said, was an 'admirable woman', but he had certain reasons for wishing to discontinue his association with her. I then dismissed the matter from my mind.

Alderney Manor

In 1909 we moved from Chelsea to Dorset, having found a suitable house off the Ringwood Road, near Parkstone. Alderney Manor was a low building in the Strawberry Hill style: a cottage

made a useful annexe, with a coach-house which I converted into a studio. The caravans provided extra accommodation, and an extensive acreage of pasture, heath and woodland surrounded us. The neglected gardens, under our care, soon recovered their luxuriance and the gradual acquisition of a pony, a few cows, a family of pigs, with our red setters and Siamese cats, completed the economy of our new home.

Provence

As if in answer to the insistent call of far-off Roman trumpets, I set out one early autumn for Provence. The classic land had been for years the goal of my dreams. I descended at Avignon. I found myself, still dreaming, under the ramparts of the city by the swift flowing Rhône. Across the river, here split by the low island of the Barthelasse, the white town and castle of Villeneuves-lès-Avignon looked like an illumination from a *Book of Hours* by Jehan Fouquet. From the gardens of the Popes' Palace I beheld, to the north-west, Le Ventoux, raising unexpectedly its creamy dome which at first I took to be snow-covered. 'Lačo dives,' I remarked to a Gypsy girl as she passed by: 'Ker'la šil,' she replied in her beautiful dialect, thought by the learned to be long since extinct. The Palace stood straight and tall like the central edifice of a noble *phalanstère*. I admired the fragmentary frescoes of Simone Martini within it: I drank cheap wine with 'Le Marseillais', a humorous vagrant whose acquaintance I had made: I explored dark by-ways where old women seated on doorsteps beckoned the passer-by to a dubious hospitality: I lingered in the company of *maquignons* and improved my vocabulary.

At last I went on to Arles. Arles, once the capital of Provence, in earlier times a Greek colony and then a Gallo-Roman town, has been celebrated for the beauty of its women: but latterly the influx of Belgian workmen employed in the building of the railway, has modified to some extent the famous classic features. The local costume, once so rich and gay, has now declined to a sober uniformity of black and white; it is worn principally by the married and older women, but on special occasions the young ones resume the ancestral garments and, with their golden hats worn not on their heads but over their buttocks, parade the

streets or dance the *Farandole* to the music of fife and drum. In the Arènes or Roman amphitheatre the provençal bull-game is played, and sometimes the *mise-à-mort* itself takes place with imported Spanish bulls and matadors.

I found an excellent lodging on the Boulevard des Lices. The family Gelet who kept this café-restaurant passed their lives amicably and in public. No quarrels were seen to take place. The children were always *sage* and their parents and grand-parents cheerful: the latter had resigned themselves to a dignified and knowledgeable inactivity: still alive to mundane interests, especially as these affected the family, they seemed, while en-joying what was left of life, to envisage the prospect of the grave with equanimity.

Martigues

> Aux Martigues d'Azur vous allez cueillir
> La Flore des Étangs,
> Pour faire la Couronne, amis, qui me décore,
> Et me garde du Temps.
>
> <div align="right">JEAN MOREAS</div>

Leaving Arles for Marseilles, the railway skirts the northern shores of the Étang de Berre. Looking south from the train I caught a glimpse in the distance of spires and buildings which seemed to belong to a town sitting in the water. With a feeling that I was going to find what I was seeking, an anchorage at last, I returned from Marseilles, and, changing at Pas des Lanciers, took the little railway which leads to Martigues. On arriving my pre-monition proved correct: there was no need to seek further.

Martigues is divided by canals into several quarters. The canals, joining, form the estuary of the Caronte, connecting the Étang with the Mediterranean at Port de Bouc. Some journalist has

inevitably surnamed the place *La Venise de Provence*. The old houses, of an exquisite picturesqueness, rise from the narrow quays, beside which are moored the fishing-boats or *tartanes*. On the balustrades of the bridges lean the fishermen in check gaiters, engaged in perpetual contemplation of the weather. At one point known as the *Coin des peintres* are often assembled a group of artists, occupied in transposing with their palette knives the pearl-white and rose of the buildings into the more popular scheme of mustard and mauve. Feeling shy of joining in this mass effort, I avoided these workers, though envying them their subjects. Some time elapsed while I sought a domicile. At length I found what I wanted. The Villa Ste Anne, on the outskirts of the town, stands by the road-side on a cliff rising steeply from the shore and commands a superb view of the vast lagoon and *toutes les Martigues*. North-east the Mont Ste Victoire, by Aix, rears itself above the cliffs and high ground beyond Rognac. The proprietor of the Villa, M. Bazin, an original character, was a pioneer of aviation. A pupil of Mouillard, author of *Le Vol sans Battement* and *L'Empire de l' Air*, he had made his own experiments in gliding flight, and his latest apparatus could still be seen mouldering in its hangar. He made no difficulty in letting the smaller portion of the villa, which had besides a pleasant garden. Across the road stood the dilapidated hermitage of Ste Anne and farther on the Café de la Gaîté displayed its hospitable beacon amidst a grove of little olive trees shining softly like grey velvet. I was now joined by my family. After a necessary interval spent in observation and experiment, I attuned my eye at last to the marvellous light of this region, and a series of panels attest, I think, the beneficial effect of it upon my palette.

A Gypsy appearing in the town with a herd of Algerian donkeys, I bought one of them, and having procured a light cart, our mobility was greatly increased; we were able to explore the country further, children and all. The donkey turned out well:

being small, he required a helping hand up the hills, but on the level there was no holding him! Our friends Philip and Lady Ottoline Morrell, while on a visit to Aix asked us over, and we decided to join them for a few days. Leaving the children in good hands, D. and I set out. It was a long march; starting at dawn we reached Aix at dusk, but found some difficulty in getting a pull-in for the night. Our appearance, it seemed, was not reassuring; but eventually we were admitted at the humble Cheval Blanc, and treated as honest travellers. With the Morrells we visited all the objects of interest in Aix, including Cézanne's house, the Jas du Bouffan, which then contained a number of his works, including the mural panels of the four seasons. These, inexplicably, were signed *Ingres*, in block letters. Could the artist have intended an ironical allusion to their defective drawing? We were fortunate to make the acquaintance of Monsieur Aude, the director of the Bibliothèque Méjane. He showed us over that superb seventeenth-century institution and in general made our visit doubly pleasant and profitable.

* * *

Sometimes Bazin would invite us into his quarters and treat us to his excellent *vin rosé*, while reading to us Daudet's *Lettres de mon Moulin*. Before his hearth a lion skin, trophy of his hunting prowess in Africa, reminded us that we were in the land of *Tartarin de Tarascon*. Our host still dreamt of flying and had a new apparatus in view: once it was perfected, he proposed that I should be its 'jockey' and try it out over the Étang de Berre. Through shortage of funds, however, this project had to be deferred. When later on, embarrassed by a gift of £300 from Mme Strindberg, I had the bright idea of sending it to Bazin to aid him in his researches, he thoroughly appreciated this wind-fall,

but I never heard that his experiments got any further advanced in consequence. A year or two after, I told my benefactress of this disposal of her money: she couldn't believe her ears and at once posted down to interview Bazin and assure herself of my veracity – and ingratitude.

Marseilles

I used to visit Marseilles now and then. Seated at the modest *terrasse* of the Bar Auzas in the Place d'Aix, I watched the comings and goings of the Spanish Gypsies, of whom there was a considerable colony settled in this neighbourhood. Beneath the triumphal arch opposite lounged the *tondeurs de chiens*. From time to time, young *Romis* crossed the *Place* in couples, like nuns of some unknown and brilliant order. I was to make the acquaintance of these people later. What presently attracted my attention was a more majestic figure which now hove in sight. It was that of a tall and bulky man of over middle age wearing voluminous high-boots, baggy trousers decorated with insertions of green and red, a short coat, garnished with huge silver pendants and chains, a parti-coloured shirt, and a felt hat, of less magnificence but greater antiquity, upon his shaggy head, This personage was making his way across the *Place* while puffing at a great German pipe, and acknowledging with dignity the salutations of the loungers. Rising, I confronted him and 'entered into conversation' with an unceremonious 'Sar San, Kako?' ('How art thou, Uncle?'). Recovering from a momentary stupefaction and after a few inquiries as to my condition and provenance, the 'Coppersmith', for as such I had recognized him, with a cordial handshake readily agreed to share a bottle of wine at the café. I learned that my new acquaintance, Dzanos Storikin by name, was one of a party of Gypsies, who, arriving at Marseilles from Belgium on

their way to Italy, were waiting to recover their baggage, lost on the journey, before proceeding to Milan to rejoin another detachment headed by one Todor, a great and wealthy man. Dzanos Storikin, however, was seriously thinking of betaking himself to Algiers with his wife and one son, but was not sure that Corsica might not prove more attractive: he asked me eagerly if I had visited these places and could recommend them.

After having practically 'done' Europe, not to speak of occasional excursions south of the Caucasus, this elderly nomad still felt the itch to travel as keenly as ever. As the evening grew late, I agreed to accept an invitation to dine with his people. To spare my genial friend further exertion I thought it best to take a cab, and so we arrived in good order at the abode of the tribe. I was introduced to, and received hospitably by, some two score of persons. The meal was followed by songs and dances, executed with great brilliance by the younger members of the society. Upon rising to take my leave, I was persuaded to remain the night, and soon was slumbering between the quilts in a corner of one of the single-roomed huts occupied by my friends. Each hut was provided with a bedstead, but the Gypsies preferred to dispose themselves upon the floor according to their custom. A week passed thus before I took leave of the band and then only on the understanding that I should rejoin them at Milan. As will be seen, this arrangement was not forgotten. No work was done by the party while at Marseilles: the men occasionally visited the Russian Consul to see about their baggage – stolen by *gajé* (gentiles) they said. Their chief and perhaps only anxiety in life was the possibility of being robbed: I understood this when Milos and Terka, his wife, whose hut I shared, showed me one night a hoard of gold and silver coins, ornaments and semi-precious stones, knotted in a towel: they said that their treasure was safer thus. Their fears were not unfounded, as will appear later, and my friends, the Demeter family, were unsuccessfully burgled in

Cherbourg, two years before, by robbers from the town whom they put to flight with revolver shots.

One morning as we lay upon the floor listening to Milos who was telling a story to his diabolically lively children, there came a knock at the window, followed by the entrance of three young men, strangers to me, but dressed in the manner of their tribe. A thunderous conversation ensued: Terka suddenly burst into lamentation, slapping her face, knotting her hair about her throat and calling upon God – '*Ai Devla, Devla!*' The messengers had announced the death of their mother in Belgium: the woman, young and strong, had been struck down by some mysterious seizure, and the entire company to which she belonged had forthwith journeyed to Marseilles and had but now arrived. As the news spread, the wild grief of the women was painful to witness. I walked up to the station to find some thirty Gypsies squatting round their samovars on the floor of a waiting-room, eating and drinking, oblivious of the crowd who had collected round them. The husband of the deceased was pointed out to me, a forlorn and solitary figure: I joined the newcomers in a search for lodgings, but it was long before we found a *gajo* with the nerve to admit them. Next day a funeral feast at which all were present was held in a densely packed room. After a deafening palaver, the food consisting of boiled pork and cabbage, was set in our midst and three long candles stuck in a loaf and placed at the side. The bereaved *Rom* then lit incense and carried it round, after which the men fell to on the viands. The feast over, the chief mourner collected the broken meat and bread in a cloth, and, followed by the men, proceeded down to the harbour where he solemnly dropped his burden into the sea. He then disappeared, leaving the rest of us to adjourn to a wine-shop.

After the songs and dancing that night I bade my hosts farewell: they entreated me to stay another night: '*beš, p'rala, beš kati mensa koda rači t' a džas tihara,*' says Milos and '*beš, p'rala, beš, para šon*

te tradés,' cries Terka; but I was for Italy and might not tarry: '*dikava tume palpale ando Milano, p'rala t' a p'eni; naiš tumengi t' a dē Devla bax!*'[1]

This society is of the patriarchal order. Individuals are often of great physical beauty and are fully conscious of it. The men especially are apt to be inordinately vain. Beards are cultivated assiduously. '*Tovdan du tiro šor, Dzanos?*'[2] they would shout in the morning, and a young girl would be deputed to attend on me with soap, water and towel while I carried out this operation. Privacy was out of the question and my occasional absences in search of it were, to them, inexplicable. I wondered how the widely separated bands communicated and reassembled mysteriously, till I discovered that they were in the habit of employing despised but literate *gajos* to do the telegraphing. On arrival at a new town, after setting up their tents, the men, without method, would set forth in every direction to collect damaged copper vessels for repair: leaving a deposit, they bore these away and, working like demons, hammered them into shape: returning them as good as new, they demanded (and seemed to get) exorbitant payment for their work, which was of excellent quality. Though closely bound together by racial and family ties there was no community of goods, some appearing to be rich and others poor.

Marseilles—Le Vieux Port

As everyone knows, the Vieux Port or old harbour is the maritime gateway of Marseilles: on the eastern side of the main

[1] 'Stay, brother, stay here tonight with us and go tomorrow' ... 'Stay; heavy-hearted am I that thou must depart' ... 'I will see you again at Milan, brother and sister; thank you, and God give you luck!'

[2] Hast thou washed thy beard, John?

quay upon which the celebrated *Cannebière* debouches, apart from
the business of the sea, the cult of gastronomy prevails: restaurants
rub shoulders and the booths outside are piled with every sort of
shell-fish upon which the Marseillais dote. Two hotels overlook the
port, the Beauvau and the Nautique. On the former, two plaques
commemorate the visits of Chopin and Lamartine: I frequently
stayed here myself, and was no stranger to the other, where Miss
Eve Kirk might sometimes be seen at her window, engaged in
limning the admirable scene outside with her sympathetic
trowel. On the western side is, or was, the old quarter reserved for
the business of debauchery: it consists of a labyrinth of ancient
streets which seem to reek of corruption and are tenanted by
harlots: these lounge before the open doors of their dens, in an
advanced stage of dishabille, ready to seize upon the bemused
sailor, who, setting foot on shore with a pocketful of pay, now
faces the realization of his ultimate sea-dreams, and is only
embarrassed by a multiplicity of choice. As far as I could see,
his decision usually leant towards bulk rather than beauty. 'How
goes it?' I inquired of a middle-aged *fille de joie* who sat knitting
before her alcove: 'Ça va doucement, Monsieur, mais le travail
est dur' ... Policemen in couples paraded the quarter, armed to the
teeth, but effective only as providing an extra touch of comic
relief to the animated scene. Sundays were the busiest, for then the
normal traffic was swelled by many amateurs from the country,
and the ladies of the quarter, of every shape, size and colour, made
an extra brave display. The *maisons tolérées*, or regular *bordels*,
belong to a vast national chain-system characteristic of our
industrial age. The stock-in-trade, rarely seen outside the business
premises, is passed on from one depot to another: these human
articles of commerce, as, in the process of wear and tear, they
become less and less serviceable, are replaced in rotation by the
next in order of entertainment value. Marriages, however, some-
times take place and these are equivalent to honourable discharge.

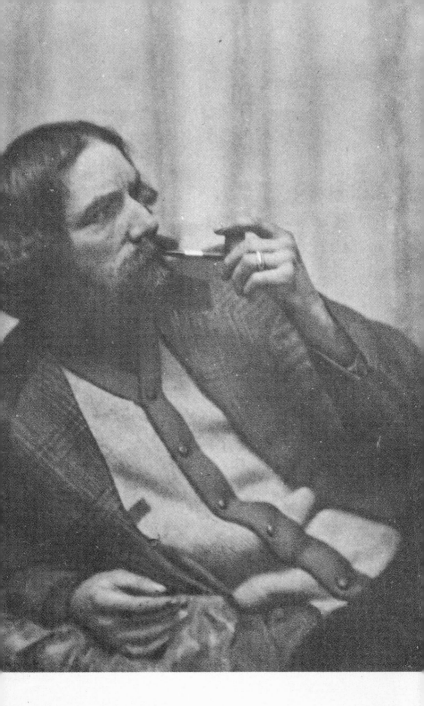

1 The author as a young man

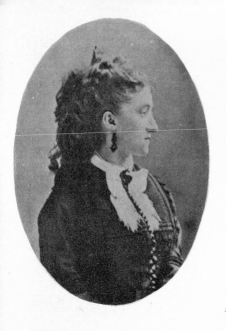
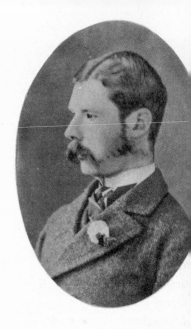

2 The author's mother and father: (*left*) Augusta John, (*right*) Edwin William John

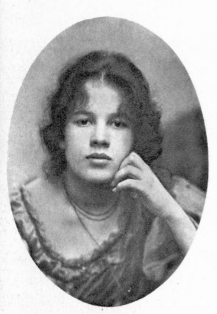
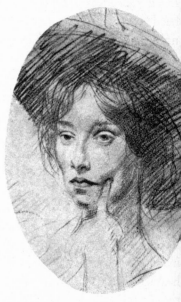

3 Ida Nettleship

4 Alick

The industry, designed to promote the virtue of French woman-hood, and the general well-being of the community, is run on sound business lines and constitutes an important source of private revenue. But let me hasten back to Martigues.

Martigues

In Provence I always look forward to those days when the sun, shining through an atmospheric veil, while casting no shadows, envelops everything in light and colour. The Étang de Berre, acting as a mirror, conduces to a magical illumination which seems to irradiate the air with an effect seen nowhere else. Martigues, amphibious, will look its best then as with a smile of pristine innocence it emerges from the water – a little republic of fishermen. Untouched as yet by fashion or big business, no squalor meets the eye, and the inhabitants, concerned only in their craft, heed not the rumblings of distant war-drums. As in all fishing communities, however, smells are not entirely absent.

Though I did not welcome the appearance of stray painters in the town, it was a different matter when one or two literary friends arrived upon the scene. First Roy Campbell came and established himself in a *Mas* near Ferrières, the further quarter of the town. Here he spent some years occupying himself with poetry, fishing, water-jousting and cow-baiting. Though never stirring from the district, he always seemed somehow to keep in spiritual touch with Bloomsbury, of which cultural centre he always spoke in terms of familarity and loathing. I was absent when Wyndham Lewis paid him a brief visit, to which he has referred in one of his books. The two seem to have passed a few hours in secret session, after which, his mission accomplished, Lewis, heavily disguised, caught his train back to Paris. T. W. Earp's reasons for journeying so far were less obscure: he seemed to think

the quiet and leisurely exploration of the Provençal scene was enough in itself to warrant his intrusion. I agreed with him, and valued his company for the rare powers of observation, the curious and gentle humour which he brought to bear on the various aspects of our little world. The composer, E. J. Moeran, spent some time with us, whether profitably or not, I cannot say. He came to collect folk songs but, as far as I could see, only succeeded in getting hold of a defective piano on which to record them. We made, at any rate, some memorable jaunts together, for he had brought his car with him. Horace Cole, too, passed a winter in the town. He was not popular, I must admit, and eventually was persuaded to leave the district by the local gendarmerie. Gendarmes, even more than other Frenchman, are impervious to the appeal of the practical joke, which strikes them, not without reason, as a form of ill-breeding and an affront to public dignity.

One day to my astonishment and delight I beheld a well-known figure walking through the town. It was Maurice Cremnitz! My Parisian friend carried a pack on his shoulders and with his stout stick was wandering well beyond the boulevards which I had thought represented the limits of his ambit. The next day a visit to Istres with Monsieur Bazin had been fixed. It was the Fête-day at this little town on the Étang de Berre which possesses a subsidiary lagoon of its own where *Les Joutes* are practised within a natural arena. Cremnitz joined us. Bazin, who was of Huguenot stock and a bit of a pedant, commented adversely on the appearance and behaviour of the young women who were, like us, flocking to the Fête: Cremnitz, on the contrary, found them 'delicious', an adjective, in this context, obviously displeasing to the elderly aviator. As, on the way, we rested under the trees by the roadside and made our rustic meal, Cremnitz enchanted me and silenced Bazin by reciting some well-known

lines from Virgil:[1]

> Tityre, tu patulae recubans sub tegmine fagi
> Silvestrem tenui musam meditaris avena:
> Nos Patriae finis et dulcia linquimus arva.
> Nose patriam fugimus: tu Tityre lentus in umbra,
> Formosam resonare doces Amaryllida silvas.

My father used to recite those lines, too, but they sounded much better delivered in the French way and in these surroundings.

[1] Eclogues, I.

Madame Strindberg

In London, meanwhile, the activities of good Mme Strindberg showed no sign of ceasing. I was never safe. The nature of my occupations prohibited flight: that is where Wyndham Lewis had the advantage of me. He was at that time unencumbered with the impedimenta of a portrait painter, and enjoyed an enviable mobility. His only permanent address, the Pall Mall Safe Deposit, in no way tied him down. As for me, I might take refuge of an evening in the most obscure retreat, but August Strindberg's 'pretty little jailor', as he had called her, gifted apparently with the power of ubiquity coupled with second sight, would be sure to discover me. Bernard Shaw once told me he was physically a coward but morally a hero. I have never been sure where to draw the line between the two categories, but I admit that the sight of Mme Strindberg bearing down on me in an open taxi-cab, a glad smile of greeting on her face, shaded with a hat turned up behind and bearing a luxuriant outcrop of sweet-peas – this sight, I confess, unnerved me, even if I stood my ground. I have remarked, somewhere, that perfect beauty intimidates, but not often, I think, to this extent. If the mistress failed to capture my sympathies, her maid, on the contrary, excited them. Anushka was a Croat. The only one of her race I have met, I should judge her to be a choice specimen of it. Her employer had noticed my response to Anushka's charm, and with her faulty psychology, thought to profit by it in the following way. An occasion having offered itself for an escape to Paris, I seized it, and, installing myself discreetly in an unaccustomed hotel, was settling down to enjoy a spell of liberty and peace after the agitations of London, when one day who should appear at my threshold but Anushka, but an

Anushka transfigured. Tastefully attired in black velvet with a hat to match, her person already so well endowed by Nature, had acquired a new and fatal stamp of elegance. Without inquiring how she had managed to track me down, I invited her to lunch. The Croat was in her most amiable mood, and in her company the time passed very pleasantly. At length she revealed the true object of her visit. Madame was very ill: she had attempted to commit suicide and implored me to come back and see her for the last time. This news left me cold. Madame frequently 'committed suicide' but as often recovered: for a woman of her constitution, no amount of veronal had any permanent effect: it merely upset her stomach for a week or two. I pointed this out to Anushka, arguing that rather than return to London, it would be far preferable, now that we were together, to depart at once for the Pyrenees, a region I was curious to visit and which I was sure would interest her too: but, loyal to her mistress, the noble girl insisted on our obligation to return; this duty once fulfilled, she agreed to go anywhere I liked, adding, 'et vous n'aurez rien à regretter'. Seeing that she was determined to carry out her instructions, I made a show of giving in, and agreed to meet her later at the Gare du Nord to catch the boat-train. I did not keep this appointment. The trap was too obvious. In payment for their underestimate of my intelligence, I failed both mistress and maid. I saw no more of Anushka. Furnished with a sufficient *dot* by the generosity of Madame, she married and was carried to America and put to work. Perhaps she would have done better in the Pyrenees. But those fine Slavonic eyes shone with little but the cunning of the peasant, and in her naive conceit she had mistaken my frankness for stupidity or worse. Disappointed but not disillusioned, I went my way. The qualities I had recognized and admired were authentic, if only physical, and I had not been deceived.

Chiaroscuro

Thoughts on Love

Business is business, we know, but in affairs of the heart things are not so simple. To the truly amorous, roguery seems out of place, for the eyes of love should shine with candour and trust. Concord, not mastery, is sought: audacity may overshoot the mark and prudence fall short of it. Lovers must be free, for the servitude of one enslaves the other. Where no decisions are irrevocable, no engagements binding, an exquisite reciprocity can be the only rule. The fate of the afflicted lies in the lap of unknowable gods. Therefore, brother, let the Blue Bird fly its way: seek not to ensnare so wild a fowl; the winged life must not be destroyed.

Is it not enough to have tarried with the stranger in the green lane? But if you would revisit the Tents, be not surprised to find the Gypsies gone, with nothing left of them but a few rags and the black circles of their fires.

Madame Strindberg in Liverpool

I had undertaken to paint the portrait of Kuno Meyer, the eminent Celtic scholar of Liverpool University. I had bidden goodbye formally to Mme Strindberg, who recently had taken a flat in Chelsea, and was composing myself in the train at Euston in pleasant anticipation of a period of alternate work and play amid the scenes of so many earlier activities, when the lady I had just left, reappeared at the door of my compartment to wish me an unnecessary and redundant adieu, with an assurance that she would soon be seeing me. My satisfaction had been premature ...

Installed in a friend's house in Liverpool, I had started my work when I received a message from the Austrian: she had arrived, but was not alone. She was now accompanied by a young French woman I knew. Andrée was a well-known figure

in the social life of Montparnasse, and Mme Strindberg, somehow or other, had succeeded in winning her sympathy and collaboration. When we met, as we inevitably did, I took the two, by way of entertaining them, to an 'oyster-dive' I knew of. I thought we would be inconspicuous and out of the way of trouble in this dim vault: I was wrong. During the feast, as a champagne bottle whizzed past my head, I realized the need for caution. The missile, though wide of its mark, convinced me that in some way I was at fault: I had been guilty, it appeared, of neglecting the elder of my guests, while momentarily under the sway of her decoy-duck's charm.

Later, when, on the way to the Ferry we entered a bar expressly chosen for its respectability, I experienced the climax of embarrassment: my companions were refused refreshment on the grounds of their – unsuitability. Mme Strindberg, who piqued herself on her good breeding, was furious.

My friends occupied an hotel on the other side of the Mersey. One evening I was persuaded to dine with them. As the hour grew late, with some difficulty, I tore myself away from an hospitality that was beginning to cloy. I had to catch the last ferry-boat. Descending the stairs rapidly I found the front door locked and bolted. Trapped? Not so: on investigation I found a window which proved practicable and by its means I made my exit. As I dropped into the street, a policeman who happened to be on the spot expressed some surprise and curiosity as to my business in these circumstances; but my explanation was accepted, and hurrying to the landing-stage, I boarded the boat. Just as I was congratulating myself on a successful evasion, Mme Strindberg appeared before me as if by magic! The implacable woman had resented my unceremonious departure and with unexpected agility had followed and overtaken me for a last word. There wasn't a moment to lose: seizing her by the arm I rushed her back to the hotel. Re-entry was not easy: procuring a chair from the

interior I succeeded by this means in hoisting my late hostess through the window: then, after restoring the chair, jumped out – into the arms of my friend, the policeman: his suspicions again aroused, I had this time rather more trouble in allaying them, but he was a reasonable fellow and, I think, a man of imagination, for he let me proceed. With a flying leap, I again embarked on the ferry-boat as it moved from the quay. At that time I was staying with Professor C. H. Reilly, the architect. On reaching his house I found every door locked. Forced to further exertions, I climbed on to his balcony and entered his bedroom. Reilly, roused from his slumbers, suffered the most serious shock of his life: I managed, however, to calm him, and passed what was left of the night in peace.

John Quinn, T. F. Ryan and Madame Strindberg

John Quinn, revisiting London, proposed that I should join him on a tour in France. I agreed, but warned him to keep the matter dark: above all not a word to anyone of the date of our departure. Useless! Hardly had we taken possession of our seats on the train when Mme Strindberg arrived to offer us her company on the journey. Only by passive yet firm resistance, and an appeal to the guard, were we able to preserve our privacy. While crossing the Channel, John Quinn, from motives of humanity no doubt, but without my approval, sought our fellow-traveller to offer her a cup of tea. I kept to my cabin, which I was careful to lock. Quinn, returning from his errand of mercy, announced that he had fixed an appointment with the lady in Paris for the morrow. He seemed to be quite taken with her. I told him to do as he liked but not to count on me. By next day, however, his ardour had cooled and he took me instead to meet his old friend, Thomas Fortune Ryan, an American copper king. We found this monarch in occupation of most of the Hotel Bristol, with a small

throng of courtiers in attendance. Mr Ryan (who was never addressed or alluded to less formally) was a tall, elderly and friendly person, holding pessimistic views on the future of the British Empire. He chewed an expensive but unlit cigar: he was pleased to see Quinn and asked him how much money he was making: Quinn quoted some astronomical figure which I suspect was exaggerated. My advice being asked as to how to spend the evening, I proposed a visit to the Bal Tabarin: agreed! The Tabarin had by now been 'done up' and was fit for any number of millionaires. While seated over our drinks, we were joined by a young Kabyle woman. The person of this dusky beauty exhaled the fragrance of musk and sandal-wood. Her smouldering eyes regarded me with child-like candour ... Before leaving, Mr Ryan, at my suggestion, distributed appropriate largesse. We escorted him to his hotel, but, unaccountably restless, I left the company and returned alone – to the Tabarin.

Quinn wanted to see some pictures: I took him to Chez Vollard, Rue Laffitte: here he was shown works by the best modern painters. Quinn saw nothing in them. On a subsequent return to Paris, Quinn, by this time more sophisticated, invested in a number of pictures by the same artists, and thus formed the nucleus of the important collection he was to build up in coming years: but by then their prices had quadrupled.

It was time to make a move. Mr Ryan lent us a superb Mercedes with a German chauffeur, and so we set out on our tour. Our objective was Marseilles and we chose the western route which took us through Touraine. Meanwhile, Mme Strindberg, we learnt, mortified by Quinn's neglect, had committed one of her suicides, but this time I, for once, was not to blame.

Personally I found the famous châteaux on the Loire rather vulgar, but I could see Quinn was impressed by them. I had begun to doubt the soundness of his judgment; first, when in the train from Calais, he removed his felt hat and deliberately

replaced it by a *slate-grey cap:* next, when at Vollard's, he rejected my advice about pictures, and, thirdly, when viewing Chartres Cathedral, he remarked, what a pity so fine a building was devoted to religious purposes when it would have served so well as a municipal hall or public tribunal (and he a Catholic!) But Quinn was full of surprises, not always disappointing. One night when the car was creeping at a snail's pace on an unknown road through a dense fog in the Cevennes, the attorney suddenly gave vent to a despairing cry, and in one masterly leap precipitated himself clean through the open window, to land harmlessly on the grass by the roadside! He felt sure we were going over a precipice; but even so ...

The man's nerves were undoubtedly on edge. I put them to the test one day when descending a tortuous mountain road leading to Le Puy. An abyss yawned on one side, and on the other, over-hanging cliffs seemed about to fall on us at every turn. Quinn inquired of me the German word for 'slow': 'schnell', I replied, and 'schnell!' he shouted to our Hun, who, with a deprecatory gesture, instantly accelerated: being an accomplished trick-driver, Eywald succeeded in bringing us down without mishap, and we arrived in good time for dinner: but Quinn, much shaken, chose to retire to bed at once. Eywald and I had a good laugh over this incident. I wasn't sorry to have an evening to myself and the chance to renew acquaintance with old familiar scenes.

Le Puy

Le Puy has spread most untidily beyond its ancient periphery, but the inner kernel on and about the central rock, crowned by the Romanesque Cathedral and a colossal Virgin in cast iron, has preserved its sombre medieval distinction.

A few miles to the south the Loire issues from the heart of a little round hill: gathering volume, the predestined stream, after

encircling the volcanic peaks and outcrops of this valley, plunges into the deep gorges of Arlemptes, whence, by a grandiose detour northwards, it nourishes its child, Orleans, and, sweeping round again, expands in the broad reaches of Touraine before losing itself at last in the Atlantic. When we got to Moulins, Quinn, to his horror, discovered he had run short of cash. He had merely to telegraph to Paris for some more, but it meant a few hours' waiting, during which he mooned about miserably, unable to interest himself in the cathedral or anything. 'I never saw a man who looked so wistfully at the sky.' The fact is, this Irish New Yorker felt *dépaysé* and ill-at-ease anywhere outside the familiar confines of a luxury hotel. As these are all alike there seemed little reason to move from one to the next. He couldn't be expected to share my tastes for low life or even my passion for medieval painted glass. Big bank accounts, I suppose, need not necessarily be counter-balanced by spiritual insolvency, nor is poverty to be enjoined as a duty (though certain religious sects and philosophies would disagree here), yet it does seem to suit some people, and has been found to provide the soil for some rare plants unknown to bloom elsewhere.

In the age of panache and the musketeers, Louis le Nain discovered in the cabins of the subjected peasants all the material he required. Jacques Callot evidently enjoyed best the company of strolling players, beggars and Gypsies: Rembrandt, having tasted the sweets of prosperity in close association with all that was polite in the society of Amsterdam, when bankrupt, blackmailed and ostracized for some infringement of the social code, he moved to the Jewish quarter and seemed happy enough; he painted better than ever. History doesn't relate that his old friends ever looked him up. A few hours in Paris and the tedium of Mr Ryan's company and we were back in England. In the homely atmosphere of the Ritz, John Quinn soon recovered from the stress and strain of foreign travel and, with the immediate prospect of returning to

his own country, his spirits rose rapidly and he was his genial self again.

Later on I had a slight passage with Quinn. He had written asking what pictures I had to dispose of. Replying, I mentioned among others the portrait of a private soldier in khaki.

He then wrote that he didn't 'like men in khaki least of all Englishmen': I thought this distinctly rude, and informed him that I, on the contrary, preferred Tommies, but the one in question happened to be a damned Irishman like himself. He seemed to take offence at this, for our correspondence ceased.

The War 1914-1918

I WILL now relate the part I took in the first Great War, brief and inglorious though it was. The knee I had injured while jumping a fence in Ireland with Gogarty grew worse. Under doctor's orders it was encased in plaster of Paris. I obtained a coster's barrow and a donkey; by these means I was able to move about the country. Months passed thus; when the plaster was removed the knee was found to be no better. By this time I was tired of doctors and decided to seek the aid of Herbert Barker. The celebrated 'bone-setter' having put me under gas, a few seconds of manipulation restored the 'semilunar' to its proper place, and carrying my crutches, I walked away like the man in the Bible. Unfortunately, I soon after damaged the other knee in exactly the same way (these were my grasshopper days); without wasting any more time with doctors, I tracked Barker down to Devonshire where he was taking a holiday, and again, though this time without an anaesthetician, he operated successfully. I had now to watch my step, for years of ignorant treatment had weakened the first joint and any capering was apt to produce 'synovitis' in both. Called up by the military authorities, I stripped for examination at Dorchester barracks, and was found to show unmistakable signs of 'housemaid's knee', thus providing Oliver Gogarty with an inevitable jest at my expense. Rejected.

In 1917 I obtained a commission under Lord Beaverbrook, as official artist in Canadian War Records, and having got myself attired as a major, crossed to France.

It was a curious experience to find myself in so transparent a disguise, but I retained my beard as did one other officer in our Army, the King. Reaching H.Q. I was allotted half a hut to sleep

in, the other half being, to my great surprise, occupied by some-one I knew, though not in a friendly way. This was a gentleman called the Hon. Reggie Coke with whom I had once come into collision in a night-club. However, faced with a common enemy such trifles were forgotten and we shook hands. We even dis-covered a fellow-feeling in a thoroughly unmartial outlook.

My rank, conferred upon me to facilitate movement in the battle area, carried with it the use of a car and a batman. I began the exploration of the Canadian sector, extending from near Béthune to Arras. At this time there was a lull in hostilities: we were treated only to intermittent shell-fire, aerial bombing and occasional gas operations. After visiting all the points of interest, including various batteries along the front, I found a place called Liévin which offered plenty of material for my purpose. Liévin was a completely devastated town opposite Lens, then in occupa-tion by the enemy. A few battered churches stood up among the general ruin: in the distance the pyramidal slag-heaps of coalmines broke the horizon. I found a battery which had been constructed within the ruins of a medieval castle. I liked this combination, so, getting friendly with the officer in command, frequented it and the neighbourhood, while making studies for the composition I had in view. From time to time, to break the monotony of the scene, a shell came over, and bursting, threw up its cloud of debris. When they came too near, our imperturbable Major, ordering his men to take cover, sat with them, deep in the perusal of the *Daily Mail*, which I noticed he held upside down: there was an ammunition dump a few yards away.

Béthune lay further north and I used to drive there now and then and look up my friend Ian Strang, established in a château on the road to Loos. On one occasion on my way thither with Wyndham Lewis (like me, now serving in War Records), my batman, who was driving, slowed down and announced that he didn't want to go any further. Shocked beyond expression by this

behaviour, I inquired his reasons: 'Mr Robertson said for me not to go to Béthune.' (Mr Robertson was an officer working for War Records.) Upon this, exerting my authority for once, I, with, I hope, a correct military oath, ordered my man to proceed! When we arrived I understood Mr Robertson: the place was a wreck and still under shell-fire: the officers' club was laid open to the four winds, and not a soul was to be seen: but the 'Cosy Corner' still stood, and there we took refuge: it was indeed cosy in the cellar. While we were here, an M.P. came stumbling down the steps, badly scared: a few draughts of wine restored him and he returned to duty.

At this time I was billeted at Aubigny in the 'château', which was merely a large modern house in the village. Here I had room to draw and paint my soldiers. Lewis too was quartered here later. Although of inferior rank to me, the fact that he had served as a combatant equalized matters or perhaps, as he seemed to think, turned the scale in his favour. This place was what was called a bridge-head and could boast of a restaurant kept by a respectable French matron. Many officers, British and Colonial, stopped here for a meal on their way to, or back from, the front. The proprietress had run a similar establishment at Arras during the German occupation. Lewis, learning this, inquired – 'Alors, est-ce qu'on vous a violé, Madame?' to which the patronne, drawing herself up, replied, 'Monsieur, les Boches se sont conduits beaucoup mieux que vous.' This excellent woman, whose husband was in the fighting line, told me she could never accustom herself to the Scottish troops with their *kilt*: for example, when they got dancing. 'Mais, Monsieur, il pourrait avoir des jeunes filles!' One evening, returning to the château I found it partly roofless, with all the windows broken: the Fokkers had paid us a visit: in the intensely cold spring of 1918, this attention was most unwelcome. An occasional call to Amiens or Paris relieved the monotony of life, for though I enjoyed painting the soldiers, and sketching

around the various batteries, and was not insensible to the camaraderie that war engenders, there were many boring hours when I felt like a fish out of water. When the final offensive came, I was ordered to decamp. All cars were needed. I would have been helpless without one. Returning to London and making use of the material I had collected, I made a vast cartoon for a mural composition, designed to decorate a space reserved for it in the War Memorial to be erected at Toronto. I even began the painting: but not a single brick has been laid of this building nor, I was told, ever will be; but the cartoon at any rate, rescued by Mr Vincent Massey, has gone to Canada.

A Visit to Frank Harris

WHEN Frank Harris was staying at Lord Grimthorpe's celebrated villa at Ravello, near Naples, he wrote repeatedly, urging me to join him there. As I knew him but slightly, though I had once lunched with him, Lord Grimthorpe and Richard Middleton, I could not understand this longing for my society and was able to resist his pressure: but when he returned to his own villa at Nice, and renewed his importunities, I, being not so far off (at Martigues) thought I might as well pay him a visit, and perhaps do some painting at the same time. I arrived at Nice with little baggage but my paints and panels. Harris awaited me on the platform in evening clothes. He viewed my corduroys with evident distaste before carrying me off to the Opera House where he occupied a box lent him, he said, by the Princesse de Monaco. His wife, Nelly, awaited us, attired for the occasion in somewhat faded and second-hand splendour. An opera was being performed and presently the composer joined us, one Isidor de Lara. This personage, I could see, regarded me with more than suspicion. Frank and he at any rate were on the best of terms, vying with each other in expressions of intense mutual admiration. I gathered that I was assisting at a meeting between 'the modern Wagner' and 'the greatest intellect in Europe'. I was glad when the 'uproar' ended. Then, Nelly having been sent home, Harris took me to some hotel where we sat up late, drinking champagne and, as far as my host's conversational flow would permit, listening to the nightingales. The 'Villa Edward VII' was situated in a suburb of Nice, and was typically suburban in character. I was shown my room which, as Frank was careful to point out, adjoined Nelly's, his own being at a certain distance, round the corner.

Next morning Frank and I went down to Nice. His method

of transport was ingenious. There were always a few private cars waiting in the high-road, and he found no difficulty in persuading one of the chauffeurs to run us down to the Promenade des Anglais where we alighted in style. This manœuvre not only saved us a walk but tended to reassure Frank's tradesmen. Frank was always reminding them that his Rolls Royce was still *en panne*, and under repair somewhere in the centre of France. I guessed that this vehicle, like Elijah's chariot, was purely mythical. Frank had a talent for buffoonery and delighted me by his clowning. It was our only spiritual link. His long-winded discourses on the subject of Oscar Wilde, whose life he was writing, bored me stiff. When he showed me his manuscript, I found the text interlarded with pious sentiments and references to our Saviour. I asked him what the devil he meant by dragging in Jesus Christ on every other page. He looked black at this but did in the end largely purge the book of such allusions. Before many hours passed in the Villa, I decided I was either mad or living in a mad-house. What I found most sinister was the behaviour of Nelly and the female secretary. These two, possessed as it seemed by a mixture of fright and merriment, clung together at my approach, while giggling hysterically as if some desperate mischief was afoot. On the evening of the third day, my relations with Frank Harris, always precarious, broke down altogether. He was looking his ugliest: neither of us now attempted to conceal our mutual antipathy. At dawn next morning I arose, gathered my belongings and silently departed: this time I descended to the harbour on foot and, entering a seaman's bar, breathed, with what relief, a purer air.

A few years later, I saw Frank Harris again. It was in the Café Vaugade at Nice. He was seated with the ever-faithful Nelly. I joined them for a few minutes. Frank was now an old and dejected man. 'John,' he growled, 'I can only understand my contemporaries.' Thereupon I left the couple.

To show Frank Harris in a high state of inflation, here follows an extract from one of his letters:

This 'Oscar Wilde' book is really gorgeous in places and I think it will make a stir. I had to write it; it was in me and now I have done it I feel better. I am at last loosed and free to try my hand at a great novel or two, from the standpoint of my brains now. Shakespeare was in me twenty years ago, I had to get rid of him, and my enormous German reading: Oscar had been in me ten or fifteen years and I had to get rid of him. I should like to get rid of Rhodes and Randolph Churchill, but they don't count much. At last I am free, as I say, to write two or three novels, bigger than anything in English, if it is in me to do it ... But at any rate I am now pregnant ... Surely I can look over the heads and under the feet of the Fieldings, Thackerays and Scotts ... It is a delight for me to read you. Your letters are the best things that have come to me since Meredith died, and they are better than Meredith ... '

Modigliani, Squire, Epstein, Pasquin

AMADEO MODIGLIANI was normally a charming young man, but he was rarely normal. His habit of chewing hempseed, if it inflamed his imagination, distorted it as well. Because he was in no way proof against the action of more conventional stimulants, the effect of the mixtures was apt to cause embarrassment to his friends, and was always a source of pain to the innocent strangers he would, at random, pick on for gratuitous insult. In his less inflated moods, he would describe himself as a 'decorator'. 'I make garden statuary,' he would say modestly. This was before he developed into the notable painter, now, posthumously, so celebrated. D. and I visited his studio in Montmartre one day, and bought a couple of the stone heads he was making at the time. The floor was covered with them, all much alike and prodigiously long and narrow. Returning with us to Montparnasse after this transaction, 'Modi' exclaimed, 'Ah, comme c'est chic d'être dans le progrès!' and pressed into my hands his well-thumbed copy of *Les Chants de Maldoror*. This was his Bible.

The stone heads affected me strangely. For some days afterwards I found myself under the hallucination of meeting people in the street who might have posed for them, and that without myself resorting to the Indian Herb! Can 'Modi' have discovered a new and secret aspect of 'reality'?

Epstein, Modigliani, Jack Squire and I roamed the town together. On one occasion Modi, feeling low, complained a little of his lot, with an allusion to racial prejudice. I said, 'Alors, c'est malheureux d'être Juif?' 'Oui,' replied Modi, 'c'est malheureux,' but Jacob Epstein exploded in violent dissent.

Perhaps the view of Paris from Sacré Coeur is the most

148

impressive in the world when seen at dusk; as the lights of the immense city below begin to twinkle amidst the emanations of a hundred thousand chimneys, and the myriad voices of the people, joined to the clangour of the traffic, reach one's ears in a general murmur, deep and vibrant as that of a cow in parturition, one's soul is seized with a kind of anguish: what is to become of us? What is happening? What can all this mean?

I asked my companion, Pasquin, his opinion of the architectural style of the Sacré Coeur. 'La Cathédrale,' he said shortly, 'mais, c'est comique.' Pasquin, with his *melon* over one eye and his air of a tough guy, was to me a sympathetic type in spite of a slight sadistic strain now and then noticeable. One day, in a restaurant, I was startled to see him, in a moment of impatience, draw his knife across the throat of his mistress, raising a little blood; at this proof of his love she at once became radiant ... It must be admitted that his elegant little girls, so wittily drawn, are not remarkable for modesty. The last time I saw the gifted fellow before his suicide was at the Café du Dôme: he was trying to attract my attention, but, at the time, sunk in gloom, I pretended not to see him and have never forgiven myself for this *lâcheté*.

Italy

On my journey in Italy, I stopped first at Genoa. I was not much taken with the place or its inhabitants until I discovered a wine-shop by the docks, where the padrone and his seafaring customers were thoroughly unbusinesslike and congenial. Here at least I felt at ease. Siena pleased me better and the landscape of Tuscany seemed not to have changed since the fourteenth century. Here I discovered, with delight, Pietro Lorenzetti. The Virgins of Sasseta moved me strangely with their sad languor and malaise. At Orvieto I paid homage to Mantegna and Signorelli, and did not fail to sample the wine for which this town is also celebrated. As my time was short I left Rome for another day and turned north. I was determined to see Ravenna. The mosaics of this city held me spell-bound for some days. It was not easy to relinquish the court of Justinian and Theodora. How shabby appeared the modern world after this semi-barbaric splendour!

The Coppersmiths Again

By way of Padua's colonnades and Giotto's chapel, I reached Milan and here I found my Gypsies. In a field outside the city a vast assemblage of them were encamped. Their great tents formed a village: work was in progress and the air rang with the din of hammering and the vociferation of the *Romané* in conversation. To my astonishment, I found not only my friends of Marseilles but some of those I had met two years before at Cherbourg. That evening a celebration was held. In his tent, seated cross-legged at the *scafidi*, or low table, Todor, the Chief, presided: before him stood several gilded flagons of wine, a foot high and elaborately chased. His wife had at his command

assumed all her jewelled ornaments, including a massive belt of metal-work. Todor, in a kind of frenzy, repeatedly shattered his great German pipe, only to be handed another: the young girls, attired in their richest finery, danced to the accompaniment of accordians and the singing of wild and melancholy airs. The dancers, without shifting their position on the carpet, agitated their hands, feet, breasts and hips in a kind of shivering ecstasy. The young men regarded me, the stranger, some with hostility, others with curiosity, but most with indifference. The malign bearded faces were now flushed with wine; eyes shone with tribal arrogance: three young men swayed together as if in a religious trance: the *gadze* outside looked on, spellbound. The Gypsies seemed to have reached a condition of mystic exaltation: they, the *Roma*, and they alone, were on top of the world. As the music surged, died away and surged again, strangely moved, I murmured to my neighbour, '*Kerel te kamav te rovav*,'[1] and tore myself away with difficulty.

As I left the field, less harmonious sounds were heard to issue from the tent: the young men had started to fight ...

These people's fears of robbery had been realized, for the *Corriere della Sera* reported that three youths had crawled under the Chief's tent and stolen, amongst other things, a large cane staff, covered from top to bottom with decorations in chased silver – an object of notable value, which, being a wand of office, cannot be carried save by the Chief himself.

[1] It makes me want to cry.

Thomas Hardy

THOMAS HARDY had good reason to view with anxiety the demonstrations of some of his admirers. One of these, hailing from the U.S.A., on the strength of a few minutes' interview produced a book entitled *Thomas Hardy's Universe*, in which the poet was described as soliloquizing before the fire, while smoking a succession of cigarettes: 'But', said Hardy, with a gesture of despair, ' I have never smoked a cigarette in my life! In the dining-room of Max Gate hung a portrait of a young woman with blonde hair hanging down; the work, it would seem, of the local photographer: this was the first Mrs Hardy. Her husband's image, by an Academician, confronted her on the opposite wall. The walls of Hardy's study, where I painted him were piled to the ceiling with books, mostly of a philosophical nature and many of them French. Hardy said 'lucidity' had always been his aim. He disliked obscurity in others and tried to avoid it himself. We attended a performance of *Tess* at Dorchester. Hardy, hearing that I was present, sent word to invite me to meet him 'behind': I was thus able to watch the play from the wings. The title rôle was filled by a Mrs Bugler, a butcher's wife from Bridport. Hardy greatly admired this extremely handsome young debutante, who, flushed with success, was dreaming of taking to the stage professionally; but Hardy, in spite of her 'evident genius', didn't feel justified in encouraging her to take this step, 'for we all know the hazards of the stage,' he said. When Gwen Ffrangcon-Davies, with a company from London played *Tess* at Max Gate, Hardy was moved to tears: his only criticism was, 'In Dorset, you know, we don't drop our aitches.' During the hours spent with the poet, the respect in which always held him had deepened to affection. On my leaving him

for the last time he gave me a copy of *Wessex Tales*, inscribed.

After Hardy's death a meeting was convened at Dorchester to discuss the question of a memorial to him. Among those present were Mrs Hardy, Miss Hardy, J. M. Barrie, Granville-Barker and myself. Asked my views on the matter, I recommended a statue of one of Hardy's best known and most popular characters, with a medallion of Hardy himself on the plinth, to be erected on some elevated site on Egdon Heath, or the moorland so named in the novels. Hardy himself was, physically, not of monumental build, though he had a fine head. The figure I suggested was that of Tess of the D'Urbervilles as most suitable to the purpose, and proposed Epstein as the sculptor, having previously ascertained his willingness as an admirer of Hardy to undertake the work. He offered first to make a *maquette* of his conception, to submit for the Committee's consideration. Though perhaps the idea found favour with some of those present, the name of Epstein seemed to excite general uneasiness, if not alarm: anyhow my project was turned down, and *Tess* rejected in favour of the depressing object we now see at the top of the High Street, Dorchester.

The 'Eiffel Tower'

THE Hotel-Restaurant de la Tour Eiffel, when I knew it first, was frequented by French business people; the frequent presence of Arnold Dolmetsch and his family, alone lending it distinction. When Rudolf Stulik took it over, the atmosphere changed. Stulik, hailing from Vienna, imported from that city a new note of gaiety and style. Himself the result (as he hinted) of a romantic, if irregular, attachment, in which the charms of a famous ballerina had overcome the scruples of an exalted but anonymous personage, he was in any case well equipped by nature for the part he played. This was before an alarming corpulence, a growing neglect of his person and a progressive deterioration of his mental faculties, began to efface the air of efficiency and charm which had made him for so long the most popular of restaurateurs. The 'Tower' became under his management a favourite resort of poets, painters, actors, sculptors, authors, musicians and magicians; not to speak of members of the fashionable and political world. Stulik's *Livre d'Or*, in course of time, included a highly decorative collection of autographs, ranging from top to bottom of the social and cultural scale.

Walter Sickert, who lived in the district, might often be met here, his manners and style of dress combining old-world elegance with the licence of artistic tradition. Dick Innes and I, though unconnected with Camden Town, were admitted to the group of that name, which used to assemble on Sundays at 21 Fitzroy Street under Sickert's presidency. Spencer Gore was then on the way to become the admirable painter he found time, in so short a life, to prove himself. He and his partner in Sickert's entourage, Harold Gilman, were often seen in attendance on the

Master when he visited 'the Tower' or perhaps, more often, a certain pub in the Hampstead Road.

A solitary figure in a corner might be observed at times to brood long over a glass of port: it is Herbert Asquith in poetic travail. The evasive Ronald Firbank struggles almost manfully with his asparagus and a bottle of wine, while following intermittently the bird-like flights of the Honble Evan Morgan. Nina Hamnett will presently burst in to announce, breathlessly, the latest news from Montparnasse. It turns out to be of no great moment. 'Buvez donc, buvez,' says the Marchesa Casati, filling Axel Munthe's glass: turning to me, the melancholy doctor murmurs, 'Monsieur, la Mort m'a toujours plus interessée que la Vie.' But who is this spirit-child with agate eyes whose pale gilt hair delimitates an elfin brow? It is Aline, a changeling of my acquaintance; she smiles in malice to find herself with mortals. In contrast Chiquita suggests Mexico, and the dark abdominal laughter of the Pueblo, heightened in her case to a shriller note, as if under the operation of the beverage called *Pisco*. And Caitlin of the tawny mane and wild blue eye; attention! at any moment she may throw herself into the air, and, revolving, land like a cut lily in the midst of Stulik's central bouquet.

Christmas Eve at Alderney

IT was Christmas Eve at Alderney Manor; we were preparing for the festivities of the next day when a telegram came from Mme Strindberg announcing her approaching end, and entreating me to come and see her for the last time. Much against my better judgment, I was persuaded at last to set out on this errand of mercy, but on the strict understanding that I was to return in time for the Christmas dinner. Arriving at the Savoy Hotel, I was conducted to the sick-chamber where I found the sufferer still able to speak, though rather feebly. I retain little of what was said, but have the impression that it was all of a tender but reproachful nature. Wearying of this, and realizing the futility of my presence, I at last seized my hat and with a hurried adieu, rushed from the room, down the corridor and into the lift, which I was just able to put in motion before being overtaken by the dying woman, who had leapt from her bed and was following in hot pursuit. I took refuge in the Eiffel Tower that night after arranging for a car to fetch me back to Alderney first thing in the morning. I thus reached home in good time but, on entering the drive, I noticed with dismay fresh wheel-tracks on the ground: the Austrian had stolen a march on me! However, I found she had gone as well as come, accompanied by her maid and still 'en déshabille': I was told she had spent an hour in conversation with my family, had made herself very agreeable; but before going, left for general perusal a formidable list of my misdeeds. I did not see this document, which had promptly been thrown in the fire, so unfortunately am unable to reproduce it. It should have enriched these memoirs substantially.

This episode demonstrates the remarkable recuperative powers of Frida Strindberg as well as her capacity for prompt action.

It must have been the lust for power rather than a taste for painting which inspired this energumen to acquire a few of my works, though without my connivance: she even tried to intercept and annex some pictures already bespoken by John Quinn, but without success. No doubt I received sums of money from her, but according to my memory and such correspondence as I have been able to discover, these found their way into Anushka's pocket when they weren't returned to her mistress's. One substantial but unendorsed cheque, however, was overlooked: I have just come upon it (too late!), at any rate it provides me with one of my rare dates – August 28th, 1911.

Sir Hugh Lane

In my studio in the King's Road, Chelsea, I was engaged on some large mural decorations. These had been originally begun in and for the hall of Sir Hugh Lane's house in Cheyne Walk; but in time I found the continual intrusion of visitors while I was at work more than I could stand, and removed the canvases after a sharp passage with Sir Hugh. One of these compositions, 'The Mumpers', now hangs in Detroit, U.S.A.; another, 'Forze ed Amore', changed into something else and finally disappeared altogether; the third, 'The Blue Lake', is now housed by Mr Hugo Pitman. A few years later, Lane visited me at 28 Mallord Street where I then resided: the 'Blue Lake', still incomplete, hung on the wall. Lane, there and then, made a new offer for the picture, which I accepted: we were now friends again: but the war had begun: the *Lusitania* was sunk and Sir Hugh with it. This was a severe hammer-blow for the picture industry in this country, for with Lane was lost an indefatigable and devoted amateur of painting.

Chiaroscuro

Visitors at Alderney

With five boys now growing up at Alderney, the employment of a tutor for them seemed advisable. John Hope-Johnstone was recommended to me as a young man eminently qualified for such a post. He had made a reputation as a mathematical genius at Cambridge, but his appetite for knowledge of every kind was immense: he added, while with us, the mastery of the flute to his stock of accomplishments: in spite of a defective ear, he was able at last, by sheer perseverance, to render a Morris Dance or two with accuracy and spirit. It is doubtful if his pupils benefited as much as they might, under the tutelage of such a paragon, but I certainly took advantage of this handy supplement to a scrappy education. Later on Hope-Johnstone, with his friend Gerald Brenan, took a house in a remote village on the southern slopes of the Sierra Nevada. Having with great difficulty succeeded in conveying an extensive library to this elevated spot, they lived here for some years under suspicion, for the natives, being illiterate, could attach only one meaning to so many books – sorcery! I shall have more to say about this Spanish adventure, for I too joined in it for a time.

Trelawney Dayrell Reid

Another inmate of Alderney Manor was Trelawney Dayrell Reid. I had met him on occasions in London. Just down from Oxford, he was often seen wearing a Venetian cape and the beard of an Hidalgo. He looked in on us one day for a cup of tea, and finding the place to his liking, stayed on for two or three years, making himself helpful in some ways, and, what is more, bringing into our humble lives an ineffable touch of style. As he and I roamed the countryside by means of a pony and trap, we gained much experience joined to entertainment on the way.

Though a newcomer, Trelawney, with his remarkable curiosity and flair soon made himself master of the history and ramifications of the local nobility and gentry of the county, becoming proficient too in the Dorset dialect, though perhaps his version of it may still betray some impurities derived from former Cumberland associations. His cavalier bearing and rounded utterance, his attire, an arresting medley of sporting and aesthetic motives, his sociability and humour together with a bubbling and well-stocked mind, soon made him a notable figure in the district. As an amateur archaeologist he realized the value as well as the charm of popular frequentations, and there were few pubs in the district within our radius where he was not admitted. These activities, leading him to an intensive study of early regional history and the Dark Ages, have resulted in *The First Battle of Britain* and more recently *The Rise of Wessex*, volumes in which his conclusions are set forth with scholarship, authority and, above all, imagination.

In view of the distinction which Trelawney has now achieved, I think a long-past episode deserves to be recorded, before it is lost sight of in the greater glory which now continues to play about his head. Reid had for some weeks endured annoyance from the commercial flying races then being held in his neighbourhood. His farm-house had been selected as the turning-point of these operations, to the great discomfort and danger of his household, cattle and hollyhocks. Having failed to put a stop by lawful means to this nuisance, he, in a moment of desperation, and with the object of drawing attention to his existence, hitherto ignored, seized his gun, and, letting it off at a venture, was unlucky enough to perforate the wings of the plane, which at that moment, having completed the encirclement of his chimneypots, was streaking back in the direction of the landing ground. Fortunately the aviator, a well-known and brilliant performer, was untouched, nor was any vital part of the machine affected.

Reid was, however, tried at Dorchester Assizes, and acquitted by a jury composed mostly of farmers like himself, though in opposition to the view of the Judge well known for severity. By his action, Reid claims to have vindicated the prerogatives of the individual, and put an end for ever to the practice of commercial low-flying.

Poole

The town of Poole being so near, I used frequently to visit the little port, where at the quay-side were generally lying a few foreign vessels. Poole was a centre for Breton onion-men. I liked consorting with these types whom as a child I used to see in Pembrokeshire: they had good songs to sing: unfortunately they no longer wear their distinctive costume.

Among the harbour pubs where we forgathered was the Lord Nelson, kept by a man of great simplicity, called Yeatman. Yeatman was an old seafarer of sailing days; he too had songs to sing in his high-pitched seaman's voice. His wife, a comely type, always wearing her luxuriant hair loose, was a woman of some refinement, or at least her husband thought so; fully aware of his own inferiority, he adored her like a dog. Philip Heseltine took a fancy to Poole and lodged for some time at the Nelson, amidst décor which I couldn't have put up with myself, but to which the musician appeared wholly indifferent. The floating population of yachtsmen regularly assembled at the 'Antelope'. The stevedores were more to my taste. Fitzgerald was a stevedore. This tall, limber young man, handsome and nonchalant, charmed me. He was a dock-side aristocrat with but one weakness; he was allergic to policemen, and 'went' for them on sight. This propensity often got him into trouble: when last I went to look him up, I was told he was then under detention for the usual reason, and lost sight for ever of my beau-ideal.

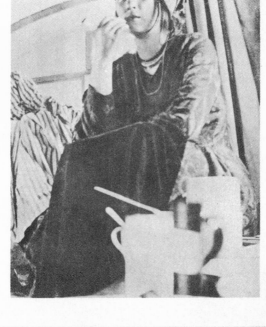

5 Dorelia in the van

Family encampment

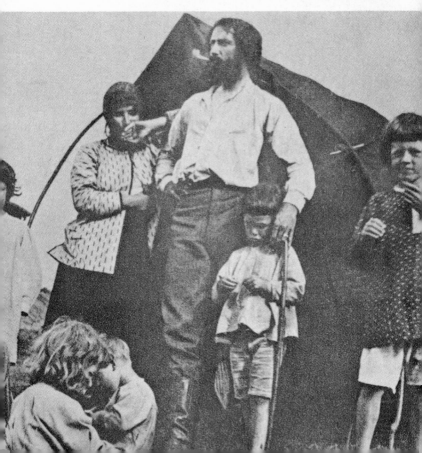

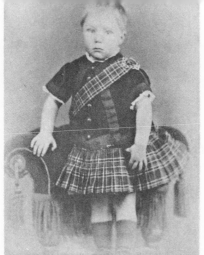

7 The author aet. three years

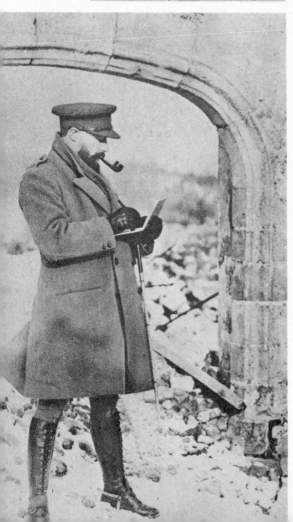

8 Major Augustus John,
1917

Berlin

ABOUT 1926 I paid a visit to Germany at the invitation of Lord D'Abernon, British Ambassador at Berlin. A friend of ours, Mrs Valentine Fleming, being also on a visit to the same capital, Lord D'Abernon deputed one of the diplomatic corps, Mr Alan P. Graves, to show us the city, for we were both strangers to it. We could not have had a better guide.

Gustav Stresemann was then the leading statesman of the new German Republic. Our Ambassador persuaded him to sit to me for his portrait. Stresemann, when not dealing with his political opponents, was a sympathetic personality: I liked him well. Cast in no heroic mould, he presented none the less an interesting exterior. That square cranium housed a cultured mind, informed with the old German idealism. His portrait, when finished or partly finished, was not in the least flattering but Stresemann faced it bravely: his wife was taken aback, I could see. Frau Stresemann, a lively and accomplished Jewess, was always to the fore in the social life of Berlin.

I also painted Frau Horstmann and Mrs Gilbert of the U.S.A., both admirable models. These pictures had to be left unfinished, but I cannot regret the time I spent with two such charming subjects. Lally Horstmann took me to see Max Liebermann, whose works met the eye in every art-shop in the city. The old Jewish gentleman showed me all his treasures. Besides drawings by Rembrandt, and works by neglected German artists of great merit, he had on his walls a number of pictures by his friends of the Impressionist School. He described a little Manet as the earliest effort of that painter: 'But,' I remarked, 'it is the work of a Master.' 'Manet was born a Master,' replied Liebermann. 'You knew Cézanne?' I inquired: 'Ah, celui-là n'était pas commode.'

Chiaroscuro

The Hotel Adlon round the corner of the Wilhelmstrasse was a handy meeting-place and a pleasant alternative to the grandeur of the Embassy. I made frequent use of it. One day a very robust gentleman came into the Bar and began talking to me. He had just flown from Sweden. His name was Count Luckner. Before long he told me his surprising history. With his ship, the *See Adler*, he had successfully run our blockade, an exploit where audacity was supplemented by ruse. Many British ships were sunk by this formidable seaman, including that in which he had first served as a runaway apprentice. 'This deed', he said, 'broke my heart;' 'but', he added, 'I have never in my life left a man to drown.' This hero was not without sensibility, if inclined to be a little boastful in a pleasant way. Before we parted he presented me with his book *See Adler*, inscribed, 'Where there's a Will, there's a Way'. We were to meet again.

Berlin—A Night Out

Lord D'Abernon, with his usual consideration, had provided me with a key to a side entrance of the Embassy, thus leaving me free to return at any time of night, without disturbing the household. By this means I passed through the Chancellery and up a back stairs to my room.

On evening while engaged in solitary exploration of the monstrous city, I found myself in a rather grim and dilapidated quarter intersected by a canal, or it might have been the river Spree. A sign over a door across the road caught my attention 'Bodega', I read. This name in other European capitals denotes a kind of tavern to which an impressive array of vats of wine and spirits lends an air of substance and respectability, a place in fact eminently suitable for rest, refreshment and meditation. But this establishment, outwardly at least, bore no such reassuring aspect it looked in fact a little sinister: however, curiosity, helped by a

certain weariness, overcame discretion: I pushed open the door
and entered a large, rather dimly lit saloon, furnished with
numerous tables and the usual counter at which the lady of the
house presided: a short stairway at the back gave access, through a
door, to further accommodation. A few female customers were
seated here and there about the room. I took a chair and ordered
some champagne. At this a stir became noticeable among the
ladies present; as I drank, one by one they rose, and, approaching
me, inquired after my health. I begged all to be seated, and
ordered another bottle; soon we became friendly. Encouraged
by the frank good-humour of my companions, I called for yet
more wine and did not omit to invite our hostess to join us. I was
made to feel at home, and couldn't have asked for better company:
the German people, I now saw clearly, though beaten in the
field, were incapable of rancour: how else explain their reception
of one like me, admittedly belonging to the hostile tribes now in
occupation of their Capital? Here, national masks were dis-
carded, and we were just fellow-creatures, by happy chance
thrown together for an hour or two. Alan P. Graves had said
German women were the most naturally affectionate people in
the world; he spoke from long experience. As if to prove his
statement, he married one of them. My new friends were natural
enough, and, I should say, affectionate too. The war was now
forgotten: reparations forgotten: governments and frontiers
forgotten: all was forgotten but our common humanity. But I
wished I could have split myself so as to view the party from
another angle: the scene must in this light have looked quite
Rembrandtesque, especially when the door above the stairs
opened and a young girl appeared in the aperture, beckoning to
me in secret merriment. This was indeed the high note of the
composition. The hour was growing late: I turned to consult my
wrist-watch: it was gone! Thereupon I rose and in my sparse
German, referred to the 'Englische Bodschaft' and the 'Polizei'!

General consternation! Someone had remarked the disappearance of a young woman but a few moments before, and at once one o two men who had by that time arrived were sent after her quickly she was overtaken and haled back: the wrist-watch wa found in her stocking: the weeping girl was now subjected to fierce tirade from the proprietress, furious that the 'arm Engländer' should have been treated thus, and above all, on he premises: another drink all round, this time 'on the house', soo restored the general good humour. The watch was a present from a friend or I wouldn't have made a fuss about it. I returned to the Wilhelmstrasse pleased with my evening: the vision of the merry young girl in the doorway, most of all, remains clear in my memory.

While in Berlin I met the archaeologist, Professor von LeCoq He showed me the frescoes he had lately transported from the Gobi desert. It had taken over two years to extract the work from caves in a hill, which soon afterwards collapsed: the Pro fessor had been just in time: he had undergone great hardship during this long and difficult operation but, as he said, 'It wa worth it.' In these frescoes are seen links between Greek and Chinese art, and the transition of the Apollo type into the Buddha Some panels represent blond, blue-eyed personages, and pattern occur identical with those seen on our playing-cards.

Potsdam, the lakes at Wansee; Sans-souci within easy reach provided pretexts for a run out in the evenings: here Mrs Gilber with her car was indispensable. Having a week or two to mysel before leaving, I decided to see a little more of Germany, so se out for Dresden, Nuremberg and Munich. From repeated visit to the *Pinakothek* in the latter city, I retain but one clear and ineffaceable impression: it was produced by a head of the Virgir by El Greco. Of the recent Munich School one painter alone excited my interest – von Marees.

Some Adventures in Portraiture

My first commission in portraiture was to paint an old lady living in Eaton Terrace. The fee was fixed at forty pounds of which half was paid in advance. As the work went on I began to tire of the old lady's personality: she too, I could see, was bored by mine, and getting restless. She even spoke rather sharply to me now and then. This didn't encourage me at all. One day, having made a date for the next sitting, I departed never to return. I had got her head done pretty well at any rate and the old lady got her picture at half price. After about half a century this work was discovered by Dr John Rothenstein, acknowledged by me, and hung in the Tate. I cannot recall the name of the subject.

* * *

My portrait of Sir Gerald du Maurier may be a good likeness, but from the point of view of a fashionable actor, it was, perhaps, insufficiently imbued with sex-appeal. In my innocence, I had omitted to repair his broken nose. I had hoped it would hang in the Garrick Club, where du Maurier entertained largely, but Tallulah Bankhead bore it away to America, where it remains. I liked du Maurier: the dear man never ceased to act and always with that consummate art which just avoids concealment.

* * *

Lord Fisher was the very archetype of a sailor. He had started his career in the old wooden ships. He told me his qualifying examination as a candidate for the Navy consisted in reciting the Lord's Prayer and drinking a glass of sherry. He had no difficulty in passing this test: though he 'couldn't spell *cat*'. The Duchess of

Hamilton always attended his sittings. I began this lady's portrait too, but failed to finish it in the time available. The Admiral remarked, 'You won't find as fine a figure of a woman, and a Duchess at that, at every street corner.' This was true enough, and my failure was all the more regrettable. Like many great men, 'Jacky' Fisher loved the simplest jokes and was well stocked with such himself. He liked walking up and down Mallord Street while talking, but no further than the length of a quarter-deck, his ideal ambit. The night before his sittings, he might have been dancing indefatigably, or sitting up to all hours drinking champagne with Winston Churchill; as far as I could see, he was never the worse for it. He described the statesman mentioned as a 'menace to the Empire' but evidently enjoyed his company none the less. This superb and lovable old egotist was never seen to lower his flag except in the presence of Lady Fisher, and then only half-mast.

* * *

I was commissioned by the Bank of England to paint the Governor, Mr Montagu Norman. He turned out to be an almost ideal sitter. His fine features always wore an air of preoccupation as though he was troubled by graver problems than beset other men. This admirable detachment allowed me to proceed with my work without interference. No curiosity led him to glance at the canvas either before or after its completion: this suited me very well, for I deprecate the intervention of my models: their comments, even if intelligent, may corrupt or interrupt the artist's vision. To see with other people's eyes is the secret of successful mediocrity. Sometimes Lord D'Abernon would come in to chat with the Governor. The subject of their conversation appeared to be High Finance. I welcomed these discussions, for they increased my sense of isolation. Although our

acquaintance seemed at rare moments to show signs of ripening, the heavy responsibilities of the Dictator of Threadneedle Street precluded anything like intimacy, and it was in a spirit of austere reserve that we used to part on the doorstep of my house, whence, after looking this way and that, and finding the coast clear, Mr Norman would venture forth to regain his car, parked as usual discreetly round the corner.

<p style="text-align:center">* * *</p>

We had made an appointment to lunch with Signor Marconi. He met us at Sandbanks, whence we were rowed to the yacht, *Elletra*, which lay off Brownsea Island. The luncheon party included Miss 'Poots' van Rallte, the Infanta Beatrice of Spain and her husband, the Infante Don Alfonso. I found the atmosphere of this gathering lacking in warmth: Signor Marconi's glass eye shone with a cold and distant gleam, hardly compensated for by the polite twinkle in the other. Afterwards we were taken to the wireless room where a formidable apparatus was tuned up, and presently gave forth strains of music: we were listening to a band, playing, not very well, in Paris. The inventor of the alphabet claimed that, henceforth, truth would be accessible to all, but as someone remarked at the time, the dissemination of lies would prove equally practicable.

At the suggestion of Lady Howard de Walden, I painted a portrait of the Infanta Beatrice. My amiable subject, persuaded by me, agreed to dress *à l' Espagnol*, with a high comb, black mantilla, fan, and dress of cloth of gold. She looked perfectly Goyaesque in this costume, though without a drop of Spanish blood: similarly Don Alfonso had all the appearance of a typical English gentleman. This Prince, having an aptitude for mechanics, was now happily employed in a garage. During our rests I introduced my model to a popular game of skill. I thought it

decidedly chic to play 'shove ha'penny' with Queen Victoria's grand-daughter.

* * *

A Japanese friend, Mr Gonnoske Komai, arranged a sitting of the Crown Prince of Japan, Hirohito. One hour was given me, starting at eight o'clock one morning. The prince arrived with a retinue of dignitaries. Hirohito was an inconspicuous young man attired in a navy-blue suit. Without being handsome, his features denoted breeding, and his manner was modest, easy and natural. Having enthroned him in an armchair I set to work, using a stool, while his escort remained standing at a respectful distance. At one moment, a member of his suite, greatly daring, approached and attempted, without much success, to smooth the Prince's unruly shock of blue-black hair. At the stroke of nine the sitting was over. Komai, in a state of great agitation, taking me apart, indicated that I should offer my picture to His Royal Highness. Rather mystified, I did so: the offering was graciously accepted: we shook hands, and the party drove away. Some months later I received a beautiful roll of Japanese script which I couldn't read, and a solid packet of bank-notes which presented no difficulty. The Prince, in his turn, had made me a present ... Komai told me that if I went to Japan I would be *persona grata* at the Imperial Court, and that if I took the chair my semidivine model had sat on, I could sell it for its weight in gold. It was quite a heavy chair.

* * *

My portrait of the late Lord Leverhulme had a dramatic sequel or series of sequels. I had been dispatched and paid for when I heard from my agent that the picture had been returned minus the head! The canvas was still fixed in its packing-case

from which it had clearly never been removed. Much mystified, I wrote to his Lordship requiring an explanation of this remarkable proceeding, to which I proposed to give full publicity. I received in return a letter stating that on finding the picture too large to place in his safe, the owner had cut out what he considered to be the most important part, that is the head, and lodged it in that repository: as for the remainder, it had been sent back by an error on the part of his housekeeper: I was urgently requested to keep the matter dark, and invited to dinner at Hampstead. My answer to this was to inform the Press of the matter: the story was then published, with photographs of the work, before and after treatment. Telegrams and cables now began to pour in from artistic bodies all over the world, including if not China and Peru, certainly Japan and the U.S.A. Public demonstrations also took place. The students of the London Art Schools united in organizing a procession to Hyde Park, bearing aloft a gigantic replica of the celebrated soap-boiler's torso, the head being absent: this was accompanied by eloquent expressions of indignation, scorn and ridicule.

In Italy they went further. A twenty-four-hour strike was called, involving everyone connected with the painting industry, including models, colour-men and frame-makers. A colossal effigy entitled 'IL LE-VER-HUL-ME' was constructed of soap and tallow, paraded through the streets of Florence, and ceremoniously burnt in the Piazzi dei Signori, after which, the demonstrators, re-forming, proceeded to the Battisteria where a wreath was solemnly laid on the altar of St John ...

* * *

I don't know how or when I came across W. H. Davies. The former tramp was now something of a celebrity and lived comfortably somewhere near Tottenham Court Road. In his simplicity he showed me a sheaf of press cuttings he had collected and

preserved, and seemed to expect me to read them. I was eager to make a record of this little man of genius, with his fine features, dark complexion and high black *toupet* and I easily persuaded him to sit for me. He sat as one inspired; his hands clasped before him, his eyes focused, as it were, on Paradise, and his ears, it might be, intent on the song of an invisible bird. I found his happiness enviable if not infectious. His naivety was almost embarrassing. Those who have read his prose works must have noticed that trifles did not exist in connection with W. H. Davies. Everything that happened to him was significant. His *Autobiography* was continued in his conversation, with a different and more humdrum background. Always faithful to the lower levels of society he knew and loved so well, his present fame made caution necessary. 'When I want to do a pub-crawl', he confided to me, 'I go to Clapham, for over there, you see, I'm not so likely to be recognized.' Nothing in the world could corrupt the innocence of this child of Nature: we make light of his foibles, and enjoy them, at a distance, almost as much as he did himself.

Deauville, Freddy Guest,
Lloyd George, Allenby and Shea

A TRIP to Deauville at the suggestion of Captain Freddy Guest yielded but fragmentary results. The idea was that I should paint David Lloyd George, whose henchman my friend had constituted himself. The Welsh statesman was staying in the district and I began a canvas, but my sitter, having to alter his plans, left for England with a promise of further sittings at Downing Street later on. These never materialized. However, when Lloyd George was Minister of Munitions, one of his admirers, Sir James Murray, induced him to sit, and on this occasion I was given more sittings though not enough, and managed, in spite of constant interruptions, to produce a portrait which would have been all the better for another week's work. Of the Minister's stream of visitors all were to me unwelcome; the two who impressed me most, for different reasons, were Lord Northcliffe and C. P. Scott. Lloyd George was much interested when I told him that my father had been to school under *his* father at Haverford-west. He asked me to inquire what impression the schoolmaster (who had died rather young) had made on his pupil. My father's reply was that Mr Lloyd George *père* was a strict but always just disciplinarian, earning the respect of all the boys, but that his wife had won their *love*. This tribute delighted Lloyd George and was all the more valuable as coming from one ordinarily in the habit of confusing the distinguished offspring of the couple in question with the Devil himself.

Deauville was not to my taste. I took no interest in *Chemin de Fer* or *Banco*, avoided the Sports and found the *Potinière* unbearable. The sea and sands, pullulating with the *beau monde*,

Chiaroscuro

looked as cheap as a poster. The 'Villa Black and White,' where the Baroness Catherine d'Erlanger dispensed hospitality, offered some relief. However, I did a few portraits here, including one of Miss Baba d'Erlanger with her friend, Miss Paula Gellibrand; Lady Michaelham and Captain Freddy Guest. One day I happened to be wasting my time in the Hôtel de Normandie when a carload of newcomers arrived: among them I recognized General Allenby, fresh from Palestinian triumphs: here, I thought, was a Man. Somehow we got into conversation and later, through his A.D.C., I was given hope of sittings in England. The General was *en passage*, and after lunching, was making his departure when, noticing the waiter shrinking in a corner, he turned aside, shook the little man warmly by the hand, and bidding him goodbye, pursued his journey.

Another military hero, General Shea, added to his laurels here one evening. Shea, always ahead of his troops was, T. E. Lawrence told me, the first to enter Jerusalem at its fall. We were lounging in the ballroom of the hotel. A few couples were circling round. Someone dared Shea to dance: he had never attempted this form of exercise, but also, he had never been known to avoid danger: after spending a few minutes in close study of the dancers' movements, he provided himself with a suitable partner, and taking the floor, in his field boots, successfully if not gracefully, made the tour of the room.

The Lord Mayor of Liverpool

When my old acquaintance Chaloner Dowdall was elected Lord Mayor of Liverpool I was commissioned by the Corporation to paint a ceremonial portrait of him. I stayed with the Dowdalls during the execution of the work. Each morning the Lord Mayor and I were driven to the Town Hall in the official carriage and pair. There, my model, having donned his cocked hat, furred robe, silk breeches, Chain of Office, etc., mounted the dais and, grasping his wand, faced me resolutely. To enrich the composition, I added, without extra charge, the figure of his sword-bearer, Smith. The sitting over, it was my usual habit to go off on my own, to explore new aspects of the city or revisit old ones. I felt under no obligation to hurry back to the uneventful respectability of Sefton Park, and firmly withstood the pressure put upon me by Dowdall to return with him in state. I had had enough of stateliness for the time being and felt the need of a break, after which I would face my sitter's features again with renewed courage. Not that I did not appreciate the claims of the Lady Mayoress, for the *Râni*, as Sampson had dubbed her, was the most engaging character in Liverpool: but her husband's new dignity had somehow lent him a weightiness of manner more appropriate, I thought, to the platform than the fireside. Lord Mayors, I decided, should be kept in their Town Halls or, if allowed out, encouraged to shed their responsibilities along with their insignia.

But my friend's craving for my company, it turned out, was due, not to any personal charm I might be credited with, but to his anxiety to keep an eye on me, lest my evening excursions be made the subject of comment in the town, and, as the Police suggested, be held to prejudice in some way the dignity of his

Office. On learning this, my attendances at dinner became rarer still, and the hour of my return more incalculable, for the knowledge that I was under observation only provoked me to wander further afield.

A Picaresque Adventure

PROFITING by a day or two of freedom, I decided to visit John Sampson, now Doctor of Literature. He was living near a village called Bettws-gwerfil-goch in North Wales. It was evening when I arrived at his house, Cae-gwyn. The peculiar character of this house led to the following adventure. I found the Rai laid up with some disorder. He welcomed me, however, and invited me to take a glass of the remedy he had prescribed for himself. Though in good health, I agreed. The whisky was good and so was the Doctor's conversation. Besides Mrs Sampson, there were present Miss Dora Yates, a Gypsy scholar, and a blonde young lady I had met before with Sampson, known as 'Kish'. Some short while after the retirement of the ladies, bidding Sampson good night, I followed their example. A room had been allotted to me, but by an oversight I had not been provided with a candle or instructed in the lay of the house. This house, as I found later, consisted of two exactly similar houses joined into one. It was in complete darkness. Dependent entirely on my sense of touch, my necessary explorations led me, it appeared, to the lower levels of the building. In order to return, I knew I had to mount some stairs, but where were they? Ah, here were the stairs! I seemed to be on the track this time but was still uncertain of my room. Cautiously I opened several doors, only to retreat hastily at faint signs of human occupation. At last I groped my way to what, geographically speaking, seemed to be my own territory: my hand found a door-knob: I turned it gently: no sound within: entering, I lowered myself with relief on to what could only have been a bed, and prepared for sleep: hardly had I done so when a terrible outcry arose: this sustained and unearthly ululation might have been heard at Bala, but its source seemed appallingly near!

Starting up, I now perceived by the dim luminosity of an uncurtained window that I was not alone! In an urgent whisper I told the unknown vocalist to desist: I had judged the voice, if human, to be that of a female, which might account for the curious yet vaguely familiar protuberances I felt, rather than saw, beside me. Hastily leaving this accursed chamber, I retraced my way to the top of the stairs, now, to my astonishment, illuminated by the light of a candle held by one of two biblical figures in white drapery who stood on the landing, confronting me, as it were, like accusing ghosts. Closer scrutiny revealed them as the two guests I have mentioned before: awakened by the cry, they had bravely ventured forth in case of need: formally saluting them, I now, thanks to their candle, found my bearings and, by a connecting passage, reached my room. Next morning, alone at breakfast (for I seemed to be the latest down), while my thoughts were equally divided between the eggs and bacon and the dreamlike happenings of the night before, a young person entered the room, and, addressing me, requested an explanation of my intrusion upon her privacy and that of her charge, Miss Honor, during their sleep. (So this was she whose dreadful clamour I had at first ascribed to some supernatural agency!) At once I furnished her with a short summary of the foregoing. The governess, for such was her condition, pondered over this for a few moments, then, eyeing me narrowly, said she would overlook the matter this time but hoped it wouldn't occur again: I had no difficulty in reassuring her on this point for I shared her hopes to the full: thereupon she left me. After all, I reflected, it might have been worse: suppose I had blundered into the arms of John Sampson! Moral. Beware of double houses ... That morning I was met at every turn by grim and disapproving looks: the little girl, Honor, alone greeted me with friendly merriment. Finding this atmosphere little to my taste, without word or ceremony I walked out of the building. I had the day before me: with every step

down the hillside my spirits rose: the sun shone: the sky was blue and white like a Chinese bowl, only brighter: to the south, Aran Mawddwy reared its majestic bulk above subsidiary hills, like a patriarch supporting himself on the shoulders of his acolytes. The village wore an air of welcome. Entering the lesser of the two inns, I called for beer. This inn had been overlooked by the Spirit of the Age: it was untouched by modern refinement: the unnecessary fire burnt sacramentally in a kind of shrine, unembellished by cast-iron ornaments or sham tiles: above it rose no mirrored overmantel cluttered with cheap bric-à-brac: the whitewashed walls were unenlivened by commercial witticisms in poker-work: no art linoleum masked the naked flagstones: in short, it was near perfect. A comely maid attended on me without showing the least sign of suspicion: 'What is your name?' I inquired, 'Blodwen, sir,' she replied: '*Dewch yma, Blodwen bach,*' I said in the vernacular, and the charming girl took a seat beside me. I was making good progress in what should have been my native language, when to my surprise and annoyance John Sampson strode in. The Rai announced rather pompously that upon reflection he was unwilling to allow my behaviour at Cae-gwyn to interrupt our friendship and would overlook it. I answered shortly that I had no apologies to make, and thanked him for nothing. Upon this, with an inward struggle, he assumed a more playful tone and ordered drinks. Could his thirst have got the better of his scruples? Our relations thus restored, and seeing no immediate chance of pursuing my studies with Blodwen, I agreed to move to the other inn, 'The Hand', where we fell in with a number of the *Kâlé* or descendants of Abram Wood, their eponymous ancestor, who had entered Wales in the eighteenth century at the head of his family, mounted on a black thoroughbred and wearing silver spurs and buttons.

Soon the inn resounded with the melodious accents of the Romani language, preserved by the Woods in a richly inflected

form. Each *Kâlo* vied with his neighbour in grammatical nicety, and solecisms were greeted with derision. The symposium was only marred by the truculent behaviour of one of the company, Howell by name. Roused to action by this graceless fellow, I took it upon myself to throw him out: a short struggle ensued which ended in the road, with Howell prone and myself astride him: dismounting, I left him to be led away by his brothers, bleeding profusely: I seemed, on the whole, to have had the best of the encounter.

It was now about time for me to set out on my return journey. Early next morning I was back in Liverpool: a necessary halt under a laurel-bush in Sefton Park preceded my appearance at the breakfast table, and soon afterwards I was at work. It had been a good weekend. Unaccountable disturbances followed the exhibition of my picture, but in spite of public denunciation Chaloner Dowdall stood up stoutly for it. Indeed, he even went so far as to supplement my honorarium with a generous contribution from his own pocket.

U.S.A.

HAVING been asked by Mr Homer Saint Gaudens of the Carnegie Institute, Pittsburgh, U.S.A., to act as British representative on the Hanging Committee of the International Art Exhibition in that city, I agreed, after much cogitation, to do so. It gave me an opportunity of visiting the States free of travelling expenses, and the chance of doing a few portraits at the same time ... So one fine day I found myself aboard the *Aquitania*, moving majestically down Southampton Water on its way to the west.

The *Aquitania* was a fine vessel. The interior, furnished in heavy baronial style, successfully disguised the proximity of the ocean. Yet here I felt at first like a lost soul; as is the case when I enter a smart hotel, but here it was worse, for there was no means of escape. As travelling companion, I had Monsieur Desvallières, a distinguished French artist, bent on the same errand as myself. As he was usually engaged in religious exercises we seldom met except at meals. In spite of wide differences of temperament and outlook, this gentleman and I got on very well together.

On this voyage I made the acquaintance of Sir Arthur Conan Doyle and his family. The creator of Sherlock Holmes was on his way to the States to deliver a series of lectures on the 'after-life'. This subject now occupied his mind completely. Lady Doyle, whom Sir Arthur described as a 'born automatic-writer', sat at his side while he made his notes, but keeping a good-humoured eye on the antics of the two boys, who never ceased to lark about the deck. Their father told me that if the ship went down, his sons would take it as a thrilling adventure, for they had no conception of death as an irremediable calamity.

I joined in none of the deck-games to which Conan Doyle and the other passengers settled down from the start. It would

have needed a wider ocean than the Atlantic to wear down my reserve. The interminable expanse of water through which we ploughed, the ever-moving yet never-changing pattern of foam alongside, some passing ship or the distant blowing of a whale – with such phenomena I occupied my daylight hours, for I withheld my social activities till after dinner. As I viewed the behaviour of the second-class passengers on the lower deck, I found them a more interesting lot than we were. They seemed to be having a better time of it too.

At last, just as I was beginning to feel 'at home', the voyage was over and we were in New York harbour. I had missed the Statue of Liberty; but did I not know her relative, the *Lion de Belfort*, only too well? Before berthing at the dockside, a bevy of news-hawks boarded the ship and, capturing me, pinned me down for a 'story'. In self-defence I stood them drinks instead: they were nice boys.

I was naturally elated on first setting foot in the New World, although a bit late. The pioneer days, which I used to be familiar with in spirit, were long past, yet I felt a new excitement in the air, a feeling of adventure, a deceptive whiff of Freedom. Faithful Homer Gaudens met me on the wharf. I was driven to the Plaza Hotel where I spent the night. Outside, a few imported hansom cabs awaited the rare seeker of old sensations: beyond stretched the meagre pleasaunces of Central Park.

In the evening, gentle Frank Crowninshield took me to see what New York could do in the way of entertainment, and afterwards deposited me at my hotel, exhausted and bewildered by an orgy of colour, noise, smartness and multitudinous legs.

Pittsburgh

Next day we entrained for Pittsburgh. Our way took us by the noble reaches of the Susquehanna. Afar in the amber air

rose a faint pillar of smoke: would this, I speculated, indicate a camp-fire of the Osages, or warn us of the propinquity of hostile Sioux?

A few days at Pittsburgh sufficed for our work in the Gallery. Two American colleagues, George Belcher and Eugene Speicher, while formally polite, seemed a little on their guard, as though suspecting Desvallières and me of questionable motives: they, at any rate, weren't going to stand any nonsense from a couple of Europeans. Our behaviour, as a matter of fact, was both correct and friendly. Desvallières, who spoke no English, found some difficulty in making himself understood, or, more accurately, held forth without seeming to care whether he was understood or not. One morning, I delicately hinted that his eloquence of the night before had been largely wasted: 'Je parlais pour moi-même,' he replied shortly. The good man, his official duties done, would disappear: he had discovered some religious establishment which interested him, but he always returned in time to assume *l'habit* for the evening's social ritual: he was elegance itself.

Impossible to describe the infernal splendour of the steel-works by night or the boundless hospitality of the Pittsburghers! The Carnegie Institute contains a permanent collection of pictures and sculpture. The Hall of Sculpture presents a comprehensive selection of casts from the Antique, incomplete only in the case of the male personages, through the absence of certain homely but necessary features, amputated at the behest of Mr Carnegie himself.

One place we visited in the neighbourhood was of special interest to me: this was an early Quaker (or possibly Moravian) settlement. The carefully preserved buildings, of an exquisite simplicity, seemed to breathe a language of archaic sobriety and innocence.

Chiaroscuro

Buffalo

Leaving Pittsburgh for Buffalo, I spent a considerable time here over the portrait of an elderly lady, the mother of my sympathetic friend, Conger Goodyear. The completion of the work was interrupted by an accident to my sitter, who slipped and broke her ankle one day when I was out with her. I shall not forget this lady's behaviour as, waiting on the pavement to be carried to her car, she made jokes with me while suffering extreme pain. Mrs Goodyear was a fine type of the old American school.

The chief and only sight near Buffalo is Niagara Falls. I visited them frequently. Even more impressive than the Falls was the spectacle presented by British policemen on duty as Conger Goodyear and I crossed the frontier to drive for an hour or two on Canadian soil.

New York

On arriving at New York, for a new campaign, I was at once called on by a young American airman, Mr Toughy Pine, whom I had known and painted in England; he had been an esteemed friend of Mrs Rosa Lewis of the Cavendish Hotel, London; he bore a bagful of counter-irritants, designed to soften the rigours of Prohibition then prevailing in the States. Next, he took me to meet Mr Robert Chanler, a celebrated character and painter of screens, who kept open house, somewhere in the neighbourhood of 10th Street: open to all, that is, who could match his hospitality with some measure of friendliness, sagacity, or entertainment. Austerity was not the rule here: bores or 'stuffed-shirts' were discouraged, and soon found themselves in the street. As a fellow-artist I was made welcome by 'Bob' and we soon became good friends. Mr Toughy Pine, having discharged his obligations, left and I saw little more of him.

Bob Chanler was a big fellow with a shock of grey hair, a 'heart of gold' and a would-be domineering manner, expressed with much flapping of arms and hands. I found his easy-going and moderate-sized house a happy refuge amidst the stupendous canyons of New York, where both the buildings and their inhabitants seemed to be engaged in a perpetual struggle for ascendancy. Bob kept on the premises a Russian familiar who called himself 'Narodny'. Apparently an Illuminate, Narodny interpreted Chanler's screens, enjoyed the freedom of the cellar, exemplified the Russian Soul, displayed his heart on his sleeve, and in moments of uncontrollable affection would rush after me, and implant a smacking continental kiss on my reluctant cheek.

Among the habitués, I must single out Carlotta, a gigantic Colombian beauty who sat for me. I was painting her as large as, or perhaps a little larger than life and doing well, until in a mood of fatal objectivity, I reduced her to reasonable proportions and ruined a promising picture. Artists, beware of the reasonable!

One evening, during dinner at Bob's, there appeared a curious hairy personage in the guise of a tramp philosopher. Evidently an old customer, he took his place among the company with ease and assurance. Having dulled the edge of his appetite and partly quenched his thirst, the newcomer proceeded to air his views on civilized society. These views were frankly adverse. He had everybody pretty well subdued, when, taking advantage of a pause, I asked him point-blank what he thought of our Banking System. This inquiry relieved the tension and gave rise to general laughter: thereupon, relapsing into silence, the sage, after a few minutes, got up and left us rather hurriedly. Puzzled, I wondered if the abundance of the fare had got the better of him, or had he merely responded to the Call of the Open Road, or perhaps both? But upon reflection, I decided that our Jeremiah was himself a

Banker in disguise, a kind of 'Professor Skinner', who, alarmed by my question, sought to elude detection ...

I had heard of Harlem, the Negro quarter, and proposed to visit it. Harlem at that time was, so to speak, out of bounds: it hadn't yet become the favourite resort of fashionable 'bohemians', and was indeed hardly mentioned in polite society. Bob hesitated before agreeing to make this expedition, but I was persistent, and would have gone alone if necessary. So we set out, three of us. We entered one of the numerous dance clubs in the district, the only whites in the place. My companions seemed ill at ease, but having no colour prejudices, I felt, if not exactly 'at home', at any rate no less happy in these surroundings. The dancing was brilliant beyond description. Leaving my uncomfortable companions, I joined a handsome Negress whose fine poise and good-humoured smile seemed to call for recognition. I had no reason to regret this move, for my new acquaintance proved to be exceptionally well adapted for a chance meeting such as this, being gay, frank and quick-witted. I told her my occupation: she agreed to pose for me some time, and, in addition, promised to regale me with *fried chicken*. This fine genial woman paid me the greatest compliment possible when she offered to accompany me back to England.

Another haunt of mine was a Russian Cabaret. Here I got to know the performers, among them a handsome Gypsy singer from Moscow. Though strange to her dialect, I knew its essentials, and we were able to converse with intelligence. My usual companion here was an actress, Greta Kendall-Cooper, who possessed an almost pure classic profile which I used to try and draw on the backs of the menus. I formed a high opinion of Russian femininity as represented at the Cabaret. The girls were enchanting.

* * *

At this time *The Miracle* was being performed in New York

with Lady Diana Cooper in the role of the Madonna. She filled it with exquisite grace and dignity. The enigmatic Dr Kommer was much to the fore in this connection: though nobody seemed sure of the nature of his activities, their importance was taken for granted by everybody.

* * *

At Joseph Duvenn's suggestion, I undertook the portrait of Mr Joseph Widener of Philadelphia. I visited more than once his famous collection of pictures in that city. He had lately acquired two magnificent Rembrandts from Prince Yousoupoff, the executioner of Rasputin, who now, it appeared, wanted them back: 'What hopes!' said Joseph Widener. This great and tenacious collector has lodged my portrait in the New Mellon Gallery in Washington. I was told his lady friends did not approve of my rendering of character: but do they ever?

* * *

The Colony Restaurant, though not the cheapest was, I thought, the best in New York, having a true 'continental' character: and if the wine was placed not on but under the table it was none the worse for that.

* * *

I enjoyed much hospitality at the hands of Mitchell Kennerley, the publisher and bibliophile, and with him I met Jo Davidson, the sculptor, who had just done a portrait of Mr Rockefeller. I found his elation at having portrayed the 'richest man in the world' disproportionate, and told him so: 'Character, not dollars, should preoccupy an artist,' I said. Though he abated his transports somewhat, I doubt if he was convinced. When I come to think of it, Jo probably scored both ways.

Chiaroscuro

Among the portraits I thought more or less successful was one I did of Mr J. Phipps. I understand his family did not share this view, but that made no difference to Mr Phipps, who, whatever he thought, showed no sign of dissatisfaction. He took me to Long Island and showed me his house and the houses of various friends in the neighbourhood, most of them built on the lines of Buckingham Palace. I resumed acquaintance here with the sympathetic and gifted Mrs Harry Payne Whitney whom I had met on the *Aquitania*. I liked best Mrs Pad Romsey's home; it was less grandiose than the others but more mature. I was very friendly with this vivacious personality and her circle, which included Tommy Hitchcock, the polo player; and it was here I met Scott Fitzgerald, the sympathetic young writer, whose books I had never read.

* * *

Hearing of my presence in New York, the actress Eve Balfour, whom I had known in London, paid me a call. I got her to pose again for me at my studio in Bryant Square. This generous and optimistic soul was interested in the occult, and used to allude constantly to her 'vibrations'. She hinted at the possession of remarkable psychic powers. Personally I would have been quite satisfied with her outstanding physical advantages: if Eve chose to *look* mysterious, that was all right; the phenomenon was visible and could be registered – but the *occult* ...? One evening we were together at the play: the lights being extinguished, my companion drew my attention to her hands: her fingers were luminous, they positively streamed with light ...

* * *

I became friendly with Mrs Walter Rosen and her husband. Their musical parties were not to be missed. Mrs Rosen, or Lucy, astonished me by her original style and grace. Attired one evening

in a Botticelli costume, she might almost have stepped out of the 'Primavera'. One incident only I would like to forget. The Rosens took me one Sunday to their country club. On arriving, Rosen, who had wisely provided himself with a bottle of whisky, dropped it on alighting from the car: the bottle was smashed and its irreplaceable contents wasted. Walter Rosen was moved to philosophic merriment, but I saw nothing to laugh at.

* * *

My meeting with Miss Belle Green, the curator of the Pierpont Morgan Library, turned out luckily. Showing me round the collection, she pointed out her latest acquisition, a small panel: instantly I exclaimed, 'École d'Avignon!' Miss Green looked at me with astonishment: I was right but was it possible that a mere artist, and an English one at that, could be capable of such perspicacity? This incident formed the basis of a valuable friendship.

* * *

I used frequently to lunch at the Regency Hotel with Stevenson Scott of Scott & Fowles, Art dealers of 5th Avenue; we were often joined by Joseph Duveen whose establishment was across the way. It was amusing to listen to these merchants enthusing over the masterpieces they were doing their best to get rid of: but Stevenson Scott, not content with selling pictures, collected them too, including some of mine.

* * *

My portrait of Mme Suggia had been bought by a Mr Clyde of New York, when first exhibited in London. He sent it to Pittsburgh where it gained the first prize. Later on Duveen acquired it and eventually presented it to the Tate, much to the satisfaction of Mme Suggia and myself. The distinguished cellist

did not approve of the transfer of this picture to America where, except by repute, she was unknown; as for me, I, of course, only wanted to chime in with Guilhermina on all possible occasions.

Before I left New York, a cable arrived proposing that I should purchase the house I now occupy, Fryern Court. Alderney Manor had to be relinquished. As the financial results of my work permitted this step, I agreed: at that distance I would have agreed to anything. On the return voyage, the liner touching at Cherbourg, I was moved to disembark there. After the glitter and turmoil of New York, the mellow aspect of the French countryside was irresistible. I made my way to Calais in leisurely style, doing no work on the way, for everything I saw seemed to have been already painted, and by a master hand.

Château de Missery

MITCHELL KENNERLY when in London introduced me to a distinguished American architect of the name of McLanahan, who invited me to his château in Burgundy, where he proposed that I should paint his wife's and his own portrait. The Château de Missery stands a few miles from Montbard. It is a perfect fourteenth-century turreted building surrounded by a moat, and had been reconditioned in the reign of Louis XIV. Mr McLanahan had with sure taste restored the elegant *boiserie*, and furnished the château throughout in pure Burgundian style. Moreover, a connoisseur in more ways than one, he had stocked his cellars with the choicest products of the Côte d'Or. Under his tutelage, I was beginning to distinguish with some accuracy the exquisite wines he put before me. Every meal (except breakfast) became an education. The solemnity of these gustations, with conversation limited to an ever-narrowing field, used sometimes to exhaust me, and I was moved to seek relief in the village inn, where the *aubergiste*, herself a foreigner, for she came from Brittany, was a sympathetic soul and dispensed liquor which, if of no famous mark, was inexpensive, familiar and plentiful. After a severe struggle, my portrait of Mrs McLanahan, suddenly turning a corner, came to life, a definite success. That of her husband, despite all my efforts, failed decisively. I was wondering if I was expected to make a fresh start, when Mr McLanahan, resolving my doubts, suggested it was time for me to leave. I thought so too but did not wish to seem precipitate.

I returned more than once to this beautiful place. My former genial hosts were no more, but their son Alexander with his beautiful, gifted and highly temperamental southern wife were

now in occupation. Under their benign and youthful sway the château awoke to new life and gaiety, and, at the magic touch of Frances McLanahan, to music too!

Portrait Painting

GOYA's dictum, 'Portrait painting is a matter of *parti pris*' is sound, but it must not be taken to imply moral judgment. The exploration of character must be left to the eye alone. Heaven knows what it may bring to light! Yet when Alvan T. Fuller, Governor of Massachusetts, accompanied by his medical attendant, called upon me at Mallord Street with a request that I should paint his portrait, I hesitated. The recent trial and execution of Sacco and Vanzetti had shocked the world. Before me stood their executioner! I knew nothing at that time of the details of the case. The innocence of the two anarchists had not then been established, but it was certainly presumed by many. In any case it was not Fuller who had pronounced the verdict: he had but carried out the sentence: but the power of reprieve rested with him and he had not seen fit to exercise it. Whichever way my sympathies might lean, and I was thoroughly biased, it was hardly within my competence to pass judgment on this functionary. In any case, if moral qualities were to be the criterion of a model's eligibility, who was to assess them? Not the artist surely: the only valid question for me was 'Can I or can I not paint a good portrait of this man?' I decided I might as well have a try. At my first attempt, I failed to achieve the necessary detachment and only spoiled a canvas. The Governor having now to return, I agreed to follow him and recommence the work in America.

America Again

FOR the fifth time I was crossing the Atlantic. The ship was an old one and, I was told, fit only to be scrapped before it foundered which in fact it did shortly after this voyage. A crowd of American boy and girl students were on board: they were in high spirits at the thought of resuming their own cosy way of life after their wanderings in Europe. We got on very well together.

As we entered Boston harbour, a motor-launch drew alongside and a military officer boarded the liner: seeking me out, he announced that he had come to take me ashore and transport me to the Governor's country house some eighty miles along the coast. I stayed at this house a month or two before the family returned to Boston. This was an isolated spot: there was little here to distract me from my task of painting the Fuller family.

The Governor was not in the best of spirits, I thought. He seemed preoccupied and kept referring to details of evidence in the recent trial: Mrs Fuller, a most good-natured woman, did her best to cheer him up. 'Forget about it, Alvan,' she would say but Alvan couldn't forget about it. Something had gone wrong it seemed, with the evidence: but the subject was avoided as being unsuitable for public discussion. This house was hung with examples of Zuluaga's work, a portrait of Abraham Lincoln, and some 'old masters'. As head of the Packard Automobile Company, Governor Fuller was in the habit of holding an annual celebration for his subordinate managers and executives who gathered here from all parts of the States. A 'barbecue' was held on the beach: numerous fires were lit, and the multitude of guests seated at a long series of tables, were regaled with hot shell-fish or clams, washed down with soft drinks. The Governor was nothing if not law-abiding. However, a less scrupulous friend in the

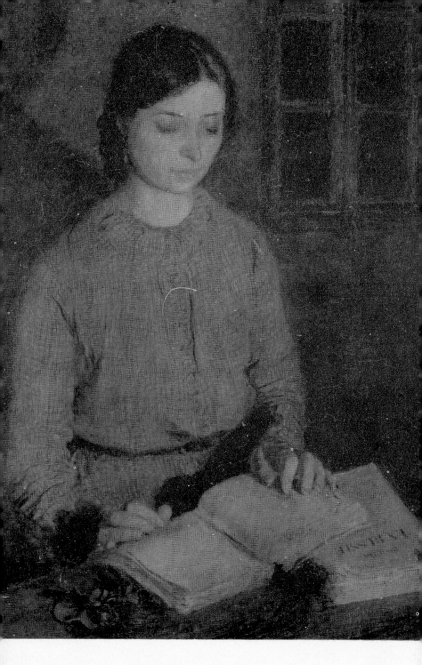

'Dorelia in Toulouse by lamplight' by Gwen John (*reproduced with the permission of Edwin John and Romilly John*)

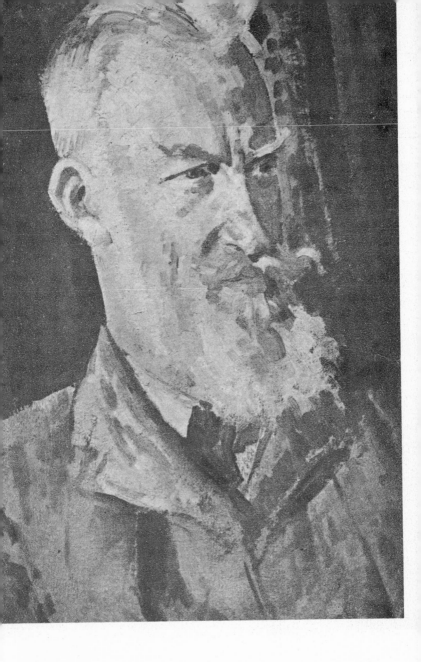

10 George Bernard Shaw

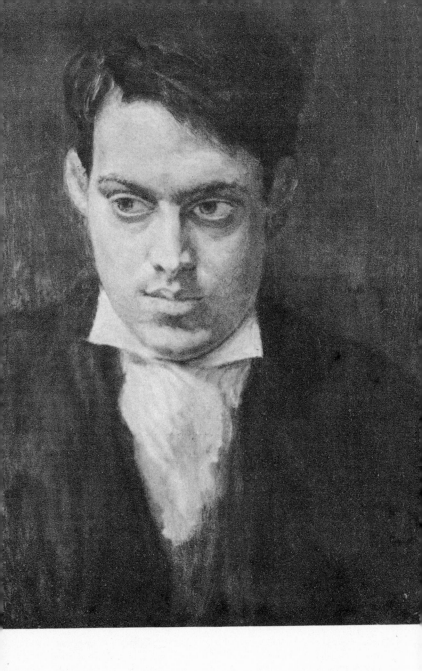

11 Wyndham Lewis

12 John Hope-Johnstone by Wyndham Lewis (*kindly lent by W. V. Hope-Johnstone*)

neighbourhood had arrived at the house with a bottle of the 'hard stuff' which, in private, he shared with me. We were thus able to join in the orgy with a little extra zest. Though obviously no 'regular fellow', and under some suspicion, I found the barbecue a pleasant break from the routine of life at Runnymede-on-Sea, and made the most of it.

Boston

Few other events marked my stay at Rye Beach. An occasional run out to Ogunquit with the sympathetic sister of the Governor; a visit to his herd of prize cattle and indulgence in a glass of their excellent milk; private conversation with one of the chamber-maids, an Irish girl from Connemara, representing an older and more remote civilization; a call on Mr Harry Sleeper of Wor-cester, who had an incredible house overlooking Boston Bay, filled with specimens of New England and Chinese craftsmanship: such were the rare delights of my otherwise laborious days. At length the time came for a general move to headquarters. I had seen nothing of Boston and had been looking forward impatiently to this date. I lived with the family at their house in Beacon Street, but was lent an excellent studio by a friendly and gifted artist, Charles Woodbury, who painted sharks in the Caribbean. Life now became more varied and eventful. I found Boston full of interest. New models turned up, but not too many. One of them, though married and a mother, appeared to have just escaped from school, but neither years nor experience will ever impair Vera Fearing's exquisite immaturity. Among my new friends, William James and Ted Spencer will always rank high in my regard. The former, like his uncle Henry, was a stickler for verbal exactitude and sometimes found himself, in conversation, at a loss for the *mot juste*. 'Come on, Bill, out with it!' Woodbury would say, as James hesitated. An artist himself, his studio was in the same

building as mine. His painting showed the same preoccupatio
with precision of style as his speech. I thought a little mor
audacity would have helped him over his difficulties, though a
some risk. My visits to his house at Cambridge were memorabl
for the quantity and quality of the bread and butter with whic
Mrs James regaled me: it was only here that I had my fill: th
Jameses' company, supplemented by that of Piero della Francesc
(in reproduction), helped to keep me going while at Boston, a cit
which, in parts, I found very much to my taste.

My experience of Harvard students was of the happiest. It i
said nobody develops essentially after the age of ten or so. Thes
boys were certainly a bit older than that, but, as it seemed to m(
had reached perfection. Bless them! Ted Spencer, Professor c
English Literature at Harvard, introduced me to the pleasan
Tavern Club. Seated with him at lunch one day at the round tabl
and feeling thirsty, I seized what appeared to be an enormou
carafe of water and filling my glass quaffed what turned out to b
the communal gin! Spencer gave a party in my honour at whic
the general conviviality attained a height comparable only to m
host's stature, which is exceptional even in a country which s
frequently gives birth to giants.

While I was at Boston, the Presidential election took plac(
Mr Hoover, the candidate favoured by the Governor, came t
dinner one evening. I found myself seated next to Miss Eth(
Barrymore. If it did not seem immodest, I would like to clair
Miss Barrymore as a kindred soul: I found her conversation an
proximity infinitely stimulating: in response, my own tongu
loosened appreciably and much long-pent up emotion found ven
Though the Governor supported Hoover, Mrs Fuller, c
Catholic upbringing, leaned privately to Al Smith. Prohibited fc
reasons of State from appearing publicly at his meetings, sh
decided to attend one incognito, and, heavily veiled, took m

with her. Personally I found Al Smith sympathetic, and preferred him to Hoover. After leaving the meeting, we boldly entered a large soda-water bar: there the first lady in Massachusetts, removing her veil, beamed on the astonished gathering of ice-cream addicts with an all-embracing smile of democratic bon-homie. She wasn't proud.

During a visit to the movies with the Fullers, I observed the Governor, at the climax of Al Jolson's pathos (the occasion being the death of a child), to bury his face in his hands while sobbing convulsively: his son, Persh, was similarly affected and so was Mrs Fuller (and indeed the whole house). As I drove away with Mrs F. who was still in great distress, I chid her for this un-necessary demonstration: 'Have you no children of your own?' she wailed; 'Yes,' I replied hoarsely, 'too many.'

My acquaintance of Berlin, the daring Count von Luckner, on tour of the States, was due to lecture at Boston one night. Mrs Fuller and I went to hear him. He narrated his life and adventures with great ability and charm, bringing the house down with his final words, 'and such has been the life of *a self-made man*!' We met him later at a reception where he entertained the company with some remarkable feats of legerdemain. I advised him to visit England where I was sure he would be acclaimed, but he seemed doubtful of this.

Before the day of my departure, I remarked to Mrs Fuller that it would be convenient if the Governor were good enough to settle my account for the work I had done. 'Go to him at once,' she said, 'he is in bed but certainly must attend to this matter right now.' I found Mr Fuller in his night-shirt. He seemed in low spirits and when I explained my reason for disturbing him and, at his request, informed him of the sum owing to me, his depression seemed to deepen, and I noticed beads of perspiration to gather on his brow. After some thought he realized he was cornered: attired as he was there was no way out: he paid up.

Next day, under the guidance of the Governor's amiable secretary, I had to visit a state bureau to declare my earnings during my stay in Massachusetts and receive a permit to take them away with me. I knew a certain sum would be deducted to pay for my footing in the country, but the official who attended to me, on consulting his books, estimated this at a very reasonable figure. But then, just as I was congratulating myself on a profitable get-away, this official, taking another glance through his documents, discovered that he had made a serious miscalculation. The sum to be subtracted now was seen to be almost unbelievably higher than he had mentioned, amounting in fact to some thousands of pounds. This news was not comforting though delivered with many apologies. Always doubtful of my own arithmetic, I had to take the clerk's for granted, *but without turning a hair*, for I remembered I was British. Yet, I hoped a further analysis might disclose yet another oversight and this time one more acceptable from my point of view. No such luck. The figures again seemed indisputable. The official and his colleagues showed me every considera-tion. I thought them the nicest and most humane of men. The seance ended in general laughter and I left the building feeling more than compensated by the acquisition of such good albeit nameless friends.

I had long admired some of the famous 'hook' rugs displayed in a shop I often passed. These rugs are made by the wives and daughters of farmers up-country. I now entered this shop or store, and, since I still had a little money left, I invested in two or three of the rugs to take home. Before leaving, the proprietor of the store took us into a private room, where he refreshed us with some excellent contraband whisky. I lingered quite a while in this congenial atmosphere before returning in the best of spirits to the gubernatorial mansion. The secretary especially showed marked elation. It had been a good break for him.

My friend, the musician Arthur Fielder, who was teaching

Mrs Fuller singing, had introduced me to the Orange Tree Cabaret: I became a frequent visitor here: I proposed that the Fullers should come with me to the Cabaret, before I caught my midnight train to New York. The Governor hesitated but, encouraged by his wife, agreed at last. Our appearance was sensational: the spotlight found a worthy mark that night! My hosts came to see me off: as I took Mrs Fuller's hand in farewell, the Governor said, 'Kiss her, Augustus'; I obeyed.

Sacco and Vangetti

Whatever complicity may be attached to him as regards the sinister event of August 23rd, 1927, Governor Alvan T. Fuller was, as the reader may have suspected, anything but an inhuman monster.

This man, who, from humble beginnings, by industry and character had achieved both wealth and honour, this pattern of domestic virtue, this devoted and indulgent father, this honourable citizen, sharing the universal ignorance, saw in 'Anarchism' just *bombs* and nothing more. To him, no doubt, the brutal crime of which the Italian couple had been accused and convicted was but an incident in the general guilt of two declared 'enemies of society'. But it was not he, but one of the judges who, *before* the trial, was heard to exclaim, '*We'll get those bastards!*' It was not he who suborned the miserable witnesses whose testimony sent these men to the electric chair after seven years of captivity, torture and repeated trial. But had he not visited the prisoners in their cell? Had he not shaken hands with them … ? We must suppose that, convinced at last by evidence 'you wouldn't hang a dog on' (as it had been described), he felt it was up to him, as the highest officer in the State, to defend the social order he represented, and, if need be, mercilessly to crush the exponents of a dangerous doctrine; dangerous because it struck at the roots of our civiliza-

tion and, in its implications, might even be confused by the
ignorant with the sacred precepts of the religion he and his like
professed. Yet this perplexed son of a noble mother had his
qualms, and, as I noted, they kept recurring. But the greatest
mistake of his life was destined to bear everlasting fruit in the
words of Vanzetti, which I am going to quote. Without Fuller
they had been unspoken. Let that be his final exculpation.

> If it had not been for this things, I might have live out
> my life talking at street corners to scorning men. I might
> have die, unmarked, unknown, a failure. Now we are not a
> failure. This is our career and triumph. Never in our full
> life could we hope to do such work for tolerance, for
> joostice, for man's understanding of man as now we do
> by accident. Our words – our lives – our pains – nothing!
> The taking of our lives – lives of a good shoe-maker and a
> poor fish-pedlar – all! The last moment belongs to us – that
> agony is our triumph!

A. R. Orage

A. R. ORAGE was a friend of mine. The literary generation of his time owes much to Orage. Under his editorship the *New Age* became the best and liveliest weekly. It carried no advertisements and in that respect was both unique and commercially unsound. I thought Orage's notes on the first World War were as judicious as they were exemplary in style: he was so often right. After a period given up to the exposition of Guild Socialism, Orage fell under the spell of Social Credit as expounded by Major C. H. Douglas. I painted the Major and was impressed by his personal dignity and charm. Unmoved by obloquy or boycott he stands apart, urbane and imperturbable; while, in the field, his youthful champions carry aloft the banner of Economic Freedom under the leadership of the inspired monomaniac, John Hargrave. Still later, Orage, leaving the *New Age* to be carried on by other hands, found spiritual harbourage and renewal under the rule of Gurdieff and Ouspensky at their colony in Fontainebleau.

The Indian Herb

CURTIS MOFFATT, who married Iris Tree, was, it must be confessed, a bit of a sybarite. His quarters at No. 4 Fitzroy Square bore witness less to his reverence for tradition than to his taste for the up-to-date.

He would be found reclining at ease, with some rare and exquisitely bound volume open at his side, placed there as much to satisfy his sense of aesthetic propriety as for perusal. His fine eyes, which always subjugated me by their warm glow, seemed to smoulder with unaccountable amusement. Could it be his consciousness of the unknown, the unimaginable source of all this luxury, which so tickled him in secret? Rather than see this expression of happy irony clouded for a moment by financial care, I would have turned out all my pockets, and sometimes did; and I would be rewarded by the return of that beaming regard, in which love seemed to be mixed with some hint of derision, like the smile of a woman. When he lived in Hampstead, Curtis used to give small parties at which sardines and wine were consumed – and sometimes hashish. I had already tried smoking this celebrated drug without the slightest result. It was Princess Murat who converted me. She contributed several pots of the substance in the form of a compôte or jam. A teaspoonful was taken at intervals. Having helped myself to the first dose I had almost forgotten it when, catching the eye of Iris Tree across the dinner table, we were both simultaneously seized with uncontrollable laughter about nothing at all. This curious effect repeated itself from time to time throughout the evening. During the intervals we were completely lucid and even grave but, as it were, in another world. People are affected differently but, speaking for myself, I found I was now permitted to see my companions in a

new and unearthly light. The girls present, selected for their personal charm, became radiant with more than human beauty, exciting in me emotions of an intensity surpassing those of sex. In the silence one seemed to hear the tick-tick of the clockwork of the Universe, and voices reached one as if from across the frozen wastes between the stars. Ping! a shifting of the slats of time and space! I see Curtis standing at an angle of forty-five degrees and smiling to himself. Even his big picture on the wall now manifests a beauty hitherto unsuspected. Is it a new dimension we have entered? Can we be approaching ultimate Reality? The crises of laughter continued with some of us till dawn, with further repercussions as I made my way home with Violette Murat, who had only been slightly amused by the night's proceedings. No ill results followed, for I had not abused the herb: but on another occasion, less cautious, I was overtaken in the end by panics indescribable. For a day or two I wandered about silent and solitary, like a ghost. Aleister Crowley, who knows what he is talking about, told me hashish had saved his life if not his reason: but then he is an Adept, and I don't recommend *Cannabis Indica* to the careless amateur.

Cap Ferrat

RETURNING from one of my visits to the U.S.A., I made the acquaintance of Sir James and Lady Dunn on board the liner. As our acquaintance ripened, the friendly financier proposed that I should make use of one of his two villas on the Côte d'Azur, and so before long we installed ourselves for the summer in the 'Villa Kavaroc', St Jean, Cap Ferrat. The Dunns' other villa 'Lou Mas', which they were staying at, was next to ours, and a little further away that of a charming old gentleman, H.R.H. the Duke of Connaught.

Just below on the verge of the bay was the Restaurant Caramello, justly celebrated for its superior cuisine and proportionately high tariff. Across the road was the bar: the kitchen too was here, necessitating the transport of the dishes at break-neck speed and extreme risk. Our occasional meals at Caramello's, usually at Sir James's expense, always terminated in a succession of diaphanous *crêpes suzettes*, just saved from monotony by a flavouring of varied liqueurs. The atmosphere of the restaurant, permeated as it usually was with the gloom of self-conscious English holiday-makers, was not, to us, sympathetic. I myself preferred the bar and passed many pleasant moments here in the company of Miss Kit Dunn and her sister Joan. Sometimes a detachment of American tourists would appear, to revive their drooping spirits with whiskies and soda and the 'snacks' which these nationals find indispensable to life. Caramello, the patron, almost at first sight, and for no obvious reason, rendered me marked respect and even, I think, affection. I hope his occupation qualified him as a judge of men. At the end of the season, he would depart for Aix-les-Bains, to resume his activities there, leaving the deserted Cap and its cyclamens to the care of the gardeners, whose millionaire

employers would by then have returned to their mysterious avocations in London, Paris or New York.

Nearby at Villefranche a French naval flotilla had come to anchor. Instantly the town, hitherto somnolent, awoke to life. Dancing started in the cafés and went on till the small hours. The sailor-boys revolved with the gaily clad girls of the town or with each other. Our daughters seemed to be in their element. One night Georges Auric and I were sitting with some sailors. I asked one of them where he came from: 'Je viens de Perpignan. C'est là où Picasso a inventé le cubisme,' was his surprising answer. Our second stay at Cap Ferrat came to an end in gloom. The peninsula was deserted. At last, with a violent effort of will, we shook off a kind of coma and departed – for Martigues.

Spain

I DID not find Madrid an attractive city but I did not have time to know it well. Such time as I had was spent in the picture galleries; the *Prado* of course, the Academy San Fernando and the little church of S. Antoine de la Florida which Goya decorated with such unangelic angels.

I saw the idol of the populace, Granero, play the bull one Sunday with extreme virtuosity and daring. Next Sunday he was killed. The bull-fighters gathered at the Café Ingles. These men seemed to vibrate with energy and assurance. At the terraces of the cafés, a hideous procession of blind or deformed beggars passed slowly by, appealing dismally for alms. In the evenings the bourgeoisie collected in pastry shops to consume tarts and liqueurs before their dinner.

I thought the Grecos at the *Prado* exhibited the artist's mawkish religiosity without the power and ecstasy we see at Toledo – or New York. What excellent decorations for a box of superfine cigars Goya's majas – both nude and clothed – would make! It seems impossible for some artists to paint the nude without a suggestion of vulgarity, and yet in European art the nude has been the touchstone of its grandest flights. A hundred per cent Rubens of the 'Three Graces' quite bowled me over, and Titian's 'Venus' with the gentleman making music seemed to me a dream of noble luxury.

Gypsy Dancers

Reaching Granada, I made straight for the Washington Irving hotel, since the name was familiar. It stands on the beautiful wooded acropolis which is crowned by the Alhambra. Whom

should I light upon in that citadel but the elegant Gitana, Pepita d'Albaicin, whom I had known and painted in London. Pepita was staying at the more luxurious Palace Hotel, and there I found Augustine Birrell returning from the Alpujarras, where I was bound for. In the cave-dwellings of Albaicin abide the celebrated Gypsy dancers. These cave-dwellings, carved out of the rock, are whitewashed, clean and cool. I was very happy drinking wine with these girls in their pleasant quarters. Given up to the lowest of trades, the entertainment of tourists, the Gypsies had inevitably lost something of their style and character, but yet were gay and well-disposed; especially to one who, though his Spanish might be halting, was yet *aficionado*, and not altogether unversed in the *Calo*. As I was driven away the cries of the friendly girls followed me, 'Señorito, Señorito!' I hesitated; should I go back?

Yegen and Valor

My destination was a village called Yegen situated on the slopes of the Sierra Nevada. I engaged a muleteer with two mules for the journey. One morning at dawn they arrived with a second muleteer for whose services I had not bargained. However, as he wore an old-fashioned Andalusian hat like a Welsh woman's, and moreover was content to walk, I made no objection to his company. With occasional halts at a wayside *posada* for a glass of *aguardiente* or a solid Spanish omelette and a bottle of wine, we plodded on till nightfall. The country as we advanced eastwards became wilder and more mountainous. As we forded rivers and followed precipitous paths we had to rely on the sure-footedness of the mules who, without appearing to notice anything, were never at fault and knew the way better than we did. At dusk one evening we arrived at a place called Orjiva. Here we were to pass the night. I was glad to dismount as mule-riding had given me

an acute pain in the diaphragm. This, the muleteers said, was to be expected. They said I should have dismounted and walked from time to time. Before turning in I took a stroll. The night was dark. Suddenly, two figures loomed before me. They turned out to be Hope-Johnstone and my son Robin, whom I supposed to be at Yegen, a day's march from here. They had come out to meet me. Great was our satisfaction; we repaired to the inn to celebrate. The muleteers joined us at our meal, and seemed just as pleased as we were. Taking turns on the mules, we were home by the next evening. The village of Yegen is reputed to be one of the most miserable in the whole of Spain, but Hope-Johnstone's house was a spacious dwelling, unique in being provided with sanitation. The flat roof, on which we slept, commanded a superb view of the strange arid country to the south and east. The donkey is the bicycle of Spain, and we employed this means of transport in an excursion to Almeria. The last stage brought us through a scorched and featureless desert. The elation we experienced on entering at last the populous streets of the city was immense.

Almeria is built under a lofty rock with the usual red Moorish citadel on the summit. The rock is honeycombed with dwellings, their façades painted in agreeable pale colours. Not a tree or blade of grass breaks the stony severity of this quarter, which would have appealed to Cosimo Tura. Female troglodytes of dubious occupation shrieked to each other across the ravines. After a few days spent here we returned by way of Ugijar and Valor.

When inclined for an evening's diversion we had only to mention to our servant that there would be dancing after dinner. That was enough. The news spread, the guests assembled and soon the principal room was full. An accordion provided the music and the couples began to revolve. I selected a partner, in my turn, and we were getting on very smoothly when, without warning, the young woman detached herself and resumed her

seat by the wall at her mother's side, leaving me embarrassed and perplexed in the middle of the room. It took me some time to realize that this proceeding was quite correct at Yegen, and indicative of modesty.

The next village along the road, Valor, was richer in material from my point of view than Yegen. I used to ply between the two on a donkey. On discovering some good models there I decided to move and found lodging in a posada kept by a woman named Incarnaçion. Her two daughters, Amparo and Josefa, were handsome girls, especially the first whom I had already observed in the village washing clothes in the stream. I painted both these girls and others as well, including one, Maria, with her pitcher of water held on her hip. Her great melancholy eyes seemed full of dreams, and I wondered what she could be thinking of, if anything.

As everywhere in Spain there were Gypsies at Valor and some of these posed for me.

In Spain it is not permissible to mention young girls, though one may discuss their mothers freely. The title *Don*, I discovered, is applicable to any man who wears a collar, not necessarily clean. It was my custom to join the local Dons in the evening at the little café by the church. The priest of the village presided at the card table. The ancient Tarot cards were used here, which was quite enough to ensure my interest in a pastime I did not usually indulge in. Understanding nothing of the game called *Monte*, I, by the luck of a novice, amassed a great pile of *duros*, but on the last night I lost them all very tactfully, and departed in good odour.

When the church bell rang, the play was suspended for some moments while the priest, removing his biretta, murmured some Latin invocations. An amiable young nobleman was of the party. He organized an expedition up the Sierra for our benefit. Arriving at his farm, we were excellently entertained and feasted on roast

kid. As an extra treat we were conducted to a gloomy cellar where an old woman lay dying on a heap of rags. To this sombre spectacle, the explosive vitality of the daughter of the house provided a necessary contrast. The Marqués resided at Valor. His was a pleasant, dilapidated house, with a flowery and shady patio surrounded by a pillared gallery. I hoped in vain, while exploring it, to come upon some forgotten masterpiece by Velasquez, Zurbarán, El Greco or Goya. From my room in the posada, I looked out on a vast landscape stretching to the southern Sierras, which partly screened the sea and the distant coast of Africa. Beneath the village the luxuriant *Vega* relieved the arid scene with the luminous grey of olive trees, and near at hand the gold and green vineyards were watered by the communal system of irrigation instituted by the Moors, if not before them. Here and there the ruins of a deserted village pointed to the emigration of the former peasantry, drawn away to South America from the lifelong servitude of this harsh land. Those that remained or, as it was said, had been imported from the north, were as poor as they were generous. The worker in the field, resting from his toil, would beckon to me as I passed, inviting me to share his sparse meal. I found it difficult to pay for anything without giving offence.

When the time came for departure we decided to cross the Sierra and descend to Gaudix on the north where there was a railway. Hope-Johnstone and Robin accompanied me thus far. The ascent was long. It was mid-summer, but snow still lay upon the heights. At last we reached the Pass. Surmounting it, we stood at the head of the downward trail. A thick mist veiled the land. Suddenly this dispersed, disclosing a vast plain in which here and there white cities gleamed. At our feet blue gentians starred our path. As we descended, the country before us became more and more luxuriant. Woods, bright lawns and gently flowing streams gladdened our eyes, so long used to the stark declivities of the

Alpujarras. The population of the villages now wore an eighteenth-century aspect, with its rustic costumes still in evidence. Gaudix stands under an agglomeration of strange serrated cliffs inhabited by cave-dwellers. In some of their cool cells wine is dispensed, and I think nowhere to better advantage. In other doorways bold eyes seem to invite the visitor to supplementary joys. Against a jagged background of papier-mâché rocks, living vestiges of classic Spain are seen to appear and disappear in the sunlight, like galvanized wax-works. At last, leaving my companions in the Fonda, I made for the railway where, after bribing the station-master, I was permitted to board the train with my belongings. At Madrid a second time, by an astonishing coincidence, I ran into Gerald Brenan who was on his way to Yegen. What can be pleasanter on arriving at a strange city than to meet with a friend who knows his way about. In my perplexity I could not have hit on a more suitable guide than the author of *Spanish Labyrinth*.

Barcelona

I had an engagement to keep at Marseilles but had time to spend a few days at Barcelona. I admired the old quarters of this busy city. The Catalan style of architecture pleased me much more than the experiments of the modern genius Gaudi. Some of these objects might be acceptable in a fun-fair, if constructed of lath and plaster but, built as they are of imperishable granite, I found them horrifying; it is true I did not see his most famous masterpieces. There was always the cathedral to take refuge in, and I spent a good deal of time in that mysterious fane. In religious gloom, I listened to interminable chanting by an unseen choir; such solemn strains might have had their source in ancient Egypt: they found no echo on the Ramblas, and the music at the 'Villa Rosa' was of a different order.

It was time to leave for Marseilles. I had sent forward my

baggage and was walking to the station, when I encountered three Gitanas engaged in buying flowers at a booth. I was so struck by their beauty and flashing elegance that I almost missed my train. Even when I reached Marseilles and met my friend, this vision still haunted me and I positively had to return. But I did not find those Gypsies again. One never does. On the way back, however, I came across a band of the 'Coppersmiths' at Béziers, and visited the encampment one evening. Some of the young women spoke English and with the most refined accent. Twice since I have passed through Barcelona on my way to and from Majorca with Philip and Joan Dunn. I intended to take a studio there, but the Spanish war put a stop to this: a return to that country under the present regime would perhaps be inadvisable.

Italy

HAVING heard favourable reports of Ischia, an island near Naples, where a suitable dwelling was promised us, we set out on, what was for me, a second visit to Italy. Two daughters were of the party, and our son Romilly, who had decided to cross the Alps and descend the Peninsula on foot, was to join us at our destination. Reaching Turin, we had time for a stroll and to taste the celebrated vermouth.

At Rome we broke the journey and put up at the Plaza Hotel, in some luxury. This hotel yielded, we all agreed, the best honey in the world. A few days were spent viewing the sights, or some of them. I admired the great biscuit-coloured city, but we found it sadly lacking in cafés with terraces where we could sit at ease and watch the Roman scene. Have the French alone mastered the technique of urban amenity? This was almost as bad as London, with fewer climatic excuses. Hadrian's sunken Forum exposed its miserable population of dead or dying cats: a fresh victim was dropped into it from a bag before our eyes.

We ate wild strawberries at Nemi of the Golden Bough. The still, dark lake at the bottom of the crater seemed to hold in solution the answer to a riddle as old as the hills around it. We emerged dumbfounded from the Vatican and the Sistine chapel. After Raphael and Michelangelo, the aspect of modern life seemed remarkably mean and trivial. At Alfredo's the good food, with a bottle of the 'old Falernian' or something like it, went far to reassure us. But, impatient to get to our island, and promising ourselves further hours at Rome on returning, we now pushed on to Naples. On descending from the train, I found myself minus my wallet. In the crush of arrival some artful train-thieves had relieved me of it: but all was not lost; I still had enough cash

in my pocket for a taxi. We drove to an imposing hotel over-looking the bay: this, I understood, was what penniless people usually did. After a few days of luxurious living on credit, I obtained some more money and forgot the humiliating experience. Upon the sea-front of Naples it was impossible to move far without being confronted by determined tenors who, barring our way, would proceed inexorably to sing Santa Lucia. Not until we discovered the Aquarium did we find, along with the Octopods, a refuge from these fat pests. One evening I came upon a singer of a different order. It was Santa Lucia again but this time the well-worn ditty, issuing from a boy's larynx, had somehow recovered all its youth and fire. The performer sang as if inspired: moved to my marrow, I wanted to reward that boy but he asked for and would accept nothing.

Ischia

The boat takes two or three hours to reach Lacco Ameno where we were to disembark. It touches at several points on the way. Passing the island of Procida, and its long frontage of tinted houses under the shadow of a fortress, we reached the port of Ischia. The great rock of the Castello, standing detached from the island, rears itself in true Salvator Rosa style, and is crowned with the remains of an old castle and a convent. Mounting by means of a steep road, tunnelled through the rock itself, the visitor arrives at the summit. The dilapidated but still formidable towers balance themselves vertiginously over the Gulf. As we explored the ruins, our attention was drawn to a sombre chamber noteworthy as a monument of medieval piety. It was furnished with a series of stone armchairs disposed against the walls and designed more for the immediate requirements of sanitation than for comfort. Here, of old, the ageing nuns were accommodated when their hour drew near and were left, naked, to await release

from life's hard bondage. One stark skeleton still held its place in quiet dignity but wearing, I thought, a somewhat forced and ceremonious smile. In an adjacent cell, a pile of inarticulate and anonymous bones had been stored against future sorting out at the summons of the Last Trump.

The house of Vittoria Colonna in a suburb of the town contains wall paintings which have been attributed to that lady's devoted sonneteer, Michelangelo. They consist of decorations, borders and panels on a small scale, but displaying, even in their present mutilated state, clear evidence of a master's hand. The mansion now swarms with the poorest people.

Forio

As we skirted the shores of the island, the outskirts of the town gave place to groves of umbrageous stone-pines, followed by interminable stretches of featureless wooded country. I looked in vain for a pictorial motif, and it was in no hopeful frame of mind that we disembarked. Lacco Ameno was distinguished by a fringe of feathery tamarisks along the front. Romilly awaited us here, rather tired after his long walk. Our destined bungalow or hut was disappointing. Perched under the cliff of a little cove, it lacked both space and light and was only rich in fleas. True, the beach below boasted an antique bath provided by Nature with hot water from Vesuvius, but in spite of this convenience it was clear this place offered nothing to a painter: we would have to seek further. The next town along the coast and the last, Forio, might offer possibilities. On investigation Forio turned out to be charming. It possessed a Saracen tower, a little harbour, a restaurant, a beautiful stretch of sand and, for background, the cone of Epomeo, a volcano now happily extinct, but as living memory attested, still capable of dangerous subterranean unrest. We found a suitable dwelling raised above vineyards by the sea.

It wasn't long before we moved to the Villa Calice about a mile from the town. Asunta and Simonello, two domestics from Lacco Ameno, continued to attend to us. We made the acquaintance of an English family at Forio. It comprised the mother, Contessa Stead, her two fair daughters, Cleves and Pita, and the amphibious boy, Michael. These new friends did much to enliven our sojourn. Their garden of oleander, nespoli, quince, orange, lemon and pepper trees was imbued with Mediterranean magic, especially at nightfall, when, under the glamour of the moon, and with the additional factor of a bottle of *Strega*, all question of the suitability of Forio as a stopping place vanished. Some have held that it was at Ischia that Calypso persuaded Ulysses to pass a protracted holiday in her society. I don't see why not.

While at the Villa Calice, an English friend, Jim Barnes, joined us for a while. He brought with him the Monsignore McShane. Barnes was a young man of great ambitions. He was never in doubt of the brilliance of the future which lay before him: only the choice of a career awaited decision. The Monsignore was said to be in the running for the Hat. He would have made a delightful cardinal, I'm sure: he was a delightful person anyhow, and the life and soul of our bathing parties. He was perhaps a little severe with the Contessa, but perhaps, in her piety, she was asking for it. Referring to our common friend, Evan Morgan, who, a recent convert, perhaps displayed a certain excess of zeal, McShane remarked with customary bluntness: 'I can't stand these converts.' They were too much concerned, he said, for the frills and furbelows of ritual, which for him, a native Catholic, were only a necessary if boring part of religious discipline. For this cleric, gaiety, good living and virtue were not in the least incompatible.

Although bathing took up much of our time, I used to paint too. The Stead girls sat for me while their mother busied herself with the restoration of the ruined monastery of San Francesco, near by; my family too did their share of the tedious business of

posing. When T. W. Earp came to stay with us, he also was subjected to the same discipline. With a poet's precision he entitled the result of my effort 'Sea, Wine and Onions', for there was something of all three in the complexion I had attempted to record. On several excursions to Naples in the company of this inveterate noctambulist, we gravitated inevitably to the cavernous resorts of the Neapolitan underworld: in these cut-throat dens we came to no harm. But Ischia was safer. Apart from drowning we ran few risks here, and as for the were-wolves reported to range the mountain, they left us alone. A closer menace came from the Corporate State. A concert being advertised, we decided to attend it. We had heard the peasants in the fields singing in a style of a more primitive 'flamenco'. We hoped to hear more of these airs which recalled the Moorish occupation. No such luck! The programme consisted entirely of recitations with *Italia* as the unvarying theme. The effect was unspeakably boring and at last we crept away, leaving a local policeman to struggle with D'Annunzio's periods in an ecstasy of prescribed patriotic fervour.

When the time came to depart, we left behind with regret the contents of our cellar, which still comprised a considerable quantity of the wine for which Ischia is noted. This we bestowed on our servant, Simonello, who in consequence was reported to have passed the following weeks in a state of uninterrupted exaltation.

As planned, we spent a few more days at Rome. We dined very luxuriously at the Collegio Beda with McShane, Jim Barnes and Evan Morgan. The last I had discovered in process of bedecking a shrine he had erected on the wall of his room to the memory of his unfortunate sister Gwyneth.

Back in England

On our return, landing at Dover, we were almost moved to tears or laughter by the appearance of the suburbs of the town.

Chiaroscuro

These rows and rows of familiar little brick houses were in a way rather touching, and so typical of England. An Englishman's home is his castle but, to look at, nobody would suppose these gim-crack little fortresses to be the nurseries of heroes. Heroism must be superior to its surroundings, or at least indifferent to them. For all we know civic virtue may be fostered in the 'pre-fabs' now being erected. May not adverse conditions be, after all, favourable to character-building – among the lower classes? Well-to-do people seem to think so, but not doctors or alienists. The fear of general prosperity is very real among the rich. 'Nobody would work if they had everything they wanted,' is a common reflection and no doubt true.

Charles Fourier

LET us pay a visit to Charles Fourier's Utopia. Philosophers from Plato downwards have built Utopias. That of the commercial traveller we are going to take a glimpse of is not the least interesting. Here we are in the 'age of harmony'. It supersedes our 'civilization' even as this has replaced 'barbarism'. The political unit here is the *phalanstery*. We will visit one of these imaginary institutions, reconstructing it from Fourier's voluminous writings as best we can, but adding a touch or two of our own. Fourier elaborated the constitution and working of his society down to the last detail, but much of this is too complicated and fanciful to be dealt with here. With a fundamental basis of sound sense, there appears in his speculations a note of extravagance. When, for instance, he envisages the harnessing of the Aurora Borealis, with the conversion of its light into heat, rendering thereby the climate of the Arctic regions eminently suitable for market gardening, I, for one, feel baffled. Yet since the writing of these *Fragments*, the newly revealed possibilities of atomic energy have included this very miracle in its programme. Few would agree with his denigration of bread as an article of diet, but Fourier found it unpalatable; besides which, he argued, the cultivation of wheat took up far too much space, time and trouble. He advocated the use in its place of fruit and vegetables with the addition of fish and the products of the chase: but milk would be available and no doubt beef and mutton, though I remember no reference to these commodities in the selected résumé of his works, sympathetically edited by the well-known economist Charles Gide, to which I have had access.

As we approach, the phalanstery shows itself, standing on an eminence like a little hill-town. Surrounded by lesser buildings

within the containing wall, the taller reminds me somewhat of the Popes' Palace at Avignon. The line of the horizon is broken by distant silhouettes of more than one such landmark. We pass a troupe of magnificent children, amusing themselves at their task of scavenging and mending the road. ('Children love dirt.') These are the *petites hordes*, to quote an example of Fourier's extraordinary nomenclature. By the river which partly encircles the phalanstery, a band of Nomads have pitched their tents. They seem to be making derisory comments on our appearance in an unknown tongue ... (Fourier himself mentions no such people). Crossing the bridge, we penetrate the enclosure by a nobly planned gateway, bearing sculpture of arresting and unfamiliar quality. The outer walls appear to serve no military purpose but merely confine the town within the bounds of expansion prescribed by the philosopher. Fourier realized the truth that human greatness flourishes in inverse ratio to the size of the community, and limited his population, at most, to 1700. A superfluity would set forth to found a new phalanstery. Thus the whole land becomes dotted by these ganglions of social life, between which there will be constant interplay and traffic. Proceeding through the glass-covered, air-conditioned and impeccably clean streets, we arrive at the Central Market Place. Under its tall trees numbers of people are taking the air: many sit before the taverns or under the arcades which alternate between the loftier façades of church, Opera-house, University, Hall of Exchange, library, theatre, Council House and such communal centres of culture. Although all is of recent date with no sign of dilapidation, a mysterious air of antiquity pervades the whole, as if a Mycenean or Huanacan city had come to life again. Raised in the centre, a great stone figure of a woman with head uplifted gazes at the Sun, which shines through a hole in her torso. It may be a work by the twentieth-century statuary, Henry Moore. Although the inhabitants show much diversity in costume, which seems to indicate

their occupation as much as the exercise of personal taste (the women showing a greater degree of uniformity), we meet with no signs of indigence. Fourier was no leveller, and admitted every degree of function and dignity in his world; but all, it appears, are shareholders in the common stock. The phalanstery, in a literal sense, belongs to all who belong to it.

In *Civilization* the family was held to be the basic unit of society; not so in *Harmony*. It was observed that this institution, instead of welding society together was, on the contrary, a primary cause of its disruption. The interests of the family were seen to supplant those of the community as a whole, giving rise to class-cleavage, intrigue, aggression, power-politics and finally war. With all its holy glamour, it tended to become an important accessory of business, with prostitution as its necessary adjunct. Here, the free association of the sexes carries no shadow of disrepute, and the resultant unions, without religious sanction or the constraints of law, are often seen to be remarkably durable, and that, moreover, without the concurrence of the brothel, which is unknown in *Harmony*. As for the ruling class, there does not appear to be one, for the philosopher, poet, man of science, artist or saint, who rank highest in popular esteem, wield no power at all other than moral or intellectual.

Some individuals, too, of no such high standing, exercise as much authority in private as in the council chamber. A certain shoe-maker, I was told, was constantly resorted to by people in difficulties for his sound judgment and advice. But have not cobblers always been noted for their sagacity? We saw no police or soldiers in evidence and asked our guide, 'What about your frontiers, how are they guarded?' 'Frontiers,' he repeated stupidly, 'Frontiers? but we haven't any.' In this somewhat primitive community money is not regarded as wealth in itself, but is merely used to facilitate exchange. By applying at the bank you can have as much as you like. It is in great request with the

children, who use it as counters in a game called 'Business' or 'Beggar my Neighbour'. Anthropologists say this game, like 'Hop-Scotch', is of very ancient origin.

And now we notice a great stir and hubbub. In every direction people are issuing from their workshops and factories and hastening to the gardens and orchards which stretch far beyond the circumference of the phalanstery. It is the hour when work is changed. In many cases a man has two, three or more pursuits which he follows in rotation: by this system monotony and rustiness are avoided. Above all, work on the land at regular intervals is found to be specially beneficial. Dancing of a communal and ritual character is much cultivated. Music, ballet and theatre flourish, and in the cathedral the rites of birth, love and death are celebrated with great splendour and solemnity. The Festivals of the Sun, Moon and Planets, with other objects of worship, as types of Ultimate Reality afford occasion for pageantry, song and dance, of a highly spectacular and exhilarating nature. Often at these events a good deal of buffoonery and horse-play is indulged in. I inquired, 'Do you never have rows, quarrels?' 'Oh yes,' was the reply, 'plenty; but for those who want to fight, there is always the Ring down there,' my informant pointing to the Stadium by the river.

As we continued our exploration, we came across a small house with a very large window giving on to a garden where was seated a venerable personage in a blouse, engaged in painting a young woman posed under a tree. 'Our oldest inhabitant,' said the guide, tapping his forehead significantly. One of our party remarked that the old gentleman looked like a revised and much improved edition of myself. I thanked him for the compliment and passed on.

Upon taking leave at the gate, the same witty fellow made a final inquiry: 'And how are you represented in the central legislature or governing body of the State; by a delegate, deputy

or member from each phalanstery, or from a group of phalansteries?' Our guide was obviously shocked. 'We mind our own business,' he murmured, then, pointing to an inscription over the arch, vanished. The inscription, in letters of gold, was to this effect: WHEN THE STATE CEASETH LOOK MY BROTHERS DO YOU NOT SEE THE RAINBOWS AND THE BRIDGES OF THE BEYOND?

Ste Maxime

PRINCESS MURAT had taken a villa at Ste Maxime: knowing my liking for the Midi, she invited me to come for a stay. I understood this place to be near Toulon which I knew already and would be glad to revisit. After some hesitation I decided the opportunity might as well be seized. The Mediterranean is irresistible; I was in a mood for sunlight and working out of doors. I packed up and left for St Raphael, the nearest station. A short drive brought me to Ste Maxime. I didn't like the look of the place, and when I mounted the steps leading to the villa I was overcome with a sense of futility. The villa 'Sourire d'Avril' was easy to live in certainly, and I was well treated, but I sought in vain for a 'motif'. Toulon was hours away. Why hadn't I looked at the map? We drove there one day and while the Princess was occupied with her mysterious commissions, I wandered down to the quays. Here was life, colour, movement, and the traffic of the sea I loved to watch. The Hotel du Port et des Négociants still opened its doors alluringly, and I wished I was staying here again.

When we visited St Tropez, I wondered why I hadn't found this place before. It was now invaded by tourists and a serried array of motor cars excluded a view of the harbour and shipping.

One day while strolling on the front at Ste Maxime I espied two figures approaching; they seemed familiar. It was E. J. Moeran and an old friend of mine, Eileen Hawthorne. What had brought them here I couldn't imagine. Our greetings were politely joyous. As we sat at a café I couldn't discover that they had any clearly defined plans, so I invited them up to the villa. We all drove into Toulon after lunch. Both Moeran and Eileen

were unlucky that evening; first of all, the latter was seized on the way back by what appeared to be some nervous disorder, and later, Jack Moeran, slipping on the precipitous steps leading up to the villa, damaged his face badly. The Princess was beginning to feel the strain but next morning, good-natured as ever, she bound up the musician's face with a black silk scarf, and deputing me to see them into their train, sent us off in her car to St Raphael. Our leave-taking was somewhat gloomy on both sides. I was distressed that their visit should have been brought to so unsatisfactory an end.

Monte Carlo

As the days succeeded each other profitlessly I may have betrayed signs of boredom. My hostess, thinking to distract me, proposed an excursion to Monte Carlo. I was all for it: anything was better than this dead-end. We set out, making first of all for the château of Comte François de Gouy d'Arcy, near Grasse. Here we lunched extremely well and arrived at 'Monte' rather late. The place was full to overflowing, but my companion with her superior energy and savoir-faire, found quarters for us at last in the Grand Hôtel de la Russie. Meanwhile I had been exploring on my own and had come across various friends – Tony Gandarillas, Napier Alington, Kit Wood and Louis Coatelen of Sunbeam fame. Lastly I made the acquaintance of a fellow country-woman. I was astonished and delighted with her name, Myfanwy Llewellyn, which designated a native of Merioneth. Here was a chance to improve my Welsh! I arranged for a lesson next day.

Mrs Reginald Fellowes took us out to her palace on Cap Martin. She had been doing it up and had arranged a room for Princess Murat which was always to be at her disposal. 'Daisy', as her intimates called her, with her delicate touch of *morbidezza*,

reminded one of some Sienese Virgin, who had submitted, with infinite grace, to the ministrations of a *modiste* of genius. She sat to me later, but spared me too little time for my purpose. Artists, if occupied in portraiture, are now expected to equal the speed of the camera, and even to produce results indistinguishable from photography.

In the meanwhile I was beginning to get restive. The Princess, who was constantly meeting friends, seemed to take it for granted that their interminable chatter amused me. Sometimes I intercepted an inquisitive glance which seemed to say, 'What is he doing here?' I asked myself the same question. I much preferred the company of Myfanwy, whose beauty, quiet gaiety and good nature had cast a wholesome spell over me. It was no doubt due to an abuse of this magic that I returned late one day to the hotel, to find the Princess gone – and, what was more embarrassing, my baggage too! What was to be done? Tony Gandarillas and Kit Wood occupied rooms at the Hotel Bristol, overlooking the harbour of the *Condamine*. I went there. It was a change for the better, the view was admirable: as for my wardrobe, Lord Alington placed his supply of shirts at my disposal; Louis Coatelen made himself serviceable in other ways, and Tony and Kit did the rest.

At last I felt I should return to Ste Maxime. My belongings and painting materials were no doubt there by now. I bore the Princess no ill-will for her desertion, though she shouldn't have taken my things with her. Underestimating the distance, I took a cab back. This was the longest taxi-drive in my experience. On arriving I was seized with mysterious pains and had to lie up. Violette Murat and Iris Coatelen, who had joined us, looked after me like a couple of ministering angels. To think that I had watched one of these angels shooting pigeons, usually, but not always, with deadly accuracy, at Monte Carlo! Recovering, I bade my friends adieu and left – for Martigues.

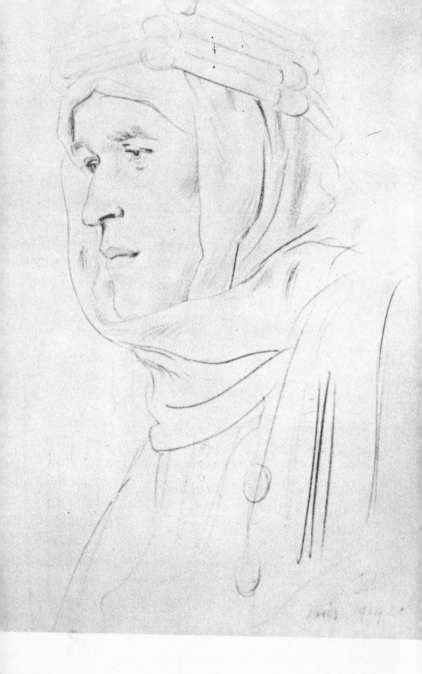

Paris 1919

3 T.E. Lawrence

14 Two Gitanas

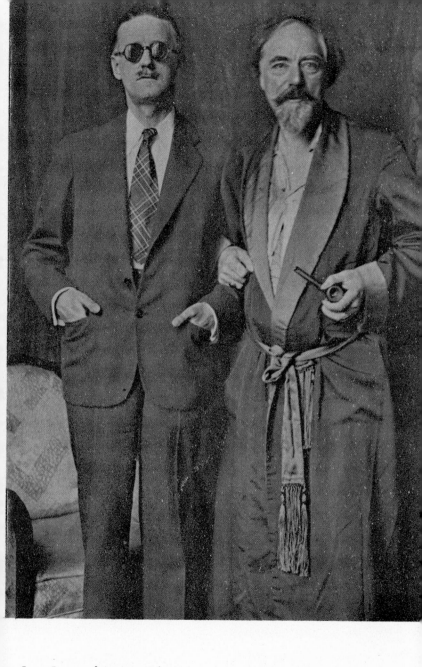

15 James Joyce and Augustus John

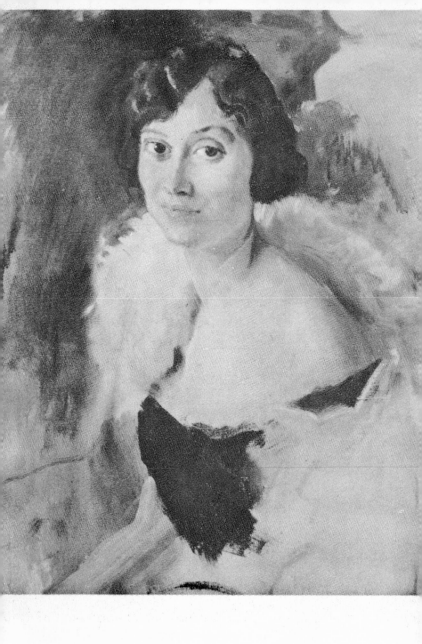

16 Elizabeth Asquith (Princess Bibesco) painted in Paris, 1919

Martigues

The *sans-gêne* and promptitude with which many painters, on arriving at an entirely new and unfamiliar place, settle down to work at once, never fails to astonish me: it seems indecent, like button-holing a complete stranger. In any case it is not the best way to establish an understanding. Audacity is necessary, certainly, but it must be well timed. To start with, a little hesitancy is not unbecoming, and gets you further. The methods of some of our Martigues visitors illustrated my argument. The results did not justify so long a journey, and might as well, at less expense and trouble, have been achieved at home. The secret of the Midi cannot be learnt in a moment; students from overseas, even if provided with diplomas, have to readjust themselves and start afresh if they want to capture it.

While we were frequenting Martigues, an enormous *digue* was under construction. Its object was to connect Marseilles with the Étang de Berre, necessitating, first, a tunnel under the rocky hills separating the two, and then this *digue*, skirting the shore of the lagoon, till it joined the natural channel of the Caronte, leading to the sea. Constructed of rough, unhewn blocks of stone, it is anything but handsome; even its practical advantages have been disputed. A French artist, living at the next village of La Méde, said one could ignore it: 'Un coup de brosse et ça n'existe plus', but, for my part, I could never get used to it.

Martigues, in submission to the march of progress, was beginning to show more than one symptom of corruption: the air of peace and innocence which this little republic of fishermen used to wear was beginning to be overlaid by the blight of commerce. There are several more cafés opened on the Cour de la République, and more motor cars parked under its plane trees, but there is less gaiety and good-humour. The young people no longer dance in the café of a Sunday evening: the new bascule bridge, while serving its purpose, leaves me, at least, emotionally

at a standstill, and the destruction of various interesting ol
buildings is to be regretted.

My family, now reinforced by two incomparable daughter
occupied the Villa Ste Anne. Bazin had died, and Mlle Bazi
had accepted the position of governess. On Sunday evening
drawn as if by some magical spell, the two girls would descend t
the Cercle Cupidon and dance, while I, more staid, watched th
scene from my corner, with a glass of *marc-cassis* at my elbov
The local youths and maidens always behaved with that cheerfı
correctitude of which the secret is known only to Royalty an
the lower middle-class. The music was supplied by voluntar
effort and was at least vigorous.

During the day, except for the afternoon's siesta, I employe
my time in painting. I found in my own family the models
needed and would pose them in a setting of olive or pine tree
against the speckled hills or the blue Étang bordered by distar
amethyst cliffs.

J. D. Innes and others

J. D. Innes had been a more recent student at the Slade than
I. We became very friendly in London before passing a consider-
able time together in Wales and elsewhere. His early efforts
reflect his admiration for Wilson Steer. Later his style took on a
more poetic colouring with a growing insistence upon pattern
which compensated to some extent for his faulty drawing. He
himself cut an arresting figure: a Quaker hat, a coloured silk scarf,
and a long black overcoat, set off features of a slightly cadaverous
cast, with glittering black eyes, a wide sardonic mouth, a prom-
inent nose and a large bony forehead, invaded by streaks of thin
black hair. He carried an ebony cane with a gold top, and spoke
with a heavy English accent, which had been imposed on an
agreeable Welsh sub-stratum. He had spoken to me of an inn he
had discovered in the Arenig valley north of Bala. He suggested
I should join him there some time: finding an opportunity, I went
down to Llanelly to pick him up as agreed. By some misunder-
standing he had already left for the north. His parents made me
welcome, however, and the next day I took the train for Bala.
Our meeting at Arenig was cordial, and yet I seemed to detect
a certain reserve on his part: he was experiencing, I fancy, the
scruples of a lover on introducing a friend to his best girl – in
his case, the mountain before us, which he regarded, with good
reason, as his spiritual property. Had he not been the first to
discover and surmount it? Arenig, though not one of the giants,
has fine contours, and at some angles is sharply precipitous: its
companion, Arenig Fach, across the valley presents a massive
bulk with blunter profile.

The inn, Rhyd-y-fen, was well placed for our purposes on the
road which leads across the moors to Blaenau Ffestiniog. Its

keeper, Washington Davies, fed us on Welsh mutton of the mountain. This man was the playboy of the district: in the evenings sometimes he would entertain us with Welsh jigs. His father, an old quarryman of a more serious character, was said to know more about the geology of this part of Wales than all the professors in London. Across the fen, Arenig, a rock of porphyry, rose steep and dark and behind, the slopes of the Migneint led up to further heights. Beyond the little lake of Treweryn, were seen to rise in the distance the peaks of Moelwyn. In the midst of the valley a rocky eminence offered, I thought, an ideal site for a phalanstery and I dreamt of building one there some day. At this time Innes's activity was prodigious; he rarely returned of an evening without a couple of panels completed. These were, it is true, rapidly done, but usually meant long rambles over the moors in search of the magical moment. Perhaps he felt he must hasten while there was time to make these votive offerings to the mountains he loved with religious fervour.

In our search for a house or cottage where we might install ourselves and work more freely, we came upon several lonely dwellings which might once have served our purpose, but were now in ruins. At last Innes discovered a cottage which we decided to take. It stood a few miles from the inn by the brook called Nant-ddu, and looked out on Arenig. We furnished it sparsely and returned in the following year and yet again.

Innes was a compassionate soul. Serving at the bar of the White Lion at Bala was a red-headed girl. Innes would sometimes take her out for a row on the lake: was he attracted by her beauty? No. She was a nice but rather plain girl and had no boy friend.

While staying with John Sampson at Bettws-gwerfil-goch, Innes and I one day set out for the neighbouring town of Corwen. In the bar of an inn we came across a family of Gypsies with whom we consorted. This family was of the rare tribe of Florence. One of the young women, Udina, was of great beauty,

elegance and charm. All Gypsy girls are flirts and this one was no exception to the rule. Uninured to their wiles, Innes no less than I was deeply moved; we both secretly established an understanding with Udina. The family were to depart next day for Ruthin. At length, reluctantly, we said good-night and returned to Sampson's. The next morning Innes was not to be found. I guessed his whereabouts. As it turned out, stealing a march on me, he had risen early and gone back to Corwen to rejoin the Florences, but finding them gone had set out to overtake them on foot. On the outskirts of Ruthin, overcome with fatigue, to which the state of his health no doubt contributed, he had fallen by the road-side, and was discovered in collapse by a charitable passer-by who took him home, and kept him in bed till he recovered. But Udina Florence, the girl of both our dreams, was never seen again.

* * *

Horace Cole had a protégée popularly known as 'Billy'. In the belief that she had a 'voice', Cole was having her trained as a singer. In due course she did appear on the stage of a music-hall. Her performance, I thought, owed less to art than to impudence. She had some beauty, much good nature, and an American accent contracted in Soho. Dick Innes became very much attached to her, though his feelings, I think, were more chivalrous than passionate. At this time he had acquired a caravan from a Gypsy, and this was resting in the yard of an inn in the remote village of Penmachno. Burning with romantic zeal, he resolved to extricate Billy from a life in which the Café Royal played too great a part, and at last gained her consent to accompany him to North Wales, where they would take to the open road, and travel the world together in healing contact with Nature and the beneficent influences of his beloved mountains. They were approaching their destination: Dick, greatly moved, pointed through the

carriage window, crying, 'Billy, look, the mountains of Wales! but Billy, immersed in *Comic Cuts*, was not to be disturbed. They reached Penmachno and spent several days at the inn. From time to time Dick would suggest a visit to the yard to inspect their future wheeled home, but Billy, refusing to budge, only called for another whisky and soda.

They soon returned to London and the Café Royal. Some years later, being at Penmachno, I saw Innes's van or what was left of it. It had never been moved: some fragments of its wheels still protruded from the ground.

Later, returning from the Basses-Pyrénées, where he had been working, Innes sent work to me at Martigues, making an appointment at Marseilles. On meeting, I proposed that he should accompany us to St Chamas, a very good place, on the northern angle of the Étang de Berre. He agreed, and we established ourselves in the Hotel Bozio. Innes, however, was feeling very ill and I advised him to return to England, which he did. I saw no more of him till I visited him at Brighton with Horace Cole, who had always been a good friend of his. This must have been in 1914, for the war had broken out, and I remember the general excitement over it and Innes's indifference. He took little interest in anything but his medicine. His mother attended to him devotedly. When he was moved to a nursing home in Kent, we again went with his Euphemia to see him. The meeting of these two was painful: we left them alone together: it was the last time I saw him. Under the cairn on the summit of Arenig, Dick Innes had buried a silver casket containing certain correspondence. I think he always associated Euphemia with this mountain and would have liked at the last to lie beside the cairn.

★ ★ ★

Derwent Lees owed much to the example of Innes: he found in his friend's approach to Nature a means of release from his

cademic shackles, and with immense will and intelligence strove
) adapt himself to a new outlook. To a large extent he succeeded,
ut industry and calculation could not quite overtake the flights
f his, I must own, somewhat elusive original. In any case, he
icked the time to pursue his experiments to the end he was
iming at for he too was afflicted and died young.

Another short-lived figure of a rather later period was Rowley
.mart. He had adopted and practised the old English style of
vater-colour drawing. His results on these lines were pleasing
nough. When it came to oil painting his efforts were less accept-
ble. His weekend at Alderney Manor was prolonged by some
10nths, and by the time he was induced to leave, he had about
xhausted us, together with the pictorial possibilities of the
istrict.

I had made the acquaintance of a family called White, up the
Dad. 'Major' White was an eccentric but friendly character and
vas never seen without a red waistcoat, a family heirloom to
idge by its quality. Rowley and his eldest daughter had formed
n attachment. She was a dark, handsome girl. Her red-headed
ster was also attractive in a more robust style. One evening
vhile I was visiting the family, Mrs White told her younger
aughter to take her clothes off. As she stood naked, her mother,
emoving her pipe, spat into the fire and remarked that the girl's
.in was as 'fair as a lady's'. So it was. I left the tent much
npressed by this domestic scene. Upon Rowley's departure, his
;ypsy sweetheart, depending on his promises, awaited his return,
ut she waited in vain.

* * *

The main problem for an artist who wants to paint in this
Duntry is to find a convenient place to stay at. Less indifferent
) his surroundings than others, his requirements, though modest
nough, are more difficult to satisfy. A room will be needed in

which to work, at least on rainy days – a plain, fairly lit, simply furnished room or shed, preferably whitewashed. But such a room is not to be found in the British Islands! The village inn may be perfectly situated, and outwardly attractive, but on closer inspection with a view to a lodging, you will retire discouraged to the bar. The degradation of popular taste in the last hundred years has now reached its nadir. Who can go to bed contentedly with the prospect of awaking amidst a clutter of mean junk? The productions of local craftsmanship which used to dignify the humblest cottage have been looted by the antique dealers and replaced in profusion by imported articles of imitation luxury. Having sold or been done out of their birthright, the people, habituated to the squalor that ensues, end, like drug addicts, by craving for it.

Visitors at Alderney Manor

AMONG our visitors at Alderney Manor were Iris Tree; Morley Kennerly, son of my American friend Mitchell; the painter Josette Jones; Ian Strang; Leverton Harris; Peter Warlock; Francis Macnamara; Lytton Strachey; Lyulph Howard; Constant Lambert; Arland Usher; Roy Campbell; Denise Cole; Sybil Hart-Davis; Princess Eugene Murat; Stuart Gray; Lady Dean-Paul; Jan Sliwinski; and our old friend Helen Anrep, of earlier Paris days, who had come to our rescue at Martigues one time when things were looking bad. Sliwinski, a Polish musician and singer, besides exercising his musical talents to our great edification, made himself serviceable in other ways, such as bricklaying, book cataloguing, etc.

Venice

My daughter Vivien and I had agreed to meet some friends in Venice. As we journeyed there by way of Paris, we met on the way an acquaintance of the Gargoyle Club. This young man informed us he was an agent or courier for a luxury liner bound for Greece on a tour where pleasure and instruction were to be combined. He strongly advised us to change our minds and join this expedition. Though tempted to seize this chance of setting foot on the rocky soil of antiquity, on reflection we chose to stick to our original plan. For one thing the thought of being herded together with a ship-load of tourists was deterring, and for another, our friend's practice of *yodelling* was beginning to pall on us. It is an art for which I have not much taste, especially when it is practised by a Scotsman: it should perhaps be restricted to the Alps. So Greece was left for another day and we landed with relief in Venice. Our hotel was conveniently placed on the Grand Canal. Opposite rose Santa Maria della Salute and a few steps brought us to the Piazza di San Marco. On disembarking at the steps of the hotel, I was hailed from a passing gondola. 'Augustus!' I nearly fell into the canal! The voice was Georgia Sitwell's. Evidently we were not going to be alone in this city of dreams. Entering the Piazza that evening, we were brought to a standstill. The vast square was plunged in a ghostly silence, presently to be softly broken by distant strains of music. Now we saw with our own eyes the familiar silhouettes of San Marco and the Campanile rising against the starry sky. The arcades, crowded with promenaders, emitted a low murmur as if a thousand secrets were being whispered. As an alternative to the Piazza, Harry's Bar was much resorted to. Here we met our expected friends the Melchetts. But there were plenty of well-known faces. There was Sacheverell

Sitwell, somewhat aloof and preoccupied, as a poet should be, and Georgia, his elegant wife whom I have mentioned. Mrs Ralph Peto with her son Timothy, known to me as a child at Renvyle in Galway, and now a charming boy in his early teens; the Baroness d'Erlanger, in the half-light of the Piazza, plunged amid the throng with the appearance of a living Veronese; my Berlin friend and model, Frau Lally Horstmann, seemed to have imported her air of inscrutability from the Far East. Young Count Labia, whose father's palaces, decorated profusely by Tiepolo, are among the chief glories of Venice, was charming but always complained of being 'so tired' (except on the tennis court or when rowing in the Bucentorio). Handsome Miss Hoyty Wiborg, from the U.S.A., disputed the dignity of the name Labia. 'It only means lips,' she said scornfully, but inaccurately. Lord Alington's sister, Lois Sturt, accompanied by a zoologist friend, joined us sometimes in our sight-seeing. Cecil Beaton was ubiquitous and looking his best in a kind of Eton suit *de luxe*. The Princess Aspasia of Greece offered us hospitality on a neighbouring island. She realized, I thought, all the implications of her name and station, and her daughter promised an equal distinction.

At a party we attended, Lifar, now *Maître de Ballet* at the Paris Opera, was due to perform. Extending himself on the lid of a piano as if in slumber, he appeared partly to awake, and still half-a-dream, descended to the floor, where he began to move with his customary skill and grace as if performing an improvised solo, when, to everybody's astonishment, and Lifar's too it seemed, Lady Melchett appeared, looking in a white peplum like a Greek divinity: approaching the Master, she joined with him in an extempore dance which revived memories of Attic vase-painting of the ripest period. The applause was general and loud. Such were our almost nightly diversions. I wished Ronald Firbank could have been with us. How *he* would have enjoyed

it all! and how I would have enjoyed his enjoyment! During the day there were pictures to be seen and the Lido to be visited for bathing purposes. The water at the Lido was delicious but the crowded beach revealed humanity in an unfavourable light: sand-hoppers, alone, show themselves to advantage in these circumstances.

A former acquaintance of mine, one Charles Winzer, now began to show a friendly assiduity which I thought excessive. It was with anxiety that we made our exit each morning from the hotel, for Winzer was almost sure to be in waiting for us on the terrace. His usual companion, a young Russian nobleman, had developed a tenderness for my daughter, 'The girl', as he put it, 'of his dreams'. This was but natural. Winzer had once described himself to me as a 'voluptuary'. He lived at the top of a rather distant *palazzo*. Once I was persuaded to visit him. The ascent to his quarters was long and exhausting. I was grateful for the wine which I was offered on reaching his airy and tastefully furnished apartment. The 'voluptary' then proceeded to show me his work with much solemnity. I now saw the reason for these attentions. He was about to visit England, and by dazzling me with the evidence of his talent, hoped to enlist my support when in that country. I left the studio encumbered with a portfolio of lithographs he had pressed upon me. Our relations henceforward became easier, for me at least. But the air of Venice was getting me down, and so were the people, the visitors I mean, or at least some of them. I had done a fair share of sight-seeing and now wouldn't move a step for a Tiepolo. Vivien at last agreed with me that it was time to leave.

Henry Elffin John

ON hearing of my son Henry's disappearance in Cornwall, D. and I immediately went down to the bungalow of my sister-in-law, Ethel Nettleship, near Newquay, to join in the search. This search took a fortnight. Henry, or Elffin, as *I* had named him, had been educated at Stonyhurst. His cousin Edith Nettleship, who had taken charge of the child's upbringing, became a convert to Catholicism. She asked my permission to send him to Stonyhurst College. I had heard very good accounts of this school and made no objection. On hearing rumours later on from various sources of the boy's approaching reception into the Roman Catholic faith, I wrote to the Head Master telling him that, as Henry's father, I thought I might have been informed of his leanings in this direction. The Head Master wrote back at great length, explaining – with apologies – that, in the first place he had never heard of my existence, and in the second, the event had already taken place.

Henry distinguished himself at Stonyhurst. He was thought to be in every way a most promising recruit for the Neo-Thomist movement. Stonyhurst was succeeded by Manresa. Henry took his preliminary vows, and his emergence in due course as a priest of the Society of Jesus was to be expected. But his behaviour, at first so exemplary, began latterly to show disquieting symptoms. His foolhardy pranks, his frequentations among the lowest scum of the East End, his neglect of his person and his indifference to social conventions, gave rise to much anxiety. Though this youth was always formally charitable, I sometimes used to suspect him of being moved as much by contempt as by love. He always avoided looking directly at any female in whose company he might find himself (thus carrying out to the letter the injunctions

237

of Loyola). His religious training seemed to result in a studied blindness to the evidence of his senses. In his boyhood he had made some remarkable (at least so I thought) essays in poetry which later he would not hear of without impatience. He subsequently found satisfaction in Rimbaud and Hopkins: he might perhaps be regarded as an early *surrealist*.

Among his friends he numbered G. K. Chesterton, whom he greatly admired. Chesterton thought equally well of Henry, as he told me himself. My son also carried on an intellectual liaison with Wyndham Lewis. Like all puritans, Henry was capable of surprising grossness, and possessed a mad sense of fun. His good looks had been modified by a blow on the nose incurred in boxing. He made some ineffectual attempts to proselytize me: once, when thus engaged, he was pointing out the advantages of conversion; how much I had to gain, how little to lose, if anything, by embracing the true Faith, when, at this moment, my sister Gwen appeared, and hearing this argument, at once contradicted her learned nephew with the statement that one accepted the truth, not as a business transaction, but for the love of God, even if it meant disaster or death itself – 'As if *that* mattered,' she added contemptuously and left the room. The young casuist was silenced for a while.

In time it seemed as if a revolution was taking place in Henry's soul. His eccentricities were perhaps the reflection of an inner conflict. He now began to draw apart from the friends of his own persuasion and sometimes went so far as to ignore them altogether. His superiors were at last forced to admit his lack of a vocation and with admirable good sense, decided to release him from his vows. He thus left the Jesuit Order, but not without testifying the greatest regard for the 'splendid body of men' with whom his lot had been cast. He was now to launch out into a new world, where there was so much more to be learnt than his reading had prepared him for. First of all, a great experiment had to be made.

Having instructed his Aunt Ethel to vacate her bungalow in Cornwall, he drove down there to await the arrival of the young lady with whom he had made a rendezvous: but the adventure in the field of natural history which he contemplated was not to take place. Driving out one stormy evening, he left his car on the verge of the cliffs and, after removing his clothes, plunged into the sea: a good swimmer, he must have struck a submerged rock, for he never came up alive. About a fortnight later his body was brought ashore some miles to the south. Though it was without a face, from the attentions of birds and crabs, I was able to identify it all the same.

I had been exploring the coast in the vicinity with the help of some knowledgeable local fishermen and their motor-launch. I got on good terms with a colony of seals who at first viewed me with suspicion but in time appeared to accept me as a harmless and well-meaning outsider. These charming animals emerging from the water reminded me of the red setters we used to rear. Cormorants gathered sociably on their favourite rock and puffins or sea-parrots went about their business in a hurry as usual. The only people I had to fear were the gossip journalists. On hearing of the sad event some of them quickly assembled at Newquay to collect or concoct a 'story'. Two of them in particular had been tracking me for days and caught me at last as I landed at the pier. They began to ply me with questions: but, well on my guard, I remained silent. Next day I was reported in thick type, as being 'speechless with grief'! Even my silence was turned to account. Father d'Arcy, S.J., came down to perform the funeral rites: he was assisted by one Tom Burns, an old school-fellow of Henry's, but one of those with whom the latter had broken contact. D., Edith Nettleship, my son Casper and two daughters also came to the funeral.

Amsterdam—and Van Gogh

In 1930, I think, a memorial exhibition of Van Gogh was held at Amsterdam. Sybil and David Fincham, D. and I determined not to miss this, and set out for Holland together. Many years had passed since I had been in Amsterdam. In the meantime much building and rebuilding had been going on. The huge blocks of modern apartments with their horizontal lines had in some districts replaced the old perpendicular style which I remembered. There was no doubt which of the two I preferred. The new Germanic developments belong to a world in which I should always feel a stranger. The fact that an architect named Van't Hoff had designed my new house in Mallord Street did not convince me of the advantages of Dutch Modernism when combined with tradition. My house was such a compromise. Van't Hoff had gone as far as to import black Dutch pan-tiles for his high-pitched roof, but with his up-to-date passion for rectangles had eschewed the characteristic curved gable.

I love the tall narrow houses which, in decorous uniformity, used to line the old canals. These rich façades, their warm dark bricks waxed, polished and repointed, show no dilapidation: they have the mellow substance of de Hooch and the *craquelé* of the years has improved them. Only the inhabitants have changed: no longer leisurely, they keep abreast of the times – on bicycles: their costumes, or rather costume, for they have now but one, have lost the style of sober elegance their jaunty forefathers affected.

I first met with the name of Van Gogh long before I knew his pictures. It occurred in a review by the painter James Ensor, published in a journal called *La Plume*, of a mixed exhibition at Brussels. The words were, 'Van Gogh, comme son nom indique,

est naif – et intéressant.' We found the greater part of the artist's life-work assembled in the Rijksmuseum. It comprised both the better-known brightly coloured pictures of his later period, and those of earlier days passed in Belgium. These dark canvases were, I thought, in essence, just as good as those painted under a Provençal sun. A diet of potatoes and schnapps in the Borinage seems to have been no less stimulating to Vincent's extraordinary constitution than one of aïoli and absinthe at Arles. As for his subjects, in any climate this man would have found himself in the same company. Like Christ, he belongs to the universal fellowship of the poor. Unhappily Van Gogh's *mystique* of misfortune, inflamed to the point of paranoia, turns to murder or suicide: he attacks the adored, the athletic, the supercilious Gauguin, with a hatchet: he cuts off his own ear to send it to a prostituted girl: the distracted fellow is jeered at in the street as he passes, dishevelled and muttering, with the maddening cry of the children following always, 'fou roux! fou roux! fou roux!' It is time to lock this lunatic up ... Goodbye little yellow house! Goodbye postman! *Adieu le bordel!* But there is always a Doctor Gachet: on the sick man's release from the asylum he takes refuge with this good little bore, who is kind enough but not really serious. Does he take the trouble to have his Pissarros framed? No, he leaves them knocking about anyhow! This is too much! Vincent takes out his revolver, but on second thoughts turns it against himself. So, smoking a last pipe amidst his pictures, he is cured at last – but not by the apothecary.

James Joyce

SOME musical admirers of James Joyce planned to present him with a book of compositions in his honour. I was invited to contribute a drawing of Joyce as my share of homage. I agreed to do so. I was to proceed to Paris on leaving Amsterdam. Talking with my friends on the platform, I almost lost my train, which was already moving, when with a desperate leap, I boarded it minus my portmanteau. I established myself in a modern studio building in the Rue Delambre, behind the Café du Dôme. There was a bar on the ground floor and one could get food sent up. But the bold pattern of the wallpaper of my studio disturbed me. What was to be done? An Indian woman with whom I was friendly solved the problem. Obtaining sheets of brown paper and borrowing a ladder, she pinned them over the fashionable decorations I had complained of. Sunita was a good companion to me during this stay. Her sister Milly, of darker colouring, was just as beautiful in her way. We used to meet in the 'Select', a café where one could have a dish of *saucisses* and *choucroute* without moving further. The 'Select bar' was frequented by psychological oddities of various kinds: but the Indian girls and I were normal enough. Sunita later on had to return to India, at the behest of her 'old man', as she called her husband. She never came back and her death was reported. Perhaps she had broken too many of the rules and her favourite divinity, Kali, had not seen fit to protect her.

Joyce posed well and frequently. I did a number of drawings of him. He had a precise and buttoned-up appearance, but would unstiffen perceptibly during the course of dinner. Mrs Joyce, a Galway woman, had to call him to order sometimes. In her

opinion the beneficent effect of the wine could be too marked.
I didn't agree.

Their flat was a model of bourgeois comfort and propriety.
Its shining brass fire-fittings, plush tablecloth and indifferent
pictures, might have been specially imported from Ireland.
Before we parted Joyce gave me a French translation of Ulysses.
A group of writers had been employed making this for years.
I inquired how they had got the Dublin accent into French. Joyce
replied, rather huffily, that a dialect had been made use of. I had
lent my original Ulysses to Will Rothenstein. I never saw it
again. I would have liked to compare the two. Once, repeating
one of his early *Pomes*, I hesitated over a word: he instantly
supplied it. In spite of his long self-banishment from Ireland,
Joyce's heart was always in the Liffey – so to speak.

He and Oliver Gogarty had been close friends and had shared
a Martello tower on Dublin Bay. Neither, in my hearing,
mentioned the other once. This, with Irishmen, may be taken
as an exchange of compliments. I have read the recently published
but earlier version of the *Portrait*;[1] it seemed to me better than
the one I had already read. What magical writing! Joyce would
keep referring to a mysterious singer of the name of O'Sullivan.
This great artist I gathered was not appreciated. He suggested I
should use my good offices with Lady Cunard to have him
employed at Covent Garden. O'Sullivan, in Wyndham Lewis's
opinion, was only an *idée fixe*, a kind of 'Mrs Harris', and had no
real existence. Lewis was wrong here: O'Sullivan was celebrated
in his day.

Joyce, although almost blind, took a great interest in my
drawings, examining them microscopically through his powerful
double-lenses. He explained that the poverty of his beard was
due to an early accident to his chin, but I did not feel empowered
to restore the missing growth. In spite of his cold and formal

[1] JAMES JOYCE, *Stephen Hero*, Cape (London, 1944).

exterior, I was much drawn to Joyce and, on finally parting with him after lunch one day, to his consternation, embraced him in the continental manner.

Above my studio was that of the painter Oskar Kokoschka. He was painting Milly's portrait or rather transcribing her into his own particular idiom. I thought a less attractive model would have served his purpose just as well, and so did Milly. In response to his appeals, I took a good deal of trouble later on to get Kokoschka out of Prague, when he stood in danger of internment at Dachau. Although this charming person and highly gifted artist failed to take advantage of my efforts on his behalf, I am glad to say he did manage to get away in the end and come to England, where I hope he'll stop.

Flight from Paris

IT was after a more recent stay in Paris that I came away in the company of Matthew Smith and a sympathetic American, Alden Brooks. Brooks, a student of Elizabethan literature, has come to some remarkable conclusions which are set forth in a book under the title, *Shakespere and The Dyer's Hand*. I had hired a studio from Richard Wyndham, overlooking the cemetery of Montparnasse. Not having seen it previously, I was appalled when I entered it. It had a glass table, aluminium chairs, shiny curtains of American cloth, and decorations by Richard Wyndham himself! I found myself in a futuristic pill-box, giving on the grave! Work was out of the question in these conditions: even sleep was uneasy! I soon got away from the place, and was driven away by Matthew, accompanied by Brooks. On our way the beauty of the Île de France was extraordinary. The landscape under the loveliest imaginable light had an opulence which might have been borrowed from my friend's palette: but could such a green as I now saw be rendered except in painted glass? Swept on to a destination promising, as I expected, only diluted hues compared with this magnificence, we crossed the Channel, only to find the English country, too, as bright and rich as if seen through medieval windows. Nature in such a mood, and perhaps in any other, is to be worshipped: submission will be rewarded. Apollo, in our zone at least, reigns without terror, and our changing skies reflect our temper more accurately than could a splendid but perpetual blue.

A Walk with Horace Cole

It was from Mallord Street, Chelsea, that I set out with Horace de Vere Cole to walk from Avignon to Marseilles. Horace was a famous walker in the heel-and-toe tradition, and with his unusual arithmetical facility, a great breaker of records. Something of a poet too, his motto might have been 'Motion remembered in tranquillity'. Perhaps his great feat was the ascent of Etna and return to the base in a matter of five hours: but then he was alone: with me the going was not up to this standard, for with my poor sense of time and a tendency to linger here and there, our mileage was apt to be reduced, though when it came to stepping out seriously, Horace used to give me full marks.

We spent a few days at Avignon to acclimatize ourselves. We then procured the services of a smart lad to convey our baggage by train to appointed places en route, and so travelled light. The main thing was to get somewhere in time for dinner. As for lunch, my friend rarely appeared before midday, so we used to start off usually after that meal. This suited me very well, for the morning was left free for me to stroll about in solitary contemplation of fresh scenes, or in the renewal of acquaintance with old ones.

On judging ourselves fit to take the road, we crossed the Rhône: our first stop was at Aramon, then, recrossing the river, we reached Tarascon by the evening. Here, after refreshment, my playful companion succeeded in arousing some of the inhabitants to a display of active disapproval. The French are undoubtedly a proud people and are said to be logical. Anyhow they seem to be incapable of reacting with anything but impatience to the antics of eccentric and unintelligible foreigners. Our next stopping-place was Arles, and it proved to be a quieter one. Left to myself, I had time to revisit the familiar by-ways of the little antique city.

Without the ramparts I found encamped, as usual, a dark Bohemian band. These despised *mangeurs de choses immondes*, as though in possession of some talisman of endurance, contrive to outlive the dire vicissitudes both of peace and war. I leaned by the arena, and, aided by an old print, saw it as in former times it came to be; a town within a town; compact with habitations squeezed within the arches, mounting in tiers to the sky-line; a congested hive of insalubrious bees. In the ruined theatre, now cleared of such intrusions and its own debris, I watched, as I used to do, the unsocked children playing on the sunny stage.

Our way led us next by a series of villages bearing such melodious names as Montmajour, Fontvieille, Paradou, Maussane, Eyguières. Someone has bestowed the title of *la petite Grèce* on this region, which is traversed by the Alpilles, that tumultuous range of speckled monticules which Provence wears on her brows, like a tiara. Turning south we strike the desert of the Crau, strewn, nobody knows how, with flattish pebbles such as are found in banks by the sea-shore. Our objective, Miramas, was far, and the day, like our tempers, was rapidly shortening. We arrived at last, but that night our after-dinner disputations were not prolonged. La Crau had got us down.

A short stage next day brought us to St Chamas, where an excellent lunch in the courtyard of the Hotel Bozio restored our spirits. The wine from our host's own vineyard was good and we tarried long at table. Here Horace's behaviour was again disconcerting. I could see that his advances to the daughter of the house were not in the best of taste, and it was clear that that handsome demoiselle shared my opinion. Rather than risk being compromised by my friend's behaviour, I took advantage of his temporary absence, and, excusing him as best I could, bade the young woman au revoir, with a promise to return. I then set off alone at a great pace. The road to Marseilles here skirts the northern shores of the Étang de Berre. Across the vast lagoon, I

descried the steeples of Martigues. Spellbound by the prospect, slackened speed from time to time and even, now and then came to a halt. Whether because of these interruptions to my progress, or because his longing for my company lent him seven-league boots, before many kilometres were covered, I heard approaching footsteps behind me. Turning, I beheld Horace coming on apace. The dear fellow had evidently not been encouraged to prolong his dalliance at the inn, which did no surprise me. But I had thought to out-distance him more than this. Rather than degrade our tour to the level of a walking match, slowed down almost imperceptibly, and presently we were marching side by side, but in silence. Meanwhile I had been struck with an idea. I discerned ahead a narrow road leading off to the right: on reading À BERRE on the sign-post, without a moment' hesitation, I turned down this road. An old saying in Provence, 'I y aura toujours Berre,' may have inspired me. I could feel Horace was both surprised and puzzled, but he followed suit without demur. Berre, where I had not been before, was a tiny fishing village, but as I was delighted to find, not without a nice little inn. Here we relaxed and after a good dinner with the inevitable bottle of Château-Neuf-du-Pape, recovered all our good humour with a bit over. I revealed the plan I had conceived on the way: 'We are going to cut out Marseilles and cross the Étang in a boat tomorrow,' I announced. Horace made some objections but I overruled them. As an amateur record-breaker, he was for carrying on with the original plan, but I pointed out that our expedition would greatly gain in character and originality by the change of programme I had thought of; but there was nothing to prevent him walking on to Marseilles by himself if he preferred: after some thought he agreed to fall in with my proposition. Next morning I found a boat moored at the quay with its skipper aboard. 'Would he take us across to Martigues?' 'Sacr-r-r-é bougr-r-re de nom de nom, mais pourquoi pas?' was his answer. We

came to terms and in two or three hours, for the wind was variable, stepped ashore on the Quai Brescon, paid the old *sacré bougre*, shook his hand, and with one accord, made for the Café de Commerce. In commemoration of our little jaunt, Horace gave me a book: *Moussia, La vie et la mort de Marie Bashkirtsieff*, inscribed and dated. From this I have deduced the year of the foregoing adventure. This is the inscription:

A. E. J. from H. de V. C.
Souvenir d'une promenade en Provence Oct. 1926
'With foreheads up, and chests outflung
We faced toward the rising sun' . . .
22nd Oct. Marseille

Chiaroscuro

Arthur Symons

One of my links with the 'nineties was the poet Arthur
Symons. Although I should have thought we were an ill-assorted
pair, we spent much time together after his recovery from the
breakdown in Italy. Always accompanied by a faithful and
sympathetic American friend, Miss Alice Tobin, and followed at a
suitable distance by his hated 'keeper', he would meet me for a
meal, somewhere in Soho. Symons, in one of his writings, has
used the phrase, 'the fatal initiation of madness'; whatever he
meant by that, in his case the event had no such sequel as death
within the two years predicted by his specialists, for he went on
living for another twenty years or more. His abnormal mental
condition was only indicated by great excitability and a growing
appetite for the lurid and the diabolical. He always spoke in
superlatives, and all humour was excluded. To judge by his talk,
he had passed a singularly hectic life; when he began to dilate on
the emotional exploits of his youth, Miss Tobin and I smiled.
With no sense of sin to speak of, I was only bored by this poet's
high-pitched professions of turpitude. I can date this period
approximately. While painting his portrait we were frequently
disturbed by the roar of passing aeroplanes. To the poet all
aeroplanes were hostile and at each alarm he would take cover
precipitately. It must have been in 1914.

Tan-y-Grisiau

I was then living in Mallord Street, Chelsea, in a house which
I had had built. The results of an exhibition I held at the Goupil
Gallery made this possible. The exhibition consisted of pictures
done in North Wales. Lord Howard de Walden, Josef Holbrooke,
Sime and I had combined to take a bungalow at Tan-y-Grisiau,
near Blaenau-Ffestiniog: standing high on the slopes of Moelwyn,

it commanded extensive views. Holbrooke installed a piano. I communicated to him the air 'Morfa Rhuddlan' of which a sadly dragged-out version is introduced in his opera *Bronwen*. It might have been here, too, that he first heard the call of the 'Birds of Rhiannon'. I imported a model to pose for me. Lily Ireland had never been out of London, and felt like a fish out of water in this wild place. She hankered after her native slum. It is true she recognized the sheep on the mountain side, for she had seen similar animals in Hyde Park. Her classic proportions had commended her to Havard Thomas. This sculptor required absolute immobility in his models: accordingly, Lily, while posing for him, was enclosed for some months in a close-fitting wooden cage, while with the aid of callipers and other instruments of precision, he built up in wax an exact – and beautiful – replica of her. Once, thoughtlessly, I said to Thomas, 'Why don't you take a plaster cast and have done with it?' Great was his indignation!

George Moore, too, had in his way made use of Lily's services: he required first-hand documentation for Cockney speech, and this girl's conversational style was rich, racy and authentic.

Welsh Whisky

Holbrooke, Sime and I had spent some time at Chirk Castle with the Howard de Waldens. I was greatly impressed to find our host one morning, clad, cap-à-pie, in a suit of ancient armour and reading his newspaper. An ardent medievalist, he provided us with bows and arrows to shoot at his deer, which fortunately were too elusive; no hit was scored. The most good-natured of Barons, Howard de Walden bore himself with an air of indestructible solidity. Sime drew him confronted by Holbrooke, an illustration of the ancient conundrum: 'What happens when an irresistible force meets with an immovable body?' The musician's demoniacal energy, whether at the piano or the wheel of his

car, was boundless: in the first case we were pleasurably excited, especially when he played Debussy; in the second, often thrilled by less agreeable emotion, shared in still greater degree by the population of the villages we traversed at top speed. But there were compensations for every risk while exploring the country-side under Joe's conduct. At Bala, the White Lion offered the unique attraction of Welsh whisky, pronounced by Sime, who spoke with authority, to be excellent. Leaving the two to their potations, I would cross the road to the Plas Goch Inn, there to cultivate the Romany tongue under the tutelage of Manfrey, and sometimes Matthew Wood. At Cerrig-y-Druidion Mr Tegid Owen entertained his guests with true Welsh courtesy, and at Blaenau-Ffestiniog Dr Vaughan showed an equal efficiency and skill as publican and medical practitioner, for he was both. As we rolled along between such stopping-places we watched the slow drama of the sky unfold itself. The mountains shifted and the illumination changed: as if under the direction of a supreme but moody artist, the land was draped in purple or exploded in a coruscation of green and gold.

George Moore and 'The Brook Kerith'

George Moore was discussing his *Brook Kerith*. He told me how he had got his friend, the sculptor Prince Troubetskoy, to shoulder a medium-sized man and attempt to carry him from the site of the Cross to the alleged Tomb. Troubetskoy, being a kind of giant, just managed to perform this feat. According to Moore's story, Jesus, having been taken down from the Cross, and trans-ported in this way, was revived and smuggled away to an Essenian monastery across the Jordan, where he lived incognito till the arrival of Paul. 'But', I said, 'could *anybody* have survived after being nailed to a cross for all those dreadful hours?' Moore answered, 'Jesus was not nailed, but tied to the cross.' I was

mazed. 'But what about Doubting Thomas, the Stigmata, and he unanimity of tradition, as embodied in Christian Art from earliest times?' Moore said, 'Let us see what Voltaire says, for he knew everything.' Reaching for the *Dictionnaire* he looked up *Crucifixion*, where it was stated that the Romans never nailed their victims to crosses but always tied them; a worse form of torture, for it lasted longer. I was still unconvinced. (Were not the Gypsies admittedly accursed for having forged those very nails?) Moore went on to relate the version of the story, which he altered later: this is how it ran.

When Paul in the course of his mission stopped at the Essenian monastery, he fell into conversation with one of the monks, a grave and reticent man of middle age. They took a walk together, and Paul in his proselytizing zeal, began to instruct his companion in the doctrines of the new Faith. This involved an account of the central events, the Crucifixion, Death, Burial, Resurrection and Ascent. The monk ventured to question the accuracy of the story, for, as he gently announced, 'I am that man!' In proof of his statement he showed the scars on his hands and feet. (Here is an inconsistency on Moore's part.) Paul, thereupon, unable to doubt the truthfulness of his informant, supported as it was by the evidence of his eyes, lifted his heavy staff and shouting, 'The Devil you are!' brought it down with lethal effect on that devoted head. This deed accomplished, he went on his way, spreading the Gospel of Glad Tidings and Great Joy. Is it possible that I dreamt all this, for Moore denied its authorship later?

I was interested in the *Brook Kerith* and also admired Moore's version of Daphnis and Chloë. I thought of illustrating both these works. Moore was well disposed to the project, but lifting up his hands with a characteristic gesture, he remarked, 'I cannot unfortunately offer you any *money*.' But I had not thought for a moment of a business transaction.

George Moore was such an extraordinary character that it

was well worth while partaking of his meagre hospitality at Ebury Street, merely to watch his behaviour and listen to his discourse: his half bottle of sour wine, his sparse collection of pictures by his personal friends, his Aubusson carpet upstairs, all made a proper setting for the almost grotesque personage in the foreground, who discussed sex and character, literature and art, with such curiosity, ingenuousness and feeling.

Synge, Moore and Quinn

Irishmen are incalculable. Once when I was in the Café Royal with John Quinn and George Moore, the subject of Synge's *Playboy of the Western World* cropped up. I was shocked to discover that Quinn and Moore, otherwise at opposite poles, agreed in missing the whole point of the play. Against all my protestations, these two insisted that Christie Mahon, the Playboy, was a fine, tall, devil-may-care type of fellow, when in fact, as Synge made it clear, he was a timid little 'stump' of a chap (while an embryonic poet), who, under the blandishments of two female admirers (played to perfection by my friends Sally and Molly Allgood), convinced himself that he *had* really killed his '*Da*', and was accordingly made a hero of, and *was* a hero till, overtaken by the victim, who, with head bloody still, but far from bowed, drove his son home, like a beaten cur. Little Willie Fay, the very counterpart of Christie Mahon, filled the role as no one will again.

The Blue Kailin

'The Blue Kailin' was a tiny restaurant on Cheyne Walk near Chelsea Old Church. It stood back from the road in a corner called 'Don Saltero's'. Nazi bombers, possibly aiming at Lots Road Power Station, near by, have obliterated all this and with

the collusion of big business and the speculative builder, these
and other bits of the Chelsea that Whistler knew have disappeared.
The little restaurant, under the grimace of the engaging Chinese
monster above the door, was kept by Mrs Osborne. In surround-
ings homely yet tasteful, meals were served which, though not
copious, were always well cooked. The clever little lady of the
house prepared the dishes herself and liked to serve them to the
accompaniment of conversational *sauce piquante* of a distinctly
Oscar Wildish flavour. The establishment set out to cater less for
the needs of the million than for the 'happy few'. In a corner by
the fireplace, a rather silent and dejected figure used to sit: this
was William Osborne. Henry Lamb, then a young artist lately
arrived from Manchester, and I soon got to know him, and the
three of us became intimate and spent a good deal of time to-
gether. We found a common interest in the subject of painting,
for Osborne too was an artist. Our senior in years, 'Billy' seemed
vastly our superior in knowledge. Undemonstrative, shy and re-
served, he would warm up after a few tankards of beer at the Eight
Bells, and his conversation led us to impute to him a point of view,
a secret, which we longed to understand and share. Here was an
aesthetician with a scientific method. He would draw our atten-
tion to the screens of ground glass which in this democratic
country are provided to shield the patrons of the saloon from
observation and perhaps recognition by the clients of the public
bar opposite. He praised their exquisite tonality, and the devices
mechanically engraved on their surface permitted, he pointed out,
a play of light of a positively Chinese subtlety. Astonished, we
regarded these banal objects: by Heaven, he was right! the
detestable contrivances now shone softly with the muted lustre
of jade. A once elegant but now dilapidated row of houses in the
King's Road, with their peeling stucco, reminded Billy of a bevy
of elderly ladies vainly trying to camouflage the ravages of time
under a reckless application of rouge. This sort of thing was very

'ninetyish' of course, but it was new to us. Our friend claimed that his method permitted him to paint in any light: by a learned transposition of colour he could deal with Nature in any mood. This was theory: practically, he preferred the weather to accommodate itself to his palette, as in London it often did. He used few colours and those sparingly. Black was his basic pigment. 'As for the rose of bricks,' he said, 'a little burnt umber and white suffices.' 'Perspective?' 'Ignore it.'

At one time a successful painter in a more popular vein, when like a divine revelation the new vision came to him, he unhesitatingly burnt his boats and his pictures with them, and entered a lonelier and subtler world. No doubt Whistler's doctrines had something to do with his conversion; but it was Chinese painting to which he was always referring, that he most admired. Conscious of his limitations and bothered too by some unsatisfactory affair of the heart, Osborne suffered from deep fits of melancholy. He would appear sometimes strangely absent and unresponsive. His eyes then showed no pupils but were dark wells of pain. Dope; that's what it meant. Faithful to his masters, he had even adopted their vices. In gayer moments he used to say, 'Some day I'm going to show you a trick.' I guessed what that trick was when I heard of his sudden death.

R. A.

My election to Associateship of the Royal Academy probably surprised others as much as it did me. I had never sent a picture before the Selection Committee. In our select circles it simply wasn't done. This made the gesture as unique as it was magnanimous. I found it impossible to decline the honour. To the members of the New English Art Club, exhibiting at the Gallery of the 'Egyptian Hall', Piccadilly, the majestic institution across the way was considered practically out of bounds. The 'New English

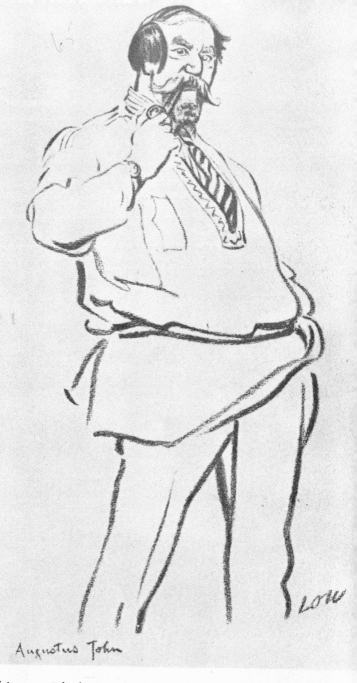

Augustus John

17 Portrait of Augustus John by Low (*cartoon by arrangement of the Trustees and the London Evening Standard*)

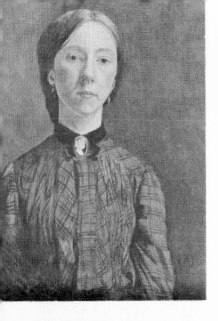

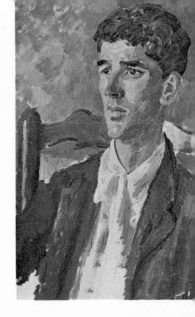

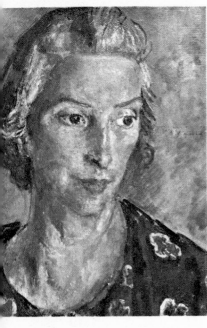

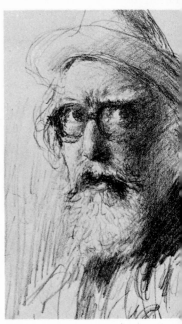

18 Gwen John: a self-portrait (*reproduced by courtesy of the Trustees of the Tate Gallery*)

19 Henry Elffin John

20 Mrs John

21 Augustus John: a self-portrait (*kindly made available by Mr George Rainbird*)

ad a good conceit of themselves. A few of them had been to
Paris and could talk glibly of Monet, Manet, Degas, Renoir and
Rodin. Whistler had been one of our foundation members, and
we could still boast of Sickert, Steer, Rothenstein, Sargent,
Nicholson, Pryde, Conder, Fisher, Clausen and other distinguished
adherents. In our eyes the R.A. was so bad that no self-respecting
artist would be seen dead in it: and yet among its more out-
standing corpses are to be numbered those of Reynolds, Gains-
borough, Hogarth, Lawrence, Turner and Constable. As a matter
of fact the R.A. has recruited itself largely from the N.E.A.C.
Steer and Nicholson alone remained obdurate to the end, thus
withholding from the older and more popular establishment the
benefits of their example and advice. A colleague congratulating
me on achieving full membership, remarked that I had gained
the crown of my career'. If that is not quite the case, Burlington
House is capacious and now always accessible, so there is still
hope.

Madame Strindberg again

I ARRANGED to meet Fabian de Castro in Paris. He had a guitar to deliver to me. I found him awaiting me at the Gare du Nord. He conducted me to the Hotel Beaujolais, near the Palais Royal. A room had been taken for me here, and I was greeted – by Mme Strindberg! After dining with her, I was carried to the *Folies Bergère*. This no doubt was considered a treat for me, but I loathed the place and had always instinctively avoided it. Next morning, waking early and in fear of further benefits, I arose, and left the hotel for a quarter I preferred – Montparnasse. I left no word of my whereabouts. I paid a call on my sister Gwen, who was then living in the Rue Vercingetorix. After this I went back to the Avenue du Maine, to sit in a café and meditate in solitude. 'Enfin seul,' I was saying to myself when Mme Strindberg bore up in a state of extreme agitation. By what occult means she had traced me will always be a mystery. On some pretext I detached myself and took a room in the quarter. Next morning, while seated in the Dome, the waiter handed me a letter. I read it with difficulty, for the writer was hardly literate. I gathered from this letter that the evening before, I had been beaten up in the Avenue de l'Opéra. I was asked how I liked that, and if more of the same treatment would be necessary. I was assured there was more to come if asked for: perhaps in time, I would learn how to treat a *lady*: I was under close observation: Beware! There was no signature. I deduced from this that some innocent person, resembling me, had suffered for my sins. Although sympathizing with my unfortunate double, I could not altogether regret the mistake which had been made. Presently I got up and strolled to the Closerie des Lilas. I had no thought of eluding pursuit, for I well knew that was impossible,

258

with agencies not of this world at work. I was not surprised then, when Fabian rushed in, and appealed to me frantically to come and speak to Madame, who was waiting in a taxi: 'Elle pleure comme une Madeleine! Elle va se jeter dans la Seine!' The Gypsy's loyalties appeared to have got mixed. Rather than assist at a tragedy, or, worse, a public scene, I told Fabian to bring the woman in for a few minutes, but on no account to leave us alone together. Upon that he went out and, after a short interval, reappeared with a 'Madeleine' no longer in tears. She had had time to pull herself together. No allusion was made to the incident of the Avenue de l'Opéra, which possibly was instigated by some partisan of hers: it would be quite simple, I suppose, to hire an apache for such a job. This interview was short, cheerful and satisfactory in that it ended in nothing more important than a rendezvous which as usual I wasn't going to keep. Instead I sought the help of two dear American friends, Bernice and Thelma. Bernice had a fast car at her disposal. She promised to drive me to Saulieu the next day. Saulieu was quite near the Château de Missery. I would be safe enough in the Château. It had a moat round it. The three of us left Paris together. It was a pity Thelma was suffering from an intermittent stomach-ache on this trip, and thus was unable to do full justice to the good fare provided at the Hôtel de la Poste.

There were several fine châteaux near Missery. Used as farmhouses, they were in a bad state of preservation but all the same very covetable. One, at any rate, besides Missery had been restored, and is now *classé*, and was inhabited by the Contessa Elisina, the Italian wife first of Grant Richards and now of Royall Tyler. Her chief treasure was a Byzantine bowl, which at first sight I took to be the Holy Grail.

The Last of Madame Strindberg

The indefatigable Frida Strindberg took it into her head to

start a Cabaret off Regent Street. It was called 'The Cave of the Golden Calf'. Knowing my interest in Gypsies, she had engaged a number of the 'Coppersmiths', who were now in England, to help in the entertainment with their songs and dances. My attendance was counted on, but I never entered the place. One look at the seething mob outside its doors, on the opening night, was enough for me. I passed on. Another miscalculation! To cut this epic short, I ended by convincing Lewis's 'admirable woman' that she was wasting her time; there was nothing doing; I wanted no help and no interference: cold, resolute, implacable, this time I succeeded in making my meaning clear: when at last she realized the truth – my truth, a sad transformation took place; her eyes, previously a dark and lively brown, turned flat and leaden, her plump cheeks quivered, and her whole person seemed to sag: I was in the presence of a wounded animal, wounded, it seemed, unto death. Outwardly unmoved, I said goodbye for good. Shortly afterwards she packed up and left for America. I received a letter from her, written on the ship. It was a noble epistle. In it I was absolved from all blame: all charges, all imputations were withdrawn: she alone had been at fault from the beginning: though this wasn't true, I was invested with a kind of halo, quite unnecessarily. I wish I had kept this letter; it might serve me in an emergency. Another letter, received from the same benevolent source, was an appeal for my help in her efforts to extricate the writer Andreieff, afflicted by T.B., from a dangerous situation in Germany.

I have just found yet another letter written from New York, written after the 1914–18 war: I will quote most of it, as it exhibits an aspect of my friend's character, a certain poetic sensibility which, I'm afraid, the absurd incidents I have chosen to relate would not lead the reader to give her credit for; this is no doubt a fault of reportage but it cannot be said against me that it minimizes the predicament in which I found myself.

My dear once friend,

In these days of forced spiritism you won't be surprised to see one of the dead come back – (another question is whether you will be very unpleasantly affected by this untimely return). Let me reassure you therefore at once, that the evil is not as bad as it may seem, for I'm really quite, quite dead . . . I'll never again commit suicide because you are blind to my charms – I never never again shall resent any happiness you find . . . but I know, that there is no memory dearer to me than yours, that no one lives to whom I wish more happiness, whom I hold higher and whose hand, just for once, I'd like to hold again, as yours . . . for the first time perhaps . . . I had not a fair chance years ago, because all that life had made of me after I had been born and reared in a compulsory strait-jacket, ethically and intellectually, was naturally hateful to you – that you . . . grew exasperated. And with all this, I was worn out with years of worry and distress. I never told you or anyone of all that – but I assure you, I was a pretty sadly tracked human animal and mildly hysterical in consequence. Why madness should always adopt an unpleasant aspect I do not know, but it seems to make a rule of this . . . I'm no *femme du monde* any longer, neither in clothes nor in thoughts, but I have become a man whom you would like . . . as a friend – were it not that your taste once more would stand between us: I know your friends *must* be thin, to a point at least – and I have grown fat enough to wish to drown and too fat ever to drown even if I wished to – fat and old.

Do I really, in spite of that and everything, hope and believe that you may be friendly towards me again some day??? Yes, because you are you – so big in your heart, and so generous and so used to *le beau geste*, unless one stops it in you by force, as I did. Yes, even in spite of your dislike of

me . . . for I could not feel for you as I do, unless there were in us somewhere deep at the bottom that in common which makes it a natural thing and a legitimate one. Perhaps we'll never meet again . . . perhaps if we do you'll simply feel; oh that horrid fat old monster how could she offend me with the sight of her . . . But there are degrees of intimacy, you know: some women look better with clothes on; some *en peau* – and some perhaps *en dessous de la peau* – Please don't be frightened . . . I only want to explain nicely and politely why I am writing to you, as otherwise you might resent it – and that would grieve me bitterly. I have been thinking of you so often – and *never* of one unpleasant hour. Every thought was beautiful and joyful, and however sad I was, after I thought of you, I smiled . . . if there were more like you all the horror in which the world was drowned would and could never have been. For, I don't believe the bloodshed was the worst – I was here all the time, and went through everything in a moral way they served over there – oh *doux pays* – you'd like America where its brutality is unvarnished, where the people are not washed and smell the vulgar brute, for there at least it is *genuine*. But its efforts at culture, art, distinction or cleanliness are odious. They don't reach beyond the oiliness of the Sunday preacher – I think Swedenborg meant them when he dreamt of the dirt-hell – but with no romance or *fin de siècle* perfume about it. When they try to be what they imagine us to be, then one feels a violent desire to be worse than what they are only in order not to resemble them anyhow. But with all that I stood here in front of the road to the sea[1] – and saw it never before so beautiful . . . because now I have it in my heart and in my mind, if I only close my eyes. That same way also I very often have you as a friend – and sometimes when I felt so

[1] A reference to one of my pictures.

lonely here that I was too desperate to cry, I crept close to you and told you many things – you were very very good ... I wish I could meet you in a very dark room, quite quite dark, hear your voice – feel your hand – and then go back again into life, having dreamt one more dream.

Peace Conference, Paris 1919

STILL holding my commission in Canadian War Records, I was encouraged to move to Paris in 1919, with a view to memorializing the Peace Conference. I put up at the Hotel Foyot, adjacent to the Palais du Luxembourg. This, ordinarily, was an inexpensive and convenient spot, well known to me. The restaurant of the same name, and in the same building was anything but inexpensive, being first class and famed for its cuisine, but the locataires of the hotel were under no obligation to use it. But here I was a long way from the Hôtel Majestic, where the British Delegation congregated, with whom I had chiefly to do. Luckily I came across Señor José Antonio Gandarillas, my Chilean friend of Chelsea, who, having two contiguous apartments in the Avenue Montaigne, very kindly put one of them at my disposal. This was lucky. Not only had I a good room to work in, but looking out on the Rond Point of the Champs Élysées, I was at the centre of things, quite near the Majestic, and the Conference itself was just across the river. Señor Gandarillas, always a man of fashion, entertained largely. In Chelsea, I had been long accustomed to visit his house on Cheyne Walk, meeting there his friends of the Russian ballet, including Serge Diaghileff, numerous musicians and artists, Artur Rubinstein, Stravinsky and Kit Wood, and my host's beloved aunt Mme Eugenia Huici de Errázuriz.

Every night the apartment on the Avenue Montaigne was thronged. *Tout Paris était là.*

A band on the landing provided music. A then new and popular tune which they always played still lingers in my memory and seems to summarize neatly enough my emotional history of that period: it begins: 'There are smiles which make you hap-py; there are smiles which make you sad' . . . The rest I have for-

tunately forgotten. I began to attend these parties; first, because they made sleep impossible: second, because they were entertaining, and third, because my uniform made the tiresome business of 'dressing' unnecessary.

I was unaccustomed to Parisian 'Society', and my native shyness put me at a further disadvantage (unless, indeed, it recommended me), but I found the people good-natured and polite.

The women were genial and loved a bit of fun; and the men for the most part seemed frank, friendly and intelligent. Quickly I lost all feeling of constraint and was able to share in the general *sans-gêne*.

Maria, Duchesse de Gramont

The painter Driand, whom I met here, invited me to a party at his studio. There I made the acquaintance of the Duchesse de Gramont: struck by her beauty and style, I saw at once pictorial possibilities ahead, but found no good opportunity to raise the question. The next day, as I was walking at speed towards the Étoile, we met again: salutations were exchanged, but, carried on by my own impetus, I had progressed some yards before I pulled myself up, and turning, overtook the lady as she ambled daintily homewards. I lost no time now in making my proposal. It was well received, and a sitting arranged for the morrow: thus began my labours at the Peace Conference.

T. E. Lawrence, Emir Feisal, Gertrude Bell and others

Meanwhile I frequented the Hôtel Majestic and made numerous contacts. Starting with the British Colonial delegates, I secured for my purpose Hughes of Australia, Massey of N. Zealand and Borden of Canada. Besides these I painted Lord Robert Cecil,

Chiaroscuro

Lords Cunliffe and Sumner and Sir William Goode. My meeting here with T. E. Lawrence began a long friendship. He sat for me frequently in Paris and later in England. Lawrence actually enjoyed being painted and always seemed vastly tickled by the results.

He habitually wore Arab costume and often accompanied the Emir Feisal, whom I painted more than once. The two would converse in Arabic while I worked, and sometimes that remarkable woman, Gertrude Bell, would join in. The Emir gave a luncheon party one day which I attended: I never ate so well: ah, those Arabian sweetmeats! Behind the Prince stood a gigantic Negro with a sword. This man, once a slave, had been liberated by Feisal: he would have died for his master, Lawrence told me. Lawrence was of the party of course, and there was a French woman reputed to have explored the desert: she tried to draw out Lawrence, but with no success: as a last appeal, 'Mais, mon colonel, vous adorez les nuits de Baghdad, n'est-ce-pas?' 'Elles sont puantes,' replied Lawrence, with his eyes on his plate. But T. E. seemed anyhow incapable of facing women – except for one or two such as Gertrude Bell, and D.: he would talk to the latter for hours at a time when later he used to visit us in Hampshire.

Marchesa Casati

One day I was present at a *thé dansant* at the house of the Duc de Gramont. This enormous house on the Champs Élysées had the aspect of a fortress. In France, tea is always accompanied by the alternative of port – white port. I was helping myself to a glass of this when a new arrival arrested my attention. A lady of unusual distinction had entered. Her bearing, personality and peculiar elegance seemed to throw the rest of the company into the shade, not excluding the ladies of the Faubourg St Germain

who are, perhaps, externally, a little dowdy. Even the Duchesse, whose natural style of beauty was unassailable, looked, by comparison, somewhat rustic. The newcomer wore a tall hat of black velvet, the crown surrounded by an antique gold torque, the gift of D'Annunzio; her enormous eyes, set off by mascara, gleamed beneath a framework of canary coloured curls. Instantly captured by a gentleman who remains anonymous, she moved round the ballroom with supreme ease, while looking about her with an expression of slightly malicious amusement. Our eyes met … Before leaving I obtained an introduction; it was the Marchesa Casati.

The Marchesa became a frequent visitor at Tony's parties and it wasn't long before I added her to my list of sitters. Only once have I met a comparable example of this *genre* of Italian femininity: this was the Contessa Bosdari, whose husband was Italian Ambassador when I visited Berlin. In both cases, a rather fantastic exterior was accompanied by a perfect naturalness of manner; a naturalness which, with the Marchesa, sometimes took on a thoroughly popular note: she had borrowed from the colloquial some important additions to her vocabulary, which, used with judgment, considerably enhanced her powers of expression, more especially when these were employed in the dissection of her friends' characteristics, mental, moral and physical.

Maurice Cremnitz and others

My leisure moments were not all passed in fashionable circles. There were familiar haunts across the river which still attracted me as of old; but my military rank and uniform, so convenient and suitable in the neighbourhood of the Étoile, seemed out of place in Montparnasse and only caused embarrassment among such friends and acquaintances as I might meet in the quarter. Maurice Cremnitz, who once had seen in me a close resemblance to

Robinson Crusoe, now looked at me incredulously: we had dinner at one of his restaurants where having engulfed one series of *plats*, my friend, just as of old, promptly ordered another. Cremnitz had been through the war but was only slightly wounded. 'I wouldn't have missed it for anything,' he said. Moréas was dead. Cremnitz had written a fine sonnet for his funeral. The Cercle was disbanded. André Salmon was now the spokesman of *les Jeunes*.

* * *

One day I met Louise Lorraine in the street. She was a rather beautiful and eccentric young Jewess whom I used to know in England. She pretended not to see me, but I knew her tricks and put an end to this comedy. She came to pose at my flat, and in the evenings we often visited a bar off the Boulevard St Michel. It was a change from Fouquet's.

* * *

When I attended the Conference, I realized that for me it held no pictorial possibilities. I made many sketches of individual delegates, but the aspect of the immense hall with its interminable rows of seated figures was, visually, merely boring. I was relieved when Clemenceau, at the first opportunity, without wasting a second, rose and announced, 'Messieurs, la séance est levée': Mr Balfour awoke with a start, and we all trooped out.

* * *

Meanwhile the parties at Avenue Montaigne continued merrily. Mme Cécile Sorel was often to be seen, elegant and genial, her indestructible charms artistically heightened by the technique we always associate with the Comédie Française, while Mlle Madeleine Le Chevrel upheld the banner of an equally exclusive

tradition. I now met the Princess Eugène Murat, with whom I was to enjoy a long and close friendship: Jean Cocteau, who at that time had opened a fashionable 'dancing' bar in the Rue St Honoré, played the kettle-drum himself, though not very well: there were many other notable figures too numerous to mention even if I could remember their names. At the Majestic, I enlisted the Maharajah of Bikaner, a superb specimen of Indian manhood, and the accomplished Monsieur Hymans, the Belgian delegate. General Botha promised to sit too but most unfortunately died suddenly. I greatly regretted this as Botha was one of my heroes, and personal contact had only confirmed my esteem for him. Though General Smuts was about, I found no opportunity of fitting him into my designs.

* * *

When Miss Elizabeth Asquith arrived in Paris, I induced her to pose for me. This brilliant young woman used to beguile the tedium of sitting by composing poetry which from time to time she recited aloud. This diverted her, no doubt, but put an extra strain on my powers of concentration.

At a certain dinner-party at the Majestic, Elizabeth Asquith, three young diplomats and myself formed a quintet. The conversation during the repast was general, but after coffee, with a bottle of brandy on the table, Elizabeth ended by silencing even the corps diplomatique (not usually tongue-tied), by a display of sustained cerebral acrobatics, unique in my, and I think in their, experience: I was glad when the bottle was empty for there are physical limits even to dumb admiration. Dazzled as I was, I had just enough wits left to escort her back to the Ritz.

Footit's Bar

The Comte de Gouy d'Arcy used privately to deal in pictures. He showed me a photograph which I at once recognized as the

269

source of a picture by the Douanier Rousseau. This represented a pony and trap in which sat several figures. The Douanier's copy was pretty exact. I had been bowled over when first I saw the work of this 'instinctive painter' at the 'Indépendants'. While I stood transfixed before one of his exhibits, an old gentleman, approaching me, inquired, 'Pardon, Monsieur, est-ce que c'est fait exprès, cela?' This question never ceases to amuse and puzzle me.

François de Gouy·d'Arcy took me one day to Footit's Bar, off the Champs Élysées. I was delighted with this discovery and returned often. It was much more to my taste than Fouquet's. The great Footit had long since retired for good from the sawdust of this terrestrial circus but Mme Footit still presided at the Bar. She, like the departed clown, was English, and in her black silk, hung with numerous gold ornaments, presented a fine and dignified front to the world. No verbal or other licence was permissible or even thought of under the eye of this monument of respectability. One could also eat at Footit's, in a little back room, though Mme Footit didn't cater for everybody. Violette Murat knew the place well, but then, what didn't she know of the ins and outs of Paris? Fearless herself, she took me to certain places where my sang-froid was put to the severest test.

Tony Gandarillas had to return to London, so I found it necessary to make a move. Mme de Gramont had recently acquired a studio with apartment on the Quai Malaquais, not for painting purposes so much as an alternative to the pomp and circumstance of the ducal mansion, for she had simple tastes. In her generosity, and realizing the importance I attached to her portrait, which was almost finished, she lent me this place: it suited me very well for a time. I had also Louisa Casati to think of. Her portrait, too, was going well. But unfortunately the two ladies, outwardly friendly, were spiritually at loggerheads. It was necessary for me, as far as possible, to keep them apart. They did not seek each other; but a collision in my studio was to be avoided.

I don't suggest they would have lost control of themselves, both being well brought up, but such a situation would only have led to awkwardness and as third party I was taking no risks if I could help it. But once I blundered: I had, by inadvertence, made an appointment with both ladies for the same hour. One sitting, at least, must be cancelled: but now it was too late. I waited, the Duchess arrived first. I pleaded fatigue and the immediate need of fresh air: we went out for a walk by the river and leaning on the parapet under Notre Dame, we watched the barges pass slowly by. At last I judged it safe to return. I was feeling better. I found the Marchesa had come – and gone. The situation was saved. I was rarely at a loss for company or models in those days. If Mme dè Gramont failed me, there was always Miska, her friendly Scandinavian maid; if Louisa Casati was engaged, Louise Lorraine would perhaps be free: if Violette Murat were out of reach – but she hardly ever was. And there were plenty of male friends too when needed; Freddy Guest, Eric Sutton, Orpen, Evan Morgan, Tony Gandarillas, T. E. Lawrence . . . The only difficulty was to adjust my company to my mood (and vice versa): this problem sometimes proved insuperable and I was left, not at a disadvantage exactly, but in a state of philosophic doubt, which sometimes led to new and unexpected encounters: strangers often make the best company; intervals of solitude too are salutary and precious. But I was beginning to tire of Paris. I had done as much as I could. The Conference was over. I wasn't going to wait for the signing of the Peace Treaty. It was time to pack up.

Some Letters from Lawrence

A SHOW at the Alpine Gallery followed. I had all my Conference portraits in, and many others. T. E. Lawrence went repeatedly. I never saw eye to eye with him about pictures but his comments are amusing. The following letters or parts of letters show that it was his own portraits which interested him most; this was only natural: I can hear him chuckling.

Dear John, I've been twice to your show, and am going again this afternoon. You see it's so crowded as a rule that things are difficult to see. The O.C. told me it was going on all April and they are issuing season tickets! Help! you called it appalling – but only one person so far agrees with you. He was about 6 feet 6″ high, and looked sourly at them, and at last said they were instances of nervous debility, all visibly brush-marked and that Velasquez wouldn't have signed any of them. He said it to me, and I suggested that Velasquez was too honest to do it . . . He then said he thought I was trying to be clever. *He* obviously wasn't: but after that we didn't seem to get on. La Casati is very different to what I remember of her in your house . . . much more lively in colour, and not vampirish so much. In fact I shouldn't object to living with her (the picture of course), though the Birm. F.A. Gallery say it would be bad for the women of the town to hang her there. It must be hot stuff if I remember Birmingham correctly. There's an odd feeling of kindness about some of them. The little Duchess: and two Canadian soldiers sitting together and your boy, and the little one of me. It's as though you had left off straining after the back rooms for their mind for a bit. The boy is off to Australia, I see. But they are all in process of going off. Feisal is for Manchester, (I still think I got the

better one there) . . . It seems that I'm a good selling line: In fact that little one of me (called the goody-goody one) went off first. O.C. gallery tells me that you told him the other one (called the rebellious one) was mine: and I wanted to ask you about it. I told you I wanted it and I think it's wonderful . . . but the value of it beats me at present and so I can't offer. There was a third (called by you a dud) which might be in my compass . . . but don't know even that, I can't say yet for my account is still all ravelled up at the W.O. . . .

. . . Partnerships off! Daily Express has torn it: says you fail completely to express your sitters who use their brains: but succeed conspicuously in two portraits of men of action – Col. Lawrence and the Emir Feisal. Your remark about my book is probably a jest – but it gives me a chance to say that I'm going to ask for licence to have one of the Feisals copied in it! I don't like authors who stick themselves in books: and it hurts the sale unless they look like Owen Nares. A friend of mine went to the Alpine Club, and said my larger one was a conscious effort by you to show how long contact with camels had affected my face! But I explained that it wasn't my face which had been in contact with camels. It's good news about the Duchess: I don't feel I could live without her. Tell the Duke I'd be still happier with a Casati on the other flank. I'm leaving the dagger with you till you're fit . . .

19. 3. 20

Dear John, Really, I'm hotter stuff than I thought: the wrath-ful portrait went off at top speed for a thousand to a *Duke*! That puts me for the moment easily at the head of the field in your selling plate. Of course I know you will naturally think the glory is yours – but I believe it's due to the exceed-ing beauty of my face . . . What do artists' models of the best

sort fetch per hour (or perhaps per job, for I might fall on a Cézanne, and I don't want to get rich): it seems to me that I have a *future*. I went to your show last Thursday with Lionel Curtis. We were admiring me, and a person with a military moustache joined us and blurted out 'looks a bloody sort of creature doesn't he?' Curtis with some verve said 'Yes.' I looked very pink. Yours ever T.E.L.

I. 3. 20

... It's a pity you haven't been able to finish a row of beauties (or b . . sts) for it, in addition to the war items: only I hope the Casati is there: vampire is the word I was trying to think about as I looked at her – only I couldn't think because she froze me. (Mixed metaphor: perhaps I meant Gorgon) . . . If ever I'm starving I hope to put the dagger up for sale, and thanks to Lowell Thomas it should fetch a lot. The gold 'sword' of a 'Prince of Mecca'. A little sword no doubt, but then a little prince. Yours T.E.L.

I returned the dagger T. E. had confided to my care. Lawrence gave me a copy of his *Seven Pillars*, only on condition that I should sell it if I felt hard up. I did sell it later as I needed a new car. I told T. E. and he said, 'How much for?' I said £400. He said 'not so bad'. A bit earlier it would have fetched twice that price. Lawrence told me he hoped to write a really good book some day.

Gwen John

MY sister was always coming across beautiful children to draw and adore. Jimmy was a boy of about twelve when we met him. He wore auburn corkscrew curls down to his shoulders, and his costume was of old green velvet. His face was rather pale and beautiful. Jimmy stood on the sands at Tenby, where he made fairy structures of coloured paper, which he would cleverly snip and manipulate into changing forms, each more surprising than the last. Everybody applauded the sweet boy with his candid smiling eyes, and pennies were produced in quantities: these his mother collected. Soon we made friends with Jimmy, and invited him to our house to be drawn and painted. His mother would come too. Our father didn't approve of these strollers but, as usual, had to give way before our insistence. Our studio was an attic under the roof. Here we worked with Jimmy and only wished his mother wouldn't come. Perhaps she wasn't his mother, for there was no earthly resemblance between the two.

I met another boy in a strange town where we had encamped. I was exploring this town when I heard a voice uplifted to the accompaniment of a mechanical piano: as I approached I saw it was the voice of a boy who stood singing by the side of the instrument, which was turned by a dark bearded man. The boy had long flaxen hair like a girl's, and was dressed in a sailor suit. His voice, of an unearthly quality, quite dominated the tinkling piano; he had the face of a Gothic angel. When I got to know this boy I found he was sweet and gentle but witless. It seems they can be hired, such boys, or even bought, like performing bears or monkeys.

In those days my sister was full of high spirits, though she had her attacks of melancholy too. Nobody suffered from frustrated

love as she did. When she joined me at the Slade we shared rooms together, rooms which we constantly changed. We lived solely on fruit and nuts, a regime to which I had been converted and easily persuaded her to follow suit. I would have liked to influence her as effectively towards a more athletic attitude to life, for her devotion to Art, it seemed to me, was accompanied by an unbecoming and unhygienic negligence, my own leanings then being towards a thoroughly muscular philosophy; not that I took the slightest interest in 'sport' or any form of organized games, but privately loved to put my powers of endurance to the test, and practised acrobatics on my own. Women, too, I thought, should cultivate their physique, though not ostentatiously, and attire themselves with grace and dignity without bothering about the fashion too much. One of my sister's unhappy crossings in love led to a drama.

She had a great friend at the Slade, a certain girl student whom I will call Elinor. Elinor had formed a close attachment to an outsider. This young man was a curious fellow, giving himself the airs of a superman with pretensions to near immortality, but apparently only occupied for the present in some form of business. Gwen decided that this affair must be stopped: so, after failing to persuade her friend to break it off, she announced her ultimatum – surrender or suicide. I strongly disapproved of all this: Elinor's disposal of her affections was, in this case, possibly regrettable, but in my opinion, none of our business. The atmosphere of our group now became almost unbearable, with its frightful tension, its terrifying excursions and alarms. Had my sister gone mad? At one moment Ambrose McEvoy thought so, and, distraught himself, rushed to tell me the dire news: but Gwen was only in a state of spiritual exaltation, and laughed at my distress; Elinor, her former love for Gwen now turned to hate, remained obdurate. I saw there was only one thing to be done. I must confront her lover and order him to make himself scarce or – fight . . . We met.

I explained the situation and pronounced my terms. To my surprise, this superman was beaten without a blow: he crumpled up, and finally agreed to quit the field and go back to his wife: nothing could have been more ignominious – and satisfactory! The immorality of my action was justified. The drama was ended, but there was no reconciliation.

Gwen's talent and originality were not unrecognized at the Slade. On leaving the school she established herself, after various moves, in a basement or cellar in Howland Street. I disagreed with her choice of lodging, which appeared to me in every way unsuitable both for living and painting in, but I failed to convince her of this error of judgment. Fortunately her sojourn in the cellar did not last long, for soon after she decided to go to Paris, where Whistler at this time ran a School of Painting, which she joined together with her fellow students, Gwen Salmond and Ida Nettleship. Here she acquired that methodicity which she was to develop to a point of elaboration undreamt of by her Master: eventually she made the acquaintance of Rodin, who was to figure so predominantly in her life. He admired and acclaimed her gifts. 'Vous êtes belle artiste,' were the words she reported to me with natural elation. She used to pose for Rodin, for she had, he said, 'un corps admirable'. Commissioned by the Society of Painters, Sculptors and Gravers to execute a memorial to Whistler, Rodin produced a colossal figure for which my sister posed, holding a medallion of the painter. This was rejected by the Society on the advice of the late Derwent Wood, on the grounds of an un-finished arm, and instead a replica of the 'Bourgeois de Calais' was erected on the Embankment. Nothing could be less appropriate! On the other hand the figure designed for the purpose (in spite of the uncompleted arm) would have been a superb and appro-priate monument to the painter. I came upon it, neglected in a shed, in the grounds of the Musée Biron, now renamed Musée Rodin. In the Master's house at Meudon numerous other studies

of my sister have recently been discovered by her nephew, Edwin. A mass of documents found after her death include correspondence, extracts from devotional and other works with notes and meditations.

I shall quote some of these, in their faulty French, as they afford first-hand clues to her life and character. Rodin's brief letters which remain are always affectionate but constantly express his concern for her well-being and his dissatisfaction with a mode of living which he judged to be contrary to the rules of health: 'Il faudrait changer de chambre qui est trop humide et n'a pas de soleil.' 'Soignez-vous, parce que vous êtes pale.' 'Vous avez de grandes facultés de sentir et de penser.' 'Cette lettre pour vous dire de faire toujours vos promenades, et de bien vous soigner car nous poserons bientôt.' 'Je vous prie, chère amie de ne pas vous rendre malade.' 'Je suis parti à Marseilles pour 6 jours: faites ma petite amie des lettres que vous m'enverrez. Mangez bien car il me semble que vous vous négligez. C'est ce qui vous donne mal à la tête. Je me reposerai le plus que je pourrai.' 'Courage, petite amie; moi, je suis si fatigué et vieux . . . mais j'aime votre petit cœur si dévoué, patience et pas de violence.' Rodin himself appears to be often *enrhumé*, *grippé* or *fatigué*.

Gwen's friendship with Rainer Maria Rilke was also warm and close. The poet used to lend her books and help her with his sympathy and understanding.

Jacques Maritain was a neighbour at Meudon. Gwen always addressed him as 'Dear Master'. The brilliant Neo-Thomist adopted a highly authoritative tone in his communications with Gwen and enjoins complete obedience, which his pupil is only too eager to render. Exercising his English, he writes: 'Your answer is too much conceit, I don't know what you wrote at more length at first, and I am regretting you don't have sent me your first writing, since I've ordered you to tell me long and entirely

what your mind finds about that subject. I'm *sole* judge of my orders and your sole duty is to obey me' . . .

Maritain's niece, Mademoiselle Vera Oumançoff, becomes also an outstanding object of Gwen's devotion. Innumerable letters or drafts of letters addressed to this young lady display a startling mixture of romantic sentiment and Catholic piety. Mademoiselle Vera appears to have been what we call a 'sensible girl' and seeks to curb her admirer's extravagances. She might as well have tried to restrain a whirlwind.

Avez-vous réellement besoin de m'écrire presque tous les jours? Je ne le crois pas – et je crois même que c'est très mauvais pour votre âme – car vous vous attachez trop à une créature, sans même la connaitre pour ainsi dire.' 'Je sais bien que vous avez une grande sensibilité, mais il faut la tourner vers Notre Seigneur, vers la Sainte Vierge.

Mademoiselle Vera disapproved of Gwen's practice of drawing in church. Gwen to Vera:

Vous avez dit que vous ne trouvez pas que c'est un très grand péché de travailler en esprit à mes dessins pendant la grande Messe. Monsieur le Curé m'a dit que c'est un péché. Alors vous m'avez dit doucement, s'il a dit cela, c'est un péché. Quand M. le Curé me l'a dit je n'ai senti ni contrition ni peur . . . mais je ne dessinerai qu'aux Vêpres, Saluts et les Retraites. J'aime prier à l'Église comme tout le monde, mais mon esprit n'est pas capable de prier longtemps à la fois . . . Les orphelins habillés avec ces chapeaux noirs au ruban blanc et leurs robes noires aux collerets blances me charment et des autres créatures me charment à l'Église. Si je retranche tout cela il n'y aurait pas assez de bonheur dans ma vie.

A moment of revolt:

Le soir est venu: j'ai été encore malheureuse et je ne peux rien finir, même ma toilette ou la chambre. Je vais à la cam-

pagne chercher mon chat. Vous avez dit que je laisse les gens
serieux comme Miss O'Donnell pour courir après des
chimères. Oui, vous et elle sont trop serieuses pour moi. Je
n'ai plus envie de vivre. Je n'ai pas envie d'aller chercher le
chat . . . Vous êtes toujours injuste. Vous avez montré de
l'impolitesse dans l'atelier et dans la rue . . .

But now friendly again:

Chère Mademoiselle Véra, je ne vous ai pas indiqué claire-
ment le chemin à la forêt. Le voici: vous traverserez la Place
de l'Observatoire (en sortant de l'Avenue Jacques Minot), et
vous prenez la rue des Capucines; vous monterez alors la
premiere rue à gauche qui vous menera à la forêt. Après que
vous avez marché la quelques minutes vous pouvez entrer sous
les taillis à votre droit et vous trouvez des clochettes bleus.

Je ne peux pas vous dire comment il est étrange de vous
entendre parler de mes dessins . . . Si vous les trouvez malfaits,
dites le moi et je changerai de manière comme je changerais
mes vêtements s'ils vous agacent.

Vous m'avez dit que ma lettre était trop longue. Trop longue
pour quoi? Je pense que les âmes dans le Pourgatoire doivent
souffrir un peu comme moi. Je ne vis pas tranquillement
comme vous et tout le monde. Quand vous me quittez, pour
vous il y aura demain et apres demain. Tous les jours de la
semaine enfin, et en effet c'est çela qui arrive. Pour moi
c'est le dernier jour. Je ne vois pas d'autres; je ne regarde pas
en avant . . . Je suis bizarre.

Chère Mademoiselle, j'ai besoin de vos yeux mais les miens
ne veulent pas les regarder. Je leur ai dit de les regarder mais ils
ne veulent pas le faire. Je vous aime comme j'aime les fleurs.
On a de la tendresse pour les petits animaux qu'on a sauvé
de la mort, n'est-ce-pas? Vous devez avoir tendresse pour moi
parce que vous m'avez sauvé de la mort . . .

Here is a letter from a child, which I fancy Gwen found more satisfactory than those of Mademoiselle Vera. 'Orrevoir Mademoiselle Mary je vous remerssie bien je vous donne un gros baisé. Je vous remercie de vos petits fleurs je vous embrassé de tout mon coeur vous etes assez bonne pour moi. EDITH BROUYER.'

Gwen has occasion to criticize le Curé de Meudon who thought it a sin to draw in Church. 'Monsieur le Curé, a en outre, fait enlever les tableaux des Stations du Chemin qui étaient simples et de belle coloris et les a remplacés par ceux que vous connaissez. (J'ai demandé a Mlle P. si elle les trouvait beaux, les nouveaux et elle disait; "Non, ils sont plutôt *fines*!".).'

Monsieur le Curé nous prends de trop bas. C'est désagréable d'être pris de trop bas. Quand nous allons en promenade en Mai, dans le train, en autobus et au déjeuner et à gouter, Monsieur le Curé croit necessaire de nous faire rire. Il faut adapter ses histoires sans doute à l'ésprit le plus bas: ca serait difficile d'etre aussi grossiere et bête que Suzanne, n'est-ce-pas?

From a letter to a friend:

Dear Nona, my mind is suffering often with regrets that hurt me and other thoughts that hurt me and sometimes fears, and suddenly I heard your word, 'My dear, dear Gwen.' Nona, what angel made you say it? Nona, when you look at me so thoughtfully and write to me you don't know what you do. In Brittany at night I used to pluck the leaves and grasses from the hedges all dark and misty and when I took them home I sometimes found my hands full of flowers. Nona, you are like a sculptor who models the clay in his hands without thinking and suddenly he finds a lovely form.

Chiaroscuro

From a letter to me:

> I told you in a letter long ago that I am happy. When illness or death do not intervene, I am. Not many people can say as much. I do not lead a subterranean life (my subterranean life was in Howland Street). Even in respect to numbers I know and see many more people than I have ever. (Some of my friendships are nothing to be proud of by-the-by.) It was in London I saw nobody. If in a café I gave you the impression that I am too much alone, it was an accident. I was thinking of you and your friends and that I should like to go to spectacles and cafés with you often. If to 'return to life' is to live as I did in London, merci Monsieur! There are people like plants who cannot flourish in the cold, and I want to flourish. Excuse the length and composition of this letter. It is from a little animal groping in the dark . . . When you want to paint me you had better name a time to come and see me in several clothes – I have two hats for instance.

Some notes from Gwen John's papers:

May 1921

Travail immédiat, même mauvais, vaut mieux que la reverie.

BAUDELAIRE

July 1923

You are free only when you have left all. Leave everybody and let them leave you. Then only will you be without fear.

April 1927

I accept to suffer always but Rilke! hold my hand! You must hold me by the hand! Teach me, inspire me, make me know what to do. Take care of me when my mind is asleep. You began to help me, you must continue.

Pentecost, 1932

Don't think (as before) to work for years ahead – and the numbers possible – you work for one moment.

Mon cœur est comme une mer qui a des petites vagues tristes, mais toutes les neuviéme vagues sont grandes et heureuses.

Are you fortified with a new hope and thought if again the cloud descended upon you?

Don't be afraid of falling into mediocrity – you would never.

Do not be vague or wavering. Impose your style. Let it be simple and strong. The short strong stalks of flowers.

In these scraps from my sister's notes and letters there is no trace of her native gaiety and humour. They belong to a period of emotional stress and torment. Gwen John's apparent timidity and evasiveness disguised a lofty pride and an implacable will. When possessed by one of the 'Demons' of whose intrusions she some-times complained, she was capable of a degree of exaltation com-bined with ruthlessness which, like a pointed pistol, compelled surrender: but the pistol would be pointed at herself . . . Heroism knows no scruples. Though she tried to cultivate the *sainte indifference* recommended by some of her spiritual guides, success on these lines was hardly to be expected while such a heart as hers continued to beat. She may have derived some moments of peace, consolation or ecstasy besides much anguish of mind from the religion she had embraced with such fervour: but the discovery that pious people can be just as stupid, insensitive and vulgar as anybody else was inevitable and tragic. It is evident that, while a member of the religious community of Meudon, she remained, as far as understanding goes, completely detached; a lost soul but for the clairvoyance and sympathy of such people as Rilke and 'Nona'. Deciding at last to leave Rue Terre Neuve, ('cette maison est si humide; les murs suintent et des petits ruisseaux coulent des murs des éscaliers'), she established herself in Rue Babie, still at Meudon, in a kind of hangar surrounded by a terrain, containing trees and shrubs. But the sea was necessary to

her and her frequent visits to Brittany had been determined by this need. At last feeling the old compulsion upon her, she took the train to Dieppe, but on arrival collapsed. Taken to the hospital, in a short while she died. She had neglected to bring any baggage with her but, as it turned out, had not forgotten to make provision for her cats.

St Rémy de Provence

Ah! que fai bon poujà senso relàmbi
Vers soun dèsir, emai siegue qu'un sounge!
<div style="text-align: right">FRÉDÉRIC MISTRAL</div>

Ah! qu'il fait bon naviguer sans répit
Vers son désir, bien qu'il ne soit qu'un songe!

ST RÉMY DE PROVENCE, a town not very remarkable in
itself, is placed at the centre of a beautiful district. On first visiting
it I was unimpressed. It was not to be compared with Martigues,
I decided. I missed, above all, the Étang de Berre. There is no clear
water to be seen at St Rémy; on the other hand there are canals in
the region flowing with what looks like a mixture of milk and
honey. But the Rhône and the Durance are not far off, and the
rocky Alpilles are close by with an endless sequence of exquisite
landscapes. As in all French towns, the main Place is provided
with its unfortunate monument to a famous native, in this case,
Gounod. A few ambitious villas advertise the pretensions of the
local rich, but as these are partly screened behind high walls, the
general air of well-seasoned mediocrity remains predominant.
But the town is not without distinction. Within a mile stands the
Hospital of St Paul with its early church and cloisters. Here Van
Gogh was interned after his breakdown in Arles. It is said Nostra-
damus was born, if indeed he did not practise at St Rémy. A
mutilated château bears the escutcheon of de Sade. The *Antiques*,
or Roman monuments, near by display in their proportions and
weathered surfaces the authentic lines of classic tradition. The
fouilles of Glanum have already revealed something of the
importance of this Gallo-Roman town. We are at the heart of
Provence and on the track of Julius Caesar's legions.

<div style="text-align: right">285</div>

Chiaroscuro

The best way to approach Les Baux from here is by taking the road which, twisting and turning, mounts the Alpilles, until the little city of ruins comes to view across the gulf of the Val d'Enfer amidst strange formations of Bauxite protruding through the sparse soil like gigantic fungi or old bones. Some of these outcrops have been quarried in deep rectangular cavities, for this stone beneath its weathered surface can be cut like cheese. Rooted in the great mother-rock of which its shattered towers are but a prolongation, the stronghold, once the seat of an empire stretching to Constantinople, was, for reasons of State, demolished by Richelieu. But the ugly wreckage of former magnificence and power, salvaged by Time, now smiles equivocally under the maquillage of sun and wind. On first acquaintance, charmed by the remote and curious site, I thought seriously of establishing myself in one of the numerous chambers cut in the rock and still weather-proof, but I had not reckoned with the force of the mistral at this height, and still less suspected the aura of madness and violence which is said to linger where once the Courts of Love were held.

One day, entering a little wine-shop in the village, I found myself listening to a stranger who was addressing the company. His voice and manner were impressive, but though he spoke at the top of his voice I was unable to follow his meaning, for he used the Provençal tongue: hearing the name of the poet Mistral repeated, I asked the speaker if he knew this famous person, whose poems I admired, and whom I had often seen at Arles, where he visited every Tuesday the Musée Arletan, an institution founded by him as a repository of the traditional crafts and culture of the region. Changing to French, the orator informed me that Mistral was his greatest friend and if I wished he would be delighted to arrange a meeting. We then fixed a date at Maillanne. He would first of all introduce me to his own home – a 'typical Provençal ménage,' he said, 'simple but dignified and perhaps a little old-

fashioned' – after which he would conduct me to the poet's residence. At the hour agreed I arrived with my sketch-book, for I hoped to make a drawing of the master. My new friend's house and family proved disappointing. His wife and children were unattractive and their surroundings squalid. I took the man out to lunch, for he seemed in need of reconditioning. By the end of our meal he had recovered all his assurance and, indifferent to me, addressed himself to the world at large. Our way took us across some fields, my guide during the walk continuing to vociferate like a madman while gesticulating wildly. On arriving at the house we met Monsieur and Madame Mistral, returning from a promenade. After a short colloquy we were admitted, Madame Mistral, a careful Lyonnaise, first reminding me to make use of the doormat. I was then offered a chair in a corner of the poet's study while my intermediary launched out in what appeared to be an agonizing relation of his private woes; to this Mistral listened in evident discomfort. At one moment after a particularly tearful crescendo, the poet, approaching me, murmured in my ear: 'Vous comprenez, Monsieur, notre ami est un peu déséquilibre.' But I had thought so all along. Feeling at last that our visit should be brought to a close, I made the request for a short sitting before leaving, but the poet would not hear of this. 'But I am not working for the journals,' I protested. This assurance seemed only to clinch his decision: 'Jamais, Monsieur, jamais!' With a last glance at the statuette on the mantelpiece, a replica of the foul monument at Arles, I took leave of my hero, and shaking off the unbalanced one, caught my train back. Upon reflection I decided that I should have been better dressed for such an enterprise. A neat *complet*, a plush *fédora*, brown gloves and yellow shoes would perhaps have done the trick. This was by no means the only opportunity I have lost through inattention to detail. In matters of good form women are often found to be no less exigent than poets.

287

Eventually, leaving Martigues, which was becoming somewhat industrialized, we acquired a little *mas* at St Rémy to which we resorted as often as possible, that is to say, every year. In the autumn of 1939, as the clouds of war began to gather ever more menacingly, it became necessary to make a decision. The painter Derain was an *habitué* of the Hôtel de Provence. He had captured, with his brush, a neighbouring hill-village, Eyguières, and as if to defy competition, plied to and fro in his fast sports car. Derain scoffed at the idea of war. Even when the Place de la République was already crowded with horses, requisitioned by the Army, 'il n'y aura pas de guerre,' he averred, 'c'est une blague.' But the signs were all too clear. None too soon we decamped, and reaching Havre with some difficulty, we embarked at the last moment to land at Southampton on the morning of the outbreak. In the course of this journey I would, at every stop, set forth to glean the latest news. The elders of the people, in the greater wisdom associated with grey hair, sought to allay the general fears: 'On s'arrangera; on ne se battra pas': but such assurances failed to convince. On the way to Havre, while picnicking by the roadside, we were joined by a Norman farmer followed by his wife. Gravely and laconically he announced the order for general mobilization. We shared a bottle or two we had brought from St Rémy with this man (his wife refusing). The good wine, a gift from Mme Onde, and a reminder of Provence, now left so far behind (perhaps for ever), proved a blessing; we did not want to think just yet of all the news meant: the sun seemed to have darkened suddenly. We were a friendly little group of miscellaneous people, confused in origin but ensnared together in one vast web of international insanity.

In 1946 we were able to return. Conditions of living then, though not up to the old standards, were tolerable. The war had left its marks. If these were not spectacular at St Rémy, everything and everybody looked shabbier than usual. Many of the children

288

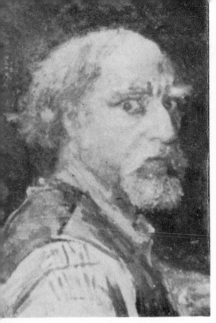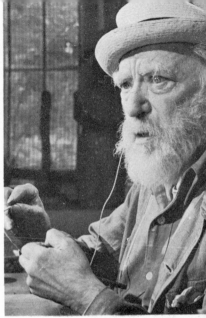

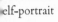elf-portrait

23 & 24 The author in later life
(reproduced by kind permission of the BBC)

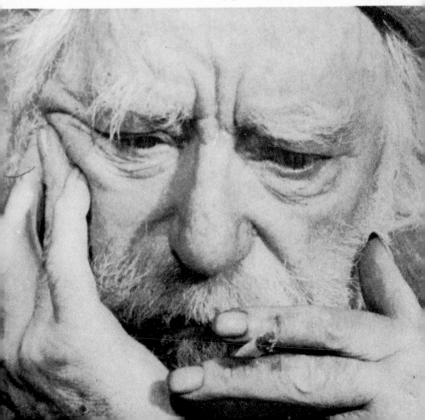

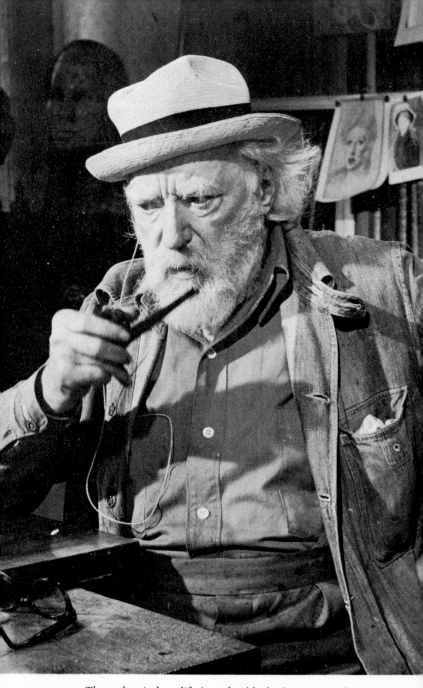

25 The author in later life (*reproduced by kind permission of the BBC*)

howed signs of privation. Living was certainly dear, yet the consumption of *pastis* in the evening seemed to have suffered no diminution. *Pastis*, a substitute for absinthe, is an infusion of herbs laced with a little cognac: on the addition of water the mixture turns muddy and tastes like cough mixture. To my mind Pernod taken in the old deliberate fashion was preferable. Our little *mas* under the rocks had been disdained by the Germans, for it had no electricity or telephone, but the G.I.s had broken into it and, in their cultural frenzy, had borne away or destroyed some of my canvases. Others, however, had been rescued by friends. On the whole, the people had little to complain of from the invaders: there had been no Gestapo at St Rémy, a place of no military importance, but the behaviour of some of our Allies and the Parisian refugees came in for criticism; the Maquisards, too, according to Madame Onde, had been 'très méchants', actually demanding the names of such women as had consorted with Germans. 'But I told them nothing,' she said proudly. 'Would they have had their heads shorn?' I asked. 'They'd have been shot . . .'

Black market dealings in a small way were winkled at, only big business on these lines arousing resentment.

At the end of the Spanish prelude to the late global tragedy, the poorer population of this agricultural district found means to dispatch a lorry of food weekly for the relief of the Spanish loyalists who, fleeing from the vengeance of Franco, had crossed the frontier, to be rewarded at the hands of French authority by internment in the atrocious camps of the Pyrenees. There are now industrious Spanish families settled happily at St Rémy and elsewhere.

The St Rémois, loyal to his father's memory, have chosen in M. Charles Mauron a worthy successor as Mayor of the town. This courageous spirit, though struck blind, has kept the deeper vision: as a man of letters he has established close relations with

English cultural circles, and has numbered among his friends and guests Roger Fry, E. M. Forster and Margaret Fry. His wife Marie Mauron, *née* Roumanille, in a growing series of novels dealing with the life of the locality, reveals a remarkable talent which places her in the long line of Provençal literary tradition.

Charles Maurras, of Martigues, was sometimes to be seen at St Rémy. As is known, the political views of this philosophe earned him condemnation and imprisonment after the war. I inquired after him of Mme Onde, one of his adherents. She assured me that, though in captivity, he was well cared for and very comfortable. Another distinguished figure now always to be seen at the Grand Hôtel de Provence is the Oriental scholar Monsieur Steinilbert-Oberlin. 'Il connait le Sanscrit; vous savez c'est la langue d'avant Jesus Christ,' remarked Mme Onde informatively. On acquaintance, this lonely old savant, with the profile of a Dante, discloses the charming simplicity of a child.

My habit of an evening usually took me to the popular resort of the town. In the various cafés I had already made acquaintance with some of the publicans and their clients. Ensconced with a medicinal *pastis* or a glass of wine, I achieved that agreeable sense of detachment-in-intimacy which the thunderous conversation of the customers, combined with the strains of the accordion, induced. I noted the grouping of the figures, the relation of the heads; and sometimes I would be rewarded by the apparition of a face or part of a face, a gesture or conjunction of forms which I recognized as belonging to a more real and harmonious world than that to which we are accustomed.

As, on an autumn evening, I ascended the road towards the *Antiques* beyond which our *mas* was situated, the fantastic rocks of Mont Gaussier rose out of the mist as in a Chinese masterpiece and I despaired of landscape painting. 'Perhaps there would be time, I thought, to pay a call on the brave Bernard and his amiable family who keep 'Le Robinson', an outlying café much frequented

on Sundays when there is music and dancing. Ordinarily the usual little circle of friends were to be found at cards. The 'Philosophe' (who keeps goats) would be there to uphold the banner of the *idéal*. No *pastis* for him but always 'un canon' (a glass of wine). Perhaps the 'Parisienne' might look in: we hoped not; she was a pretty little woman, certainly, and well educated, but making no pretence of virtue or even correctitude, her presence and behaviour were apt to be embarrassing. Soon, a short ascent by olive grove and vineyards brought me to the Mas de Galeron, standing by a group of pines on a spur of the Alpilles. The terrace of the *mas*, above an intervening vineyard, faces Mont Gaussier and the nearer rocks. Here at a megalithic table under the almond tree, we took our meals. The view northwards was wide and comprehensive. Beyond St Rémy the tall towers of Châteaurenard stood half way between us and the distant gleam of the Popes' Palace at Avignon. To the north-east rose the bad dome of the Ventoux (our barometer, for the weather prospects are judged by its visibility), and beyond the valley of the Durance, the mountains of Luberon overlooked the road to Aix.

Though Provence has recovered its ancient language, which, unlike Breton, is not yet banned by the Government, it has not escaped the corrosive blight of the Industrial Age. When I visited a prosperous-looking farmhouse, such as the home of Pierre Galeron, which seemed to promise an interior dignified by the solid and elegant productions of local craftsmanship, I suffered a severe shock. Ushered into the salon, I found myself in the midst of an appalling agglomeration of junk. These manifestations of modern domestic technology have everywhere displaced the household treasures left by a previous generation; these, long since sold, are now only to be found in museums and the collections of amateurs. Hastily confessing a preference for the kitchen, I was conducted thither and offered a ceremonial glass of wine. There is no doubt that the new style of interior decoration is

popular and greatly admired, but so, in its day, was the old. How this surprising transvaluation has come about is a matter for specu-lation, but I may remark that the phenomenon seems to be related to another widespread symptom of decadence: I refer to the sense of futility and boredom which, together with general restlessness and unease, marks the end of an epoch.

Jamaica

It must have been my meeting with the occultist Mr Robert Bruce that led up to my expedition to Jamaica: he volunteered to cast my horoscope. Having drawn up a chart setting forth my position in relation to the Zodiac and Planets, Mr Bruce retired with it for a week or two of contemplation. In the end a mental picture emerged, revealing with considerable accuracy the salient facts of my life and character and a glimpse into the near future, which promised me a visit to one of the British territories overseas. Pleased with these deductions, I would have been sorry to leave the astrologer's forecast unfulfilled and his prophetic powers in dispute. Upon reflection I decided a visit to Jamaica would satisfy Mr Bruce and perhaps turn out profitably for myself, too. Jamaica is one of the smallest, nearest and perhaps the oldest of our Colonies; the name, suggestive of rum, treacle, white devilry and black magic, attracted me. And so, on a November day, we embarked, D. and daughter Vivien, Miss Brigit Macnamara and the child Tristan, on the steamship *Arawa*, an old, reconditioned and still fairly seaworthy vessel, bound for the Antipodes via Kingston. The voyage, which usually takes a fortnight, proved longer this time, for running into foul weather we were blown out of our course, and reached our destination some days late. The buffeting of the wind, the pitching and rolling of the ship, the crashing of crockery, the profuse seeping of water through the ceiling of our cabins, formed a kind of symphony of discomfort until, entering a calmer and sunnier zone, it ceased, and we were able to air ourselves on the deck in ease and merriment. Only the grinning mask of one of my daughter's followers, who had contrived to get himself sent to Jamaica by the same boat with a commission to write an account of the Colony, while incidentally,

prosecuting his suit, marred the picture. We cast anchor first of all at Curaçao to take in oil, and the passengers were given some hours ashore. This Dutch island, though flat enough, is remarkable for its wealth of colour and the variety of its motley population. I was tempted to stay there, but the entreaties of some Dutch officials, who came aboard for a chat, confirmed me in the original plan. The prospect they held out of housing us luxuriously in their country club, far from the vulgarities of the capital, left me cold. When in my innocence I told them how delightfully we had lunched at a certain Chinese restaurant frequented by elegant young Negresses, the shocked silence which ensued convicted me of a serious indiscretion: this restaurant was not in high repute it appeared. The life and colour of Curaçao moved me deeply. As I explored the harbour of Willemshaven, flanked by many buildings in the old Dutch style, a great grey monstrosity in the form of a ship passed slowly seawards to the strains of solemn music, its decks and rigging lined by the human machinery of the crew. It was, I was told, the German battleship *Gneisenau*.

Re-embarking, we awoke the next morning to find ourselves at Kingston Docks under the shapely contours of the Blue Mountains.

I had heard of a hotel well spoken of, called Mona Great-House, situated a few miles outside Kingston. We directed our taxi thither. Seating ourselves on the veranda of the hotel we awaited with much anxiety the verdict of the proprietress: would she take us in . . . ? She would. She even allotted us a bungalow to ourselves. This suited us perfectly, for we are not very good mixers. The hotel was an old planter's house standing in pleasant grounds with a fine view across the plain of Liguanea to the mountains beyond. Flowering tropical trees decorated the little park; we inquired the name of one with snaky branches, bearing exquisite pinky-white blossoms: 'frangipani'! Near by, a small bathing pool reflected the luminous winged foliage of banana

trees: a tiny bar was presided over by a majestic Negress who, in her leisurely way, mixed 'planter's punches' or other concoctions by request: humming-birds darted or hovered amidst the bougainvillaea: lizards on the walls inflated their throats offensively: above, foul carrion birds circled slowly. The prim black servants submitted demurely to the taunts of their mistress, one of the old school; they made a pet of Tristan, whose blond curls were found irresistible. I got some of them to sit for me, and found other models. The Jamaicans show many shades of intermixture: their complexions are as various as their fruits, which they seem to imitate, assuming banana, apricot, citrus, paw-paw, mango or plum-like tints: there are some even as white as coconut pulp, but these are rare. But the pageantry of the native life is less vivid than at Curaçao. A kind of blight seems to have fallen on the island, an English blight, which has curbed the natural exuberance of its people, trimmed the native costumes of much of their style and character, and reduced the once ornamental shacks and cabins to a sober monotony of battleship grey or chocolate. Corrugated iron is never a sympathetic material; when employed as lavishly as it is in the domestic 'architecture' of Jamaica it becomes not only aesthetically repellent but even alarming as one imagines its behaviour under the impact of the next hurricane, although, at a safe distance, some might view the prospect with entire satisfaction. Kingston, with its ugly public buildings, its miserable slums, its almost shadeless boulevards (in an island noted for its peerless and super-abundant vegetation) is nothing to boast of. It has no soul, mind, or heart of its own, and is always on tenterhooks, waiting like a prostitute for tourists, or the temporary visitors from a passing ship.

Once installed at Mona Great-House we proceeded to explore the island, engaging for the purpose a car with a black chauffeur in charge. Mounting from the hot coastal belt to the temperate uplands, the country begins to unfold itself in landscapes not

unlike the best of those we knew at home; some have a park-like character but the curious conical formation of the hills generally is distinctive. Here an old-fashioned native cabin, washed in blue and pink and thatched with palm-branches, sparkles like a jewel in the shadowy verdure, and there, a fine Great-House presides more proudly over its domain.

The tumultuous peaks and ridges of the Blue Mountains could be paralleled though hardly surpassed in Scotland or Wales. As we moved from one district to another, the physique of the inhabitants seemed to change, as if the integrity of the tribes from which their ancestors had been recruited was still preserved. Was I wrong in thinking I could detect in some remote communities a strain from the exterminated Arawak? The beauty of the island views at many points defies description unless by the pen of Lafcadio Hearn, who, in his book on Martinique, was able to supply a word for every hue and shade. Montego Bay, though too fashionable for our taste, justified its reputation for those who like swimming, but apart from the hotels, the town was of the usual squalid ramshackle type, though not without interest for a wandering artist. Driving back along the northern coastline we tarried at a pleasant inn situated in a mangrove swamp. Here we were regaled with the fabulous tree-climbing oysters – these were small but of excellent flavour. At Ocho Rios our road took us through fairy woods rising from a bed of gushing torrents, and thence up a long and deep defile between perpendicular cliffs hung with a luxuriant and exotic vegetation. Such scenes reminded me of the dream-like vistas of *Paul et Virginie* on a similar island. Subdued by their magic, I seemed to catch some of the wonderment of Columbus, a whiff of the buccaneers and a momentary glimpse of the original Rima. Finding an attractive and lonely spot called Robin's Bay, we took a bungalow and stayed there some weeks. Near by a club house, frequented in the evenings by neighbouring planters, offered its amenities. I found more

models here, including some pretty East Indian girls. The East Indian settlers had been imported along with their cattle. It was a fine sight to watch the handsome beasts herded by boys galloping on ponies while blowing their conches in classic style.

At dusk we sometimes heard from afar the mysterious liturgy of the drums. I had listened at Montego Bay one night to a very strange and alluring kind of music proceeding from a strolling band of unseen players. That the Jamaicans possess the artistic faculty is proved by the decoration of the gourds they sell to tourists. They have admirable wood-carvers, too, and a few sculptors of merit. At the fashionable cabaret, the 'Silver Bucket', the best show I saw, by a long way, was put on by a native company of dancers, singers and comedians. But such evidence of talent, if not discouraged, is looked upon with at best an amused and contemptuous indifference. The superior race, with few exceptions, takes little interest in the population of the Island, except as affording an inexhaustible supply of cheap labour. The blacks, lacking political organization and business ability, are at the mercy, for the most part, of the United Fruit Company, a 'benevolent tyranny' with its roots in the U.S.A. All the principal shops in Kingston are in the hands of Syrians, Chinese and Jews. Having made the acquaintance of one of the leading exporters of rum, I suggested the advisability of establishing a *Jamaica House* in London where his famous commodity would be dispensed, together with other products of the Island, including its excellent cigars and the best coffee in the world. I envisaged a handsome Jamaican *décor* executed by or from the designs of local artists or craftsmen, with views of the Island, and a selected staff of coloured servants attired in the traditional West Indian fashion. I would have been keen to lend a hand in this enterprise for I had no doubt of its success. Such an establishment, I argued, in the heart of London, would 'put Jamaica on the map'. Though the idea attracted him, this gentleman failed to do anything about it. As if

overcome by the languor of the tropics he found himself incapable of the initial effort demanded by the scheme, and preferred to sit back and dream in the odorous seclusion of his spacious dockside Bar, where I left him.

Pokomanya is the word used to designate the peculiar religious practices of the more primitive people of Jamaica. In these ceremonies the cult of African witchcraft (white or exorcist) is combined with a form of Baptist doctrine. The meetings we attended, thanks to the good offices of a talented Negro sculptor, were held at night in a large barn half open to the sky, placed in a spacious yard in which stood an immensely tall bamboo pole. Within the tabernacle the spiritual leader, or Shepherd as he was called, sat at a table upon which lay a large Bible. At his right hand was seated a row of Negro damsels dressed in white satin with great white turbans on their heads. These were called the Revivalist girls, and were accredited with special sanctity. The congregation gathered round, leaving a wide rectangular space in the centre. The service consisted of hymn singing, readings from the Bible, a discourse by the Shepherd, more singing and a queer form of dancing. The singing was led by the turbaned girls who accompanied it with the rhythmical motions of the arms. A kind of sistrum was used too. Now and then, one of the girls, rising, would stagger into the centre with glassy, unseeing eyes, and perform, as if under a spell, a hesitating dance. She 'had the Spirit' . . . Among the congregation a worshipper would sometimes suffer a more violent seizure, and crouching like a beast, give vent to inhuman cries. The Shepherd rebuked such a one and at his bidding she was led away: 'We want Peace, not turmoil,' he said. The service over, all left the barn to gather round the bamboo pole outside. Now the Shepherd, a powerful black, was robed in vestments of crimson and gold by his attendant women. His flock then circled in procession round the pole, some holding banners and many, adopting a crouching position, emitted rhythmical grunts. Next,

the Shepherd, divested of his robes and almost nude, performed a remarkable feat. At a sign he suddenly began revolving round the pole in a wide circle at great speed, at the same time turning rapidly on his own axis. After an unbelievable time, he came to an abrupt halt without a stagger. Perspiring freely he was rubbed down and reclothed by the female acolytes. I noticed the circling of the pole was performed 'widdershins'. On one of our visits a kind of ritual drama was enacted, though I couldn't follow its meaning. It centred round the figure of a young girl and might have been an initiation ceremony. A chorus of maidens accompanied the chanting with rhythmic and violent bowing up and down from the waist. Repeatedly the priest or Shepherd assumed, with his attendants' help, a change of finery. The proceedings were interrupted unfortunately by the catechumen, who, now stripped, was seized with the 'Spirit' and had to be hurried away shrieking. The whole performance was conducted with perfect decorum and even reverence, though I heard expressions of disapproval from some sophisticated young men in the background. For my part, I could imagine no better way of passing an evening and was deeply stirred. I was not lucky enough to witness the baptismal rites by the riverside which, I was told, took three nights to celebrate, and left some of the assistants prostrate for a week.

The *Obeah* man is much resorted to in the Island, for his ministrations are found to be more efficacious and cheaper than a white doctor's medicine.

Who can begrudge these simple folk their naive beliefs and customs? They are immemorial and belong to the childhood of the world. The gymnastics, performed with such astonishing endurance, skill and gusto, seem at any rate to demonstrate the ascendancy of spirit over matter, and if the yellow fever is seen to subside under the potency of some witch's hell-brew, why worry?

Another interesting spectacle was the annual commemoration of the death of Hussein by an East Indian colony in our neighbourhood. At the appointed date a procession of these people was seen approaching to the sound of music and chanting. A great structure of coloured paper in the form of a stylized shrine or temple was borne aloft: the procession halted in front of the hotel, and the last combat and death of the Prophet's nephew was enacted ritually. This dance or ballet was beautifully performed with the principal role filled by a young man of perfect physique. The women, disposed by the roadside, joined in with intermittent singing.

At an out-of-the-way spot called French Bay we found a little, newly established hotel where the food and cooking was surpassingly good. The proprietor, a young man as *soigné* as the fare he provided, would have passed muster in any gathering of Bloomsbury aesthetes: but such refinement is not unusual in Jamaica, where even the photographers habitually gild their toenails.

Here I could bathe in complete freedom and swim out undeterred by warning shrieks and gesticulations from the beach. The stories of sharks and barracudas I had heard seemed to me mythical and I saw none of these terrors. The village near by was largely inhabited by descendants of the followers of Prince Charles Edward banished to this island after his defeat in the rebellion of '45: these luckless scions of a prouder ancestry now share the common squalor of the Negroes, but in their abjection still bear discoloured traces of their breed. It was surprising to hear in these surroundings the remnants of familiar ballads and folk-songs sung to the guitar. My companions now took their departure, leaving me to stay on as long as I liked or as weather permitted. I was anything but satisfied with my efforts and felt compelled to continue them at least till the coming of the rain. The people I was interested in seemed always aloof and difficult of access.

The room I was given to work in was unsuitable. Perhaps the proper course would have been to build a house of mud, mahogany and palms in a village by the sea, and become one of the villagers; but this would take time, and the rainy season was approaching. I was handicapped by my colour too, and still more by the invisible impediments of memory and habit: meanwhile I was tired of being treated as a kind of pukka sahib by my coal-black chauffeur, himself a monument of respectability. I thought of trying another island, Haiti, Martinique, Guadeloupe? But means of transport were few and precarious.

In my idle day-dreams I imagined myself heading an uprising of the Island, driving the whites, the good Governor and all, including a number of my new friends, into the sea, and in-augurating a reign of Harmony in this potential Paradise; could I count on the Maroons? There were rumblings of discontent to be heard. I saw trouble ahead but as yet no Bustamente had risen. A group of the local *intelligentsia* visited me. In these, the famous Negro nonchalance, once the protective colouring of the slave, had given place to a thoughtful perplexity. Although I had not been able to find a book worth reading in Kingston, they had evidently discovered means of instructing themselves: they were in error in taking me for a Member of Parliament, but not in enlisting my sympathy. Their disclosures were disquieting. The housing situation was abominable. A general wage of ninepence a day was inadequate for a married man with a family. Under-nourishment was sapping the vigour of the people: disease was rife ... etc. I had heard it all before. What could I do about it? At least I could pass this information on. It was easy to prate of solidarity, and so on: not so easy to expound the doctrines of a political theory which included the whole world in its purview. Such academic formulas as I could quote, with the addition of a bottle of rum, were all I had to offer my guests. As they took their

leave I perceived something in their eyes which might have been a gleam of humour, or hope – or just a tear . . .

And now the rainy season was beginning and I had to think of departure. With the rain a great gloom descended upon me, almost depriving me of volition. An immense effort was needed to book a passage and pack up. At last I found myself aboard a fruit-boat bound for Southampton. In the English Channel orders reached the captain to divert our course to Rotterdam where the passengers were to be transferred to a Dutch boat and so conveyed to Greenwich. On boarding the new vessel a strange elation took possession of me; an intoxicating sense of relief! No more excruciating meals at the captain's table, no more talk of cricket – that good man's sole topic – no more tramping round the deck with my friendly German fellow-passenger. In this Dutch ambience I felt at home. Hailing two ladies with whom I had scarcely exchanged a word during the voyage, I insisted that they dine with me after a few preparatory glasses of *Bols* or 'eye-balls' as one of my guests ventured to call them. She had taken a round cruise to the Caribbean while writing a novel: had gone ashore with the captain but once at Vera Cruz to watch a cricket match, and so home. I felt now I should have cultivated her earlier.

I was a little disappointed by the appearance of England at first sight. It was too early for one thing and my country was not looking its best. Perhaps I should have warned it. My return appeared to be like that of too many soldiers home from the war, inopportune; only in this case, the girl I had left behind me was on the wrong side of the ocean. I would have to readjust myself somehow before going much further. But it wasn't going to be easy, with the frangipani, even at this distance perceptibly in blossom, the sound of the surf of Treasure Beach still in my ears, and my last 'planter's punch' as it were, but half begun.

Monty

FIELD-MARSHAL MONTGOMERY wrote to me at the end of the Second World War asking me to paint his portrait. I replied that I would be proud to do so and the first sitting was arranged. The familiar figure appeared at 33 Tite Street punctually at the time agreed. He was dressed in his usual field uniform with the famous beret and a dazzling series of decorations on his chest. He was accompanied by a young A.D.C. The portrait started, and the next sitting fixed, the General departed. A crowd had somehow got wind of the hero's presence and he was well cheered as he entered his car. The picture after three or four sittings was beginning to take shape, when the General one day, mentioning Bernard Shaw, said he'd like to meet him. I said I would try and arrange this with Shaw, and wrote to him accordingly. The General offered to send a car to fetch Shaw and take him home after the interview. Shaw consented to meet the General, for he admired success more than anything. Any man who knew his job could be sure of Shaw's approval. Though I grudged the time this meeting was going to take up, for I knew 'Monty' couldn't spare me much more, and I certainly needed all I could get, I hoped to be able to proceed with the work during the interview. I was mistaken. At the appointed time the old warrior mounted the stone stairs to my studio on the third floor, and I found him at the door, erect but a little exhausted after the climb. I put him in an armchair before the General, who, sitting in his usual place on the dais, vainly attempted to keep his pose. After a few minutes to collect himself, Shaw launched forth on a disquisition which lasted an hour by the clock. 'Monty', if once or twice he tried to get a word in, was, as it were, brushed aside. In any case sociology wasn't the General's strong card. I beckoned the A.D.C. to

303

approach and listen to the words of wisdom: it was the chance of a lifetime. Myself, enthralled by the steady stream of cerebration issuing from the lips of the Sage, had to give up all thought of painting, even if my sitter had kept his pose (which he hadn't). Only once I butted in. The orator, having, it seemed to me, pretty well reviewed the whole of history, with special reference to Napoleon and the military art, reached, I think the subject of Communism, when I intervened with 'What about Anarchism?' Shaw, turning towards me for a moment, answered, 'All Artists are Anarchists.' I crowed with delight at this and the discourse was then resumed till, his hour being up, the Philosopher rose and after shaking hands all round, departed. It had been a wonderful performance. If only I had thought to have it recorded!

Half Way House

This must be about half way on my retrospective journey and high time to call a halt. By fits and starts I have retraced my steps from childhood, but leaving, obviously, much time unaccounted for and a multitude of events unnoted. Though I am concerned to tell the truth, this is not so easy. Truth is not arrived at by means of a catalogue of one's deeds and misdeeds in exact chronological order: I wouldn't be able to supply this anyhow for I have never kept a diary. The communication of truth is atmospheric as well as factual. Since (fearing reprisals) I am not accustomed to lay bare my heart to the first comer or, indeed, anyone, I have refrained from touching on matters which concern hardly anyone but myself, and will be content if I have succeeded in establishing a friendly and discreet relationship with my readers, even at the risk of disappointing some of them by failing to provide more intimate and sensational fare. In any case I would be the first to be horrified by a *succès de scandale*. I am aiming higher. True as far as it goes, this broken narrative can only be a rough cross-section of a part of my career, illustrated by a few typical episodes and varied perhaps by too many random reflections on life in general. No doubt everything comes out in the wash eventually; but I see no reason to anticipate this process and spoil other people's fun. The lacunae will be filled in according to taste by experts requiring no exact data for their discoveries.

Chronology is not my strong point. The landscape I look back upon is often hazy, but where the sun breaks through the clouds, bright patches appear, revealing scenes vignetted as in a crystal ball: sounds, too, reach my ears from afar; sounds of laughter and tears, and of strong sweet voices singing hymns in Welsh.

Age may not improve one's memory but it brings no diminu-

tion of sensibility along with its other consolations, which include the privilege of standing a little apart from the general turmoil. It may be that one is thus better placed to contemplate the noisy game of life, and judge more accurately the issues in dispute: from here, assuming that the sacred fire still burns within us, may we not catch fresh glimpses of the immortal Form, eluding us so long, yet still to be pursued? The lineaments of that more than real Presence are to be traced in trees, rocks and pools, in earth and sky and everything that lives.

To extract a pattern from this wild abundance, the student, exercising his trained faculty of choice, separates the elements required for his purpose and reassembles them in equilibrium according to the space at his disposal. This sounds easy enough but calls for much preliminary thinking out and experiment.

My own difficulties have not been lightened by scientific method. The ruined canvases which encumber my studio bear witness to a sad lack of system. Foresight, calculation, patient planning have not been within my grasp. I was never apprenticed to a master whom I might follow humbly and perhaps overtake. Without much thought I act on the impulse of the moment. Such impulses are often destructive.

Today photography brings before our eyes, in endless profusion, the artistic products of every time and land, to feed, excite and bewilder our imagination. Such rich and varied fare may lead to ill results unless we are accorded an extra allowance of years for its assimilation. As we cannot count on this priority, we must seek the corrective in an immediate return to Nature and simplicity: thus may we find fulfilment as, abasing ourselves, we drink at the inexhaustible source of all goodness, truth and beauty, besides many less desirable things.

An early, heroic phase, followed by one of crypto-erotic romanticism, which in its turn gave way before fresh illuminations derived from several sources, but all converging towards a

super-realistic view of life, reached a high point in my discovery of *Leaves of Grass*. I found Walt Whitman intoxicating! Here, I thought, was my Poet! Henceforth I was to live for Freedom and the Open Road! No more urbanity for me, no more punctilio, and, as for clothing, according to my Golden Rule, the 'importance of appearances' insisted on at home, already had made my neglect of them a duty. But now a new kind of exhibitionism was born; in its way, as exact and conscientious as my father's cult of the clothes-brush: a kind of inverted Dandyism. If my shoes were unpolished, they were specially made to my own design. If I abjured a collar, the black silk scarf that took its place was attached with an antique silver brooch which came from Greece. The velvet additions to my coat were no tailor's but my own afterthought, nor were my gold earrings heirlooms, for I bought them myself: the hat I wore, of a quality that only age can impart, might have been borrowed from one of Callot's Gypsies, and was as a matter of fact a gift from one of their descendants. My abundant hair and virgin beard completed an ensemble, which, if harmonious in itself, often failed to recommend me to strangers.

'Méfiez-vous des hommes pittoresques,' said Nietzsche. My appearance at that time would have aroused his worst suspicions. But in course of time, growing tired of my exceptional visibility, and the hostile demonstrations of small boys, I once decided to disguise myself so effectually as to pass unnoticed anywhere; *I bought a bowler:* but this, I found to my astonishment, only made me more conspicuous than ever. I hastily discarded a form of headgear which evidently didn't suit me and would have only led to trouble.

The early sans-culottism was succeeded by a higher form of anarchism, vehement only in a growing apprehension of the corruptibility of Power, and the moral bankruptcy of the masses, since, Esau-like, they have bartered their birthright for a

mess of pottage, which is about all the Vote amounts to. I was too shy (perhaps too fastidious) to join in public demonstrations, but one solitary gesture may be worth recording. This occurred at a public dinner at Liverpool, given by the protagonists of the future University to their wealthy supporters. When, as is customary, the King's health was proposed, I remained seated. This piece of ill-manners will be, and was, condemned by all, but it took a bit of doing. (Incidentally, I may say that my relations with the Family have since been of the happiest.)

My discontent may not have been divine, but it was anything but materialistic. As a schoolboy I suffered from grave short-comings: my geography was excellent but my history weak: if my spelling was faultless, my sums always came out wrong. Political economy did not enter into my curriculum: if it had, my response would have been only lukewarm. No figures but human ones interested me. Almost from the start I seemed to recognize Man to be the Measure of all things, though I had no Greek.

Women, as exemplified in the smart set of my Tenby days with their wasp-waists, boaters, bustles and walking-sticks, presented a difficult problem. These good-timers bore no family resemblance to the Blessed Damozel, nor could they possibly be included in the wistful population of Burne-Jones's dream-world: yet they were contemporaries . . . One saw beauties of course, but of a very odd shape. It was no use looking for them in the marshes though: they happened in church or on the Promenade. Secretly fascinated as by the Devil himself, I did not know then that the Artist can only legitimately occupy himself with visible appearances, even when these are distorted by fashion. Moral sentiment corrupts the young. Children are the first to lose their innocence, artists the second: idiots, never.

The line of lawyers from which I spring, weakened apparently by repetition, seems to have exhausted itself, and in a final spasm, brought forth a kind of recidivist, throw-back or survival of an

imaginary golden and lawless age . . . But there is no need for alarm: the monster is amenable and responds to kindness.

My early fear of policemen (and of nobody else except girls), though still latent, is now masked under an air of innocence, which comes natural to me: I have even made some good friends in the Force. Contrary to the code of the stevedore Fitzgerald, policemen are not all unpleasant characters, and shouldn't be attacked indiscriminately. They have their orders. If it be true that the Law is a 'hass', the philosopher has all the more reason to keep out of its way. I have rarely been on the run myself, but when encamped on Dartmoor I always bore in mind the possibility of sheltering, if only for a hour or two, some exhausted fugitive from 'Justice'. While on the subject of Law, it is to be noted, if I am not misinformed, that the Common or Customary Law has been robbed of its natural elasticity and popular character by codification. This, it appears, instead of diminishing, tends to increase delinquency. Some important phases of Chinese history support this view, as do the lessons of anthropology; according to Kropotkin and Sir Arthur Keith, the behaviour of many animal groups shows, without a trace of central authority, striking examples of order, stability and collaboration. 'Go to the Ant, thou Sluggard, consider her ways and be wise.' Without proposing to imitate ants altogether, the present state of human society is, I think, giving rise to much misgiving, and we begin to suspect that some bogus political principle must be at the bottom of it.

Finishing Touches

Half Way House

THE above heading must not be taken as indicating my actual situation, which of course lies much further ahead; but I use it as a convenient metaphor, since from this point, before I reach the dark barrier ahead of me, I have as far to go again, in retrospect I mean. This barrier I mention is the Virgin Forest I must traverse if I am to gain those distant heights I see above the tree-tops: would these be the Delectable Mountains of which another traveller has told, and can that be Beulah-land I see beyond? I wonder ...

* * *

The Inn is closed, and though refreshed I am in no hurry to take the road. I sink into a bed of heather and dream. In my dream I seem to stand at the end of a long gallery, of which the windows on one side are hung with tattered curtains and some are boarded up; but through a few of them the light shines unimpeded, to illuminate a series of tapestries upon the opposite wall. The designer of these, it would seem, under a more powerful compulsion than mere obedience to the accepted rules of good taste, but rather as if inspired by the whispered adjurations of a private demon, has assembled elements of a surprising incongruity, which perplex when they do not offend the beholder; and yet at a certain distance they resolve themselves into a consistent and harmonious pattern. In one panel Beauty smiles derisively in the embrace of Satyrs, while Homeliness, gathering her skirts, prostrates herself before the throne of Eros. In another, old men are observed to dance together, but the young, disdaining pleasure, seek to climb impossible cliffs. Here, issuing from a

crowd of drunken peasants, a Fairy bounds into the air, and with her starred wand imposes upon all her Empire of Illusion, while at the same time a professional clown, made up in the likeness of Divinity, pokes his head through the sky and winks ... Children without the least sense of propriety disport themselves everywhere. The landscape, consisting mostly of brown paper rocks, is decorated with dwarfed trees bearing preposterous flowers, and, above, diaphanous clouds swim like fish in a pond. Many of the compositions are unfinished or partly rubbed out, but all strike me somehow as vaguely familiar, as if I had been there before sometime ... long ago ...

* * *

To change the slide:

I find myself in a dusty lumber room, seeking treasure where it is least likely to be hidden. In a corner I come upon a decrepit bureau. Pulling out an obviously secret drawer, a packet of old letters and picture postcards and post-dated cheques is disclosed. These may be worth looking through, for I must have once considered them worth keeping; perhaps a few of them may still have interest and will help to fill a gap or two in this hotch-potch, or by association revive old memories upon which to draw, for the purposes of what it pleases me to call my

Magic Lantern Show

Behold a youth setting forth into the world to earn a living. He carries a portfolio and a small case to hold his few necessities; a copy of Shakespeare's *Hamlet* is included among these. From time to time he stops, consults this volume as if it were a guide book, and then proceeds more resolutely on his way. Who can it be? Reader, not to deceive you, this youth is, was, or will

314

be myself ... I had been commissioned to do two drawings through the intermediation of a fashionable lady of Hampstead whose husband's acquaintance I had made. Before going further, I will give a short account of the circumstances of this young man's brief appearance on the stage I sometimes trod myself. George, for that was his name, was, it was generally agreed, on the threshold of a brilliant career. In addition to his native gifts enhanced by academic training, he was understood to be well connected and to have great expectations. How he and Will Rothenstein had come together I do not know, but no doubt the attraction was mutual.

Rothenstein at that time was living in Church Row, Hampstead, where he and his wife Alice were in the habit of entertaining a small elite of writers and artists of their acquaintance. Among the habitués usually to be seen at the time I am speaking of were Joseph Conrad, Cunningham Grahame, W. H. Hudson, and sometimes W. B. Yeats, if not George Moore himself. These stood for Literature. Art, or more precisely the New English Art Club, would be represented by Wilson Steer, Henry Tonks, Charles Conder and Walter Sickert and our host himself, while as odd man out Max Beerbohm, although he misrepresented everybody, was claimed and acclaimed by both sections.

These symposiums were notable for a discreet cheerfulness. It was as if the participants had been able to bring with them only a moderate provision of good spirits, which, in order to last out the evening, needed careful husbanding. If Cunningham Grahame were inspired to contribute one or two of his funny Scottish stories, he could be depended upon to clothe them decently under an impenetrable layer of dialect. There might be ladies present ... There was always Alice Rothenstein. Her comprehensive smile seemed to entoil everybody in a common enchantment. This was the nearest we got to intoxication, for our host's rule of austerity prohibited any closer approach. Aware of this, I used sometimes

to visit The King of Bohemia on my way up the hill. The name of this pub attracted me powerfully and its magic was not belied by the quality of the liquor to be obtained within. Thus, after a salutary draught or two, I arrived to face the refinements of Church Row in better fettle, though sometimes a little late.

Rothenstein's new recruit, though only just recovering from the nervous breakdown following his recent marriage, seemed to enjoy the fresh and easy-going character of these gatherings, an atmosphere no doubt very different from the climatic conditions of the homelife to which he was as yet uninured. Under the stimulus of Will's tireless ebullience, which however did not conceal an undercurrent of seriousness (in the passage of years to become more and more marked), he began to expand and blossom forth himself, in a style combining scholarship with an attractive diffidence and humour. He felt perhaps that here was a means of escape from the insidious encroachments of domesticity, and accordingly attached himself to Will Rothenstein with the desperate haste of a man caught in the quicksands. This led to close intimacy, but never, I believe, to any relationship exceeding the bounds of propriety. The liaison was of the spirit. Will, on his part always on the lookout for signs of intelligence, especially in his admirers, took George, so to speak, to his bosom, and constituting himself his mentor and guide, put him to forced marches on the Heath, but only under the closest supervision. This discipline, which might have suited a taller and stronger man, soon began to tell on the novice, who, sadly out of training, found himself out-classed at all points, with his toes, his morale and his mental equilibrium all in danger. As he gave ground under the pressure of Will's dialectic, their progress began to take on the form of a succession of spirals (in imitation it would seem of the upward flight of the greater birds), allowing me from my station in the background to regain, by a short cut, contact at each point of intersection: but I soon fell comfortably behind ... On such

occasions Will was at his most formidable. Released from the difficulties of painting, of which he so often complained, his spirit was free to soar beyond the reach of an intractable brush and the maddening problems of light, into regions of pure speculation, whence he would look down on struggling humanity as from the top of a tower; not, it is true, with the majestic calm of his friend Rabindranath Tagore, but with the understanding, tolerance and humour of one who had himself, as the saying is 'been through it'.

Life, golden and mysterious Life, was ever the object of this Prospector's quest. The mastery of Life! Was not that after all the ultimate meaning of Philosophy? Even Art came second to this, and Business, of course, only third.

Sad indeed for all who knew him was George's untimely collapse under Will Rothenstein's tutelage; but the tragedy fell, I fancy, most heavily on the senior partner in an association which meant so much to him in the present and promised so much more in the future. Alas! Now no longer could he envisage with complacence the hour he was preparing for, when, his task ended, he could safely hand over his Torch to the beloved disciple and so, turning his face to the wall, murmur his *Nunc Dimittis* like a Christian …

To return to the drawings. The work I had undertaken meant a journey to the west of England. My first stopping-place proved to be a magnificent house standing in a great park. The lady of the house (who was to be my model) received me graciously and with an absent-minded gesture poured me out a cocktail. I was at once struck, even awestruck, by her beauty, but was just saved from complete intimidation by an air of naivety which, I think, almost matched my own. A pretty young girl at her side greeted me, too, but without warmth. Perhaps she held the old-fashioned view that artists should be kept in the kitchen when not at work. If this was the case, I was inclined to agree with her. Dinner that

317

evening I found, like all the subsequent meals, was a gloomy business. An atmosphere of excruciating boredom seemed to pervade the whole establishment.

Next day I commenced my drawing, and after two or three sittings produced something which I thought passable, and which elicited the languid approval of its subject. Before leaving this house I was taken upstairs by my sitter and shown a private chapel she had contrived under the roof. This was pretty but not, I thought, quite convincing. Perhaps in the absence of a husband who, it appeared, was always away – shooting – life in this remote place had its dull hours and so the lady took to a mild form of religiosity as a means of lightening the little cloud of melancholy which hung about her, and which, in my opinion, only added to her charm. Within the wall of her sanctuary I noticed a recess which, at a glance, might have been a boudoir or a confessional – or both; but I had no time to investigate this feature, for I had now to move on to my next assignment. Here I found myself in similar surroundings but in an atmosphere less tense with hidden drama. My new hostess was no less amiable than the first, but kept no supercilious girl at her side, nor did she betray any symptoms of the 'blues', but she had one thing at least in common with the other, in that her husband, too, was away – shooting ... The drawing done, I returned to London with two cheques in my pocket. These were perhaps my first professional earnings, but I was the richer in more ways than one.

A Bang on the Head

WHILE I was a student at the Slade an event occurred to which was attributed undue importance at the time. It may now prove amusing to recall it. I had returned to Tenby for the summer holidays. I might have been about sixteen years old. One day my father and I took a walk along the beach to Giltar Point. I intended to bathe and took a towel with me. The tide was far out, but on the turn. Exploring this unaccustomed bathing place, I found a rock which offered, I thought, a good take-off. The water below appeared to be deep enough for a dive, but was by no means clear, the surface being encumbered with seaweed. Still, taking a chance, I stripped and made the plunge. Instantly I was made aware of my folly. The impact of my skull on a hidden rock was terrific. The universe seemed to explode! Yet I wasn't stunned. Perhaps the cold water saved me for I was able to get out of it, replace the flap of scalp I found hanging over one eye, tie the towel round my head, dress and rejoin my father, who was much alarmed by my plight. We made for home as fast as we could, but did not take the nearest way up the cliff, for that would have probably meant publicity which was at all costs to be avoided, but we ascended by zigzag steps further on, which permitted us to cross the Esplanade quickly and gain our house beyond more discreetly. I was feeling now decidedly weak and went to bed to await the doctor. When he arrived I was surprised and pleased to recognize, not our usual practitioner, but Dr Lock, a much more exciting personage. I had often admired him as he drove past in his smart gig, attired for the occasion in a style as sportive as it was appropriate, or on foot taking his 'old-fashioned' sheepdogs for a run. He had a strong handsome face and looked superb and perhaps a trifle haughty in his loneliness, for I never

319

saw him in company. Could he have been under some cloud? I wondered. Certainly there was gossip. From what I overheard, this gentleman had been involved in an affair of the heart, which actually culminated in an elopement, but not a very serious one (which made it all the worse), for the fugitives got only as far as the next village, where, on second thoughts, they decided to renounce the project and return, the lady to her teeming family, the doctor to his dogs. This reasonable Don Juan was now engaged in thrusting an apparently very blunt needle through my scalp, an uncommonly thick one, it appeared (a circumstance to which I probably owed my life). The stitches held, there was no concussion, and in due course I was discharged cured and returned to the Slade, wearing, to conceal my wound, an out-of-date smoking-cap of black velvet with gold embroidery, produced by my father. My entry into the life room thus attired caused a sensation which my subsequent performances with a stick of charcoal only increased: and thus was born the myth of my *genius*, due, it seemed clear, solely to the bang on the head I had incurred while bathing. This, it was thought, had released hidden and unsuspected springs ... It was all nonsense of course; I was in no way changed, unless my fitful industry with its incessant setbacks, my wool-gathering and squandering of time, my emotional ups and downs and general inconsequence can be charitably imputed to that mishap.

* * *

It was time to leave the Slade and set up as a real artist. As Evans and McEvoy were just as hard up as I was, we decided to club together and take a studio in Charlotte Street, and as we couldn't afford models we sometimes posed for each other. This studio was quite small, too small in fact for three students, but we spent a good deal of time roaming about the town with our

sketch books. In the evenings, whenever we could afford it, we
went to the music halls. On Sundays, when I was usually alone, I
often used to go to Hyde Park and listen to the orators and watch
the people. There was to be found then a far greater variety of
character than can be met with now. What must have been the last
tattered remnants of the Strolling Players would give performances
of an Elizabethan crudity and charm, while amidst the crowd
philosophers would engage in subtle disputation. Wisdom rubbed
shoulders with buffoonery; heresy with orthodoxy; the sacred
with the profane. But all this was long ago, before the bobbies
had cleaned up our civilization and forced us to be good.

I used sometimes to paint all night. The landlady informed my
friends that she had been awakened one night at about four
o'clock in the morning by vague noises. She got up, lit a candle
and explored; seeing a light under my door she entered, to find
me at work. 'Oh, Mrs MacGilliveray,' I had said with simplicity.
'I'm painting my Adam and Eve!' ...

My next move was to Albany Street near Regent's Park. The
studio here was lit by a skylight and resembled a ship's cabin
except for the absence of port-holes. I had it all to myself. The
landlord was French and so was his wife, who was young,
beautiful and had golden hair. I saw little of her till she came to me
one day in great distress, weeping, for she was in deadly fear of
her elderly husband, who, she said, might beat her to death. But
what on earth could I do about it? The husband next confronted
me, hopping mad. I don't know what he said. He was quite
inarticulate. I don't know what I said either, but at least I kept
calm. At last he took himself off, though still spluttering. Never
have I met such a flagrant case of outraged impotence! I pitied
his young wife, and perhaps, if I had had money, I would have
taken her away to safety. In any case, that I think is what I ought
to have done. But soon after I left the studio, and with regret lost
sight of this ill-matched but interesting couple.

The Girl with the Flaming Hair

IN QUEST of a model, I made the acquaintance of a young woman late at night in Tottenham Court Road. She had hair of flaming red which contrasted, I thought pleasingly, with her pale mask of a face. She appeared to have no regular work, and readily agreed to sit for me. Uneducated, her conversation was somewhat rustic, but it was unaffected, original and often humorous. We became quite friendly as the work progressed. Such was her good nature that, though God knows poor enough herself, she would sometimes offer me a pound or two if she thought I needed it.

One morning, during my temporary absence, my model dropped off to sleep on the divan. On returning I received a severe shock. There lay the familar figure, but something terrifying had happened to it. The head seemed to have been replaced by a barber's pole, hairless, featureless, and in this connection horrible beyond words. Cerebrating wildly, I had to dismiss the idea of a practical joke. There could have been no substitution. I kept no lay-figure in the studio. As I gazed round in my perplexity, I quickly discovered the explanation. There half hidden on the floor by the divan, gleamed the ruddy locks of my model's chevelure, her chief, perhaps her only glory .. After all, then, it was only a wig, which becoming detached, had fallen while its owner turned face downwards in her sleep, thus exhibiting the gratuitous indecency of a denuded occiput.

Great was my disillusionment. A judicious touch of the toe followed by hasty retreat, sufficed to bring the sleeper to her senses, and on my re-entry after a few minutes I found her awake and smiling, and busy with the arrangement of her hair which had naturally got a little tousled.

Though my model was now looking her best again, I felt strangely loth to continue my work that day. Perhaps the state of my nervous system, overwrought by what had passed, precluded that moral detachment and calm which my work required. I could not blind myself to the difficulties now facing me. How, to begin with, could I hope to dissimulate successfully my knowledge of the awkward secret? Why, indeed, should it be necessary to do so? After all, congenital baldness is no crime, neither is it anything catching; it is merely unusual. Should it not be accepted frankly, and, among friends ar least, with humour? Considering the susceptibilities of a girl dependent wholly for a living on her appearance, I knew this was impossible. But equally impossible was an association based on misunderstanding and deceit. Without doubt, the young woman would continue naively to keep up a pretence, which, by an unlucky chance and without her knowledge, had been laid bare, thus giving rise to a cruel and ridiculous situation, which no show of dignity on her part or innocence on mine, could possibly save, or even fail to intensify. No! I couldn't trust myself to take part in such a farce. Rather than court failure and the certainty of eventual discomfort for both of us, I more wisely dismissed my young friend and turned her unfinished picture to the wall.

A Visit to Picton Castle

AT A DATE unspecified, I found myself staying at Picton Castle, near Haverfordwest. My host, Sir John Phillips, Lord Lieutenant of the County and a sympathetic young man, was no stickler for formality and left me free to rove, for I was bent on exploration. Here, at what might be called the centre of Pembrokeshire, I felt at home, in the widest sense, since it was in this vicinity that my dim ancestors first emerged from anonymity; here, on or under the flanks of Precelly Top (our Celtic Venusberg), might, I thought, be found some clue to my true origin, a secret, as it seemed to me, too jealously guarded by my respected but uncommunicative parent (if indeed he was aware of it). I was disappointed by such few glimpses as had been afforded me of our more recent family history. The annals of mediocrity, even if carefully bowdlerized, fail as a source of inspiration, and I was never attempted by them to cultivate a restrospective ambition. Rather am I apt to search much further back than human memory can tell of, to Pre-history and the Dawn, for clues to a clearer sense of personal identity, and some fellow-feeling to go with it.

The megalithic monuments which are found on the Precelly range have always aroused in me, besides the normal reactions of surprise, curiosity and awe, some stranger sense of recognition, as if I had seen and known them already, some time long ago ... However, not being an archaeologist, I must leave the mystery of the stones for my friends Professor Stuart Piggott, Sir Mortimer Wheeler and others to investigate, if they have not already done so. For the time being I must be content to gaze and wonder. We know the famous blue stones of Stonehenge have been imported (like me) from Precelly, for (again like me) they are found nowhere else. These are sacred stones and Precelly is a

sacred mountain, facts which provide another reason why I should feel an attachment to it, though its delicate profile forming the apex to the county, together with the long contours of its subsidiary ridges, are of themselves quite beautiful enough to ensure devotion.

'Know thyself,' said the sage: by all means, but for this some introduction seems necessary. Who *am* I in the first place? The answer is not so easy and may take the form only of a rough and ready approximation to the truth. The elements composing the population I belong to are so many and various as to make precision impossible. 'A Pembrokeshire Man' will have to do, since the definition briefly and happily summarizes the proud resultant of a multitude of ethnic strains, each in turn claiming precedence in a community permanently and geographically split by language and further fragmented by religious, political, cultural and sartorial differences. The chief line of division (linguistic) passes through Haverfordwest, where, on a market day, one may hear English spoken on one side of the High Street and Welsh on the other, with a mixture of both in the middle.

It was to this capital town that I would first repair of a morning, for my car might need petrol, oil, or a look-over. The garage was conveniently placed on an open space, or square, on the other side of which stood what was formerly the Salutation Hotel. It is now called the County Hotel, but cannot be said to live up to all that title usually implies. At some previous date the old Salutation, coming under new management, had been subjected to the irresistable march of progress, and at the hands of a gang of painters, plumbers, carpenters and plasterers, quickly transformed into a very fair imitation of a popular sea-side tea-shop or café. The result, however dainty and refined, was untraditional, and, taking into account the character of the clientele, inharmonious. The public, in spite of the new splendour, persisted in remaining unresponsive to the appeal of art and

aluminium, and, wonderful to relate, it was the *new look* which first gave way, not the customers! Obdurate in their basic conservatism, these callous but necessary drinkers were proof against the allurements of modernity, while, before their indifferent eyes, the paint peeled off, the plaster cracked and the spurious metal wilted!

At the rear of the establishment, however, I found a large bar, so faintly illuminated as to leave all modern improvements, at whatever stage of decay, mercifully in the shade. But behind the counter, dramatically, a young lady serving seemed to gather to herself such beams of light as succeeded in penetrating the wholesome gloom reigning elsewhere, while at her back a generous supply of bottles reflected them in gleams of liquid gold. This Hebe's colouration at once revealed her origin: its Rubenesque quality could only have derived from Flanders, and – more immediately – from the village of Langwm down the river, where flourishes to this day the last authentic remnant of the Flemish settlement. I am now voicing the popular belief; but, as a matter of fact, we know that a pure racial type can, and often does, reappear after generations of reckless cross-breeding; and as for the Flemings, their descendants are to be detected everywhere in the southern part of the county.

Sometimes, while I brooded alone in the half light of this bar, a group of young fellows might come in for a drink; brave, good-looking boys with tousled hair, cheap clothes and easy manners, they would now and then vary their conversation with a short burst of song. This seemed quite usual here and surprised nobody. Their jokes, to a stranger, might sound obscene, but at any rate they clearly owed nothing to metropolitan standards of humour and personally I found them none the less acceptable for that.

At last, after failing to decide on any particular itinerary, I would bestir myself with an effort, recapture my car, and make for the coast, where I found the lovely shores of Broad Haven

decorated by innumerable black turds. It looked as if an International Peace Conference had taken place here, but at the lowest level.

The last time that I had visited Haverfordwest, as a small boy in my father's company, we lunched at the Salutation accompanied by a gentleman with whom the lawyer had much to talk about. I was left out of this conversation, since, as it consisted entirely of local gossip, I was out of my depth and could contribute nothing of value. The discussion ended in a dispute. Was a certain person, known to both, dead or alive? That was the question. My father insisted on the former contingency; his friend, more quietly, on the latter. There could be no possibility of compromise here. At last, neither party giving way, we left to catch our train back to Tenby, my father being visibly elated at what he foresaw would be one up to him, and was banking on his opponent's discomfiture, when the truth became known beyond a doubt. But on the way a poster arrested his attention. The announcement contained clear evidence that the subject of the recent disagreement was quite alive and active. My father was greatly agitated. He had committed a serious bloomer. 'I must go back and apologize,' he said. So back we hurried and found his friend still at the table. The *amende honorable* was received good-humouredly and the incident closed. But we missed our train.

I think this rather painful object-lesson in good (and bad) manners was worth more than any number of copy-book maxims. My father's attitude had been overweening but in the end his sense of correctitude prevailed. He acted properly at some inconvenience and saved his honour.

Near Picton Castle stands Slebech Hall. It is a tall, tower-like house, designed perhaps by one of the Adam brothers. It seemed to be derelict and there was nothing to stop me going in, for the door was open. I found the principal room had been decorated by frescoes of a more than Pompeiian lubricity. These spirited though

327

ephemeral productions were no doubt the work of a soldier, for I learnt that the house had been occupied by the military. The artist had seen the possibilities of these spacious walls, and had certainly let himself go. I, too, felt my imagination stir as I explored the interior. The house was empty and neglected. Could I not somehow get hold of it? In the wilderness below a ruined church thrust a broken arch above the trees, and further down a fine and well-kept vegetable garden followed the left bank of the River Cleddan for some hundred yards or more up stream. Upon inquiry I was informed by my host that Slebech belonged to his sister, who, he said, didn't use it and no doubt would let me have it for nothing – especially if I would draw her portrait. How excited I was to hear this! How wonderful to have at last what I had so often dreamed of, a foothold in the heart of my own country; nay, much more than a foothold, a place in which I could work, and a kind of ivory tower in an enchanting ambience from which I would never want to stir and where there was room for all my dreams to come true!

But tragedy rudely intervened: poor Johnny Phillips died in his bath. The drawing was never done and Slebech Hall was sold.

Some say one should be indifferent to one's surroundings: but how is that possible except to an architect, an idiot or an anchorite?

Fitzroy Street

FLEAS or no fleas, the Fitzroy Quarter in those days was in every way much livelier than it is now. It was cosmopolitan, of course, with French and German elements predominating, but every other form of low life abounded. Living was cheap, according to modern standards, and the restaurateurs humane.

It was still the Artists' Quarter, its only rival being Chelsea. Its numerous studios, especially when they were 'To Let', bore witness to a long-standing picture-making industry, going back to Constable, and further. Some of them still housed a few exhausted survivors of the Pre-Raphaelite age. Had not Ford Madox Brown inhabited the haunted house with the big stone vase in Fitzroy Square? Other sky-lights illuminated the last feeble convulsions of the Neo-Classical revival whose princely leader, Leighton, had built himself a palace – and a tomb – in a more respectable district. But in my time, figures no less illustrious, though alive and sometimes kicking, were to be met with in the street. Here I renewed my acquaintance with James McNeil Whistler, whom I found most polite. I mentioned Ida Nettleship, who had been his pupil in Paris, had posed for him and was now my wife. Mr Whistler spoke of her with much sympathy, asking me to make her his compliments, then, raising his black straw hat, proceeded on his way to a French restaurant, where he was due for a one-and-sixpenny luncheon: he never paid more. Walter Sickert, too, was a neighbour, although somewhat intermittently, for he frequently changed his address. Ida and I had installed ourselves in the top floor of No. 95. I had a small studio at the back. Next door McMurdo and Selwyn Image kept a kind of Post-Pre-Raphaelite stronghold. Sometimes the tall grave figure of Sturge Moore, crowned by a large gardener's straw hat, would be seen to issue

from this abode; but whoever might appear, nobody could hold me when there was music in the air: and not the music of Arnold Dolmetsch either, but something of a more popular kind from up the street. The source of this was a piano organ, manipulated by a young man with a painted face and dressed in motley. A young girl in a ballet skirt and tights danced vigorously to the music, while a third bedizened member of the band rushed hither and thither among the audience, extending an inverted clown's hat to all within hearing.

These strollers were not unknown to me. I often saw them. I used to get the ballerina to pose for me. Those flashing eyes, that swart mongolian face (the nose seemed to have been artificially flattened), framed in a halo of dark curls, made an impression not to be shaken off lightly. I had been reading Heine with delight and his *Florentine Nights* had helped to condition me for such encounters, to which, in any case, I wasn't at all unresponsive by nature.

Opposite No. 95 was Thackeray House, or 'The Newcomes', where laboured Herbert Everitt, son of my evangelical friend Augusta Stewart Everitt, who now kept a boarding house at Swanage.

Everitt's studio, littered with trophies from the tropics, bore witness to his extensive voyages. Sailing was his passion and the ocean the eternal setting for his top-heavy windjammers. Whatever might be said of these stately craft, nobody could dispute the artist's exact disposal of every rope of their complicated rigging.

A Dublin Affair

WILLIAM ORPEN had a cavernous studio in the basement of the same house, where he once painted a most regrettable portrait of me. Having selected Whistler's 'Carlyle' for imitation, he posed me seated in profile against the wall, attired in a cast-off top-coat provided by Charles Conder. Unfortunately the result of his industry revealed no trace of the subtlety and distinction present in his exemplar. Nor, considered as portraiture, could it be said to communicate the least hint of the shy, dreamy and reticent character of his model. It has been said that the greatest portraitists, at their most inspired, in some mysterious way imbue their subject with some reflection of their own personality, so that the least noteworthy or ambitious sitter gains, by the magic of Art, a nobility and refinement hitherto unsuspected by his friends, and only perhaps dreamt of by himself. If this is so, the picture in question must be considered as an unhappy illustration of a reversal of this process, for in this case the artist in degrading his model has betrayed himself. Our physical dissimilarities were such as to admit of no confusion: we could not be said to overlap in any way; in short, we had nothing in common but our psychological differences. But such a division, in its nature incomplete, will still permit of a limited degree of contact, nor, while it holds, need it prohibit the indulgence of light play, excusable at any rate among the young of whatever species.

A visit to the zoo will be enough to convince anybody of the truth of these observations, for here, and more especially in the monkey house, we may watch the association of elements ordinarily incompatible but now united by the limitations of a common barrier.

Talking of zoos, Orpen gave me the following account of an

episode at the Dublin Zoo, in which he figured honourably enough. It appears that as a student he was in the habit of visiting the zoo for the purpose of sketching the animals. One day, he was sketching a large anthropoid ape when he was surprised by this creature's behaviour. It would approach as near as the bars of the cage permitted, and, stretching out its arm, endeavour to divert the attention of the young artist, but without malice, while at the same time uttering soft, conciliatory sounds. Orpen, touched by these overtures, and perhaps a little flattered, responded with a smile and a cordial handshake. 'It seemed the only thing to do,' he said. But on succeeding visits, for he had still his studies to finish, he observed with some anxiety that his model's friendly attentions not only persisted but became progressively warmer and more intimate. The hesitating touch had now become a frank caress, and there was an expression in the creature's eye which could mean only one thing – Billy Orpen was loved by a monkey! Was he offended? Not a bit! He was but a youth and still a tyro in amatory experience, although subject no doubt, like most boys and girls, to the mysterious urgencies of sex. Besides, as he confessed, he had grown, if not yet to love, certainly to esteem his simian suitor, and if the latter could hardly be classed as a beauty by European standards, no more, for that matter, could he himself. The situation was difficult, but in the end common sense, with which he was well provided, prevailed. There could be no alliance. Popular prejudices were too strong; there was the Law to think of, too, and what about his career? He consulted the keeper, who, taking the only sensible course, arranged a swop, and his disconsolate charge, in exchange for a duck-billed platypus and a young South American peccary, was removed to another establishment. I will not attempt to describe the final scene, except to report that it was heart-breaking – and violent.

Back to Paris

PARIS, as I knew it when a young man, was a city of perpetual excitement. I explored it in wonderment and awe. The spectacle provided by its life and movement, its sounds and smells, never ceased to surprise me. I could never get accustomed to it, and even in rare intervals of exhaustion was always restored in time by some fresh and unexpected manifestation from without. I was the incurably naive provincial who could never hope to attain the easy self-sufficiency of those grave personages I marvelled at as they sat over a book with so formidable an air of detachment. In Paris we are never far from the Middle Ages. Villon may still be lurking round the corner, and to judge by popular physiognomy, Jehan Fouquet's descendants still survive in a land so often laid waste by war, pestilence, and famine. Our reveries, not un-attended by danger, may be interrupted by the Garde Républi-caine, which, passing like an antique cavalcade, quickens the blood and silences for a moment both the laughter and the murmurings of the people. 'Ça coûte cher, vous savez, mais c'est beau tout de même.' With such a remark the good bourgeois acknowledges the conflict which tears him for ever between avarice and a passion for grandeur.

A Night Out

In the company of Maurice Cremnitz, the *Prince des Poètes* (Paul Fort), and a young anarchist, I found myself in an obscure *bouge* near Les Halles one night. Our ideological friend, a handsome fellow, appeared distrait and in no mood for gaiety. Paul Fort, anxious to rouse him from this fit of melancholy, inquired, some-what tactlessly I thought, and in his habitual falsetto, what he had

been up to; were things not going well? 'Mais vous ne tuez pas, mon ami: surtout il faut tuer.' At this the young man began to show signs of nervous irritation, and to save him further discomfort and Paul Fort from possible reprisals, I proposed moving to another and a more respectable café on the Avenue d'Orléans, where Mme Fort was likely to be in wait for her wandering poet. Sure enough, we found her there in the sympathetic company of André Salmon, another member of our *cercle*, and the literary spokesman of *les Jeunes*. Paul Fort, having climbed on to his wife's lap, was good-naturedly nursed by her. This meeting-place was on my way home, too, and upon leaving the society, the Prince dismounting, accompanied me into the street. 'Où allez-vous?' he inquired. Perhaps he had another place of entertainment in view, but I answered somewhat mysteriously, 'Je retourne à la Montaigne.' The poet looked puzzled, for there are no mountains nor even hills in this district. Perhaps he suspected a hidden meaning in my playful allusion from *Also Sprach Zarathustra*.

At that time my family and I occupied a little house or *pavillon*, as it was called, in the Rue Dareau, beyond the Lion de Belfort. An almost mummified couple acting (though grudgingly) as concierges, inhabited a dark cell by the entrance. A studio in a little garden was at my disposal. In a word, it was ideal. We had made the acquaintance of a nice English doctor, who often visited us, less for medical reasons than in the hope of converting us to the doctrines of Auguste Comte of whom he was a fervent disciple. Unfortunately we were soon to seek his professional services.

A Birth and a Death

My wife had engaged a room in a private nursing home, for she was expecting a baby. When the time came the baby arrived in good order but alas such was not the case with the mother. In

an establishment where, above all, a punctilious cleanliness might reasonably be counted on, she caught an infection. The French, so meticulous in most respects, in the matter of hygiene have sometimes incurred a suspicion of laxity.

It became necessary to move the patient to a hospital on the Boulevard Arago. This hospital was run by nuns and was spacious, airy and light, and I thought our prospects were brighter. I relied on Dr Tucker. A friend came to take charge of the children. But as the days passed there was no improvement; further complications ensued and a specialist was called in. My wife's mother arrived from England. She conferred with the specialist, whose fee for an operation was discussed and a bargain struck. The operation was performed but it was of no avail. After a few more days and nights the end came.

The usual column of smoke was rising from the tall chimney of the Crematorium of Père Lachaise. 'Ah, comme il fait chaud,' remarked the man with a shovel as, wiping his face, he collected a few calcined bones from the furnace.

I am not going to set down a catalogue of my sensations during this long-drawn-out crisis. Apart from my natural anxieties, I was oppressed by the futility of my visits, by my impotence and insignificance. Under the onslaught of high fever, my wife's mind fled to refuge in other places. In her own words, she was 'wandering in miraculous caves'. I could only beg for more opium. But there were moments of contact. 'I want some violets,' she said one morning. I hurried away at once: but where should I find violets? There were no shops near and there was no time to be lost. Descending the stairs, an open door gave a glimpse of an interior and, to my astonishment, there stood a table bearing a vase of violets! I crept in – the room was empty. Seizing the flowers, I returned in triumph. The violets were not quite fresh but they smelt of the good earth.

At the last vigil, a young nun sat by the bedside with me.

Finishing Touches

Silent and motionless in the dim light, she had the aspect of a Gothic carving. When next day, all was over, far from feeling cast down, I was seized by an incontrollable elation: I had had enough of despair. I rushed out on to the boulevard. The sun was shining gaily. I could have embraced any passer-by. I had escaped the dominion of death at last and was free. My friends were obviously mystified and no doubt shocked by my indecent behaviour, but I laughed at their long faces and called for wine.

But, needless to say, this state of exaltation was short-lived, and soon I relapsed into melancholy.

William McElroy and Others

I MET William McElroy in Chelsea at some studio party. A man of middle age and stature, of a comfortable girth, with grey hair just short of the venerable, and a voluble tongue, he was entertaining the company with jokes and funny anecdotes, to which a Belfast accent lent an extra piquancy. His evident good nature and general air of dubious prosperity, together with agreeable manners, recommended him to all. A kind of minor Horatio Bottomley, I thought. He got me to paint his portrait later and sat valiantly for several hours, though in the deepest gloom.

Oliver Gogarty and he were close friends. Though McElroy had the greatest reverence for intellect, he was unable himself to lay claim to much erudition. Nothing could silence him so effectually as a Latin quotation, and here of course Oliver was his master. They may have had business interests in common. McElroy, the coal merchant, could hardly be introduced into the circle of Gogarty's aristocratic buddies. Even Provost Mahaffy, who, though only (as far as I know) a scholar, was in the habit of prefacing his reminiscences with the words, 'As one of the most charming Emperors I ever met said to me ... ' could not very well be expected to greet a tradesman with enthusiasm.

But, to do him justice, McElroy's interests were not confined to coal. Starting his sporting career with wooden horses, he gradually worked up to real ones. He bought, for a song, a horse called Pastures New, got it trained, and entered it for the chief race on the Curragh, having put his bottom dollar on it and ten pounds for me. At the last moment, thinking the horse had caught a cold, he called off his bet, but the complete outsider won all the same. I think this was my first success on the Turf; the price was most favourable. McElroy, who had more than one iron in

337

the fire, soon recovered his buoyancy, and, not to be discouraged, acquired another horse, or rather part of a horse – the left hind leg, I think it was, which, in concert with the others, was doing very well. He and his fellow owners decided to run it for the Derby – the whole horse, I mean. McElroy kindly invited Dorelia and me to Epsom to see the race. A pub stands right alongside the paddock, and it was there we congregated. This pub, the only one on the course, was doing a roaring trade. It was swimming in beer. McElroy's horse was not successful on this occasion, but Dorelia, examining the list, picked a winner in another race simply because the animal's name appealed to her, so we had nothing to regret after all.

It was on this occasion that McElroy introduced me to Mr Sabini, the celebrated racecourse gangster.

Sabini

There was nothing gangsterish about Sabini's appearance or manner. Dressed correctly, without ostentation, he lacked only that extra touch of elegance proper to this occasion (a touch which I, too, had omitted); he spoke with that pleasing modesty and even diffidence we associate with a public school background. I understand that the cream of our criminal population derive from Eton, or at least claim to, but Sabini was singularly unpretentious. We took a stroll together. Seeing a group of Gypsies, I went up to them to exchange a few words of Romani speech. There is always a chance of picking up a variant of a word or a new locution. Sabini showed the greatest interest in this incident, and on leaving the Gypsies questioned me closely about these people. He was so used to seeing them at race meetings that he had just taken them for granted as part of the landscape, like jackdaws.

He then led me to the enclosure, which we entered without opposition, the mounted police on the course saluting my

companion formally as we passed. Mr Sabini then bade me farewell, having some business to attend to. Soon after this event he retired, I believe, from public life, for I have heard nothing of him since. It is true he had rivals in his peculiar field of activity, and clashes did occur from time to time between the opposing organizations. I would be sorry to think such a nice man had got the worst of it, but the bookies might not agree with me here.

Sean O'Casey

It was through William McElroy that I made the acquaintance of Sean O'Casey. The two were close friends in spite of ideological differences. McElroy, in his role of capitalist, engaged the Court Theatre, Chelsea, for a season of O'Casey plays, with a cast of well-known actors and actresses from the Abbey Theatre, Dublin. These plays being a great success, O'Casey became a kind of hero of the hour. Elegant ladies emerging from the theatre would attempt to rush him as he, too, made his exit. But they got no encouragement from O'Casey. His questing nose was directed elsewhere, his myopic eyes held other images in view, his Dublin accent seemed to grow still thicker as, with caustic and perhaps too brief acknowledgments, and a cigarette behind his ear, he made his getaway. Had he not a beautiful Irish wife waiting for him? Or did she arrive later? I forget, but I don't forget her …

McElroy, meanwhile, had undergone a kind of sea-change: the coal merchant had turned, as if by magic, into an impresario. As he descended the *escalier d'honneur* of the little Royal Court Theatre in his new evening clothes, complete with white tie and diamond studs, he looked as if he owned – well, Sloane Square including the pub next door.

I was taken down to a private room to meet my well-beloved friends, the delicious sisters Sally Allgood and Maire O'Neill, and others. There was nothing to drink but champagne; even the

austere Sean had to have a glass. *His* intemperance is purely literary, and I used to think if he only drank more he'd blabber less. Pathos should be administered in drops, like medicine, never in a bucket; a subtle flavour rather than a thirst-quencher, to be guessed rather than gulped. Even sincerity itself is best taken for granted: it may be suspected but should never be displayed, for in itself it can be out of place, stupid and even indecent. Its only possible merit lies in the quality of thought in which it is en-wrapped.

However that may be, I could swallow any quantity of O'Casey's superb fun, and ask for more.

Thank you, great-hearted Sean!

* * *

Just as a too sustained attack on one's lachrymatory glands defeats itself, so does misapplied enthusiasm lead to discomfort. When McElroy, who had some experience in the boxing indus-try, felt my shoulders appreciatively and announced to a room-full of people my evident qualifications for a career in the Ring and his unalterable intention of bringing me out as a middle-weight, with the certainty of a championship to follow, I was not only incredulous but resentful. As he should have known, I had other ambitions which included no dependence on him.

Vaverteméskri Romané

In observance of what was becoming a habit, i.e. an annual visit to Epsom Downs during Derby week, I became involved on one such occasion in an unusually complicated chapter of accidents.

I must say at once that these expeditions were in no way directly concerned with racing. I admired the horses certainly, but was out for other game. The reader will have remarked a predilection for a despised and outcast race, which I have betrayed before; and may have attributed this eccentricity to some weakness of the mind, or just a foolish pose.

I repudiate both these assumptions, though I might confess to a mysterious, though probably harmless, abnormality, the true significance of which I am unable to determine, but which is evidently deep-seated and persistent. I always went alone on these outings; indeed, in any circumstances, I prefer to visit the Gypsies unaccompanied, unless by a fellow initiate; but such are scarce and not always satisfactory. Imagine me then having a drink and a chat at one of the little open-air bars found near the racecourse in company with some members of an undistinguished tribe, whose name I have forgotten, but who included a young woman of remarkable charm, although a blonde. Struck by her almost classic style, I would have willingly sought her acquaintance (for I had my sketch-book) and no doubt would have done so, at least tentatively, but for the fact that she kept hovering at a distance, making communication difficult, except by means of the language of the eyes, in which she seemed to be very well versed.

My own responses were, I think, intelligible though guarded, for I was aware that among my companions there might be some of her brothers and possibly a husband ... These fellows, though

not of the purest blood, might yet preserve some traces of an honourable if severe tradition derived from the more reputable of their assorted ancestors.

I ordered more beer, thinking to drown any such archaic prejudices and make it possible for me to convert a fellow-feeling, so far purely ocular, into a closer and more tangible reality; though how the necessary privacy was to be obtained amidst the hurly-burly of a racecourse I couldn't imagine. I would leave this detail to my vis-à-vis, who seemed untroubled by doubts of any sort and still smiled seraphically over her shoulder, while raising one hand as if pointing the way to a better land.

While thus preoccupied, my attention was diverted by unusual sounds which now made themselves heard close at hand; a kind of drumming accompanied by rhythmic chanting of a barbarous kind, the words being indistinguishable. It wasn't the Salvation Army, I felt sure, but what could it be then? Leaving my companions temporarily, I pushed my way through the crowd, to discover a band of wild outlandish people who were making their way slowly along while stopping here and there to pass the hat round. They were of both sexes, tall, dark, nonchalant and superb. Some beat on enormous tambourines, others led gigantic monkeys or rather apes, and all joined, when they felt like it, in the chant. Foreign Gypsies! or, as I have entitled this chapter, *Vaverteméskri Romané.*

Immensely excited by this encounter, I watched the fascinating spectacle, while considering what part of the world these people could have come from. The Balkans, no doubt, I decided: but there are many tribes in the Balkans, speaking variants of the Romani language in greater or less degrees of purity. I addressed one of the young men, using only such words as I thought would be understood in any dialect. '*Avés mansa, p'rala, te pias kitané.*' (Come, O Brother, with me that we may drink together.) The young man gazed into my eyes, but made no sign of comprehen-

sion. I tried again with no success. A young woman then joined us. From what she said in an unknown tongue, I caught the word Roumanian, or something like it. They understood *Roumanian*, she seemed to say, not *Romani* …

These people, looking as if they had formed part of the hordes who at the beginning of the fifteenth century arrived in Vienna led by 'Dukes of Little Egypt' on horseback, disclaimed all knowledge of their language, their provenance and even their generic appellation. I was baffled. Were they deceiving me? As the band moved on I determined to pursue the matter further, but now an interruption occurred. I found myself wedged at the centre of a group of ill-favoured fellows, apparently engaged in a violent quarrel. Insults and even blows were being exchanged. As I attempted to extricate myself from this unpleasant situation, voices in the background reached my ears. '*Lurs skai, bâ, av avri!*' (Thieves here, friend, come away.) I had some sovereigns in my trouser pocket. Forcing my hand down, I found another hand already there! I seized and managed to withdraw it, and then with an herculean effort, freed myself to rejoin my Gypsy friends, who hurried me away, telling me I'd get *mârd* (kicked to death) if I stayed in the vicinity. But the leisurely approach of a policeman had now caused the racecourse gang to disperse.

This tale just shows how serviceable a slight acquaintance with the Romani tongue can be in a tight corner. I found I still had some coins left in my pocket, so after all 'more was lost on Mohac field'. My new friends practised a side-line in cozenage which was new to me. They had a roulette table which they set up in some advantageous spot with chaps posted in the offing to keep cave in case any inquisitive policemen appeared. When warned, the contraption was quickly disguised and removed to another quarter. It seemed a popular game.

Alas! I never saw the interesting blonde again and failed to overtake the foreigners, who seemed to have vanished as

mysteriously as they came; yet on the whole, it was a good day's outing.

The mention of golden *sovereigns* in this narrative will roughly establish the date. It was pre-Bradbury, or as one might put it, B.B., but that is as near as I can get.

A Fisher King

EQUIHEN is a village of fisher-folk of a rather primitive sort. When I used to stay there the inhabitants were very poor (and still are); but there was one exception to the rule: this was a man of the name of Labouret. Labouret had been a fisherman, too, like the rest, but soon discovering in himself superior imagination, greater cunning and perhaps fewer scruples than his humbler colleagues, he quickly rose above them, not by catching more fish but by selling fishing tackle – and other commodities. He became a Man of Business, in fact. He started a shop, the only one in the village, which soon developed into a kind of emporium where everything necessary, and much that wasn't, could be obtained without making a journey into Boulogne (where you'd be diddled anyhow). The villagers felt that Labouret, being one of themselves, could almost be trusted; he, knowing them from A to Z, could trust them too, and did – up to a point. Whatever his system was, it worked, and before long he had most of his customers in his pocket.

When I looked him up a few years later, he was occupying the house I used to rent from him. I dare say he owned most of the village by that time. I asked after Mme Labouret, who was not present; I had greatly liked and admired this very fine and amiable old lady. Labouret without a word indicated a young woman at his side. This young woman certainly was pretty, but she looked very glum indeed and was speechless. Labouret himself was visibly ill at ease. In fact, the whole establishment seemed as if labouring under a curse. I made no further reference to the former Mme Labouret of course, although I would have been interested to know the circumstances of her death which I greatly regretted, but I left rather hurriedly without dropping any more bricks.

Euphemia at Boulogne

I WAS working along in my little studio at Equihen, when a knock at the door interrupted me. Opening the door I was confronted by a young man I had met in Paris. He was a Swedish poet who, I had been given to understand, lived and moved in a world of dreams. Entering, he explained the cause of his visit. Euphemia, an old friend of mine, was in Boulogne and very, very ill. I must come at once to see her.

'But I am not a doctor,' I protested. 'You must get a doctor.'

The young man was insistent. I must come at once, he repeated, in his slow Scandinavian way; Euphemia wished to see me.

Hoping this was only one of his dreams, I agreed to come, and we both walked into Boulogne together. I found Euphemia lying in bed.

'What's the matter?'

'Diphtheria,' she replied feebly.

'Open your mouth.'

I gazed into the cavern and seeing no trace of a white spot, told her to get up and dress at once, for we were going for a walk. She did so, and to my astonishment I now saw before me a charming boy in a sailor suit! It was in this costume that she had arrived from Paris. We went for our walk on the sands of Boulogne and in the evening, on my advice, Euphemia and the poet took a train back.

That dream was over.

Liverpool Revisited

UNDER the name of Francis Audrey I once broke a long sojourn in Paris to revisit Liverpool. Moved by a kind of nostalgia, or perhaps the magical *hiraeth* of my Welsh ancestry, I set out in the company of a young female whose appearance, I calculated, would go far to enhance my own: neither conforming strictly to the fashion of the day, but both sufficiently outlandish to ensure some degree of anonymity. As for the University College, where my disguise might betray instead of concealing my identity, I was to avoid that seat of learning, while allowing no consideration to prevent a renewal of my friendship with its Librarian, the Gypsy scholar John Sampson (or the *Rai*, to give Sampson his title).

Our meetings took place well outside the danger area of Brownlow Hill in various pubs known to us both of old; a favourite one being inconspicuously situated in a back street, near, but not too near, Sampson's home. The landlord of this establishment, known to us as *Hüfa Kekávi*, or Captain Kettle, was a man of the 'fancy' or *afficion*, and as such not entirely unversed in the Romani tongue. He responded with alacrity to the request for *dūi posh parno lils*,[1] at once producing two small glasses of a certain brand of whisky favoured by the Rai, my young companion contenting herself with a port and lemonade or some equally innocuous mixture, as the stronger drink was known to bring about immediate muscular reactions followed by collapse and even unconsciousness. Such a disaster was at all costs to be avoided, as much for reasons of convenience as of humanity. With what must have seemed to be the corpse of a young woman on our hands, we would hardly have reached our destination without comment from the public, or perhaps interference from

[1] Two small White Labels.

the police. Sampson and I agreed then in upholding the principles of temperance in the case of our fair companion, but the *posh parno lils* continued to repeat themselves with almost monotonous regularity. Why not order a few big ones, I thought, and have done with them till our next stop? But it was useless to hurry the Rai, who I knew was capable of remarkable obstinacy. This bald and inexorable scholar, under a haughty and sometimes overbearing exterior, nursed in secret the sensibility and the ardour of an adolescent. His innate romanticism, which had led him into such fruitful byways of literature and life, responded at once to the mildly clandestine conditions of these meetings. He enjoyed them, I think, and found in them a happy relief from the unwholesome constraints of his Library, with a chance to unbend temporarily while exchanging official responsibilities for the more open and genial mood proper to *Hüfa Kekávi's* establishment.

A few more *posh parno lils*, and we took the air, our objective usually being a large piece of waste ground known as 'Cabbage Hall', though there was no Hall to be seen nor cabbages either, the site being occupied by the tents of our Gypsy friends only. A cab was needed, for we had some miles to go and night was already falling. The Rai marched ahead, for he knew the terrain. He made an imposing figure as he strode along, with his battered hat at a commanding angle, his cutty alight, his chin thrust out, and his powerful legs moving rhythmically. One could see that he was feeling good. A vehicle offering itself, we took our seats in it and were off on our adventures. The night I am thinking of was a dark one, but the darkness within our antiquated 'growler' was such as could positively be felt: this I realized when a distinct but not painful pressure applied locally to my person convinced me that someone had blundered. Addressing myself to the corner opposite our companion, where I judged the Librarian to be sitting, I remarked conversationally, 'By-the-by, Raia,[1] that's *my*

[1] Raia: voc. sing. of Rai, Sir.

eg you know.' This information was received in silence, but the
pressure was instantly relaxed and it was in silence that we con-
inued our journey. My interruption, though timely, had some-
now intensified the surrounding gloom and I could see nothing
ahead of us but a further series of *posh parno lils*.

The McNairs

THE McNairs taught what was known as *design* at our art school on Brownlow Hill, where I was supposed to teach *drawing*. In England alone, I believe, the functions of the two are held to be separate. In France the same word, *dessin*, includes both. This is only logical, for the two are complementary and should inter-lock, like the McNairs themselves, who always worked, as I imagine they played, in perfect unison.

Among the advance guard of *L'Art Nouveau*, a movement which originated in their home-town, Glasgow, and was destined to pervade Vienna, Germany and Paris, this cheerful couple saw themselves as Heralds of a New Age which was to sweep away the last remnants of Antiquity – not to speak of the Renaissance – to replace them, along with their decrepit human survivors, by a new and infinitely more vigorous manifestation of creative energy, liberated at last from the servitude of tradition, and still more drastically from the tyranny of nature itself.

Warming as such a programme was bound to be to one as young and naive as myself, I suffered a distinct lowering of temperature upon being confronted with the works of the two charming protagonists. I responded as frigidly to the curly door-knockers and the rectangular tin troughs fitted with night-lights etc., of the one, as to the quaintly pretty embroideries of the other, in which bulbous gnomes or fairies figured largely in sur-roundings of a totally unidentifiable order. To me they might have been the dreams of a babe, signifying nothing, or at least nothing I knew anything about. When pressed by McNair for a personal appraisal of his industry, I with much reluctance com-plying, the honest fellow, forgetting that he had volunteered a similar estimate of my own efforts, broke down, saying he would

ust like to swim and swim right out to sea till he drowned. Without going to these lengths he did leave Liverpool eventually to return to his native land, where, I was told, forswearing Art, he became a first-class postman.

His brother-in-law MacKintosh, whose friendship I enjoyed in Chelsea, was of course a much more serious figure: an architect of indisputable distinction, he certainly left his mark on the face of things to come. *L'Art Nouveau*, after a short period of hectic commercialization, became an object of ridicule, to be followed by the more important innovations of Surrealism, Fauvism, Cubism and other experiments of our times.

In Search of Charley Boswell

HARKING back to earlier days, I have told how I made the acquaintance of Esmeralda Groome, née Boswell, when she was camping on the Wirral, and later met her younger and equally eccentric sister Dorelia, who shared a van with, I am sorry to say, a red-haired Irish tinker. In spite of this mésalliance, Dorelia Boswell was in other respects a splendid specimen of her race. She left a deep and permanent impression of beauty and child-like candour on my wax-like mentality.

I had heard of another prominent member of the family, Charley Boswell, otherwise known as Charley Lock, or *Klizn* in the Romani tongue. He was well spoken of, so upon visiting North Wales on one occasion I got wind of this Gypsy's presence in the neighbourhood, and determined to track him down. I was at this time at Bangor, having just returned from Beaumaris where I had pursued and run to earth a young female belonging to the Clan of Abram Wood, whom I found working in the chief hotel of the town, and disguised, to my embarrassment, in the uniform of a menial. My efforts to persuade the young recreant to reform her ways, shed this livery of servitude and return to the open road, were unavailing, so, leaving her conversion for another day, I set out to find Charley Boswell. According to the *patrin* or secret indications of the fraternity, one was most likely to find him near a certain village a few miles from Menai.

The day was magnificent. Although blazing hot, the air was light and heady like champagne. I strode along at a great pace, and, with a little extra length of leg, could have done justice, I felt, to a pair of seven league boots, though I hadn't so far to go. Passing through Menai, I noted (and avoided) the proximity of the police station. Little did I dream that I was to visit this sinister

establishment ere long and of my own volition. Upon reaching the village I aimed at, my observations led me about a mile further where I found an encampment of several ornate vans and Charley Boswell himself with his family. Having introduced myself, I was made welcome, accommodated with a chair, and, it being tea-time, the beverage known to the Gypsies by the poetic title of *mūterimangori* was served in excellent style. Charley, who was noted for his good manners and charm of personality, was geniality itself, and moreover he and his family, I was glad to see, shared and were to perpetuate, no doubt, the good looks of this branch of the Boswell tribe. They spoke a good and partly inflected dialect of Romani, though it was far from having the depth and complexity of that of the tri-lingual descendants of Abram Wood, known as the *Kalé* or dark people.

Time passed in agreeable gossip and discussion on 'affairs of Egypt', for we had a number of friends and acquaintances in common. As I rose to leave, Charley apologized for his apparent inhospitality, assuring me that were it not for the fact that his wife was abed in expectance of a new baby at any moment, he could have afforded me shelter and rest for the night in one of the vans. Before I left, however, he made me promise to call again next day, for he was sure I could find a night's lodging near by.

I felt no desire for sleep, and upon inquiry was not distressed in the least to find no bed available in the village. The evening was of a warmth and mellowness unusual even in this zone, where nature contrives to disseminate and hold longer than elsewhere the reflection of a sun already hidden beneath the ocean's rim. Subdued by the sweet solemnity of the scene, I realized I stood in truth on holy ground: for was not this the sacred island to the Great Lord of the Sea, the Celtic Poseidon: was it not Inys Mon?

But at this point my musings were interrupted by the approach of two figures, one of whom presented the unmistakable silhouette of a policeman. Without greeting or ceremony this helmeted

353

busybody proceeded to seek an explanation of my appearance in the district. He inquired my name and business for a start. I gave my name but confessed to have no business. 'Have you no lodging?' 'I was unable to find any in the village but am quite content to sleep out on so warm a night, in fact I prefer to do so.' 'Have you no money?' 'I have sufficient for my needs at present, thank you.' 'Have you proofs of your identity?' 'Yes, I think so.' I searched in my pocket and brought out a letter written in the 'deepest' Romani from John Sampson, Librarian of University College, Liverpool. This letter in no way reassured the policeman, who, having studied it for some moments, handed it back, remarking, 'This looks very suspicious.' 'Yes,' said his companion, who had been looking over his shoulder and read the address, 'they do say there's some very funny people comes from the University.'

In spite of his suspicions, the policeman now said he thought his wife might let me have a bed if I was prepared to pay for it, mentioning a substantial sum. I declined this offer, saying I would be quite happy if they would kindly leave me alone. 'But you are breaking the Law.' 'Perhaps, but I am breaking nothing else,' I replied and was moving away when one of my interlocutors called out, 'You could try the Castle. The Marquis of Anglesey's got a Pantomime on, and he'd be sure to let you in.' Whether this was meant as a gibe or not I cannot decide, but I thought I would in fact try the Castle. Anything for a change of company! The Castle was near at hand. On my ringing the bell, the butler came out. He was quite the nicest of butlers. On hearing my predicament, he seemed deeply touched, but had to confess he hadn't a single spare bed to dispose of – people were even sleeping on the billiard-tables! He was full of apologies, and I left feeling by no means cast down but on the contrary rather elated, as one who has made a new friend.

The problem facing me now was how to avoid the custodian

354

of the Law, or *Prastermengro*,[1] who, with his hired assistant or *muscro*,[2] were still lurking on the main road as I returned. They were not going to lose sight of me; that was certain. A plan formed in my mind which would not only inconvenience my persecutors but baffle them and at the same time ensure my keeping the appointment with Charley Lock next day. Turning my back on the village I walked briskly towards Menai. From time to time I paused to make sure of being followed. Upon arriving I found the police station I had noticed in the morning, and, stopping, rang the bell. After a short wait the door was opened by a policeman who was evidently none too pleased at being roused from his slumbers. I said I wished to lodge a complaint of interference from a constable in the village of —— The policeman, having noted this down in a book, eyed me narrowly. Then, having made up his mind, he advised me to cross the Menai Bridge; once on the other side, he said, I would be outside his jurisdiction and might do as I thought fit. With that we parted. I crossed the bridge and, in full view of the helmeted figure and his companion who had conscientiously followed me thus far, threw myself under a hedge and slept. Next morning I walked into Bangor where I hired a trap and returned for another pleasant seance with the Gypsies. As I was driven through the village, I passed my two ill-favoured ones, who gazed at me with astonishment, but I made no sign of recognition. I fail to remember the name of this village but it was not the one ending in Llandisiliogogogoch.

[1] *Prastermengro*, from *praster*, to run: one who runs you in.

[2] *Muscro*, a Gypsy word; originally *mūiescro*, pertaining to the mouth: a hue-and-cry man.

Move on! A Glance at the Gypsies

JOHN BUNYAN the Tinker, or as some say the Gypsy (metal-work is an old Gypsy craft), for he describes himself, if I remember rightly, as belonging to an 'outlandish and despised people', spent a good deal of his time in gaol for airing religious views then unpopular with the authorities. Being literate, he was able to occupy his enforced leisure in writing the immortal works we so much admire today.

Ordinary Gypsies cannot for the most part read or write, and, nomads by tradition and upbringing, are accustomed to gain a living while moving about the country with their horses, tents and wagons. Devoted to this way of life, they are more likely to find the discipline of imprisonment both irksome and unrewarding (to put it mildly) than other people; but their petty misdemeanours hardly call for great severity. Criminality is rare among them.

For some years, however, a new drive against the Gypsies has been in operation in the southern and some other counties of England, with the aim, apparently, of exterminating 'these antisocial pests', as they were described in Nazi Germany. Although this policy may not include the summary methods of Himmler – the 'hedge-crawlers' (to use another Nazi epithet) are not caught and gassed outright as if they were Jews – the treatment adopted will prove no less lethal in the long run. Harried into the slums of our big towns or the 'ground-worm' infested filth of New Forest concentration camps, they are condemned to squalor, disease and degradation. Freedom being their one and only political concept, these born conservatives are strangers to the ballot box (but not to the recruiting officer), and are thus overlooked by the Welfare State. If some of the ones who are better off are

persuaded to make use of 'council houses', such recreants have been known, disconcertingly, to repay conversion by setting up their tents in the garden while according the amenities of the house to their animals.

Francis Hides Groome, who was an eminent Gypsy scholar of a past generation, wrote in the *Encyclopaedia Britannica*:

The better sort of Gipsies are quick witted, courteous, likeable and trustworthy when trusted. Untrammelled by prejudices and vexed by no lofty ambition, they have picked up a sort of peripatetic philosophy, lead a pleasant cuckoo-like existence and make the best of life …
Great criminals are few among them …
The best gipsy is the gipsy *au naturel*, the life-long dweller in country lanes; and he like all *ferae naturae* is threatened with extinction. Gipsies' virtues are largely their own, an outcome of open-air life; their vices are ascribable to centuries of oppression, which has left them a singular compound of deep-seated gloom and quick-silver light-heartedness, and has made them suspicious and hostile towards the rest of mankind.

One may add that the last-mentioned attitude is fully reciprocated by the majority referred to, though without similar warrant. Having quoted an excellent, though no longer quite contemporary authority, I now add a letter which I have recently received from a living Gypsy:

Dear Sir,

As a caravan dweller I read in to-day's News Chronicle with much interest and pleased to think someone has a feeling for Romany and his cattle. I for one no what it is to be moved on. Ordenary Folk grumble at next to nothing. But had they to put up with the life of a Gipsy Im sure they would think

357

again. Ive no need to tell you what a Gipsy and his horse has
to go through, you must already know. Some Folk may say
why does he have to put up with it. Why dont they come off
the Road and live in houses and work in a factory. Well it
would be like taking a wild Bird and putting it in a cage.

<div align="right">E. E. SMITH</div>
<div align="right">Caravan, Little Brookham, Surrey.</div>

If asked what it is that has fascinated some people about Gypsies
(a fascination which is incurable), I might allude to their physical
comeliness; their pleasant manners; their fastidiousness; their
ready wit and gaiety combined with pride; their essential honesty
even when combined with prevarication; their love of children;
and their exotic language and strange taboos – all these I might
mention and still leave unexplained a mysterious something of
which I do not know the name, but which I recognize with a
thrill from a mile off.

But wandering Gypsies (though always wandering with a
purpose) are not everybody's fancy. The grocers of Kent have
now adopted the precaution of pasting up the notice over their
shops, 'No Gypsies served here'. This sweeping and discriminatory
generalization, coming from a class of uncreative middlemen
popularly known for their practice of mixing sand with the sugar
(on the Continent, the designation *épicier* is but rarely understood
as a compliment), moved me lately to send a letter of protest to
The Times, resulting in a flood of highly sympathetic expressions
of opinion from friends of the Gypsies all over the country, with
only one dissident, a correspondent whose communication was
both abusive and anonymous.

Without the testimony of Gypsy scholars the world over, these
letters prove that among ordinary people there are not a few who
have found themselves well repaid by friendly contact with the
dark strangers in our midst, once the attitude of suspicion and

hostility, induced by ages of ignorant persecution, has been re-placed by the bonhomie and merriment more natural to them, as to other children. For Gypsies never quite grow up. They remain naive and transparent even in their humbug and should have no difficulty in entering, when the time comes, into that Kingdom promised by another Wanderer, who like them was not exactly *persona grata* with the Authorities, nor, one may add, with Big Business, in Kent or anywhere else. Long before the age of myxomatosis, the Gypsies (and others) did their share in reducing our superfluity of rabbits, though at some risk; and one wonders by what means they have replaced this popular and important item in the poor man's larder. Hedgehogs, I know, are only at their best in the autumn, and the Gypsy is a fastidious eater. Doubtless the grey squirrel will to some extent fill the gap, being a proven delicacy, with, in addition, a bonus attached to every tail, but if the worst comes to the worst, there is always the *Bare Hochipen* or Big Trick to fall back upon. Credulity at any rate is inexhaustible, thank goodness.

Those of us who love liberty and enjoy variety must surely stand up for a small and politically powerless people from the East, who have made this country their own and have enlivened and ornamented our country-side since the fifteenth century while, for the most part, preserving their racial integrity, their traditional customs, and even in parts their ancient language, in a usually hostile world. However, it is a world they love and flourish in, if left to their own way of life (which by the bye is now imitated by hosts of highly respectable holiday-makers, so there must be something in it). In any case, before condemning these people out of hand, it would be as well to make their acquaintance. This may take some time and trouble, but with goodwill and good manners, it may be worth while and even rewarding for such as have a taste for human nature, and no axe to grind.

Early Indiscretions

I USED to be rather shy and undemonstrative as a schoolboy, except when on the football field, where I displayed considerable dash. Out on the sands for official exercise, too, I was capable of remarkable initiative which could sometimes be embarrassing, as when, without a by-your-leave, I would strip and, seemingly 'possessed', perform miracles of speed and agility, to the astonishment of all, and especially the Head, who would stop and contemplate my complicated evolutions with an expression which seemed to betray the painful irresolution of Authority confronted by the Ungovernable. Perhaps these performances awakened in the schoolmaster's mind long-suppressed feelings dating from a classical background, and induced in him a kind of moral paralysis, for I was never punished for these departures from the academic rule, though I remained under the suspicion incurred, upon the discovery by the Head's brother, when he was second-in-command, of certain studies of the nude which I would have preferred to keep to myself, but which the ex-policeman hurriedly requisitioned, no doubt to enrich his private collection, for I heard no more of them.

But not all my early strivings were misunderstood. A portrait of the Devil turned out successfully. It was a good likeness, I thought, and so did Father Bull, who should know; he said that under the Mask of Evil I had succeeded in disclosing something of the beauty of a Fallen Angel.

Father Bull, at this time employed as tutor to a few pupils, was a young man with whom I became friendly. He often joined me and the other boys at our favourite bathing place, known as The Point, on the north shore of Tenby, and at a sufficient distance from the town to permit of perfect freedom or even, as some

might object, licence. From this little promontory one could dive straight into deep water, and it was here I was taught to swim by the simple process of being thrown into it.

My Catholic friend, who used to draw a bit himself, encouraged me in the practice. He seemed to see some merit, or at least promise, in my sketches, although being a stickler for purity (in Art), he found my nude studies sometimes faulty, in that they were not always nude *enough* for his taste. A thorough classicist, any concessions to modern notions of propriety were, in his view, *improper*. When I asked him to explain certain anatomical anomalies to be found in the traditional treatment of the female figure, which had begun to puzzle me, he was unable, or unwilling, to throw any light on the subject, nor, I may add, has anybody else done so to this day. This matter seems to me important, and I think of seeking Arthur Koestler's help in my perplexity, for he seems to know everything, and it is too late to consult Freud himself, who indeed, for all I know, may have treated the subject already, but, considering its delicacy, probably in Latin, a language which, although taught at school, I have never thoroughly mastered.

Lunching in style

When Cardinal Vaughan visited Tenby to officiate at the dedication of the new church of St Teilo, Father Bull, with whom the Cardinal was staying, was kind enough to invite me, among a few others, to luncheon. Unused to such social conditions, and overawed by the grandeur of the principal guest, who looked every inch a Prince of the Church, I was surprised by the general levity of the conversation during the course of the meal. Everybody but I seemed to be enjoying himself, especially the Cardinal. Father Bull, too, was in the best of spirits, and naturally, for the occasion marked the crowning of his labours in the successful

establishment of this new outpost of his faith and he had collared the Cardinal! The church was built and sanctified: was it not pardonable to relax for a little while and indulge that spirit of laughter and fun, which, first discovered in childhood, should never be wholly abjured? We cannot all be blessed saints, and for that reason the lesser joys of poor humanity are not to be frowned at. Remembering Cana, Father Bull sent the port round again. Without being able to follow all the witty sallies which now excited general hilarity, some of them I thought were not, in substance, unlike those I was accustomed to at our bathing parties at Lydstep and other out-of-the-way places. In these circumstances I was quite capable of enjoying much without turning a hair; but here, strange to relate, it only resulted in embarrassing me, while my complexion deepened from bright pink to a deep crimson. At a given moment Father Bull, noticing this phenomenon and unable to master an increasing tendency to facetiousness, inquired pointedly if I *painted*. This brought the house down, and with all eyes directed at me, I wished myself safely under it. Even now, such a question would induce a discomfort and cause a slight blush to modify for a little while my customary pallor.

The Hermaphrodite

In MY own experience, I have found the nearest living approach
to the Greek ideal in the person of a hermaphrodite seen in Paris
some years ago, to which monstrosity I was introduced by a
friend with a passion for the bizarre.

Displayed stark naked on a couch, it possessed all the attributes
and some of the charm of a woman save for one notable absence,
here, as in a masterpiece by Phidias, glossed over and left blank;
except for the surprising introduction of a feature borrowed from
the other sex, which rudely raised its head in defiance of all
probability as well as of artistic convention, though, incidentally,
in a somewhat abbreviated form.

Unable to control my curiosity, and forgetting my manners,
I boldly inquired in my own French: 'Pardon, Madame, ou
Monsieur, quand il vous arrive de sentir le besoin de l'amour,
comment faites-vous?' 'Mais, Monsieur, je me masturbe,' was the
answer, delivered without hesitation, to my naive and really
inexcusable impertinence ...

At Galway

When staying in Galway, I made a few contacts with local society, but came after a while to recognize some of the more redundant elements of the population I used to meet with while strolling about the town. These types seemed, like myself no doubt, to have nothing better to do than to 'pass the time', but were animated, I couldn't help thinking, by very different motives. Natives of the town or district could hardly be expected to view the life and movement around them with a stranger's curiosity and wonder. Long familiarity had blurred for them the peculiar rhythm of the place, a rhythm of which, probably, they had never been really aware, unless subconsciously, as children – and which was, in any case, already well on the way to extinction under the deadly blight of commerce and the blundering exigences of law.

The shawled women murmuring together on the quays, with the white complex of the Claddagh glimmering across the harbour; the echoing streets; the purple waters of the bay under a weeping sky – all such phenomena were taken for granted, and I was experienced enough to keep my observations of them strictly to myself, if I should happen to strike up acquaintance with a fellow time-waster in one of the innumerable bars with which this sea port is provided. For I felt that if I was indeed 'passing the time', I was none the less engaged in storing my mind with impressions which, I promised myself, would one day be realized not only to my own private satisfaction but to the edification of the world at large. This thought sustained me, while my fellow pilgrims, instead of looking outside, as I did, for encouragement, were apt to seek within for a quicker antidote to boredom

and a more effectual means of exorcising, if only for a while, the grinning spectre of futility.

Timon of Athens

I once found myself in the company of some interesting fellows, with whom I was invited to sit down and take a drink. One of them, whom I took to be the leader because he paid the rounds, remained with me after the others had left. This young man was not in the best of spirits; he was disillusioned, it seemed. He had put his faith in others and had been deceived. Always generous (for he was well off), he had been surrounded with flatterers, who, under the guise of friendship, consumed his drinks and his cigarettes ('threepence a packet'), only to ridicule him behind his back. Such, said the melancholy youth, had been his experience of humanity. 'I am like Timon of Athens,' he said. He repeated sadly, 'Timon of Athens, that's me!'

Another social event took place at the Railway Hotel, in a private room, such as were provided here before the hotel was modernized and lost its character. This was more than a friendly meeting; it developed into something like an International Test Match, but minus any pretence of fair play. The teams consisted of about six young men on the Home side and just myself on the visitors'. The question to be decided was: which would be under the table first? Well, to make a long story short, I found myself in the end, alone and upright. Stepping carefully over the recumbent forms of my opponents, I left the building, and having nothing particular to do, walked down to Flaherty's Bar on the New Dock to have a drink and a chat with the barmaid, a girl I admired greatly. Her name, Kitty McGee, describes her perfectly, though she had something more oblique and veiled in her look than her name denoted.

I would not have told this story if I had any intention of

revisiting Galway City, but since the Claddagh has been demolished and replaced by the concrete tenements of the Republic, the classic shawls exchanged for cheap finery from Manchester, and Kitty married, it will be better, safer and more rewarding to try another port in future.

Gordon Craig

IT MIGHT have been at Will Rothenstein's that I first made Gordon Craig's acquaintance. Afterwards I used to meet him in a side bar of The Markham, a pub in the King's Road, Chelsea, where one could lunch. He was often found there in the company of Martin Shaw, a musician who shared his taste for folk-song but in a more professional way.

At that time Craig was addicted to Walt Whitman, and besides had recently come to acknowledge the spiritual authority of Tolstoi. *War and Peace* was for him a sacred text, and the Christian Anarchist Count was accepted as the herald and expositor of a better world.

As for Whitman, I, too, had been aroused by the barbaric yawp, though much earlier. The gentle Jesus used to make me cry as a child, but since adolescence it is Walt who alone similarly affects my lachrymal glands (especially when he is read aloud by Orson Welles). Making no pretensions to divinity, he has superseded the Greco-Jewish Man-God, with whom, in other respects and from a different angle, he has much in common.

Craig, exquisitely adjusted to his Craiginess, might sometimes be considered a little pernickety. The appearance of a dancer with oriental leanings, Ruth St Denis, had greatly attracted me, but Gordon Craig did not approve of her. There was something *sinister* about her, he said, though he did not dispute her accomplishment. I was undeterred by this and wrote to her, craving a sitting, but my request was disregarded.

As is well known, Craig was all against the modern theatre, with its imitation realism and actor worship. 'Why,' I once ventured to ask, 'do you not get a circus-tent, travel the country and give your "representations" freely in your own way?' 'But

I don't know how to make a tent,' he replied. This I thought rather pedantic, but I see his point. To quote John Sampson, who quoted Walter Raleigh in another context, he was apt to be 'as jealous of his privileges as a maiden aunt at a Dorcas meeting'.

Later on Craig acquired the Arena Goldoni, in Florence, and set up a school of the Theatre. He collected but few pupils, but these were taught to fence. Meanwhile, he carried on his journal, *The Mask*, which he wrote mostly himself. Anyone interested in the Commedia dell' Arte had better get hold of numbers of *The Mask*. I went to see his production of Ibsen's *Vikings* in London. For 'scenery' he employed simple cubes of various heights. When motoring in Provence a year or two ago, we discovered a wonderful hill-town in the mountains behind Nice. As we approached, the town presented a frontage of tall cube-like habitations rising from the precipitous rock. I was instantly reminded of Craig's designs.

Having explored the dark and narrow alleys of the ancient town I returned to the central *place* where I found a game in progress. It was a form of basket-ball, played by young people of both sexes, who for the occasion were attired in garments of a remarkable economy: but there was no evidence of false modesty and certainly no exhibition of old-fashioned coquetry to be noted. I was watching young France disporting itself in a medieval ambience.

Having dined at a restaurant on the outskirts of the town, we were about to leave when some new clients arrived. These consisted of a romantic-looking but elderly gentleman in a black cloak and a sombrero, accompanied by some ladies. This was Gordon Craig. It seems he lived there!

Heroically uncompromising as an Artist, as Craig has always been, he has lately made one concession to our vulgar age. His broadcasts have surely been among the best ever delivered.

Lord Beaverbrook Entertains

IT WAS during the first War to end war that, being for no adequate reason domiciled near the Front, I was summoned by Lord Beaverbrook, the Head of Canadian War Records and my supreme officer, to appear in Paris.

Glad of a break from the infernal dullness of the Front at that time, I set forth with batman and car to the appointed meeting place, the Ritz Hotel. A party was in progress, with my Chief and Capt. Freddy Guest in control. A number of Canadian officers and some ladies were assembled for it was cocktail time. After the departure of the ladies, the word was passed round for the gentlemen to tarry awhile, for, as it appeared, there were further delights in store for them. We were in fact bidden to another party later in the evening at the nearby Hotel Bristol. A wink or two delivered with this message clearly hinted at some *real* fun this time. Accordingly everyone assumed the correct doggy expression while lapping up a few extra cocktails as a precaution.

At the appointed hour we all gathered at the Bristol, where a suite was placed at our disposition, and a well-furnished supper table awaited us. The guests were so spaced as to allow of further seating accommodation between them. The reason of this arrangement was soon seen on the arrival of a bevy of young women in evening-clothes, who without introduction established themselves in the empty chairs.

These girls (shall I call them?), the pick of a local emporium, had been recommended for their efficiency, one or two of them were even said to be able to bring the dead to life. At this point our host and benefactor tactfully withdrew. He had done his part in princely fashion, and would now leave the boys to make the most of it, uninhibited by differences of rank and breeding. Orpen too,

absented himself at this juncture (it is possible for a mistress to be no less exigent than a wife).

A sustained outburst of gaiety now became imperative, and accordingly the well-known properties of champagne were fully exploited by all. Yet, as I looked round the table, a curious melancholy took possession of me. I felt, as the French say, distinctly *hors de mon assiette*. As far as was visible, the charms of our new companions had, I thought, been exaggerated. Although I am strictly speaking no great aesthete, the occasion, in my opinion, seemed to call for more spectacular effects than these rather overworked whores were capable of. I had no parlour tricks, nor did my companions-in-arms seem much better equipped than I was in this line; except for one gallant major, who, somehow recapturing his youthful high spirits, proceeded to emit a series of comical Canadian noises, which instantly provoked loud shrieks of appreciative laughter. This act saved the situation somewhat, but was followed by an uncomfortable silence. At last, in desperation, I seized the houri I found next to me (the best looker of the contingent), and planking her on the table, effected a successful *retroussage*, in spite of her struggles. Collecting herself, she then resumed her seat, but informed me with some asperity that she was '*avec le Général*'. I had made a serious bloomer! '*Le Général*', on examination, proved to be an elderly gentleman, who, silent in two languages, had so far contributed nothing to the entertainment of our visitors. Perhaps he was reserving his forces.

But my action, though crude, gained general applause and helped to break the ice a bit.

The feat over, we rose and, ushered by a kind of butler, were shown further evidence of our host's thoughtful consideration for our comfort in the shape of a series of well-appointed bedrooms, complete with fires burning, bidets, and capacious beds with the coverings turned down neatly.

But nobody seemed to be tired! Nobody? Well, there was Orpen's brother certainly, and he, being a lawyer, wasn't going to miss a thoroughly legal opportunity of getting something for nothing.

And now, all the ladies (save one), as if acting in response to a signal, departed quite politely. I inquired of the General if he approved of taking part in this sort of school treat, but his answer was unintelligible.

Isadora Duncan

I HAD never seen Isadora Duncan dance when I met her first, but I had heard her praises sung by people of discrimination, and it was with much curiosity and even excitement that, by a lucky chance, I made her acquaintance.

But was I to be disappointed? I tried to adopt a prudent reserve, for I had been 'had' before ...

The appearance in England, some years earlier, of the dancer Maud Allan, had been followed by regrettable excesses, reminding one of the less creditable phenomena of religious conversion. The Prime Minister of the time was said to have caught the epidemic, which, it seems, first made its appearance in the upper levels of society. It was William Orpen, by then pretty well established on the fringe of fashion, who brought me the glad tidings. The credulous little Dubliner, his eyes moister than usual, assured me that the new dancer was something unheard of. Not only was she possessed of the secret of levitation, but, I was assured, she was able to ripple her bones as though they were made of india-rubber! Without questioning the advantages of the latter accomplishment, and to change the subject, which was beginning to bore me, I promised to look in at the theatre and examine this prodigy for myself. And so one evening I found myself standing at the back of the dress circle awaiting my conversion, but without much confidence.

The performance started with a dance illustrative of Mendelssohn's 'Spring Song'. I retained imperfect memories of my fathers' rather laborious renderings of this and other works by a composer to whom, as a good Victorian, he was much addicted. Miss Allan's interpretation could not be called laboured; it was extremely brisk: there was much rippling of the arms (but not

372

the legs), and the performer's other movements seemed to be equally unnecessary and repetitive.

My response was violent, and would have been audible but for the storm of applause which drowned it.

I had had enough, and was turning to go when a messenger approached me with an invitation from the management to come 'behind' and join a selection of other enthusiasts in doing homage to the exquisite terpsichorean. I declined the offer and hastily left the building.

So, thought I, such was the classical dance as conceived in the U.S.A.

But I was wrong. Isadora Duncan also hailed from the Wild West.

*　　*　　*

I had been lunching with the Princess Murat at the Ritz in Paris. On leaving the hotel we found Isadora waiting at the entrance. She was accompanied by a tall, handsome personage. It was Walter Rummel, whom later I was to know as 'the Archangel'. My companion, who 'knew everybody', presented me, and a few words were exchanged before their car took them away.

I was left with the impression of having met a remarkable and highly sympathetic personality. The dancer's countenance, which was round and open, breathed candour and gaiety, and her figure, although veiled disturbingly in some shadowy and to me un-identifiable material, disclosed the accents and contours of an unfashionable opulence, but betraying at no point any trace of fatigue or the over-blown. Tall rather than short, her proportions would, I think, upon analysis, have fulfilled satisfactorily all the requirements of the antique *Section d'Or*, and her costume *à la mode* showed the imprint of a master couturier. Raymond Duncan would not have approved of his sister's attire; but then he dis-approved of her habits in general. These cocktails, these smart

373

restaurants, these fashionable togs; how wrong it all was! How expensive, how deleterious, and – yes – how vulgar!

I often stopped to gaze through the window of Raymond's establishment in the Rue de Seine. Within, a faithful little band bent over their looms as they wove the woollen fabrics from which were made the simple garments prescribed by the Master, and affected by him as by all the members of his cult. This garment or *chiton* is worn by both sexes and may be long or short. With a pair of sandals, it suffices both for warmth and decency; it is becoming and dignified; it is also cheap and durable, compared to the evanescent products of fashion and commerce. It may be unsuitable for the business man, for it seems to have no pockets, but a bag may be carried over the shoulder at the end of a stick. A top hat, unless a very old and obsolete one, would certainly be out of place, and as for general wear, it will be long, I think, before the *chiton* comes into fashion – though it might well prove popular at the seaside.

After this meeting I saw nothing more of Isadora till she came to London on a professional visit. I was among those who welcomed her.

Since she had been wondering where would be the best place to stay, I had suggested the Cavendish Hotel in Jermyn Street, which I knew to be extremely well appointed; besides, its proprietress, my old and esteemed friend Mrs Rosa Lewis, constituted in herself, I should say, a sufficient 'draw' for anybody. Americans, I knew, took to Rosa Lewis on sight, and acclaimed her as the archetype of an age and way of life of which she appears to be the only representative still to be met with. Unique in England, she has become a legend in the States. We shall certainly never see her like again, though when I come to think of it, her spiritual ancestry being Elizabethan or even Chaucerian, the immortal strain is bound to reappear in the future, even if it is, for reasons of state, carefully disguised.

Isadora Duncan

My suggestion was acted upon. Isadora, however, took little
advantage of the talents and charm of her hostess, or the unusual
amenities of the house, and kept to her own quarters, but only
for a few days. I have often found that my enthusiasms only
excite incredulity and suspicion in others, and I cannot claim to
have made, in my time, a single convert to any cause dear to me.
Perhaps, though but a few yards from Piccadilly Circus, once
considered to be the hub of our Empire, and its spiritual navel,
dominated as it is by the soaring image of the god of love,
Jermyn Street, would not at once strike the foreigner as the dis-
tinguished thoroughfare it has some claim to be. It will have for
him, no doubt, the air of a secondary or even a back street, but
back streets sometimes fill front pages, especially in London, and
Isadora, uninstructed, was unaware of this as of the many other
incongruities of our capital. At the zenith of her short career her
outlook had been conditioned by the more stately background of
her continental triumphs, and, childlike, she judged this to be
indispensable, or at least appropriate. Was she then exclusively
committed to the expensive mediocrity of the smart hotel? The
answer is no. But in this case she soon abandoned the Cavendish
and moved to the Berkeley, or perhaps some other home from
home – I have forgotten. Here, at any rate, her visibility would
be increased; there was her box-office to be considered ... I con-
tinued to visit her, of course, though I sometimes missed the
peculiar cachet of Mrs Lewis's establishment; a cachet which
might escape the casual visitor, and which Isadora, isolated in her
private apartment, remained unaware of.

After supper the Archangel would usually seat himself at the
piano, and Isadora, from time to time, as the spirit moved her,
rose and danced. She wore a loose short-sleeved gown, pleated,
of terra-cotta silk. Raising her arms heavenwards, and her now
transfigured face too, she would take a step or two forward, side-
ways, backward, forward ... and that was all! But the dancer

375

moved as if at the behest of unseen powers and she moved in rapture, not abasement ...

Isadora had complained rather bitterly of the scarcity of millionaires in this country. Elsewhere she had been accustomed to keep one or two within call, upon whom to discharge the burden of such practical matters as she was constitutionally unfitted to cope with. 'Where is my millionaire?' she wailed. But one day she reappeared in very good spirits having, she announced, just come upon a specimen who would do extremely well for the time being. A luxurious Daimler was now placed at our disposal – I say *our*, for to some extent I shared in Isadora's good fortune. With no more taxi fares to be paid, I could now, without afterthought, agree to an excursion after the theatre or of a morning. I knew of a good old-fashioned inn at Hampton Court where the cheer was good. I have hinted that Isadora's tastes were no more ascetic than my own at that time. However divided we might be in some respects, over a roast chicken and a bottle of good wine we were as one. The Hampton Court resort had only one drawback: there was absolutely no *réclame* to be gained there. Even after openly engaging a private room for our meal, we were never once interrupted or pursued by fans or photographers.

Isadora had established a school of dancing for children in Moscow. Her presence was needed there and she departed by air. I would have accompanied her as she suggested but, as usual, I had work which kept me. A good thing in itself, no doubt, in some circumstances industry makes a poor excuse and is best kept dark. And so, whatever my motives, I left them to be guessed. I was in Paris when the news came of the fatal accident at Nice. There was a memorial ceremony held in Paris which I should have attended, but, always shy of public demonstrations, I missed it. So ended my acquaintance with Isadora Duncan, the dancing Wonder of the World.

Actors and Actresses

It has been said by a good judge 'All the World's a stage and all the men and women merely players'. But why *merely*? Play-acting is the essence of life. Everybody tries to act a part and thus extend himself in space. Unfortunately many have been allotted unsuitable roles in which they cannot possibly do themselves justice. This is a common complaint, and due partly to native incompetence and partly to the carelessness of an over-worked Producer. But there is still a chance for these misfits. Let them exceed themselves in inadequacy and they will end by making a triumph of failure! It should not be too difficult since they always have the looking-glass to guide them. 'Nothing succeeds like excess.'

Children are born mimes: even their shyness can be assumed and used as a means of display. Cats and dogs, too, when young, constantly resort to make-believe – sham fights, wrestling, ratting, bird catching, and all such fun. They seem almost human, as we say, like monkeys who also run us close when it comes to action. Hence our verb 'to ape'.

But the proof of our superiority lies in our ability to disguise ourselves convincingly and impersonate somebody else. Failure to do so provides the stock-in-trade of comedy; tragedy, on the other hand, depends on the degree of success we attain in this line. The ridiculous misunderstandings of the one are matched by the heroic cross-purposes of the other, and to each the element of duplicity is common. Hence we deduce the rule that deception is as the breath of life – that is, on the stage of course.

But I find I have wandered into the theatre now, where we see the world boiled down to a convenient size; the actors, somewhat enlarged and provided with masks, try to look natural while

declaiming, in surroundings of a fascinating improbability, lines which, taken as a whole, with perhaps an occasional effort by the orchestra, combine to conjure up the illusion of reality or the shifting phantasmagoria of our dreams.

I used to think actors (and actresses), when off the stage, must be mentally vacant: living only fully in their parts, they would, I thought, be pretty dead outside them. Nothing of the kind! Actors are often better off the stage than on. They are still acting, of course, but in their own role. This allows them plenty of time for rehearsal, and, being naturally ambitious, they make the most of it. As nearly all people are slightly asymmetrical, each has to decide for himself which is the better side to lay stress on, and dispose himself accordingly. 'L'Art,' said Prosper Mérimée, 'c'est l'exagération à propos.' But under-emphasis is also important, and a good actor will employ both devices when necessary. This discreet interplay of accent constitutes style. Sacha Guitry certainly had it, as I observed for myself at one of du Maurier's luncheons at the Garrick Club. In his case the result was a genial naturalism, for which, even if it was assumed, I fell: just as one applauds a piece of trickery by a skilful conjurer, who leaves one both incredulous and delighted.

Sacha Guitry's professional partner, Yvonne Printemps, went further. As she spoke to me, while facing the light, her open mouth permitted me to examine its interior, and, to my astonishment, I realized this exquisite sound-box had not been neglected in the process of make up, for its nacreous surfaces repeated in all its nicety the delicate magenta of her lips! Again I fell, but this time with a more marked and lasting concussion.

Gerald du Maurier's style, an urbane and highly wrought genre, served him equally well on and off the stage. There was no need to vary his technique which, in each case, provided a perfect medium for his limited purposes. Though, as he told me, each movement cost him months of thought, experiment and elabora-

tion, the outcome was always a triumph of subtle verisimilitude, and, like the grapes of Apelles, might be pecked by the hungry birds of criticism, but never punctured. His artful economy in the use of the sincerity motif alone was almost enough to take one in.

Though I have had little to do directly with the stage, I have had the good luck to meet many of the profession, and, at the instigation of Charles B. Cochran, did undertake the decor of two plays which he produced, *The Silver Tassie* by Sean O'Casey, for which I designed the principal scene, and *The Boy David* by Sir James Barrie. The first went very well, in spite of some short-comings in production, but the second came to grief. I had taken a great deal of trouble with the more ambitious possibilities which Barrie's play offered. My principal scene, a rocky landscape of Judea, was very well carried out, after a great deal of trouble, and when properly illuminated I thought it looked magnificent. I have never been to Palestine, but the late Lord Melchett, who was familiar with it, told me when he saw my designs in the studio that I had exactly captured the character of the country. I had provided a dark and lowering sky, with immense rocks in the foreground, from which descended a slender waterfall, giving rise to the brook from the bed of which David chose the pebbles he was to sling at Goliath. The water presented no difficulty to the technicians, or if it did they overcame it. How charmingly it glittered as it fell! I had finished my share of the work within a week or two of the opening, when for some reason unknown to me Cochran found it necessary to change his producer. On the first night a tragic surprise awaited me when the curtain rose on my cherished landscape. Gone was the stormy sky. It had been replaced by a plain white backcloth! Gone was my waterfall, an indispensable adjunct to the design. Gone, in consequence, was the unity and character of the whole picture. As for the other scenes, they had been repainted by another hand, without, as far

as I could judge, being in any way improved. I hurried to the bar and stayed there. This play was a complete flop from the start, and I wasn't sorry. But I *was* sorry for poor Elisabeth Bergner, who had been turning head-over-heels so playfully and industriously during so many rehearsals, and all for this fiasco!

It dawned on me too late that I had neither the technique nor the physical attributes for this sort of work, apart from the question of my artistic ability. Work necessitating collaboration, as in this case, calls for the authority of a field-marshal coupled with the moral and material equipment of a gangster. Hitler, who as we know shone in both capacities, besides being a bit of an artist, had at least a good run for our money, and if he failed in the end he had only himself to blame, since there was no one above him to accuse. I, who at least had Mr Cochran over me, certainly did lodge a complaint, but that amiable and adventurous being, secure behind his cohort of Young Ladies, succeeded – though with some difficulty – in appeasing me; his apologies were reinforced by a satisfactory cheque. I am glad to say we remained friends but not collaborators.

J. M. Barrie had not been helpful. He found my view of Bethlehem topographically incorrect. It was. I had imagined an austere little hill-town, decorated with olive trees, terraces and perhaps a few cypress trees such as are found in Provence, and probably, I thought, in Palestine too, for the two countries are in much the same zone. But Barrie produced a sketch by a friend of his of the place as it really is, or at any rate as this artist saw it, being on the spot. In the middle distance one detected an insignificant village with what might have been a church, set in the dreariest of landscapes, of a flat and muddy green. In spite of this evidence and Barrie's insistence, I preferred my own idea and stuck to it: for one thing, it was better 'theatre'. Upon reflection I have begun to think this conflict of opinion was the cause of the subsequent mutilations of my designs. C.B. was not the man to

betray a friend at the behest of the author of the play, and that author J. M. Barrie himself.

As a youth I saw Henry Irving perform several times at the Lyceum. The tall black figure plunged on to the stage as if propelled by destiny. He might be inarticulate with passion, but his voice preserved the poetic tempo none the less distinctly. His exquisite gestures could be those of a saint, a warrior or a king. The nobility of his progression deathwards might perhaps be matched in a fresco by Giotto.

My sister Gwen and I went to see an Arthurian drama in which Irving figured, and on reaching our lodgings, still under the spell of the Master, I seized a heavy walking stick, raised it above my head, while reciting appropriate lines, and smashed the chandelier! Excalibur had struck again ...

Ellen Terry was one of those rare women who, reversing the usual rule, gain in liveliness with every year. When she came to live in Chelsea, though by other standards an old woman, she seemed to have reached the summit of vivacity. Demure young girls, relying on delayed action, discharge their amorous missiles unobtrusively, with an eye to catch their quarry later, as defence-less they lie in bed and dream; but older ones like Ellen (if there be any such), having less time to spare, engage at once in frank aggression: careless of their dwindling ammunition, it's hit or miss with them. Practically invulnerable themselves, they laugh at opposition for they have Death on their side. In my own case, rather than join a queue of corpses, I surrendered without a blow.

Gwen Farrar, who later lived in the house mentioned above, was a genius of a different order. Of course she belonged to a very different world from that of her happier predecessor. Hers was the Faery world; the world of cacodemons and pigwidgeons; the world of the unblest. She was the up-rooted one, the change-ing, the proud pilgarlic, the play-girl of the moon, and she had a voice like a coal-heaver.

Finishing Touches

I have never cultivated coal-heavers; I prefer to keep out of their way; not that I have anything against them morally, but I find their make-up repellent; to me it is affected without being witty. Unlike the cunning maquillage of the clown, it is based on no ancient tradition but seems to be purely haphazard and misses the morbid appeal of the nigger-minstrel who does at any rate give tongue to the inarticulate yearnings of the holiday maker, in strains of a transcendent if transatlantic vulgarity. I welcome the rare street-cry, but the hoarse call of the coalman does nothing to lighten the gloom of the back street.

Gwen Farrar's voice, when first she turned it on in my hearing, gave me an enormous shock. I hesitated between laughter and dismay. Could this be the real Gwen Farrar? If so, what could she have been drinking? Was she merely doing a turn? With actors you never know ...

The fact is, as I realized later, she was only indulging in one of her private impersonations; but it was a favourite one and seemed to come quite naturally to this perverse and adorable being. I soon got to love it. Come back and talk to me, Gwen!

I was overcome by Eleonora Duse. She was acting in a play by Ibsen. The intensity of emotion which it was her business to suppress communicated itself to me. I found myself in an exactly parallel situation. As a Welshman, it would have been natural and proper to give full vent to my feelings, but my English veneer made such an exhibition unthinkable. This resulted in a familiar and painful dichotomy which could only be relieved by a pistol shot. I was astonished to discover that Italians are not, as I thought, all born actors. The Duse's entourage was most inadequate. But perhaps her countrymen are only first rate at heroics in this play, conspicuously apart from the principal role, no such opportunities presented themselves.

I think I can claim to have had a share in the eventual success of the Sicilian Players on their first appearance in London. Then

must still be some who remember Grasso and his company. Their season started badly. Moved by some mysterious impulse, I attended the opening performance. The theatre was practically empty: my applause must have seemed disproportionate but I persisted; gathering a few friends, we constituted ourselves an unprofessional *claque* and night after night created a terrible din after each act. Gradually our exertions began to bear fruit; our enthusiasm spread, more and more people began to trickle in, till after a strenuous week or two the theatre filled itself nightly. The battle was won!

Walter Sickert joined in with the Partisans, and with his knowledge of Italian made the acquaintance of some of the Sicilians, especially Mimi Agulia, the principal lady. She was persuaded to come to his studio to pose for some drawings. This brilliant little actress said of herself and her confrères: 'We just try to be natural.' She was modesty itself. Everyone insisted that I should present her with my drawing. I did so. It was hung in the foyer of the theatre till the end of the season, when the company departed with it to South America. I would very much like that drawing back, if it exists, or to have a photograph of it.

The return of the Sicilians brought disappointment, at any rate for me. As usual, success had spoiled them. Unnecessary elaboration had taken the place of simplicity; a more showy but less talented leading lady had been substituted for Agulia; even Grasso had lost some of his pristine innocence and swagger.

When the Jewish Vilna Players gave a season in London I became a frequent spectator at their performances, and so did Sickert. Though I had no Yiddish, such was the excellence of the acting that it was easy to follow the gist of what was said. The weird and disturbing play, *Der Dybbuk*, above all enthralled me. The terrifying phenomenon of 'possession' is a rarity in this country, but not I think unknown. I wonder one of our own playwrights has not made use of this motif.

Finishing Touches

I once saw Sarah Bernhardt, but not on the stage; it was at the entrance to a theatre. She lay on a litter, having had a leg amputated recently. A play was in progress, but the divine Sarah hadn't come to see a play: she had come *to be* seen. The auditorium was in darkness. She demanded that the lights be turned on. The manager, with infinite apologies, refused to do this, for the play was in progress. Furious, she was carried out again, with the face of a Gorgon. Was the manager right or wrong? A nice point.

The stage used to be well represented at the old Eiffel Tower in Percy Street. This restaurant in its palmy days used sometimes to become over-crowded of an evening. On one such night Stulick, the patron, implored me to help him keep out any newcomers, for there was hardly standing room and the waiters were distraught. Accordingly I went to the front entrance and managed to dissuade some fresh applicants from entering. Unfortunately one of the oldest and most esteemed clients turned up. It was none other than that prince of comedy, Ronald Squire. What was I to do? I could only explain the situation and stand firm. Squire's indignation was only matched by my discomfort. How willingly I would have given up my chair had I not been inextricably involved with some guests that evening. I returned to my more legitimate responsibilities in no happy mood. Ronnie, being an unique combination of artist, saint and philosopher, and with, I suspect, more than a touch of second-sight as well, remains in spite of our contretemps my very good friend and hero.

At that time Robert Newton had not attained his present eminence. His manly beauty was unenhanced by the costly accoutrements of Californian fashion which now he wears so bravely. But Bob was always brave; brave, simple and above-board, even when under the weather. This man of many parts, in his good fortune careless; with the great heart of adolescent humanity beating more quickly at his nod, may even in his heyday profit by a word of warning. Such a warning I take it upon myself to

administer (a septuagenarian must be indulged): 'The Gods have conferred on you, my dear Bob, among other gifts, a generous allowance of Sentiment. If you would enjoy this abundance to the full, you would do well to use it sparingly and with an eye to the stomach, for it might come back on you – or worse, on some innocent person in your neighbourhood. To vary the metaphor: when running a race, with such a horse as Sentiment under you, the strongest and the most vicious in your stable, beware lest you come a cropper or be run away with. Let your steed always feel the rein, dear boy, but not the spur; by keeping well within the not too exiguous limits of Dickensian Melodrama (though I myself favour a narrower course) you and your noble beast are bound to romp in – winners every time!'

Esmé Percy, a pure Elizabethan if ever there was one, though he never told me his age, must be a good deal older than he looks, though not so old as I am. Perhaps, like me, he has forgotten the precise date of his birth, which at a guess I would place somewhere in the sixteenth century. Although I am his senior, the gap between our years is not so wide as to have divided us as children, though it would doubtless be enough to have thrown into relief, more than it would today, the precocious gravity of the older child as compared with the gay ebullience of his playmate; but as there is not the slightest evidence that any such association took place, I will at once abandon a utopian speculation and turn to facts, or rather possibilities.

At the period suggested, I might well have been a simple shepherd boy watching his flock upon the rough pastures of Prescelly, for it was from these windy uplands that my forbears sprang, without, it appears, landing in any instance far from the take-off. But clues to such activities are scarce; mountain mists make exploration hazardous and the trail to the Ancestral Stones has long been overgrown.

To beguile the reader for a little while, let me by a process of

association reconstruct the story of my meeting with the distinguished Player named above, and, in a new perspective, place the event midway between an almost legendary past and a too photographic present.

For this purpose, borrowing the licence usually reserved to poets, I will add a flavouring of historical colour by the introduction of persons, circumstances and names known to everybody in connection with the period chosen, and entitle the result:

An Elizabethan Interlude

When, having won a scholarship, I was sent to Oxford to be civilized, I found Jesus College simply pullulating with my compatriots, few of whom knew much English, and in some cases only indifferent Welsh. Welded together at last under the common tyranny of a masterful fellow countrywoman, each tribesman brought out his pedigree entitling him without a doubt to a seat at the Round Table, a choice of the attendant virgins and an unlimited supply of metheglin. Arthur had come again, it seemed, or was due to return at any moment. In this hot-airy atmosphere my studies languished, my behaviour worsened, and when at last sent down, I came to London to seek a job. After a time, as luck would have it, I succeeded.

It was a pleasant change to leave my filthy lodging in Shoreditch and come to live in Chelsea, then a village, though I missed the Playhouses to which I was addicted; 'The Theatre' or 'The Curtain' which, with the new 'Rose' across the river, had been my favourite haunts of an afternoon before the plague drove people out of London, were of course shut for the time being, and the Players for the most part had taken to the road. But I was at least fairly safe in Chelsea, and with other fugitives at no loss for company. Besides, on becoming tutor to the children of a lady of substance, I was not without means wherewith to pay my

standing in the local taverns on the river bank, of which, considering the limited population in normal times, there were perhaps too many.

It is noticeable that danger adds an extra zest to life, and at the time I am speaking of the proximity of death, in a most loathsome form, induced a certain recklessness and appetite for pleasure which ordinarily would have been judged reprehensible and even vulgar.

My employer, subject like all young people (and indeed to some extent the old) to the general urge, having been left in affluence as a result of the industry and forethought of her late husband (a highly respected and substantial wool merchant), had already begun to entertain somewhat largely, when, having been presented by a common friend, I made her acquaintance. Touched by her beauty and amiability, I soon became a frequent guest at her house, where, having some facility for dancing and conversation, I was made welcome. The defencelessness of this lady began to cause me concern, for I knew the village to be crowded with strangers from the city, many of whom being but ruffians and tricksters, out as much to line their pockets as to save their skins; among them too, and they the worst, were some disguised as gentlemen.

Our acquaintance developing into friendship, at my hostess's suggestion I readily agreed to take upon myself the instruction of her children. For greater convenience I was lent a room in her spacious house where I might sleep and do some work of my own, had I the mind. This arrangement pleased me greatly, for apart from my own profit, it empowered me to keep an eye on the visitors and, if need be, discourage those I deemed unworthy or worse. I could thus serve my young Mistress better than she bargained for, and without her knowledge. Having become a trifle arrogant in her good looks and enviable circumstances, the widow would have ridiculed any suggestion of her incompetence

to take care of herself, and certainly would have scorned any offer
of protection from so insignificant a person as myself, although
my occasional interventions were not ill-timed nor were they dis-
approved, as I could see.

The party was breaking up; many of the guests had gone home,
but a few enthusiasts remained, and the musicians, though half-
fuddled, still played on. I was standing at the improvised bar
contrived in a corner of the ballroom, when two newcomers were
announced. I caught a familiar name, that of the Player Esmé
Percy, whom I had often admired; I had supposed him to be
absent in Wiltshire with the Earl of Pembroke's men. These tardy
revellers, having paid their respects to the hostess, now joined me
at the bar. Vague introductions took place. I did not catch the
name of Percy's companion. The two had just come up the river
from Southwark. It seemed they had been spending a considerable
time in that quarter, especially at the drink-shop in the Clink
belonging to one Will Shakspere. I had heard of this man, who
was well known in theatrical circles and reputed rich. Besides his
work as prompter and sometimes actor, he was dispenser of robes
and costumes, of which it was said he had a fine collection, and
he dealt in Plays, too, and would employ hard-up writers of
talent and even genius to emend, alter and patch up these for him,
when he would sell them as his own. This wily factotum, among
other activities, was said to run a smart brothel in Blackfriars. I
had heard all this gossip myself.

Though I overheard the name of Shakspere mentioned more
than once by Percy, it was mostly in ridicule; his companion
appearing to be uninterested in or impatient of the topic. A
strange fellow this, I thought; dressed with great simplicity in
black, in contrast to the fashionable elaborateness of the actor's
attire, his style was that of a gentleman, but I found his manners
insupportable: disdainful, truculent and provocative. I began to
consider the propriety of exerting my privilege as chucker-out,

when, to my astonishment, an extraordinary change took place in this humorist's demeanour; whether the effects of Master Shakspere's bad sack had worn off or taken a new turn, or whether my Mistress's superior liquor had wrought a miracle, in any case the unknown, drawing in his horns, now apologized for his ill-manners, and addressed me with the utmost modesty and solicitude. To my surprise my resentment vanished instantly under the illumination of the stranger's smile, and, as I listened to his voice, my heart began to burn: where had I heard that voice before? As my eyes met his, I trembled, for in them I seemed to discern the majesty, the sorrow and the understanding of – a god in exile ... ! Inexpressibly moved, I would have cast myself at his feet, for I had lost all sense of time, identity and my surroundings, when Percy broke the spell of this enchantment: 'Come,' he said, 'the tide has turned, we must go back.'

The ballroom was empty. As in a dream I saw them to the door, where the stranger, throwing his cloak about him, murmured a good night and disappeared. Before the Player could follow, I seized him by the arm: 'Esmé,' I cried, 'tell me, who is that man?'

'What,' he replied, and in a whisper, 'didn't you guess? Why, that is The Poet ... !'

Portraits of Prime Ministers

Winston Churchill

I haven't painted many Prime Ministers. I can think of only three or four colonials and our own Ramsay MacDonald; but I have *drawn* A. J. Balfour and Mr Winston Churchill. The former came to sit for me in Fitzroy Street at the behest of his sister. I had always admired this statesman. His philosophy of doubt appealed to me and, what is more important, so did his appearance and manner. Having placed him in a comfortable chair, I set to and completed the drawing within an hour. Whereupon, waking up, Mr Balfour glanced at my effort, and remarking 'A very fine piece of work', disappeared.

Mr Churchill was much more difficult. I first met him at John Lavery's studio a good many years ago. He had brought some pictures to show which I thought commendable. After that I used to see him now and then at the luncheon parties Mrs Valentine Fleming gave at 'Turner's House', Chelsea. 'Turner's House' had gone through drastic changes since the great painter lodged and died there under the name of Booth. Booth was really the name of his landlady (who was a widow): it was at once adopted by the artist. This simplified matters, I suppose; anyhow 'Old Billy Booth' was known to all the ragamuffins in the neighbourhood who used to pursue him with their gibes.

The little house has been transformed since then, and a large studio built at the back by a man I knew at the Slade called Balfour, and my future friend Lionel Curtis. Later, during the tenancy of Mrs Fleming, the nice little beer house next door called The Aquatic Stores, which I found so sympathetic, unfortunately lost its licence and was then taken over and embodied in 'Turner's

House'. In spite of the plaque on the front which commemorates the name of its former august tenant, it is certain that if Joseph Mallord William Turner came back, he would have had some difficulty in recognizing his now transformed little lodging house on the river-side, and it is most unlikely that he would feel at home at Mrs Fleming's luncheon parties, even if he were ever invited to one of these distinguished gatherings. No; for him the simpler and perhaps grosser amenities of Wapping were to be preferred, and it was thither he was accustomed to repair for recreation of a Saturday night.

On a visit to the House of Commons one day as a guest of the late member for King's Norton, Mr Raymond Blackburn, we approached the Prime Minister and I raised the question of a drawing. A picture had been long mooted, but involved as he was in affairs of state he agreed to sit for a drawing only and a date was fixed. On the day indicated, a car was sent by the P.M. to pick me up at Tite Street. My daughter Poppet and Mr Blackburn joined me by arrangement, and we all three were driven down to Mr Churchill's house in Kent, where we were received by young Captain Soames, our host's son-in-law, Mrs Churchill, for whom I had the greatest regard, being unfortunately laid up with a cold. Presently the great man appeared in his 'siren suit' and the operation began. I soon discovered that my model, however efficient in other ways, was no great shakes at keeping still. My target turned out to be a moving one. But I had often drawn charming but restless children before, and was now to tackle a somewhat similar proposition. In this case, I was limited to a single sitting, so had to make the most of it. On the whole the result was not too bad, I thought, considering the difficulties in my way.

Luncheon was now served. Mr Churchill of course took the head of the table. His charming daughter, Mrs Soames, sat at my left. Mr Blackburn at the other end of the table faced the P.M.,

his fine eyes glowing with the love and adoration of an early Christian convert in the presence of his Saviour. My daughter, also a great fan of the P.M., sat opposite me. During the meal Mr Churchill entertained us with reminiscences of his schooldays and early manhood. It appeared that as a schoolboy he had never distinguished himself either at his books or in the playing field, but apparently he woke up a bit while serving as a soldier in the Sudan, especially on one occasion when a black warrior offered to transfix him with a spear, at Omdurman or somewhere. Young Lieutenant Churchill felt he had to get his in first, and you bet he did, though, mind you, he 'didn't like doing it'. Luncheon was over, but, spellbound, we still lingered over our coffee, which in my case had been reinforced by a generous share of the Prime Minister's brandy. I fully appreciated this mark of favour and noted with approval that the member for King's Norton had not been similarly honoured. Our host's easy flow of reminiscence had gradually come to include our own times in its purview: his passing reference to the bombing of Nagasaki and Hiroshima, for which, it seems, he shared some responsibility, provided me, I thought, with a legitimate opening for an expression of regret that this atrocity should have been perpetrated by our allies. 'But it may have saved thousands of lives,' declared the statesman sharply. 'Perhaps,' I replied, 'but our soldiers are not expected to take shelter behind the corpses of non-combatants, nor are they accustomed to buy immunity at the price of the blood and agony of helpless women, old men and children. Besides, the war was virtually over and ... ' but well before I had got as far as this I saw that I had exceeded my time allowance, and Mr Churchill had already entered on a further chapter of his memoirs. I was much too slow for this agile septuagenarian.

Before leaving, I assisted at a demonstration of a new kind of paint Mr Churchill had taken to using. It was a Swiss production inaccurately called 'Tempera'. Put up in tubes, the stuff could be

squeezed out and diluted with water. Setting up a good-sized canvas, my instructor who had now recovered his normal good spirits, attacked it vigorously with his new medium – and, quickly, a mountainous landscape appeared, complete with a lake and a chalet. The latter feature requiring a window, this was instantly supplied with one straight right from the shoulder, a master stroke! Before I left, Mr Churchill loaded me with a parcel of his new pigments to take home, and added a bunch of suitable brushes too, but alas, by the time I was ready to try the colours, I found they had solidified. As a final gesture, the kindly old gentleman handed me an outsize cigar; in fact, I was given a very good send-off.

'*The Soul's Awakening*'

If Ramsay MacDonald in his day could never be said to rival Mr Churchill as a National, or rather International institution, nor, as a mere Parliamentarian, hold a candle to Mr Churchill in pugnacity, perspicacity, wit, and general God-damnedness; yet he, in one series of tests at any rate, showed himself the better man.

I am not concerned here with politics, but only with a matter of manners, and then only in so far as they affect me professionally. I have mentioned Mr Churchill's strange inability to keep still while I was trying to draw him. He was evidently unhappy under my scrutiny. How else to explain these fits and starts, these visits to the mirror, this preoccupation with the window curtains, and the nervous fidgeting with his jowl? All this agitation didn't help me in the least, and with only an hour or two at my disposal (without counting a rest now and then), it was all I could do to keep calm myself and avoid an explosion. But I was aware of the alternative which faced me. You can draw a man, or you can punch him; you cannot do both ...

Finishing Touches

Although in the business of portraiture, the artist must be prepared to accept every deviation from the normal, and even perhaps accentuate them, in so far as they afford a clue to the elucidation of character, he will require to some extent the collaboration of his model, if he is to bring out the more pleasing aspect of the latter's personality. It has been found that the practice of an attentive yet easy immobility best assures this, together with a resolve on the part of the subject to look his best, or what he thinks is his best, which comes to much the same thing and is equally revealing. Whatever may be thought of the work now under consideration, its shortcomings cannot be blamed on Mr MacDonald, who, following my suggestions, took every risk and stuck it out to the end.

Moved by some mysterious premonition, I posed my P.M. with his head turned over his shoulder and almost in profile, while an open book occupied his hands in the centre; his eyes, like those of a visionary, being directed upwards and far away. Thus I obtained a suggestion, less of the dour and horny-handed champion of the People than of the dreamy knight-errant, dedicated to the overthrow of dragons and the rescue of distressed damsels held captive by them. A stray lock of hair breaking the too severe contour of his brow, provided, I thought, an appropriate note of romantic informality. I could not help feeling, though, that my sitter was not wholly reassured by my reading of his character. As he examined it during the rests, I observed the beginnings of a wry smile struggling with an expression of perplexity, as if there were something odd and perhaps important on the tip of his tongue which yet eluded capture.

'There is a well-known picture,' he remarked at last, 'which your portrait reminds me of, but I cannot recall its name.'

Instantly Sant's masterpiece sprang to my mind. 'Do you mean "The Soul's Awakening"?' I asked. 'Yes, that's it,' he cried, ' "The Soul's Awakening"!' We both had a good laugh at this discovery.

Decidedly, MacDonald was not entirely without humour, though the responsibilities of high office sometimes got in its way. A little less *empressement* would have served his purposes better, and have reassured his friends while worrying his enemies equally.

George Moore's funeral coincided with the completion of the portrait, and, as we had both known the deceased, at MacDonald's suggestion, we attended the last rites at Golder's Green together. On this occasion I was unimpressed by the preliminaries incidental to the cremation of an unbeliever, and after seeing the case containing the corpse, propelled by some hidden mechanism, disappear through an orifice in the wall, I made for the open air with much relief. As we made our exit the appearance of a group of clergy startled me. I had forgotten that such types existed. Byzantine in character, they were at the same time not unlike the stylized figures found in early Saxon art and quite unbelievable. I had thought of a drink at the Café Royal, but affairs of state, no doubt, claimed my politician, and I saw the last of him standing on the door-step of an important-looking house, his fine head slightly bowed in thought, with his erect figure, half-turned towards the public, showing a graceful curve. I was reminded at once of the stately occupants of Parliament Square, but I had to admit the line of his trousers belied this comparison, and, although his boots, so blunt and workaday, seemed to shine with more than their usual lustre, this was probably an effect of the rather theatrical sunset which was blazing in the west, as if in acclamation of my model, or (it occurred to me), more likely in honour of George Moore, by now just about due at the turnstile of the Irish Valhalla.

Asides

PERFECT physical union, though never to be despised, is soon forgotten unless constantly renewed; but complete fusion of body and spirit, ah! that indeed is rare, but it is remembered for ever!

* * *

Those fellows who think they can dominate a woman by bawling at her will soon find they are mistaken. Such conduct is ill-bred besides being the lowest form of Noel Cowardice.

* * *

To Robbie Ross and Reggie Turner fell the job of cleaning up after Oscar exploded. They told me it was awful, like picking up confetti, and they had to use their hat-pins!

* * *

When Wyndham Lewis got Bozie Douglas to sit for him, he hadn't seen his Lordship before, or he might have thought better of it. After the first sitting he asked me what he ought to do about Bozie's nose. I told him, of course, to make it a bit bigger; but Lewis demurred: he said he had to draw the line somewhere.

* * *

It's all very well for Lewis to issue a clarion call to Artists at this time of day to stop abstracting before they go 'over the precipice' as he puts it. But I think my son Robin went further

than this about twenty years ago. He went to Paris anyhow, and there succeeded in pushing *his* abstractions to the point of complete invisibility: he framed the results and hung 'em up in his studio, where they are still not to be seen, even by Lewis, unfortunately. It is true Robin himself *has* gone over the edge in a way, but I haven't lost faith in him yet. He isn't dead and I expect a call from the depths at any moment.

* * *

Sir John Rothenstein seems to have inherited some of his father's pugnacity. But when Will knocked Charles Conder down, the latter wasn't in training, and anyhow his leg-work was never considered satisfactory, although I know he could make good mileage, given a sufficient motif. None of that lot were really athletic, except perhaps Robert Sherard; but then he simply *lived* on something called 'Vi-Cocoa', if one can believe the advertisements of the period. Will Rothenstein was certainly quick enough on his feet when it was a question of the last helping of *Cœur a la Crème* after lunch; he was no good at drinking though, it always gave him jaundice. As for Max Beerbohm, perhaps the less said the better, but he always looked to me as if he'd had enough.

* * *

'All art is a memory of age-old things, dark things, whose fragments live on in the artist.' – Paul Klee.

Dylan Thomas and Company[1]

THESE sketches of three men I have known and admired make no claim to exact portraiture, though they do aim at registering as accurately as possible some aspects of them I have noted during our long and fairly intimate acquaintance. For the rest, I have done nothing more than avail myself of the first privilege of a friend, which is to speak with complete frankness, combined with a touch of malice when necessary. No attempt at embellishment will be found, I hope, nor anything like defamation, which would only recoil on my own head.

The late Nina Hamnett (who, like me, came from Tenby) introduced me to the Fitzroy Tavern – a largish pub on a corner of Charlotte Street. It was kept by a Jewish family, whose head, an elderly man of the name of Kleinfeld, I became friendly with; he used to teach me some words of Yiddish, a few of which I remember (such as *muzzle* for luck), and others may crop up in my memory when I have no need for them.

Mr Kleinfeld knew all about 'Der Dybbuk', a terrifying spirit which had been the subject of a play by the company of the Vilna Players which I used to frequent, as did Sickert. Mr Kleinfeld saw nothing funny in 'Der Dybbuk', nor did I or anybody who had seen this play so wonderfully acted in Yiddish; but Mr Kleinfeld, though he had the simplicity of a child, was no fool. If I knew the Yiddish for 'gentleman' I would use it to describe Mr Kleinfeld.

A custom at the Fitzroy Tavern was to collect enough money to send the local poor children to the seaside every year. The clients contributed towards this, if they liked, by throwing their

[1] First published in *The Sunday Times* Magazine Section on September 28th, 1958.

money, wrapped up in paper and attached to darts (provided by the management), up to the ceiling, to which the missives stuck if correctly aimed. Charity thus became a popular game of skill. Nina Hamnett, although she might often miss the target herself, encouraged this practice, for she was the soul of generosity, as many a forlorn artist of Montparnasse in search of a drink, a meal and a doss-down could testify.

One evening I entered the tavern to find it unusually crowded. There were many faces which were strange to me, but Nina's was inescapable as she tottered around for a refill and seemed mysteriously to be in more than one place at a time.

There was a sprinkling of music-hall comedians, with that curious air of unreality about them which these artists always wear when off the stage. Perhaps this was due to their having washed their faces, for they carried no make-up or very little; but the knowing look of the 'profession' gave them away (as it was meant to do). Their superior knowledge of the world could not and should not be disguised. 'Hullo, Augustus,' says one veteran. 'You're growing old.' 'Yes,' says I, absently; 'but I'll never catch up with you, Arthur.'

I found a seat some distance from the counter, which was inaccessible except by the language of signs, but there were willing hands to fetch me my drink. In the hurly-burly words were indistinguishable to me, but the peculiar *miaulement* of a group of epicenes could be recognized clearly, and nearer at hand the cultured ejaculations of Cambridge vied with the somewhat blurred but no less authoritative accents of South Wales.

My companion whispered in my ear, 'Dylan Thomas!' Could she be right? She could, for at my side I found the Welsh poet established. It was our first meeting. I lost no time in ordering drinks all round to mark the occasion. As beer seemed to be the order of the day, I wisely forwent my usual double rum and brandy in favour of the popular pint.

Finishing Touches

The other personality of our little group, Mr William Empson, although at this time enjoying none of the Welshman's notoriety, played no second fiddle but, as if under the spell of the *hwyl*, or divine afflatus, gave one at moments the illusion of rising like a bird above the ground! To achieve the Top of the World is worth taking a risk, no doubt, but I wouldn't advise lesser men than Empson to try it. I was moved greatly by his performance, being something of an old mountaineer myself, and on a lower plane may call myself one of his fans.

In a distant corner Professor Haldane might have been observed. Notebook in hand, he appeared to be in deep thought, but his Nietzschian features showed on this occasion no irradiation proper to an amateur of the *Gaya Scienza*; on the contrary, it seemed that he might be murmuring to himself: 'Là où vous voyez des choses idéales, moi je vois … des choses humaines, hélas! trop humaines!' I don't suppose any of the specimens he contemplated were in any sense 'idéal', but that some of them were 'trop humaines', or perhaps not human enough, is quite likely. The professor was possibly engaged on a new anthropological study, to be entitled 'How the Poor Live'.

My own new acquaintances made a happy contrast, very dissimilar structurally. Empson's features recalled a late Michelangelo based on some recently unearthed and slightly damaged antiquity, while Dylan's face was round and his nose snub. His rather prominent eyes were a little veiled and his curly hair was red, or auburn rather. A pleasant and slightly sardonic smile registered amusement and, I think, satisfaction. If you could have substituted an ice for the glass of beer he held you might have mistaken him for a happy schoolboy out on the spree.

When he spoke I was astonished by the purity of his vowels, but then I remembered that the best English is heard in Carmarthenshire. In spite, as I noticed later, of his being tone-deaf, his voice had a beautiful resonance and, thanks to his Welsh-

400

speaking parents, his accent was just enough to lend his speech an additional note of character and distinction.

In spite of his upbringing he had little or no Welsh himself, but he would readily break into the mixed dialect when telling a story or indulging in local *facetiae*. Even his English was limited, and a word of four syllables might baffle him. He had no French or Latin, of course, and showed interest in no other literatures but English, in which he was, however, far from being widely read, apart from the 'thrillers', in which he was so well versed. Dickens to him came next to Shakespeare, and it is doubtful if he knew any other English writers unless by hearsay.

He professed the usual sympathy for the underdog, for he was one himself, and at one time, like many other simpletons, he was persuaded to join the Communist Party, though he had no knowledge of sociology or of any political theories from Plato to Poujade.

Later, however, on being ordered to make himself the poetic mouthpiece of Moscow, he had the sense to quit the 'Party', and after that attached himself to no other political movement, unless his propensity for sponging on his better-to-do acquaintances could be dignified by such a name. In any case he could always be relied upon as a borrower, and such was his magnetism that few would grudge him the price of a drink, let alone free residence for a month or two. As for food, he seemed indifferent to it, but was familiar with several little clubs where drinks could be procured between or after hours.

Perhaps the chief difference between a writer and a painter is that the latter depends so much upon the weather in this climate. If he stays up late he is conscious of wasting his time, for it may mean getting up late next day and perhaps missing a valuable ray of sunlight. A writer, and especially a poet, suffers from no such anxieties: for him breakfast may be deferred indefinitely. Furnished with a fountain-pen, an exercise-book and a packet of fags

he brings his studio with him. Among friends he feels at his best at night and the later the friendlier.

I was always glad to meet Dylan in the day-time but often gladder still to see the last of him at night, when his magic had departed, leaving nothing but the interminable reverberations of the alcoholic. It is possible that some of his grassiest verses originated in the fetid atmosphere of a pub or a night-club. But I have never been a student of his poems, and though I have read (and enjoyed) some of them, not a single line remains in my memory.

This, however, means nothing derogatory, for my memory is often defective. Yet, when put to it, as at school, I was able to beat every competitor at memorizing Walter Scott (and by more than a canto!). But on those occasions I had the incentive of annoying the Headmaster, who had seen fit publicly to asperse my veracity and morals and even throw doubt on my chances of salvation after an early death in a mad-house. When, shortly afterwards, this pedagogue cut his throat in a railway carriage, he was probably as unaware of the power of the Evil Eye as he had been of my capacity for learning poetry by heart, let alone truth-telling, etc.

But to return to Dylan Thomas. I went to a memorial performance of his *Under Milk Wood*, and other works, where I was provided with a seat in a box already crowded. Half way through the performance, most of which I couldn't hear, I made my escape to seek out Caitlin Thomas, whom I knew to be present. I succeeded in finding her.

Seizing my arm, she said, 'Come out of this – I've got a date to keep.' We got a taxi and were driven to a pub, where we found a group of her friends awaiting her. After a few drinks we went back to the theatre, in spite of Caitlin's delaying tactics: I wanted to say how-do-you-do to two or three of the actors whom I knew and admired, including Edith Evans and Emlyn Williams. I thought on meeting them that their reception of me lacked

warmth; I suppose they resented my furtive exit from the theatre with Caitlin, who had not disguised her contempt for the whole show.

I have read and listened to *Under Milk Wood* since. There is no trace of wit in this work. Some of the characterization was passable, for I thought I recognized a type or two from New Quay in Cardiganshire. But I did *not* recognize the so-called 'Gypsies': such unearthly dummies couldn't have taken in a policeman! The whole hotch-potch is a humourless travesty of popular life and is served up in a bowl of cold *cawl* in which large gobbets of false sentiment are embedded. Pouah!

In his rendering of Welsh life Dylan Thomas never got near the level of Caradoc Evans, a far more conscientious historian, who was of course reviled by his countrymen, for he exposed their vices unmercifully, as an artist must. Like God, he chastised those he loved (or at any rate their nearest relations), for every year he left his miserable employment to go back to his beloved country for a fortnight.

He asked me to go with him, and said that he would introduce me to some of 'the most beautiful girls in the world'. Unfortunately, I couldn't go just then and will always regret missing the opportunity of associating more closely with so fine a spirit as Caradoc and on such a quest!

After Dylan Thomas's marriage to Caitlin Macnamara, at which, having been by accident instrumental in bringing them together, I acted as second best man, they came now and then to stay at Caitlin's home between Fordingbridge and Ringwood. We frequently met, usually at Dylan's favourite pub in the latter town. Dylan had become a devotee of shove-ha'penny, a game to which I was (and am) addicted: he played well, too. I got him to sit for me twice, the second portrait being the more successful: provided with a bottle of beer he sat very patiently, which is more than I can say for several other distinguished people I could

name, and they not exactly teetotallers, either. He was not conceited and, though he could be pugnacious at moments, he and I never came to blows.

As for his life in America, a devoted and long-suffering American friend has written an admirable account of this, the poet's last deplorable phase, in *Dylan Thomas in America*, while Caitlin herself, not to be outdone, has recorded her later experiences as a widow in Italy with remarkable frankness, and some humour. Unlike Dylan, she is never guilty of sentimentality, and, while apparently in a perpetual state of disgust with the world in general, seems to have chosen instinctively the lowest and dirtiest dram-shop of a mining town in Elba as her refuge from it.

Whence comes this *nostalgie de la boue*? Hardly from her irreproachable Irish and French antecedents! The fact is that only in salt water can Caitlin find the purity and freedom she seeks. She swims well – is not her maiden name *Macnamara*, which (accommodating the genders) means: Daughter of the Son of the Sea? For a long time her father, Francis, did in fact keep a boat tied up in Galway Harbour, of his own design and rig, a boon, as Oliver Gogarty remarked, to the local washer-women ...

I would like to scotch the popular legend that Dylan Thomas was perpetually drunk, bawdy and licentious. In my experience he was none of these things. Under the threat of T.B. he certainly sought confidence and distraction in beer, but he could stomach more of this beverage than most people without getting sodden. He hated solitude and loved the atmosphere of a good pub or, in a lesser degree, a night-club, for he was always loth to go to bed. Perhaps towards morning he might grow repetitive and tiresome, but he was never gross himself, even if he had some droll stories to tell ...

One night at the Gargoyle I was sitting with him and the then proprietor, David Tennant. The latter, trying to draw him out, asked, 'Do you believe in multi-matrimony?' Dylan replied, 'No,

I don't, I believe in one wife only.' And he was very serious. But at that time he wasn't married, nor had he visited the U.S.A.

It was in New York that his system broke down. It was there that whisky, which he shunned in this country, played hell with his brain, with the dire results we know. And it was there that his poetic faculty deserted him completely, though he still did his stuff on the platform with tremendous success, and it was there that he re-wrote and finished *Under Milk Wood* which I have derided. The truth is that Dylan was at the core a typical Welsh puritan and nonconformist gone wrong. He was also a genius.

Elephants with Beards:[1]
The Enigma of Wyndham Lewis

As I have already reported, I became an inhabitant of the Fitzroy Quarter of Tottenham Court Road after leaving the Slade. I found this district sympathetic, with its varied foreign population, its numerous cheap studios and restaurants and distinguished artistic traditions. (These remarks, except for the last, no longer apply.)

Wyndham Lewis, a later Slade student, also lodged here for some time. Somehow we came together and established a friendship which lasted on and off for a lifetime, with of course a good many long and salutary breaks.

His studio was in Charlotte Street, like mine. One entered it to find oneself up to one's knees in wastepaper: at that time he was composing sonnets in the Shakespearian form but of a more than Shakespearian obscurity. He seemed to be suffering from a form of verbal constipation which made it practically impossible for him to express himself in plain language, and this condition became still more marked in his handwriting, which was so squeezed and tortured in style as to be often quite illegible.

Not that he was constitutionally tongue-tied: indeed, when it came to assessing the shortcomings of his contemporaries he could be quite fluent. He had a particularly sharp eye for other people's physical defects, and was fully conscious of his own (for instance, he once, with unusual simplicity, confided to me his dissatisfaction with his *nose*). He was no athlete and admitted envying me my swimming accomplishment; he, too, would have liked to swim, but made no effort to learn. He was certainly interested in girls, but he found himself no match for their back-chat – I refer to the

[1] First published in *The Sunday Times* Magazine Section on October 5th, 1958.

factory girls we sometimes tried to consort with as potential models. His own rather recondite style of humour was wasted on them or answered in a spirit of levity which would have made Rabelais blush.

The advent of Dostoievsky on our consciousness was an important event about this time. In spite of a bad French translation, we both succumbed to these nightmare-like dramas of the soul, with their interludes of almost Dickensian absurdity. Turgenev was put aside (but in my case, at least, only for the time being). But to complicate matters, Nietzsche next appeared on the scene with the impact of a home-made bomb, scattering everybody and forcing even Dostoievsky to a secure but secondary eminence. Baudelaire alone remained immovable, as I suppose he still does; that old *marchand de nuages* is not easily dislodged ...

Surrounded spiritually by such a team of intellectual top-notchers, Lewis found himself in a serious predicament. Where did *he* come in? That was the question. First of all, for a start, he must drop Ingres. Didn't he, Lewis, have more than a talent for draughtsmanship himself? This Beauty stuff was overdone – no! *sarcasm*, with daring touches of scurrility, was to be his strong card. Hadn't Yeats hailed him as a second Swift? There was an opening here: in fact, life was full of openings, if you kept your eyes open.

But no truck with the proletariat! Shaw and others had pretty well exhausted that line, which in any case didn't attract P.W.L. in the least. There was no money in it.

About the time I have in mind we both made a change of address; Lewis found a studio somewhere in the Hampstead region and I in a street off the Marylebone Road. Visiting him one day I found him in his usual squalor, but I was surprised to note upon his desk a number of drawings of elephants. They were not ordinary elephants: *these elephants had beards*!

Expressing my astonishment, I taxed him with inconsistency: 'Elephants,' I said tentatively, 'do not, as far as I know, grow

beards.' But Lewis, brushing me aside, answered rather sharply, 'You may be right, but I happen to *like* beards.' This was unanswerable, and I made no further cavil, zoological or otherwise, for I knew it was not a bit of good arguing with P.W.L. over questions of fact during one of his creative moods.

A similar *impasse* occurred during a show of his work arranged in her house by the amiable Lady Drogheda. Among the exhibits, hung a picture described as a portrait. Although taken from the back, the artist had included an attractive pair of breasts, apparently attached to the subject's shoulder-blades! (Was this the origin of Surrealism?) I thought it was going too far myself but, wisely, I think, made no comment. After all, I might have been mistaken. What I took to be the lady's back hair might have been her face in shadow or something; you never can tell.

When Lewis started his campaign of serious self-advertisement with his magazine *Blast* he made some important changes in his get-up at the same time; for a start, he had his hair cut. Up till then he had worn it long like any old Baroque artist, and his clothes were none too tidy. Now he smartened up a bit, for he was out for Big Business and no nonsense. As may be remembered by a few survivors of the period, he collected a small group of stalwarts round him, including the only incurable cubist in London; I refer to the gifted William Roberts, of course.

Under a banner with a strange device, 'The Vortex', these heroes conspired to overthrow one or two minor notabilities in the world of art, such as Henry Tonks of the Slade and Roger Fry, the Cézannist. Both these doctrinaires believed in cultivating the Old Masters – a thing which at that time was simply not done!

Roger Fry, an emancipated Quaker, became quite learned in this department of aesthetics, and for a start set up a pottery, dangerously near the headquarters of the Vorticists. Later he shifted his forces to the other side of the Tottenham Court Road,

to blossom out eventually as the 'Bloomsburyites', with Clive Bell as their open mouthpiece, emitting tirelessly his brand-new slogan, Significant Form, where as a matter of fact neither form nor meaning was to be discovered!

Although Lewis was, of course, fully conscious of the importance of the Old Masters, he regarded them, I think, with some suspicion, as possible rivals. He wanted no competition from this quarter, though in the world of ideas he feared no rival – at least, not on this side of the Channel. In a word, his career must come first, but once *arrivé* he could afford, perhaps, to be less exclusive.

First of all, there were certain elements like Tonks and Fry and now Clive Bell to be liquidated. Others, on the other hand, were to be courted like Lord Beaverbrook or even Will Rothenstein, who without being great himself appeared to be on close terms with the Almighty.

And then there were *women*. As a student of Stendhal he was theoretically well versed in the technique of seduction as illustrated by that author, and the attitude of respectful servility he adopted in the presence of a beautiful woman of title might have been a useful gambit in the days of Julien Sorel, but seemed to me, and I think to the ladies too, a bit overdone in ours.

But Lewis was in favour of over-acting, for the truth is his view of life was based largely on the Commedia dell'Arte, a theatrical performance where everyone was allowed to invent his own gags or *lazzi*, and, provided he stuck to his role, could over-act as much as he liked, like clowns, who are, of course, in line with that incomparable tradition, the oldest in the world!

Unfortunately, he was a shy man and therefore could not himself take the lead in organizing a revival of this popular art; but how he revelled in any heaven-sent amateur of the tradition who might from time to time appear on the scene with his bag of tricks! Watching such performances attentively, he would applaud the miming, the postures and the bawdy witticisms, till,

overcome with satisfaction, he would drop his mask and howl with laughter like a human being!

But it was the adherence to, even more than the deviations from, the norm which intrigued him most. This tendency is well illustrated by the admirable series of 'Tyros' in *Blast*. In these he presented a number of specimens of human fauna which were so closely related in form, teeth and colouring as to constitute what was practically a separate species, and which, though common as dirt, had never before been catalogued by science ...

Again, the Hell of Lewis's great trilogy is largely populated by crowds of indistinguishable ghosts who move about in concert, like bugs. Even the politicians who control them are easily recognizable types such as one sees by the score on any railway station here or on the Continent. Lewis was certainly a great anthropologist, but one who concerned himself not so much with *primitives* as with the people next door. It was for this reason, probably, that he frequented boarding-houses, preferably Polish ones, where he could study these highly undifferentiated nationals at his leisure.

In course of time my regard for Lewis suffered many setbacks, as his *pose* became more and more accentuated. This pose was composite, being based on several diverse models. After his return from the U.S.A. the conception of a 'Tycoon' or 'Big Shot' held pride of place in his repertoire, although the necessary accompaniment of dollars had been overlooked (I noticed with some anxiety). On a higher level still, Zarathustra himself was more than hinted at, though Lewis did not follow this lead to the heights of sublimity associated with that name; and then there was Baudelaire, of course, always good for a note of sombre disillusionment and misanthropy.

This mixture did not suit me at all. It was too strong for one thing, and I found it both unappetizing and repetitive.

But were these disguises really necessary? I asked myself. Was

Lewis a fugitive of some sort? But who on earth was after him? I had never heard that he had ever been (like me) locked up. No, I decided: such behaviour could only be the desperate stratagems of an incurable Romantic *in flight from himself*!

This was the grand secret he had to keep or at least partly keep, for he *enjoyed* being under suspicion, and would have loathed to be placed in any known category by a psychiatrist or even a policeman. After all, who could know better than himself what was wrong – or right – with him? To be understood at all, there lay the danger!

After the calamity to his sight, living as I did in the country, I saw little of my old friend 'The Enemy', but would get him out to dinner on occasions when I was visiting London. I made a point of engaging some young female to join us, preferably a handsome Scandinavian or a nice middle-European girl I knew, as I had noticed my guest enjoyed the proximity of both and preferred to hear an honest foreign accent rather than the hideous vocables of the pseudo-genteel sub-dialect now cultivated in this country by all classes. Besides, the stricken man was grateful for a helping hand with his cutlery, etc. (His gastronomical tastes remained simple and conservative to the end: soup, a mutton chop or two followed by a trifle or an ice was all he asked for with his champagne.)

He still wrote, I knew; and when first I heard of his calamity I had wired him to bear up and above all stick to his art-criticism! This impertinence was received, as I had expected, with complete equanimity: he even seemed slightly amused. *Never once, during our subsequent meetings, did my afflicted friend allude to the disaster.* Instead of souring his spirit it seemed rather to have sweetened it.

The heart which he had so successfully disciplined was now allowed to make its appearance at moments, though never vocally. Lewis was incapable of pathos, and practised to the end the reserve of a philosopher.

Finishing Touches

But now the game was up. No more delusions of power or Big Business; art politics were at an end for W.L. Art itself was out of sight, but, as it seemed to me, the humanistic basis of art, of which he had ever fought shy, now reasserted its gentler dominion over the fallen warrior who, wounded unto death, and now miles beyond questions of visibility – and of everything else – died, without recrimination or complaint, an Artist, if not a Hero, to the end.

The Flaming Terrapin:[1]

Roy Campbell—Poet from South Africa

I WAS sitting in the old Café Royal one evening with Thomas
Wade Earp, whose acquaintance I had lately made. He told me
his friend Roy Campbell was due to join us shortly. Earp, or
Tommy as I soon learnt to call him, was at that time at Oxford,
where he held the distinguished position of President of the
Oxford Union. He spoke of his friend. The young man was,
I gathered, quite wonderful, not only good-looking but a poet
of the highest promise ...

Presently the prodigy arrived. He was certainly a fine, tall
young fellow with a careless buccaneer air about him which
contrasted sharply with Tommy's cultivated precision of speech
and manner. I took to him at once.

He hailed, it seemed, from South Africa, having been born and
raised at Durban. He spoke in rather a high-pitched but not
effeminate voice, occasionally employing the *click* characteristic
of the Zulu language. Not once could one detect a trace of the
famous accent of which Tommy Earp was, perhaps, barring one
or two bishops, the sole exponent.

Sent Himself Down

Wyndham Lewis, with his acute powers of denigration, once
described Roy Campbell's speech as resembling the call of an owl:
not the screech-owl of course, but more the barn-owl variety – a
kind of *hoot*. Roy had large misty eyes, directed, I noticed, quite
frequently towards the tall rococo mirrors of the Café, in which,
given a favourable angle, one saw oneself reflected to some

[1] First published in *The Sunday Times* Magazine Section on October 12th, 1958.

413

advantage. Tommy, as usual, was right; Roy Campbell was undoubtedly a good-looker, though not otherwise, perhaps, up to the standard of Moss Brothers Ltd.

I gathered from my first meeting with the young South African that, far from succumbing to the glamour of university life, he had reacted most unfavourably to it, and, with that touch of violence which we were to recognize in due course as the *leit-motiv* of his career, had, in despair, taken to the bottle in a big way as a means of counteracting the almost pathological condition of moral discomfort with which he had been troubled during his sojourn in our oldest seat of learning. At last, finding this situation intolerable, he decided to put an end to it, and without waiting for the formal dismissal, which no doubt was to be expected, he stole a march on the authorities and sent himself down.

Though Tommy may have been a little bit shocked by this behaviour, I was delighted myself, for in a sense Roy was now in my power. Being professionally an opportunist, I seized my chance and without any difficulty got him to sit for me at Mallord Street. The portrait, having been exposed in London where it excited no comment, eventually found its way to the United States (the nursery of many a good ugly duckling).

Masquerade

Having taken a house in Dorset at this time, I invited Roy down to stay with us at Alderney Manor, and on one occasion he brought with him his fiancée Miss Garmon; a charming and beautiful girl. Trelawney Dayrell Reid, a character I have already sketched in another place, was present to lend a necessary touch of style to the party. It was he, if I remember, who proposed the play-acting we organized one evening to amuse the children. This took the form of a kind of masquerade designed to celebrate the engagement of Roy Campbell and Miss Garmon. Trelawney

himself took the role of the priest, for which he was admirably equipped, and Tommy Earp made a very good choir-boy, while I pretended to be an acolyte or something. It was good fun and I thought wanted very little to make it a true and valid ceremony. As a matter of fact, there could have existed no closer union in the world than that of Roy and Mary Campbell.

Wiping the Sword

Our next memorable meeting-place was at Martigues, where Roy and his family abode some years. But this, again, I have alluded to somewhere else. Afterwards, I regret to say, I saw but little of Roy, though I read what from time to time appeared of his poems and prose. We did meet now and then in London by accident during and after the Spanish Civil War, in which he claimed to have taken an important part; but I never took such pretensions very seriously. It was understood among us that Roy, however fine a poet, failed conspicuously when it came to faithful *reportage*; but nobody minded that – nobody who knew him, that is.

His vaunted prowess in the bull-ring seems to have passed unnoticed except by himself, though the *aficionados* are quick enough to acclaim valour when they see it. He may have joined in the *défilé* on horseback with his two little daughters, but the photograph he sent me of this feat showed, of course, no sign of a bull. At Martigues, indeed, he had indulged in the local sport of cow-baiting, and was, I believe, once knocked over by an irate milker whose new-born calf he was unsuccessfully attempting to skewer, but he never won a rosette or we'd have seen it displayed in Chelsea.

In his last book he had the impudence to vilify the brave *Anarqhistas* under Dureuti, who, armed with *sticks and stones only*, put Franco to flight at last, and would have settled his hash once

and for all but for the intervention of Italian and Moorish troops and German planes, and the treachery of the Moscow-inspired 'Communists' in Barcelona.

But it is in his lofty scorn for the Gypsies that Roy Campbell reaches the nadir of venom. Why these people, after centuries of bestial persecution, should feel inspired to fight for anyone but themselves is beyond imagination! Here our Poet has sunk to the level of a public executioner, and he actually 'laughs' as he 'wipes his sword', stained with the blood of the poor, the innocent and the defenceless!

Regard Explained

How then, it will be asked, do I explain my continued regard for him? Well, I reply, for the reasons given already; I am not taken in by these purely literary exercises in bombast. I suspect this affectation of gigantic strength and ruthless courage. Vain as an exhibitionist child, he looks round for applause as he stretches out his hands for the baubles allotted to the prettiest, cleverest and bravest little man in the nursery.

In his last book, *Portugal*, Campbell proves himself to be a conscientious and thorough student of the literature of the country where he finally established himself. In numerous translations he manages to convey the diversity, charm and depth of a great poetic heritage which has by no means dried up and in which he seems to wallow luxuriously.

I, for one, do not find a similar wealth of sensibility in his own interminable effusions, of which the unceasing grandiloquence soon exhausts the reader, often causing him to turn with relief to the limericks, where our author's verbal facility is necessarily curbed in the harness of a more exacting form, but where he can still find room for the corrosive banter which came so naturally to him.

In this book on Portugal, Campbell, somewhat grudgingly, makes the *amende honorable* to the despised Gypsies, who after all, he admits, are the principal purveyors, if not indeed the originators, of the *fado*, that national instrument for the expression of a fundamental melancholy, the *cri de cœur* of the unloved!

Groaning Unheard

Nothing, however, to my mind, that he finds in his rummagings in the Portuguese treasure-house equals in beauty, depth and passion his versions after St Juan de la Cruz; but these, I cannot but think, are masterpieces in their own right. I think it must be to Campbell, too, that we owe the discovery of modern novelist, Eça da Queiros, two of whose admirable books he has translated.

The abject servility of his references to Salazar must disgust all but those who are blinded by religious prejudice; according to better historians than himself the stench of the poorer quarters of Lisbon, during what Campbell calls her Third Renaissance under its dictator, rises to heaven, but none may hear the groans of the unfortunates who languish in the filth of medieval dungeons without trial or hope.

Here, lest I be judged irreverent or unfriendly, I will borrow a few words from Roy Campbell himself and 'take my leave hoping I have given them a laugh or two (because that is partly what life seems to be for!). But also there is plenty of room for thanks, wonder and admiration' – and, I may add, *love*.

Old Masters

THE aspiring student who thinks he may best find himself by pursuing the Old Masters, is in grave danger of losing sight of his guides as well as his goal. He must take his directions, as did his distinguished predecessors, from life itself. Fidelity to venerable traditions too consistently practised and for too long may rob him of his fire and end in impotence. The subtle magic of antiquity can induce a form of hypnosis from which there is no awakening. The conjuration of an illustrious name, instead of fortifying, may only corrupt the student's innocence and damp his courage so that he sinks into the false security of precedent and the second-hand. Danger, not safety, must be wooed. Blunt crudity is better than polite sophistication: as frankness is superior to innuendo, and rusticity to metropolitan *chichi*. Aesthetic considerations can be overdone: unlike hair-dressers, we cannot all be concerned with beauty alone.

Beauty crops up anywhere: a divine accident, it depends on illumination chiefly. It is distributed at random among human beings; some are awarded more than their fair share, some less, and others none at all. But fortunately tastes differ, and, as Montaigne observed, there is no wench so homely but will find her gallant.

Homeliness, indeed, as Thoreau noted, is next to beauty and a very fine thing. Any good drawing-master will tell his pupils to go first for character, not beauty. Character, in the art school, seems to consist of deviation from the norm: that is, implying imperfection. Therefore, it follows that perfect beauty must be characterless, and when found in the female of our species, is always so described by the less well-favoured, who presumably are compensated by an extra allowance of brains. But brains,

being invisible, can hardly interest the budding draughtsman, unless he practises abstraction, when direct observation may be dispensed with.

I was standing at the bar of a French club I know of, when finding myself next to two young gentlemen of serious aspect, I invited them to join me in a glass of wine, the unique form of refreshment offered at this establishment. This offer being accepted, we entered into conversation of a rather tentative kind; but I soon became aware that I was in the presence of a couple of Abstractionists, who, as I began at once to hope, could be led to reveal something of the principles underlying a cult to which I had to admit myself a stranger; though it is true I had more than once listened to the airy bellowings of my friend, Victor Passmore, on the same subject, without feeling any the wiser. With an eye to an opening and a chance of enlightenment, I ventured to introduce what I thought would be a non-controversial issue to start with. Would they, I asked, be prepared to accept the validity of the European tradition of painting, and recognize, for example, the pre-eminence of Rembrandt as a draughtsman? A pause followed. Then the elder of the two replied: 'No,' he said gravely, 'we cannot admit Rembrandt.' With that I realized my indiscretion, and bidding these gentlemen good night, withdrew.

How dark, how Rembrandtesque, the night seemed as I made my way home!

Rembrandt, like our Abstractionists, might as reasonably lay claim to a mystique of his own, and hold secrets incommunicable unless to the initiate. The miller's son, after a youth and middle-age of constant labour, success and even glory, crowned by a fashionable marriage, was to suffer a tragic change of fortune. With the death of Saskia, he entered on the latter period of abandonment and obscurity. His association with Hendrike Stoffels, the wife of a policeman, involved him in blackmail, bankruptcy and social ostracism.

True, he had fallen from grace, but he landed on his feet. In the Jewish quarter of Amsterdam he was to find in abundance every element of life his soul delighted in. In these shadowy purlieus, full of cries and movement, were to be plucked the finest flowers of poverty. There was music, too. Hark! Whence comes this chanting we hear, and this quavering melody with its continual drone? It is the hurdy-gurdy man who slowly approaches with his talented family. There is his old wife and their handsome daughter who sings, the young girl who dances, the boy acrobat, the negro in faded splendour who plays the clown, quite a little troupe!

We are not alone in stopping to watch the strollers. Half-hidden in a doorway stands a robust figure with grey curls under an ancient hat. This man is sketching intently. It must surely be Rembrandt himself. Yes, there can be no doubt about it, it is Rembrandt van Ryn! But how different a Rembrandt from the one we knew from the pictures seen at Yan Six's house! Gone are the fine clothes, the feathers, the armour, the gold chain; all the swagger gone. Can this really be Rembrandt, this poor old man in rags … ?

Dionysian Fury

IT MUST be admitted that there are times when the bright crown of modesty (the glory and the despair of youth), with every rule of decency on which we English are taught to build our lives, must be cast aside and flouted at the call of a greater and a more mysterious necessity. He who hears that call can have no choice but to surrender. At once abandoning the allegiances of custom with all their hallowed subterfuges, he strips himself and – dances! He is enraptured: he is intoxicated: he is free! For the voice he heard was a divine voice such as was listened to of old, when men and gods were accustomed to meet on a more reasonable and, I think, a more congenial footing than is now usual.

I am no theologian, but I am by nature inclined to dispute the wisdom of those grave myth-makers who refuse their pantheon to all but one divinity. As far as the gods go, I confess myself a pluralist, though holding them, like earthly monarchs, to be all the better for careful limitation. No totalitarian! Even Christian theology, somewhat grudgingly, admits three, or, including the Virgin Mother, four members of the ruling Family, without counting Lucifer of course, while at the same time insisting on the essential singularity of all together. Such scholastic subtlety is too fine for some of us, and leads inevitably to argument or worse.

These reflections should be taken only as an introduction to a type of so-called supernatural experience met with chiefly in adolescence, but capable in some aspect of recurrence in maturity or even old age. It may be called the *Dionysian Fury*, and under that title will ordinarily manifest itself in the form of a gratuitous and ecstatic dance. On one such visitation which I remember

pretty clearly, though it is far from recent, I was most inappropriately seized and possessed by the irresistible urge, while taking part in a formal promenade with my schoolfellows under the surveillance of our Headmaster. This inconsequence is the despair of philosophers and cannot be defended. I can only protest that in my case it was not induced by Art or favoured by precedent. Innocent (and ignorant) as I was, it took me by surprise: as it did my audience, apparently. The sun at least seemed to shine approvingly, and the sea to turn a deeper blue, as, throwing off my detested garments, I capered upon the shore as David might have danced before the Ark! My notions, if unrehearsed and wild, were, I am sure, no less vigorous than the Psalmist's, while developing, I seem to remember, an almost hieratic character, particularly as in my temerity I approached the Head. This tendency must have been instinctive, since my performance, I repeat, was quite impromptu. I found myself in a word 'full of the God', though I swear I had drunk nothing stronger than cocoa that morning. Meanwhile my schoolfellows, completely uninspired, looked on in wonder, and so did Mr Evans; but in his case wonderment was mixed, it seemed to me, with perplexity, and something else too: could it be *alarm*? Perhaps some long-forgotten impressions left over from a too cursory acquaintance with the classics now rose to the surface to bother him again and undermine his judgment. After all, wasn't he an M.A. or something? Anyhow, I suffered no penalty, nor even a reproof, for this indiscipline, though my reputation had already declined since the ex-policeman had on one occasion confiscated my drawings.

From now on the quality of the relationship subsisting between the Headmaster and myself began noticeably to deteriorate: the charming, humorous and idyllic misunderstanding I had so prized was foregone, to be succeeded by suspicion and even blunt antagonism on the one side, with bewilderment and disillusion on the other. My idol turned out to be of clay, according to its

nature rapidly disintegrating before my eyes, with its beautiful mask (which I had provided) fallen to reveal the sad reality underneath. I have recorded elsewhere[1] the conclusion of this unfortunate affair (if that is the right word for it).

[1] *Chiaroscuro* p. 37.

The Prado Revisited, 1954

El Greco

Two gigantic old gentlemen, lightly clad in paper dressing-gowns, trip buoyantly in a landscape of cork and bottle-green, under the illumination of a gibbous moon which shines balefully between the incandescent shuttle-cocks of a sky in uproar. To judge by the mawkish satisfaction on the Saints' faces, they have at last hit upon the secret of accommodating logic and dogma, while making use of the same digital contortions as invariably accompany their inquiries into the relationship presumed to subsist between Aristotle and Holy Writ, or indeed any other dichotomy.

The Artist with his aversion from daylight and the commonplace, and his pious horror of sex, encloses himself in a dark box, peopled by manikins of his own invention who move like ghosts under the fitful gleams of a candle. Here he finds his freedom, as, luxuriating in his unparalleled rhythmic sense, he manipulates the distracted creatures, detaching them from the flames which they resemble, to bow in stark abjection before the blessed Intermediary, who, himself half-human, raises piteous eyes towards the majestic but yet benevolent looking Occupants of the *Gloria*.

Velasquez

This perfectly normal painter, with a more than normal mastery of his tools, surpasses himself with his little Infanta, who, in her way, is as great as Olivarez on Horseback. This painting of a plain child in her official finery defies description. Without its faultless colouration it would still be too clever by half. But, what an eye!

In the Lanzas the artist shows the finest sensibility and the most

delicate dramatic sense in portraying the exquisite courtesy of the victor, as, with a gentle smile, he lays his hand reassuringly and almost apologetically on the bowed shoulder of his defeated comrade-in-arms, who with equal grace and no less modesty proffers an unstained sword.

Goya

Leaving the age of the *hidalgo* and good-breeding, we come down with a leap into an epoch of vulgarity, brutality and witch-craft; an epoch which precedes our own more scientific, more universal ignominy. The French Revolution, like all revolutions, had betrayed itself, leaving behind human elements of incalculable grandeur, mixed with and overridden by the blood-thirsty pro-tagonists of Power. But a new political entity has arisen, that of *The People*. This cannot now be displaced but it can be circum-vented and utilized by cunning and trickery. The people ask for it: they seem born to be bamboozled. They even breed their own tyrants if necessary, for tyrants are always in demand, since they always come bearing gifts, which unfortunately have to be paid for by the recipients later on and with interest.

Francisco Goya y Lucientes, in spite of his grand name, was a man of the people, but he also became Court Painter, for there was no doubt about his supremacy, and he must have been personally irresistible. At that time photography hadn't begun to debauch people's powers of observation, nor were their minds yet befuddled by the abracadabra of literary pundits to which we are now beginning to be quite accustomed and may ignore. Students, condemned to the routine of State schools, weren't switched over to the study of 'Abstraction on Tuesdays'. There weren't any State schools. Goya, like everybody else in those days, learnt painting from a master, whose daughter, so as to be in a good tradition, he married. His portrait of his father-in-law is

425

surely one of the best portraits in the world; even Gainsborough never did better, or so well. Gainsborough just lacked Goya's guts. Perhaps, like most Englishmen, he wasn't quite serious, and with all his fine sensibility, just a bit too easy-going. He could never approach Goya's 'Queen Marie-Louisa on Horseback'. This immense canvas is magnificent and disturbing. It beats Velasquez's similar arrangement of another royal equestrienne. He, Goya, wasn't overawed by his model, nor did he seek to flatter her. On the contrary, he saw her possibilities and enjoyed them. In spite of a strain of vulgarity she has an air ... slightly sinister perhaps, slightly *canaille*, but definitely not insignificant, and on this occasion even stately, like her horse ...

Goya, no doubt conventionally polite, was, it appears, too outspoken at times: he didn't disguise his sympathies for the poor, the outraged and the reviled. This sort of thing didn't do with his Royal Family, and when exiled in Bordeaux, he simply went on painting and drawing, just as if nothing had happened. *Aficionado* born and bred, he never forgot the bull-ring, as his late *Tauromaquia* testify, and probably had nothing to regret, except his inability to join in his favourite diversion any more. But he was never to old to paint.

A Visit from the King of Spain

'Du sang, de la volupté et de la mort.'

IT WAS during a showing of my pictures at the Chenil Galleries, Chelsea, now extinct. This institution, as it might be called, had arisen on the site of some studios I used to occupy between the Town Hall and the Six Bells Tavern. It consisted of picture galleries, a shop for artists' materials, and a projected restaurant. The aim of the founder, John Knewstub, had been to provide a cultural centre in a district long famous for its artistic and literary associations.

Although this ambitious project came to grief, several notable exhibitions and concerts were held before its eventual collapse. The restaurant, however, never materialized, and if the kitchen, which occupied the most important position on the frontage, was of a capacity to meet the requirements of a regiment, it was never, as far as I know, productive of so much as a boiled egg. The distinguished architect, George Kennedy, who is to be held responsible for this anomaly, must have suffered partial paralysis while under the influence of the megalomaniac it was his fate to collaborate with. If so, he wasn't the only one to wilt under the persuasive oratory of the founder, who, when words failed him, as they often did, was in the habit of replacing them by an even more meaningful silence, accompanied by an expression of mystic rapture acquired in the neighbouring tavern, and more effective even than the longest words his vocabulary might have furnished when in working order. In these circumstances Knewstub's two distinguished brothers-in-law, Orpen and Will Rothenstein, agreed for once in maintaining an attitude of strict neutrality, not to say aloofness, which was a pity, as such a combination of financial solvency and spiritual illumination would have supplied

427

all that was necessary to the successful launching of the concern. As it was, its begetter mostly had to rely on the co-operation of strangers, who, as a matter of fact, with less réclame and no matrimonial claims, proved better sportsmen.

Thus the building proceeded, though precariously, by fits and starts. The foundation stone at any rate was well and truly laid as I saw for myself; but one indispensable factor of success was missing – no life was lost in the building operations! No corpse could be adduced to guarantee the protective agency of a domestic ghost: nobody even had been hurt! As any mason knows, such immunity can only be purchased at the price of good luck. And although some coins bearing the image of the reigning sovereign were included in the foundation ceremony, these after all amounted only to a convenient substitute for a purer and more effective sacrifice. Blood, and blood only, has always been held to be the necessary adjunct of salvation, and there were found individuals among the more generous supporters of the enterprise, who, later on, were heard to express the view that, *faute de mieux*, Knewstub himself might very fittingly have been offered up on his own altar. However this may be, some successful exhibitions and concerts were organized before the debacle, and are to be credited to Knewstub's zeal and vision. It was here that John Barbirolli made his debut, and here that I once trod on the toes of Vaughan Williams, who, like myself, was at the moment wholly absorbed in the songs of Philip Heseltine as interpreted by an attractive soprano. For this *faux pas* I incurred the expostulations of the Master, who received my apologies so kindly as to make him my friend as well as his admirer for life.

It was here, too, that a show of my paintings provided the occasion to which the heading to this note refers, and for which a friend at Court, as good-natured as she is beautiful, was responsible. After examining my efforts King Alfonso expressed a wish to visit my studio in Mallord Street, and, a taxi being found, we

all drove thither. I was quite ready for some refreshment and I think so were my guests, for compliments, even when sincere, can be tiring in the long run, to the maker and to the recipient, and a change of subject becomes a necessity. The conversation turning to bull-fighting, the King said that although he considered himself 'the first Spanish man' and as such compelled by ceremony to attend the *corrida* on occasions, he did not approve of this national mania, for it reflected unwholesomely on the Spanish character and reputation. 'Foreigners,' he said, 'are apt to think us barbarians. But,' he added, 'this form of sport cannot continue much longer, for such is the enormous number of old horses killed in the arena on Sundays throughout Spain that even these wretched and decrepit creatures are becoming alarmingly scarce and costly.' This observation was made before the present practice of providing protective quilts came into force, an innovation which certainly prolongs the life of the animal while, of course, reducing its value in the market. No sign is to be remarked yet of any diminution in popularity of this game or ritual. The arenas are still packed to the sky-line and the cult of valour, skill and grace still holds the field in a country where the imminence of Death is accepted as the irremediable corollary of Beauty, Power and Love. This folk-drama is of the people, and it is at once gay, elegant and grotesque. The Beast is always slain and sometimes the Hero, too. There is no betting.

Before parting, the King astonished me by confessing his inability to make me his Court Painter, much as he would like to. To appoint a foreigner to this office, he explained, would seriously endanger his popularity and would be certainly opposed by his Ministers: he would however be glad to sit for me sometime in Madrid. The possibility of such a development had never occurred to me, except perhaps as a joke, but it was the result of the generous impulses of Lady Irene, my charming intermediary in this encounter with a most sympathetic Monarch.

Notes from Hospital

IN SPITE of the general debasement of taste and manners in this age; in spite of the cult of uniformity and the substitution of the polling-booth for the mote and the Witenagemot, with the delegation of authority to professional spell-binders at Westminster, and the resultant stultification of the electorate; in spite of the new journalism, with its indifference to truth and its venal plugging of the sensational; in spite of the ever-widening gulf between the professional and the wage-earning classes; in spite of the decay of popular handicrafts, the vulgarization of science and the abuse of machinery; in spite of the ruination of our coastal scenery by the military and the desecration of high places by misguided engineers; in spite of everything in fact which distinguishes this New Elizabethan Age, are we to submit, to be stunned into acquiescence by the hammer-blows of Big Business? Are we to connive at mass-cozenage and the suppression of the politically powerless? Are we to strike our colours at the command of any majority? No, because our banner is sacred to the memory of the unconquerable dead, through whom reach us intimations of better things to come. But who are *we*? Well, there's myself and possibly somebody round the corner.

El Dorado
The poor are always with us. Fortunately; for after all it is they who provide the millions.

Noblesse Oblige
Every Englishman loves a Lord: starting with Our Lord Jesus Christ, of course.

<p align="center">*　　*　　*</p>

Despairingly, I enter a certain restaurant club in the King's Road, Chelsea. The hour is unfashionable, the bar empty. I order a fiasco of Chianti. A pretty Italian girl serves me, and, with a roguish smile, remarks: 'S'nice to sit down with a good drink and enjoy yourself, isn't it?'

* * *

Among the Gypsy Coppersmiths I met in Italy, I found to my astonishment some friends I had met at Cherbourg two or three years before. These consisted of a young man, his very handsome wife and some children. We were seated in their tent and were drinking wine. Recollecting a song I had learnt in earlier days, I proceeded to repeat these verses, which were of an amorous nature, and included a line I would have done well to omit, a line I regret to say of the greatest indecency. Carried away by the lilt of the melody, however, and heedless of the sense of the words, I failed to arrest myself in time, and the extreme embarrassment of my audience which followed convicted me of a serious breach of the proprieties. It took considerably more than another bottle to restore our equanimity. These are the offending words. I do not propose to translate them: '*Spivado ančo mui o Kar.*'

* * *

The sense of modesty quickly disappears in a nursing home. The patient soon submits to the closest inspection without a qualm, and as for the nurses, their professional training admits of no squeamishness, though it by no means excludes the genial byplay appropriate to youth and good looks. The discovery that nudity is neither erotic nor shameful permits one to ignore the taboos without danger or discomfort.

The young nurses who keep passing across the square opposite

431

are rather fascinating. They wear triangular white caps, like those so fashionable among the male inhabitants of Tierra del Fuego. Their little black capes are worn so that they appear to have no arms. Their legs are enshrouded in blue skirts and they wear white aprons. I see everything double, which adds to the strangeness of the scene. They remind me of old-fashioned paupers out for exercise. There are green lawns and some tall plane trees painted in the Pointilliste manner of Seurat. Often a tall black student walks past, with an open book in his hand and an air of abstraction.

* * *

Although, in the past, a great frequenter of Gypsies, I have painted but few, so fascinated have I been in their society that I have always felt loth to set about operations on the spot. It would have broken the spell. However, I have sometimes lured individuals among them to sit for me, and have in some cases been able to reconstruct whole groups from memory and without much difficulty. One such composition, life-size and containing scores of figures – Coppersmiths met with in Italy – was bought by Horace Cole, the practical joker. Later, repenting of this deal, I bought it back and then sold it to a Japanese collector for three times its former price. Cole was much annoyed when he heard this.

* * *

Propinquity is the greatest of stimulants. It may lead to love or murder; like a bottle of wine within reach, it can provoke both thirst and nausea, according to the label and the state of our stomachs, but never indifference.

* * *

The painted tombs of Etruria, the gay Minoan palaces, the stately towers of Mycene, all these compel our admiration and envy, but the attractions of the Misses Tickell at Dulwich are, for me, just as valid, and, being so accessible, warmer.

The Greatest Repartee in History

Paris. A café on the right bank. Oscar Wilde among the company, which includes also a youngish writer then to the fore called Ernest la Jeunesse. This writer was in the habit of illustrating his books, not with drawings, but with snapshots of his characters in action. He was regarded as a mysterious figure and spoke in a piercing falsetto. After a while he left us and Oscar told the following story:

'Everybody,' he said, 'used to wonder what could account for this man's extraordinary voice: could it be natural, a freak, or was it assumed? Well,' said O.W., 'once when this subject was under discussion, the publisher of La Jeunesse, who happened to be present, intervened. "There's no mystery about it," he announced, "my poor friend is completely impotent, and that's all there is to it." This crude statement was in due course reported to La Jeunesse, who, after giving it careful consideration, decided that he must do something about it. Such a remark was injurious, besides being in bad taste. His publisher, rich and powerful as he was, must be taught a lesson. After much thought, he finally devised a plan of action which would not only provide an adequate answer to the libel, but would at the same time illustrate those strict principles of ultra-realism to which he as an artist was committed. Since, according to his calculations, the success of his operations demanded the collaboration of a third party, who in fact had, necessarily, to be the publisher's wife herself, a lady not exactly young but of spotless reputation, the task our talented friend had set himself seemed indeed formidable. If, as the

protagonist of a new iconoclasm, La Jeunesse could be imagined as bearing anything so trite as a banner, the device inscribed thereon, would, I fancy, take the form of a slogan much more homely and practical than *Excelsior*. However that may be, the young man set to work and though the siege was long and arduous, goodwill and tenacity prevailed as usual and the day arrived when, his honour vindicated and his manhood proved, the happy though somewhat exhausted warrior could sit back and relax in peaceful contemplation of his victory, and he, being by now, as you may guess, treated as a member of the family, was usually to be found in the neighbourhood of the *nursery*, whence the shrill cries of a lusty babe seemed, like his own penetrating treble, to proclaim the triumph of actuality and goodbye to dreams. Thus,' wound up Oscar, 'was contrived *The Greatest Repartee in History*.'

I have made no attempt, of course, to reproduce Oscar Wilde's narrative style in this excerpt from my memories of the great raconteur. I don't suppose the peculiar quality of his English could possibly be conveyed except by expert mimicry, nor could his French (also spoken with an Oxford accent) be reconstructed from memory or recorded by means of any known system of phonetics. In the former language he expressed himself through the medium of what was practically an artificial sub-dialect of his own invention, which has fortunately almost died out, since when employed by lesser wits it at once became an intolerable affectation. In the Master's own entourage, however, it was indispensable in those days, as it conferred upon its practitioners a certain *cachet* suggestive of a culture and breeding which, without it, might have passed unnoticed. This entourage, usually composed almost exclusively of snobs, lick-spittles, social hangers-on and crawlers-up, might sometimes include an artist or two of the school of Burne Jones, but in general would be about as sympathetic to a painter as an assemblage of church workers at the vicar's annual garden party. (But professional actors mustn't quarrel with their

audiences.) The Reverend Oscar Wilde was always a cut above his company, for he had more wit and fun in him than all his parishioners combined, and more wisdom, too, if it comes to that, in spite of his occasional lapses in taste which were only in the spirit of the age after all, and more than matched in the music hall of his time. I cannot accept the mouldy old caution Lautrec made of him, sitting *alone* in the Folies Bergères, like a partly warmed-up corpse. (As if he ever sat *alone* anywhere!) There was nothing lugubrious or sinister about him. He fancied himself as a kind of Happy Prince, or, admitting a touch of vulgarity, the genial although permanently overdrawn millionaire, and if he suffered from the blues, sometimes, what could be more natural? With luck there would be Robbie Ross round the corner. 'Oh, Robbie, I've had such a *frightful* dream!' 'What was it, Oscar dearie?' 'I dreamt I was dining in H-H-Hell! Oh, Oh, Oh!' 'There, there, Oskywosky, but Robbie's sure you were the life and soul of the party.' In another mood. Will Rothenstein: 'But I sometimes feel so *ridiculous*, Oscar!' O.W. in a stage whisper, 'But, *of course*, my *dear* Will, didn't you *know*? *All real* artists *are* ridiculous!'

Yes, it was a bright spirit who passed away at the little Hotel d'Alsace near the Beaux Arts, where I used to stay myself, but without ever being inspired to make anything like so endearing and memorable an impression on the management as Oscar did when he blew up with such a lovely bang! What a brilliant idea! What a perfect exit! Though I never saw him as a young man myself, my memory of him isn't of a middle-aged man at all, but will always evoke the frank, open, friendly, humorous face of a young one, for the fact is he had too much sense to grow old, and wisely left that process with complete confidence to his detractors, his apologists and Mr Punch.

Communism

> 'And all that believed were together, and had all things common. And sold their possessions, and parted them to all men, as every man had need.' – Acts ii, 44–5.

THE above quotation will of course be familiar to Bible students. But as most people, like children, are apt to take their beliefs on trust, its republication at the present time may not be out of place. It affords unequivocal evidence of the kind of society recommended by the Apostles and practised by the Early Church, i.e. a form of Communism, in fact. I, and probably many others, have waited long and anxiously for a more authoritative reference to this important passage of the Scriptures, preferably emanating from the clergy, a bishop, or other competent source, together with an appropriate commentary, since the intrusion into such a field by a layman like myself might easily be dismissed as impertinent or pass unnoticed.

At a time when the forces of Christendom and Communism (of another variety) are mustering for the final struggle, it is above all necessary to avoid doctrinal hair-splitting and wholeheartedly to join forces under a single banner. It is a question of freedom or slavery, life or death, black or white. It is as simple as that: or is it?

But some of our scientific Jeremiahs warn us that the outcome of the coming test match can only be the disappearance of civilization itself, and with it the destruction of all values, including every monument to the spirit of man or the Glory of God raised by Art and Genius of the past down to those of our own day. Since these are irreplaceable, the fate of any possible human survivors is of no great consequence; in any case the results of

the new weapons with their chemical concomitants will have completely dehumanized and distorted them beyond recognition or possibility of recovery.

But whatever the outcome of the grand catastrophe envisaged, the immediate cost of our preparations for it will soon lead to bankruptcy, and will never be met by our unfortunate descendants, who will have been forced to take refuge underground, where they will eke out the remainder of a precarious existence in darkness and a permanent state of insolvency. Such is the outlook.

To return to our document. We know already that the somewhat happy-go-lucky way of life briefly illustrated therein would be quite impracticable in any highly industrialized society such as ours, and that the law has provided severe deterrents to its practice. The sacredness of private property has always been the head-stone of civilized societies, and we can depend on our admirable police force to ensure its enforcement despite the aggression of thieves, murderers or even the subversive activities of Utopian doctrinaires; wandering and penniless agitators are not encouraged, and the dangerous experiments of Winstanley, Lilburne *et hoc genus omne* are not to be repeated with impunity now, any more than in the time of the Diggers. Although Cobbett might ride all over England on Common Land, it would be unwise to try that now. For one thing, there *is* no Common Land to speak of left. There is only the House of Commons to remind us of it. Along with the disappearance of this ancient institution, the march of progress has obliterated much of the engaging diversity of the old tribal life, such as we now look back upon with mild nostalgia, replacing it with a more manageable uniformity, dear to the hearts of our legislators, both central and local. If regional customs and costumes are now only fading memories, and the rustic dances and songs of our merrier ancestors are now enjoyed only in the inaccessible circles of learned

dilettanti, have we not in compensation the boundless resources of wireless to draw upon, to fill our leisure and refresh our minds? And, as our indigenous culture recedes into the dim background of history, more up-to-date techniques of entertainment exported from the U.S.A. take its place. The heartrending ululations of the crooner have effectively silenced the voice of the turtle, and our intricate old dialects give way before the clipped vocables of a newer and smarter world. But stop! I am going too fast! The Lancashire accent still provides the most reliable medium for our best comedians, and an artificial sub-dialect of Cockney, only heard on the air, remains to this day the favourite instrument of our worst.

With these few exceptions, the North-Americanization of this and other countries proceeds apace, although it must be admitted the behaviour of the G.I.s when released from the restraints of their homeland leaves much to be desired. These wayward crusaders somehow fail to make themselves generally popular in Europe, and, unlike our own countrymen abroad, are only tolerated, rarely loved. Is this perhaps due to the fact that the great cultural stream, issuing from the Mediterranean Basin, has never washed the shores of the U.S.A.? Yet it appears to have been a 'Wop' who first gave his name to the country ... The later infusion of blood from Italy and other classic lands has not yet been thoroughly assimilated, unless in a few areas such as Chicago or Boston.

These gentle influences take time to make themselves felt; it is a nation in the boiling-pot we are considering, not the eventual Irish or other stew.

We are lucky indeed on this side in having the services of a Prime Minister [Churchill], himself a hybrid, whose acute and discerning mind will know how to provide the stepping-stones towards a fresh rapprochement. In the meanwhile, we may well for the time being waive our political differences in the contem-

plation of such exotic and endearing figures of recent memory, as, say, the incredible Mizners, the poet of the Sierras, Jaoquin Miller, or even, though perhaps with less unanimity, the graver personality of ex-Governor Fuller of Massachusetts, happily still at large. We have nothing comparable over here. But we cannot yet turn to our cousins overseas for help in the resolution of all our ideological problems, since their minds are for the moment fully occupied with the spectacular menace of a formidable Eurasian Power professing a brand of Communism as much at variance with the doctrines illustrated in our text, as it is with the Way of Life which both our peoples have since developed and apparently prefer. But the reiterated injunction of the Master, 'Feed my Sheep', in its simplicity will always appeal to me at least with greater force than the Marxian slogan, 'the Dictatorship of the Proletariat', with all the bloody methods of its attainment which we are familiar with. I myself dislike to be dictated to by anybody and am inclined, like Thucydides and others of his time, to be an *anarch*, or 'agin the Government' and the lust for, and abuse of, power which invariably goes with it. This brought ruin to ancient Greece and many other countries. It may do the same for ours.

In my view, the best way to combat error is first to ascertain the truth, and then tell it, even if this be risky. Those with a taste for heroism may easily indulge it without resorting to chemicals or guns. The use of napalm may, and indeed does, deprive your opponent of his flesh; it lays bare his bones, or turns his skin to 'crackling', but does it teach him his grammar? How is he to express himself intelligently in such circumstances? You will have left him unconvinced, painfully shy, and probably resentful. Such conduct is not cricket or even football, and should be eschewed.

Warfare, let us admit it, has now lost all its glamour. *La Gloire* is out of date, and, as all good soldiers know, the spectacle of terrified men clawing at each other's throats is by no means

edifying. A better field for action, where courage, scientific resource and perhaps personal sacrifice is called for, can be found in our Dependencies overseas. The islands of the Antilles, which, like an exquisite necklace of pearls, enclose the blue Caribbean, are found upon exploration to reveal under British administration, coupled with the benevolent intervention of the United Fruit Co. Inc., anything but paradisaic conditions: disease is rife, squalor and slums abound, although the people are free – to vote as much as they like or even refrain altogether. It is only in Australia and the U.S.S.R. that this privilege has so far been made compulsory.

The unpleasant aspects of colonization may not immediately strike the tourist, who sticks to the beauty spots and the best hotels. He is out for a good time and no doubt gets it. He sees and perhaps admires the charming cabins of the islanders, roofed with palm and washed with pink and blue, gleaming like jewels amidst the iridescent verdure of an enchanted island, but he doesn't go too near. Instinctively he fights shy of poverty which always makes him feel uncomfortable and might mean a call upon his purse. 'Carry on, driver!' Writing home, he becomes quite literary: 'This isle is full of noises, sounds and sweet airs, which give delight and hurt not' (except for that God-damned piccaninny howling under my window, he murmurs in parenthesis); and naturally he makes a point of mentioning 'the still-vext Bermoothes', even if he doesn't land on them. But Nassau he will love. Good society, good clubs, English peers, Indian maharanees in Parisian saris; good bathing and drinks; no economically-minded millionaires, no sign of Caliban, and, best of all, not one beauty spot to bother about.

But these digressions are not getting us much further in our inquiry. We are still faced with the original dilemma: the complete incompatibility of the two forms of Communism confronting us. They cannot both be valid, nor can they, as opposites, be

equally bogus, but both offer alternatives to our present system, which, whatever its merits, is, as has been seen, doomed to disappear. For the first, the Apostolic order, we have in support the example afforded by primitive societies which without their communal basis could hardly have survived; these cultures, it is true, are now rapidly disappearing under the impact of civilizing agencies from Europe and the Far East. But unfortunately the appearance of the whites among a coloured population seems to have a lethal, or at least a stupefying, effect. For that matter, it has been known in some cases to produce similar results at home; but in the Pacific Islands, where whole populations have withered away before the White Man's fatal magic, it would seem better to have allowed such societies to flourish in their own way, though the newcomers, without forcible interference, might yet give them the benefit of a superior technology: their primitive methods of agriculture, for instance, are unsatisfactory, and their therapeutic practices inadequate, particularly when faced with the problems arising from contamination and epidemic disease. I am aware that much is now being done in this line, although a little late in the day, and usually in association with the imposition of less appropriate political conceptions, irrespective of tradition.

As for rival theologies, let us leave the gods to fight it out among themselves! The employment of penicillin requires no religious sanction. For 'savages', life is an elaborate game in which we can take no part. It involves outwitting the demoniacal powers by means of methods well within the compass of the shaman's or medicine-man's voluminous repertory. No spiritual dogmas need be insisted on by our protagonists, no conventions of imported propriety set up. Paganism, too, can boast her virtues, and even a pre-eminence of style, and, as in Art, two or more cultures have been known to associate without discord. Perhaps, indeed, the outcome of racial interfusion may lead to a happier form of society founded on freedom, understanding and good

will; the resolution of all creeds and the eventual celebration of the Marriage of Heaven and Hell in a harmony undreamt of except by a few religious visionaries such as William Blake or Shelley. In such a happy denouement, even the mild injunctions of the Galilean might not be wholly ignored, but the Hegelian erection of an almighty police state would certainly find no support: we have seen too much of that. Man cannot surpass himself, but he can rise to an occasion, for his psychological make-up includes, besides his normal propensity to delusion, an equally fundamental capacity for hope.

Index

Index

Index

Index

Index